DRAWING AND PAINTING HORSES

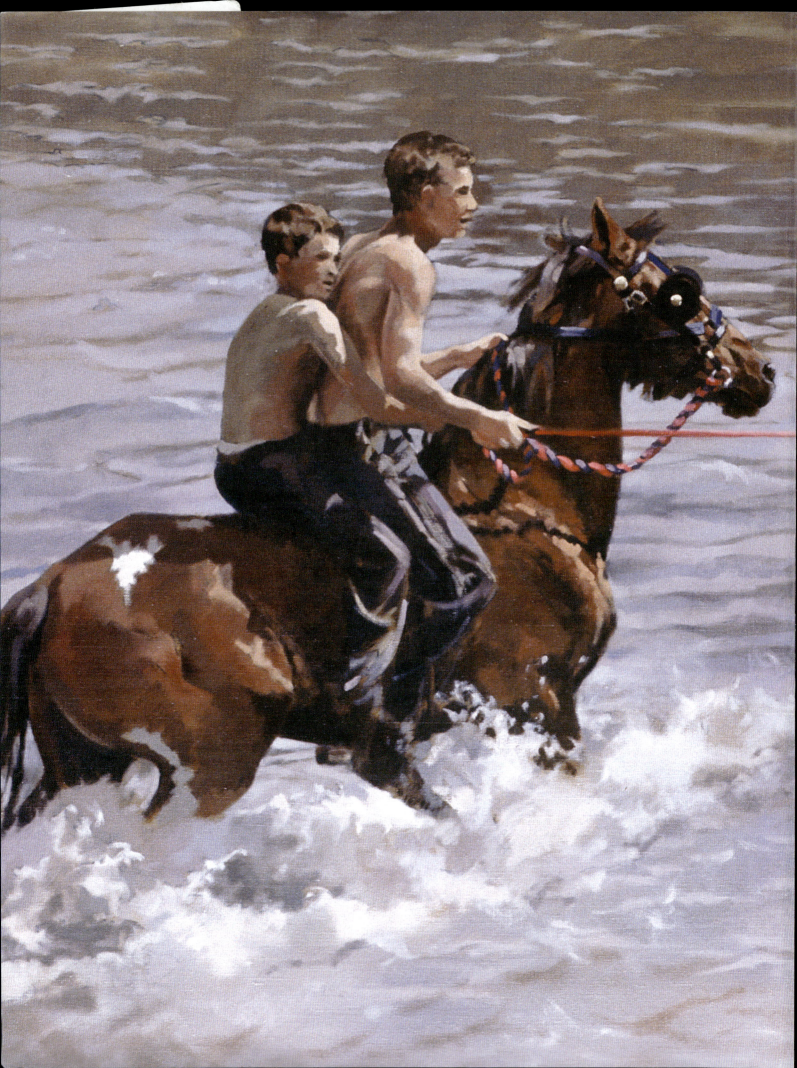

DRAWING AND PAINTING HORSES

ALISON WILSON

THE CROWOOD PRESS

First published in 2013 by
The Crowood Press Ltd
Ramsbury, Marlborough
Wiltshire SN8 2HR

www.crowood.com

© Alison Wilson 2013

All rights reserved. No part of this publication may be reproduced or transmitted in any form or by any means, electronic or mechanical, including photocopy, recording, or any information storage and retrieval system, without permission in writing from the publishers.

British Library Cataloguing-in-Publication Data
A catalogue record for this book is available from the British Library.

ISBN 978 1 84797 599 7

Frontispiece: *Appleby Fair, Two Lads* (detail)

Dedication
For Jonathan, David, Brian and Rita

Typeset by Sharon Dainton, Isis Design, Stroud.
Printed and bound in India by Replika Press Pvt Ltd.

CONTENTS

Introduction		7
1.	Equestrian Subjects	11
2.	About Drawing	19
3.	Practical Drawing	37
4.	Acquiring Specific Knowledge	61
5.	More Drawing	83
6.	Painting Theory	103
7.	Practical Painting	117
8.	Developing a Composition	133
9.	The Painting	153
10.	Professional Practice	179
Glossary		184
Bibliography		186
Acknowledgements		188
Materials Suppliers and Useful Contacts		189
Index		190

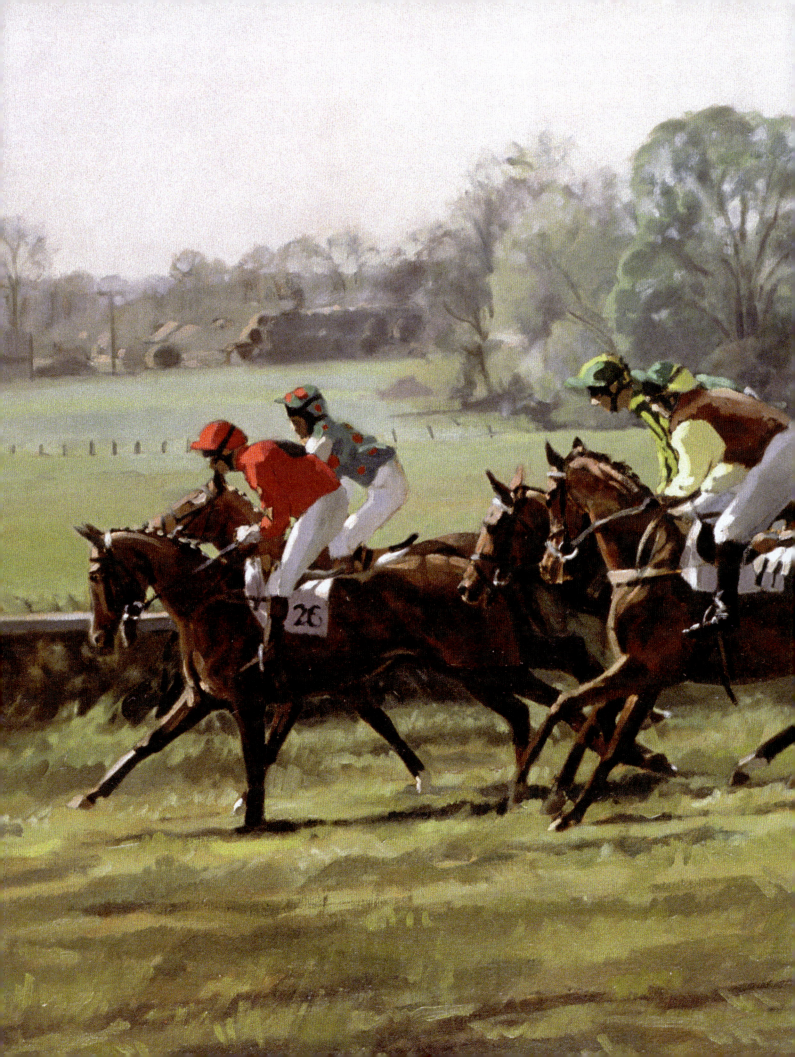

INTRODUCTION

'All painting is drawing, but all drawing is not painting.'

W. Frank Calderon, *Animal Painting and Anatomy*

It is my hope that this book will be helpful to artists at many levels, from artists who have done a little work on horses and want to take things further, to experienced artists who are new to the horse as a subject. However, it isn't a book for complete beginners to drawing and painting; it assumes at least a basic working knowledge of practical techniques on the part of the reader (for example, the capacity to mix colour accurately).

Drawing and painting methods are explained in the specific context of drawing and painting horses, though much of the text should also be helpful to painters of other subjects.

For readers not already familiar with general horse anatomy and terminology, such background information can be found in Chapter 4, including the names of the 'parts' of the horse which will be used throughout the book. Explanations or definitions of other technical terms and expressions not in general usage will be found in the Glossary. Where detailed specialist information might be useful, but where space constraints mean it can't be included in this book, the detailed bibliography will direct readers to other sources of reference.

For brevity, throughout the book the word 'horse' is used to include both horses and ponies, and horses are referred to as 'it' rather than he or she (except where a specific individual horse or group of horses is being referred to). I have used equestrian terminology for coat colour, i.e. grey instead of white, and skewbald rather than brown-and-white. An explanation of the common colours can be found in the Glossary.

The illustrations are all by the author and are in either graphite pencil or oils unless otherwise indicated. In order to make this book a genuine account of my ideas and working methods, I have used as many drawings as possible from my working sketchbooks, so inevitably some of them will appear worn or otherwise not pristine. The majority of the drawings come from sketchbooks that are between A4 and A3 in size.

The book begins with a short overview of the most common traditional equestrian subjects, and includes examples of the work of some contemporary artists. Context is important in any subject, and we all need to be aware of the work of our contemporaries and those who have gone before us. Other artists have so much to teach us, however different their style may seem to be from our own, that it is foolish to ignore them. (Later, in Chapter 5, there is some direct advice on how we can make use of the work of our predecessors to assist our own development.)

The next section of the book is concerned mostly with drawing. I make no apology for spending a lot of time on drawing. As the artist Walter Sickert said, 'drawing is the thing', and no serious artist gets far without it. Even if your own personal interest lies in painting, and your instinct presses you to skip the drawing chapters, I urge you to read all the chapters in order, including the ones on drawing. Drawing is the grammar of art, and even if you don't enjoy doing it for its own sake (and I hope that you do, or at least that you will, having read this book), regular drawing is as necessary to us as artists as practice is to a musician.

Good drawing is the foundation of good painting, and without sound drawing skills underpinning them an artist's paintings will eventually reach a 'glass ceiling' beyond which they cannot climb to better things. On a purely practical note, there are also some explanations in the drawing chapters that you'll need to be familiar with when reading the painting chapters. So please trust me – and don't skip the drawing chapters.

The third section of the book covers colour and paint. I work in oils rather than in acrylics, and only rarely in watercolours, so all the paintings in this book are in oils unless labelled otherwise. Acrylics dry faster than oils, which means that overpainting can

LEFT: *Down the Hill, Easingwold.* **Detail.**

be done more quickly, but blending edges etc. can be more difficult. Alkyds' properties are in-between the two. Other than allowing for the effects of these variable drying times, for the purposes of this particular book the differences between oils, alkyds and acrylics are not significant.

Watercolours are less often used in equestrian painting, and will require rather more adaptation. Their tone range is more restricted, and overpainting and layering in particular are not such straightforward options in watercolours. Nevertheless, most of the points I make about painting are equally applicable to watercolours, with or without body colour, and gouache.

Throughout the book I use the word 'tone' to mean lightness or darkness, 'intensity' to mean chroma (or saturation) of a colour, and 'colour' to mean hue.

SAFETY WHEN WORKING WITH HORSES: A FEW 'DON'TS'

Don't feed anything to a horse without the owner's permission, don't wear perfume around stallions. If you are taking photographs don't use flash.

For safety's sake, never put yourself within biting or kicking range of any horse when drawing or painting. This includes all horses present, not only those you are working from. Despite what books may say, some horses can also kick sideways as well as backwards or forwards (for a few years I had the hoof print of a recalcitrant Shetland pony on my leg to testify to this) and, as horses have long legs, their kicking range is large. Horses can, even if held or tied up on a short rope, swing their hindquarters round at considerable speed without warning. If other horses are being led past your subject, be especially watchful. Sometimes horses will lash out at each other as they pass. You don't want to be in between. If a horse's ears go flat back along the top of the head, then keep well out of its way; this can be a sign of anger with violent action to follow.

Don't make sudden movements or noises. Move slowly and deliberately and don't emerge suddenly from behind them. Horses don't like surprises. Avoid rooting around in plastic bags and flapping paper about. Horses don't like the sight or sound of either, and if by some unfortunate chance anything blows away from you towards a horse, it may cause mayhem as the horse shies away from it. If you must use plastic bags, unpack them well away from horses and secure them so that they can't blow away. This advice applies wherever horses are, and whether they are being ridden or not. They are herd animals, and are prey not predators, so their first reaction in a crisis is to kick/bite/run first and ask questions later. To horses, anything that moves at the edge of their vision or makes a strange noise may be a wolf, so be calm and quiet, and switch off the ringtone on your mobile phone.

Paradoxically, the sleepier a horse seems, the more it may be startled if something unexpected happens.

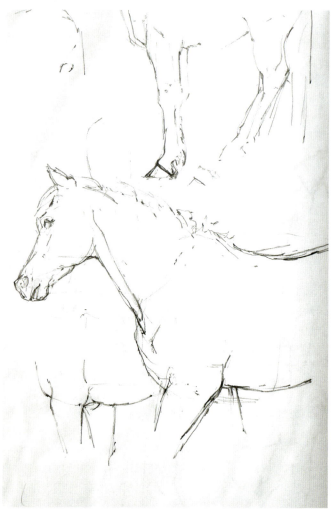

Working drawings from a sketchbook.

The final chapter of the book offers advice for working professional artists.

This book offers encouragement and practical help to serious artists who want to take the horse as their subject. It doesn't offer short cuts or formulas. That's because, for those aiming for real quality in their work, the hard truth is that there aren't any. You won't, for example, find any colour recipes for horses here. That's because a horse doesn't look the same colour in different light conditions. Early on a sunny winter morning, a black horse will look blue-black out of the sun, but will appear positively brown when led into it. A grey circus horse under pink and blue stage lighting certainly won't conform to any standard 'formula' for the colours of a grey horse. With colour, you have to look at each situation as it is. This is a book about fundamental principles, which can be adapted to any situation, whatever the light, or whichever materials may be available. Mastering fundamentals gives an artist the greatest possible flexibility, and is the route to artistic independence.

I have no wish to interfere with or influence the personal style of any artist – I believe that all artists should find their own style and not imitate that of others. By the same token, I don't think that imitating photography is a worthy enterprise for artists. I'm concerned about what is now a very common practice, the slavish copying from horses from photographs, sometimes only their heads as if lopped off by an axe. Even the horses in paintings that have bodies and legs are also often left isolated and with no backgrounds, apparently floating in space. (Horses don't float, they weigh around half a ton, for a start.)

Though for commissioned portraits it may be appropriate to exclude any surroundings, or paint a head only, even then the work should not just be a slavish copy of a photograph, and in their other work artists should be looking to do more than just studies of isolated horses adrift from any surroundings. I want to encourage artists to get out of their limiting comfort zones, and engage with real horses in real environments. It is far more stimulating and rewarding for the artist (and a lot more interesting for viewers too).

Equestrian art has the potential to be so many things – exciting and sporting, contemplative and pastoral, amusing and narrative, dramatic and powerful – but it can't be any of them without artists who aim high and have a good solid range of technical skills. The aim of this book is to help and encourage artists to acquire those skills and make good use of them whatever their personal style, and to try to help artists avoid some of the common pitfalls that can be particularly associated with working with horses.

It is my hope to see the traditions of equestrian and sporting art revive and thrive in this new century, with artists making drawings and paintings that our descendants will enjoy and treasure, just as we enjoy and treasure the work of our predecessors. If this book can contribute in any way to that, I'll be delighted.

Artists can never sufficiently repay the artists who taught them. We can only pay those debts back to our own students. This book is part of that debt. I'll end this Introduction with some words to students from the great Sir Joshua Reynolds' *Discourses*: 'If you have great talents, industry will improve them; if you have but moderate abilities, industry will supply their deficiency. Nothing is denied to well-directed labour: nothing is to be obtained without it.'

CHAPTER 1

EQUESTRIAN SUBJECTS

'Avoiding any preconceived system, and without prejudice, I have studied the art of the Old Masters and the art of the moderns. I no more wanted to imitate the one than to copy the other, nor, furthermore, was it my intention to achieve the pointless goal of 'art for art's sake'. No! I simply wanted to draw forth, from a complete acquaintance with tradition, a reasoned and independent consciousness of my own individuality'
Gustave Courbet, 1855.

Those illustrations in this chapter that are not my own are from contemporary artists, showing a cross section of styles and subjects.

SUBJECTS FROM THE PAST

When the horse was the main mode of transport for humans and goods, and was used extensively in war and agriculture, horses would have been everywhere. Artists would have seen them every day and been completely familiar with them; they would have drawn and painted them as a matter of course. Horses found their way into many paintings where they weren't the central subject, and artists who were not horse specialists and had no particular interest in horses still had to paint them – admittedly in a few cases with rather strange results. However, on the whole, most artists learned to draw and paint horses competently, just as they would any other common subject.

As a result, horses have appeared in thousands of drawings and paintings: religious paintings, paintings of mythological subjects, military paintings, portraits of important (or self-important) secular leaders (for whom horses were a symbol of power), paintings of contemporary life, and history paintings. Horses even appear in manuscript illumination. However, the horse has now almost completely disappeared from everyday life in most Western countries and, due to changing fashions in art and the advent of photography, paintings containing horses now form only a tiny part of the mainstream of fine art.

The call for many of the traditional equestrian subjects has gone, though it can be fun to attempt them for our own amusement (it certainly makes one appreciate the huge range and great depth of skills our predecessors had to have). Thankfully, however, some traditional equestrian subjects have survived and a few new ones have emerged, as horses continue to be part of the lives of so many humans, whether owners or admirers. In fact, there are more horses in Britain now than in the early days of the combustion engine, they just aren't as much in the public eye on a day-to-day basis as they were.

Artists from the past whose horse work in general we should look out for include Peter Paul Rubens, Anthony van Dyck, the Tiepolo family, Theodore Géricault, Sawrey Gilpin, George Stubbs, Edgar Degas, Robert Bevan, Alfred Munnings, George Morland, James Ward, Aelbert Cuyp, Abraham van Calraet, Rosa Bonheur, Alfred De Dreux, Frank Calderon, Lucy Kemp-Welch, and Edwin Landseer.

HORSE RACING

Horses have probably been raced for almost as long as they have been domesticated, but in Britain horse racing became a distinct identifiable genre in the artistic sense at about the same time that racing started to develop formal rules; that is in the time of Charles II, himself a keen rider and 'running horse' (racehorse) owner. Early depictions of horse racing in Britain were largely painted by artists who trained elsewhere in Europe, but British artists soon caught on to the idea. There are, for example, some very large paintings of Newmarket Heath by John Wootton and James Seymour from the first half of the eighteenth century showing the Heath dotted with horses in training, being watched by owners and spectators all on horseback (sometimes even falling off).

As the genre developed, conventions emerged for the representation of horses in the act of racing. When in motion, horses were shown in the 'rocking horse gallop' with all four legs off the floor at full stretch, forelegs forward, hind legs backward. Though some artists were aware that this might not be an accurate depiction of a moving horse, the convention persisted until the late nineteenth century, when photography proved for certain that this position was not part of the normal

LEFT: *Chestnut in the Paddock at Rhydygwern*. **Detail**.

EQUESTRIAN SUBJECTS

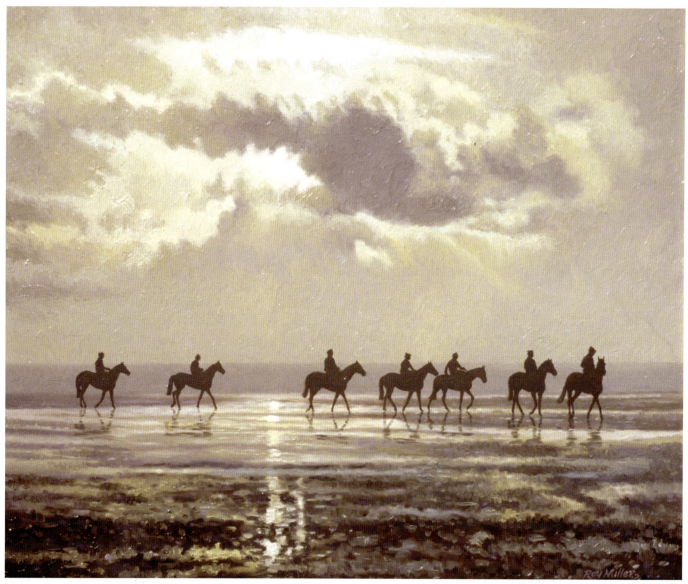

The Water's Edge. **Oil on canvas, 20 × 24 in (51 × 61 cm) by Roy Miller. A very atmospheric painting, precise and elegant.**

leg sequence of the gallop. (Leg sequences for the common gaits are described in Chapter 4.)

As fashions changed, the depiction of horses changed to reflect them. Generally this would just involve showing the way manes and tails were plaited, hogged (trimmed very short) or braided at the time, and, rather more unpleasantly to modern eyes, how tails were being docked, and ears cropped to be fashionably small. Sometimes artists went a little further than reflecting current fashions. For example, at times when small heads were fashionable, they were sometimes shown rather smaller than they would actually have been in order to 'flatter' the horse and please the client. There is an interesting section in Sally Mitchell's classic book *The Dictionary of British Sporting Artists* showing how fashions in the appearance and tack of horses changed over the years from 1700 to the late 1950s.

As racing scenes became more popular, so did portraits of racehorses. The owner of a horse that had won a major race (and often also a very large bet) naturally wanted a painting of his horse to show to his friends; frequently this would include the jockey in the owner's colours as well. Indeed, the eighteenth-century painter Ben Marshall is often quoted as saying, 'I discover many a man who will give me fifty guineas for painting his horse, but who thinks ten guineas too much for painting his wife.' Some of the racing paintings of the time were quite elaborate, including the trainer, his staff and sometimes the owner as well, going substantially beyond horse portraiture to become group portraits, or social narratives, sometimes described as 'conversation pieces'. Horses were shown on the

gallops, in their stables, and before, during and after racing. Some paintings of racing scenes were huge and incredibly complicated, with many figures in the crowd also shown on horseback, for instance William Powell Frith's famous *The Derby Day* (Tate Britain, London), painted in the 1850s.

Artists to look out for in the racing subject area include Thomas Spencer (a contemporary of Seymour), Harry Hall, Emil Adam, Ben Marshall, the Herring family, Peter Biegel, the Alken family, Peter Curling, Michael Lyne and Terence Cuneo.

Modern racing subjects tend to be confined to the formal standing horse portrait (now only occasionally with the jockey on board), horses exercising on the gallops, or the on-course scene, usually within the race itself.

Since the advent of photography, a higher proportion of paintings show horses in motion. Artists before that point seldom depicted horses going faster than a trot. (I suspect they were aware of the problems with the conventional 'rocking horse' gallop and so avoided the issue altogether wherever possible.)

Heading for Home. **Oil, 18 × 14 in (46 × 36 cm) by Hannah Merson. A small, informal painting, almost a sketch, in a modern style.**

HUNTING

Hunting has for centuries been a popular pastime, both for participants and spectators. In Britain, the stag was the original quarry, but the fox was later selected as a quarry species, and eventually overtook the stag in popularity for hunting purposes. Early paintings of hunting show a relatively sedate sport, with ladies riding side-saddle (this was before side-saddles were redesigned in the 1800s to be suitable for jumping).

By the mid-Victorian period, due to changes in agriculture, hunting style and hound breeding, fox hunting had become a far faster sport with longer runs and more jumping. It became an increasingly fashionable pastime in the more affluent parts of British society, and the highest-performing horses became stars.

According to contemporary valuation bands by Goubeaux and Barrier, in their book of 1890 *The Exterior of the Horse*, a top performing English hunter might cost an astonishing 600 to 750 guineas at that time, far more than their estimates for a senior Army officer's charger, and between eighteen and twenty-two times the *annual* wage of a British agricultural labourer at the time. The only horses that were worth more were the top racehorses of the day.

It is hardly surprising therefore, that, in addition to wanting paintings and prints of events out hunting and group portraits of hunt meets etc., owners of hunters, just like owners of racehorses, wanted to commemorate and show off their best horses – in this case often with themselves on board.

Examples of artists whose work included hunting subjects are: Heywood Hardy, Lionel Edwards (facsimiles of whose sketchbooks have been printed), George Denholm Armour, Jacques-Laurent Agasse and Thomas Gooch.

Both racing and hunting scenes became popular subjects for prints, which were distributed widely and spread the popularity of racing and hunting paintings amongst people with smaller incomes who didn't own horses but were still interested in racing and liked to have pictures of rural life on their walls.

LOOKING AT PAINTINGS

If you visit large country houses in Britain you will often find portraits of both racehorses and favourite hunters, though you may have to seek them out – they are not fashionable at present and therefore are not always displayed in the principal rooms. Some of these paintings are by the finest artists, such as Stubbs, Morland, Gilpin and Herring, and would hold their own against the best paintings in any genre. At the other end of things some are almost naïve in style, though often rather charming. A good place to look for the more naïve examples is often the billiard room, or in dark corridors amongst assorted paintings of alarmingly oblong prize pigs, sheep and cattle.

EQUESTRIAN SUBJECTS

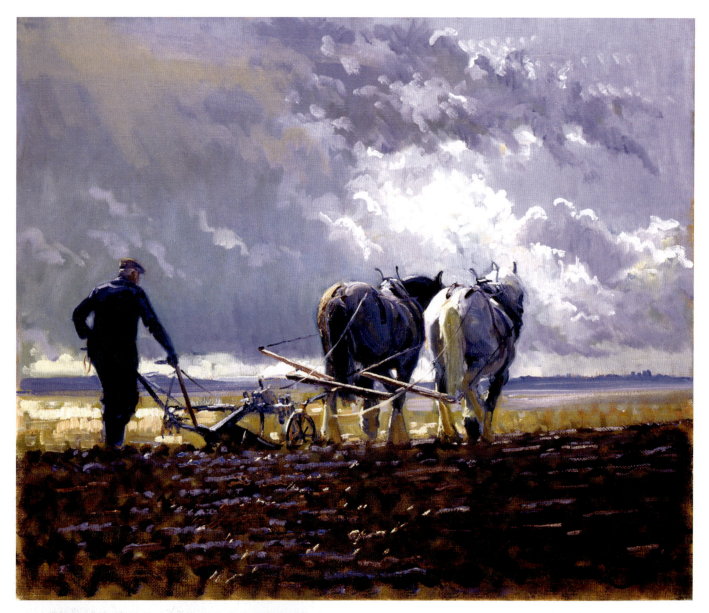

ABOVE: *Ploughing*. **Oil, 20 × 24 in (51 × 61 cm) by Malcolm Coward.**

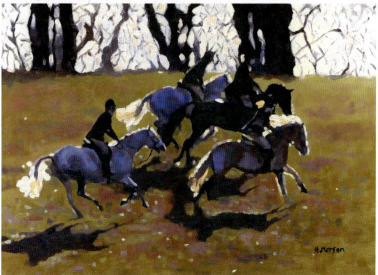

LEFT: *Exuberance*. **Oil, 10 × 12 in (25 × 30 cm) by Hannah Merson.**

EQUESTRIAN SUBJECTS

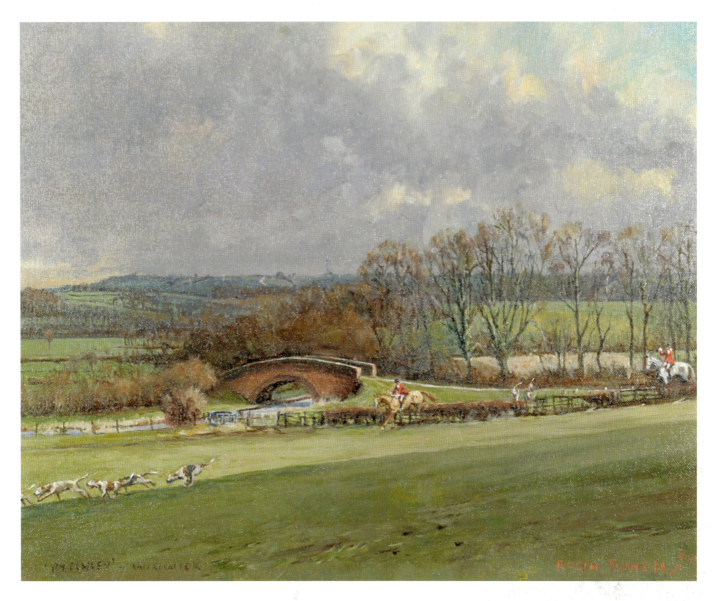

The Pytchley–Winwick Grange. Oil, 16 × 20 in (41 × 51 cm) by Robin Furness.
This painting is in the tradition of Lionel Edwards, and is of hunting in the English Midlands. It shows a typical open landscape of fields and trees, a winter sky, hedges being jumped, and a canal bridge in the middle ground. The painting tells a story as well as describing a place.

The simple, quaint style of the most primitive examples varies little, despite the changes that were taking place in mainstream painting at the time, and they seldom have more than rudimentary, often local, landscapes in the background; the standard is more that of a liberated pub sign than an escapee from the National Gallery. One useful way of assessing equestrian paintings from any period is to imagine them without the horse – how good would the painting look as a landscape alone, or stable interior? In the case of the best artists, the remainder will still hold up as a decent painting on its own, without the horse.

The more primitive paintings show some very oddly shaped horses, and are usually far less well observed in general than the 'mainstream' paintings done by artists who had more access to training and to the work of their peers and predecessors. Systematic training of artists in art schools didn't become the norm for artists until after the advent of the Royal Academy in 1768. Prior to that time, most artists learned their trade by being a working pupil in the studio of a practising professional artist or engraver.

In 1766 George Stubbs' book *The Anatomy of the Horse* was published for the first time. Stubbs drew and engraved the

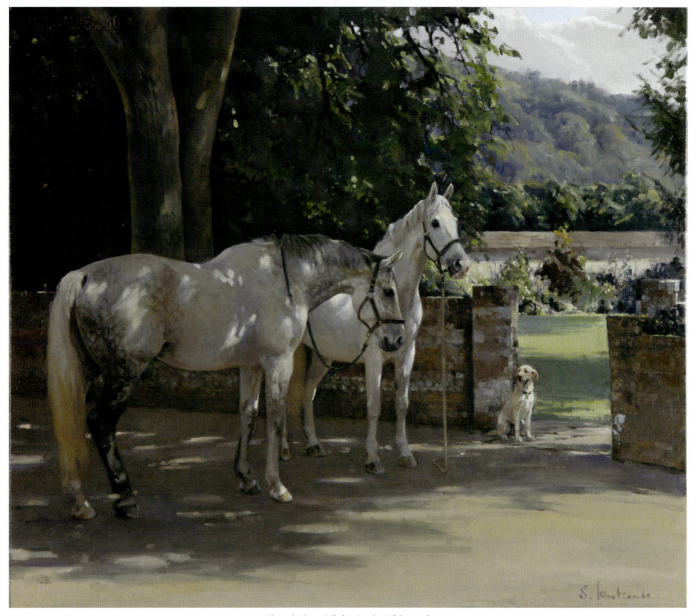

Basil and Blue. **Oil, by Susie Whitcombe.**

illustrations, dissecting the specimens himself. Though this wasn't the first book on the subject in Europe, it was a vast improvement on its predecessors, and is still in print and in use around 250 years later. Although it added greatly to the understanding of horse anatomy, at the time it would have been a very expensive book that few artists could have afforded. It is easy to forget, in these days of very fine public collections of paintings and the ready availability of art books with colour plates at comparatively low cost, that the only way artists of the past could study the great masters or their own contemporaries was via the medium of black-and-white engravings (some of which were back-to-front due to the printing process) or by travelling long distances at a time when travelling was slow, difficult and very expensive, to see the paintings themselves in private collections. Travelling is now much cheaper and easier, books are cheaper and there are many more available (most of which will be printed in colour) and we can visit many national and local state-funded art galleries with very fine collections free of charge. With the advent of the Internet, many galleries have also made some or all of their works available to view online. We are very fortunate to have access to all this, and our predecessors would have envied us; we should make the most of it.

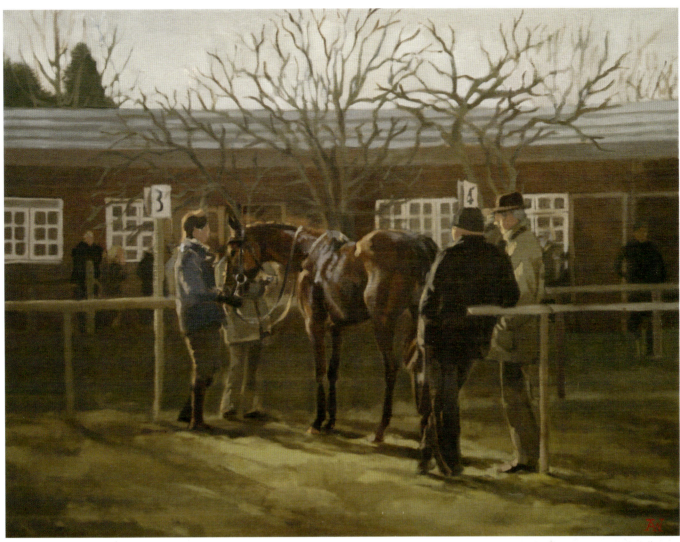
Cooling off, Howick. **20 × 26 in (51 × 66 cm).**

MODERN SUBJECTS

Horses are now mostly used for leisure pursuits, and therefore usually appear in paintings where they form the subject of the painting rather than being incidental to it. Contemporary horse subjects are now broadly confined to racing, 'drag' hunting, pastoral subjects (horses in landscapes, whether wild or not), and horse portraits, either privately commissioned by owners, or of famous racehorses for the general market. More recent horse pursuits, such as show jumping, eventing, and the like, do appear in paintings, though the market for those subjects remains comparatively small and specialized. (Paintings and illustrations of polo have a long and distinguished history in other parts of the world, though polo as a sport only became established in Western Europe fairly recently.)

Some artists are happy specializing in only one or two areas of equestrian painting, but I enjoy working across a broad range of subjects, including those outside the horse world, as this helps me avoid staleness and repetition. However, whatever we choose to draw or paint, we need to get on with doing it, which leads us neatly into Chapter 2.

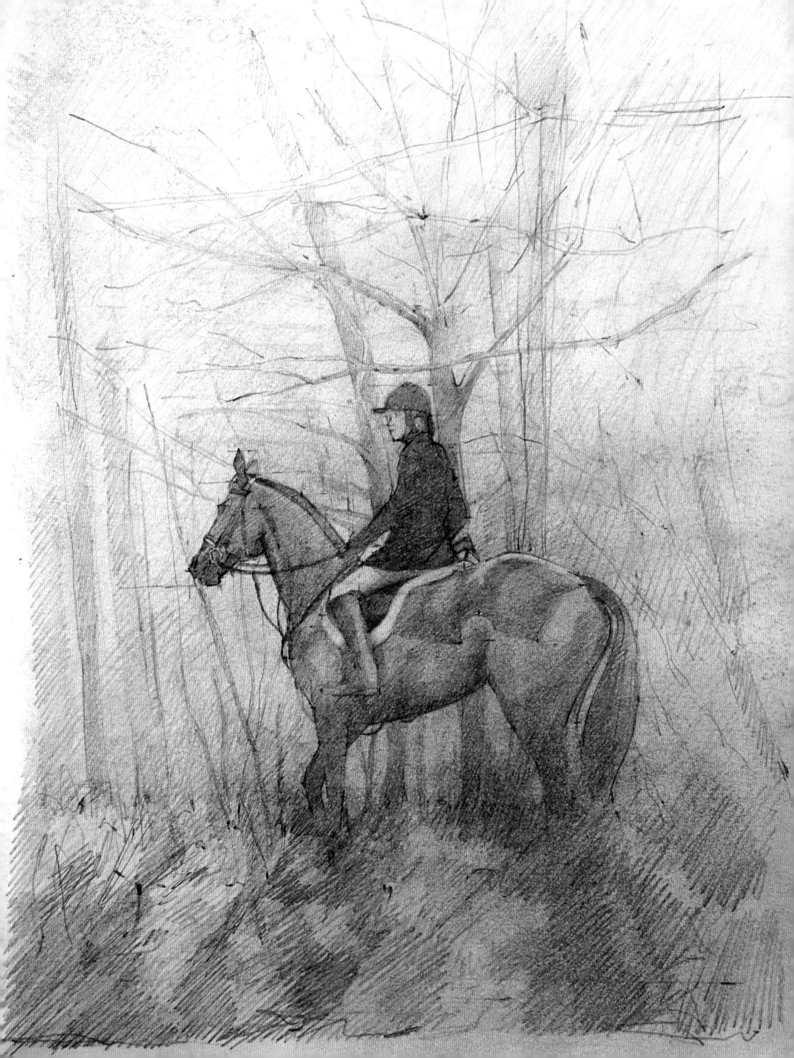

CHAPTER 2

ABOUT DRAWING

'You can't make a line mean anything unless you know what you intend it to mean.'
W. Frank Calderon, *Animal Painting and Anatomy*

Drawing is the foundation of everything an artist does. We draw to record, to study, to communicate, to help us see. We draw to understand the three-dimensional form of a horse, to plan compositions of paintings, to record details of tack, to study the work of our predecessors, to explain to fellow artists a problem we have, to capture a fleeting movement of a colt in a field. We draw in sketchbooks, on expensive handmade paper, on the backs of envelopes. At the most fundamental level, drawing is our language. When we paint, however freely, we are still drawing, whether we realize it or not. Every decision about where paint goes is drawing.

Traditionally, art schools didn't allow students to paint until they had demonstrated that they were competent draughtsmen. Though I wouldn't suggest following quite such an austere policy, I would certainly agree that a good grounding in drawing from life is an absolute necessity for anyone who wishes to learn to paint well. If an artist's draughtsmanship is weak they may get away with it for a while, though they won't fool more experienced artists, but eventually their deficiencies will restrict their development as a painter and limit the sort of subjects that they are able to attempt.

Fortunately, just about anyone can learn to draw from life to a reasonable level of competence, though it requires time and hard work. It's important to remember that even the best draughtsmen struggle with their work at times, but we all have to persevere. None of us can ever afford to stop practising, as there is always more to learn. Luckily, most of the time this is as enjoyable as it is challenging. (For those completely new to drawing horses from life, you will find some guidance in Chapter 3.)

As stated in the Introduction, it is every artist's responsibility to develop their own style. Within traditional representational drawing there are huge variations not only in style, but in technique, materials, scale, measuring systems and mark making. No methods are 'right' or 'wrong' in themselves; they can only be appropriate or inappropriate according to the purpose of the drawing in question. However, what all representational drawings do have in common is this: they are recording a three-dimensional world on a two-dimensional surface. If we are to do this effectively, whatever our style or methods of working, then we need to be able to do two things: to observe objectively, and to record accurately. Even if we choose to distort or change what we see, we should be doing this from a point of understanding, rather than one of ignorance. In the words of the artist Harold Speed, 'If you can't paint what you see, how can you paint what you imagine?'

OBSERVING OBJECTIVELY (LEARNING TO SEE)

Seeing objectively sounds as though it should be the easiest part of drawing, but it is probably the most difficult thing that an artist has to learn to do, and we never stop having to work at it. It is all too easy to 'see' what you *assume* is there, what your 'knowledge' tells you *ought* to be there, or what your personal taste would rather *like* to be there, rather than what really *is* there. Here are some examples of failings in the 'seeing' process.

Making Assumptions

Most people know that a horse's two forelegs are the same length. But they won't necessarily look the same length. If one leg is further away from you than the other, it will look shorter. This is a manifestation of perspective, and is called foreshortening (perspective and foreshortening will be covered in more detail later). The closer you are to the horse, the bigger that difference in length will be. If, because you assume the legs are the same length, you make them the same length on your drawing, then you will be in trouble; this trouble will get worse as you go on to draw other parts of the horse.

LEFT: **Study in pencil for the painting** *In Bishops Wood.*

Over-Standardization

If you spend too much time studying anatomy and conformation and not enough on drawing individual horses from life with all their individual quirks, you may subconsciously get into the habit of tidying up every horse to more 'ideal' conformation, or to more standard proportions for its type. Doing this consciously because you choose to in a very specific situation may be appropriate. Doing it without thinking (such as when working on a commission of a dearly loved old horse, part of whose charm to his owner is that he's always had a crooked foreleg and a strange way of standing) is incompetence. The great George Stubbs painted a horse called 'Bandy', and the painting clearly shows the bandy leg that gave the horse his name, and his painting of 'Molly Longlegs' speaks for itself. Like humans, few horses have perfect proportions and conformation; that's often what makes them interesting. It is necessary to be able to observe objectively first before you can consider tinkering with reality.

Personal Tastes

Personal preferences can subconsciously distort what we see. If you prefer a Thoroughbred or lighter type of horse, it is all too easy when drawing a cob to subconsciously underestimate its bulk or the thickness of its limbs. To make a horse pulling a gypsy varda (caravan) look like it ought to be running in the Champion Hurdle is, to be polite, a little unconvincing.

TECHNIQUES FOR ACHIEVING OBJECTIVITY

Achieving genuine objectivity in observation requires a lot of practice. There are some specific techniques artists use to help them to avoid the traps mentioned above. Checking verticals and horizontals, comparing proportions, and drawing 'negative shapes' are quick and effective. A more complex method that some artists employ to assist them in accurate observation is 'measurement'. If used correctly, measurement is an excellent objective way of checking observations. All these techniques will be described later in this book.

RECORDING ACCURATELY

Once you have made your observation, you then have to record it. Though in many ways this is the easier part of the two, it still requires skill and practice. I generally recommend that people work in line alone without any shading when learning to draw, when drawing from life, or when dealing with any difficulty other than a specifically tonal one. Line drawing makes it easier to get to grips with proportion, scale, composition, and structure. If corrections need to be made, line drawings are also easier and quicker to correct. A clean line, suitably broken and weighted, suits this purpose better than a scribbled or 'hairy' one, which can make a drawing unreadable and flat. Hairy lines tend to average out into one woolly contour, losing any carefully observed subtleties in the lines. Shading over a line drawing, whether done up to lines or across them, can also cause a significant loss of information from the lines.

I don't encourage the routine use of erasers for making corrections. I was taught to draw without one, and it taught me to think about the marks I made and to place them accurately.

Once you have made your observation, decide where your particular line needs to be, and what its shape should be, and then put it down lightly and cleanly 'in one go'. If you make a mistake, don't mess about with it or panic and reach for the eraser. Calm down, work out what has gone wrong, and then just correct the line with a slightly heavier one. Be methodical about it.

As a drawing evolves, you may wish to add some more detail to a line. There is still no need to reach for an eraser, just add your new information with a slightly heavier line. This makes the drawing a record of the 'seeing' process, giving it a richness which is pleasing to the viewer; it shares with them your own pleasure in your exploration of your subject. In effect, the drawing is telling a story, saying 'first I saw this, then I looked again more closely and saw that'. Only if you make a very big mistake, which will continue to confuse your drawing whatever you do, should you give up and rub a line out.

The exception to this is where a drawing has been specially commissioned to be in a style that doesn't permit any visible corrections, such as a technical illustration, for example.

THREE-DIMENSIONAL FORM

When we draw, it is all too easy to become absorbed in observing edges and to forget that horses aren't flat. A horse is a substantial animal, wide in the body and around half a ton in weight (if a horse is lying down on its side, you can more easily see how bulky its body is). The overall contour around the horse's body that is observed from a single viewpoint is not a continuous single edge, it is composed of the outer surfaces of many component parts which are overlapping and crossing over each other. If you draw an outer contour as a single continuous line with no breaks or variation of weight (that is, the thickness and blackness of the line), you are not 'explaining' these surfaces and structures, and the horse will look like a cardboard cut-out, or as if it has been made from a wire coat-hanger.

ABOUT DRAWING

A drawing showing overlapping lines, broken lines and variations of line weight being used to describe the roundness of the form. Where a line has needed correction, a new, heavier line has been added, rather than rubbing earlier lines out. The background has also been taken into account, which gives the drawing some depth, and the horse some space to live in.

Building up lines as we observe more can add substance to a drawing, but making lines 'woolly' from the outset tends to obscure subtleties in shape and detail, making the drawing rather flat.

Drawing contours without consideration of how forms overlap and/or blend into each other makes a drawing appear very flat, and can cause confusion later if we wish to work from the drawing.

We need to be able to understand what we are seeing in three dimensions if we are to make structural sense of it when we record it in only two. To develop an understanding of form it is necessary to work from life, where it is possible to walk up to the horse and/or around it to clarify our understanding of the form when we are unsure about what we are seeing. Drawing from a photograph doesn't help to develop this understanding, as the horse has already been resolved into two dimensions.

In theory, a perfect draughtsman doesn't need to know any anatomy or conformation to draw accurately; they will observe completely objectively and record exactly what is there. In practice, and provided it is used thoughtfully and with discretion, a knowledge of basic anatomy and conformation can be genuinely helpful when working from life; it can help us see and understand things we might otherwise miss. For example, a contour may not be the result of a single muscle, but of two muscles that overlap each other. Being aware of those muscles may prompt an artist to look more carefully, and therefore see and represent the form more accurately.

LINEAR PERSPECTIVE AND FORESHORTENING

Linear Perspective

Linear perspective is a huge subject, and there are essentially three ways to approach it. You can study it in great detail and apply it rigidly, you can ignore the theory altogether and observe everything you paint purely objectively, or you can find some combination of the two that suits the way you work.

If you draw and paint only from your own observation, provided you observe accurately (and that's a big proviso) you have little to worry about. If you work a great deal from your imagination, then you may need to make an extensive study of perspective theory in order to ensure that your paintings have spatial coherence. Most of us fall somewhere between the two; we work mostly from observation, but at times wish to add things to, or move things within, our compositions. In such cases, we need to be aware of at least the elementary aspects of linear perspective. For most paintings of horses, the most important things to be aware of concerning perspective are:

- Things look smaller the further away from you they are.
- Things at your eye level will stay at a constant level.
- Things at a uniform height above your eye level will appear to fall towards your eye level as they recede away from you.
- Things at a uniform height below your eye level will appear to rise up towards your eye level as they recede away from you.
- Verticals stay vertical (a big approximation, but it works for most situations the equestrian artist is likely to encounter).

In practice, if you and all your horses are standing on level ground, their feet will appear to move up towards your eye level the further away from you they are, and any parts of them that are above your eye level will gradually appear to drop towards

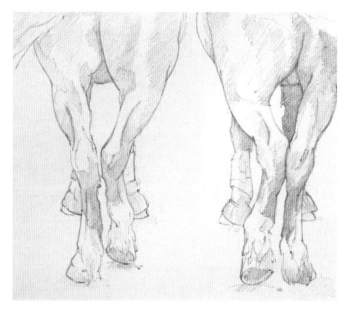

In this detail of a drawing from later in the book, the lines describing the shapes of surfaces cross the outer contour of the horse, establishing the form.

your eye level. Any parts of the horses actually at your eye level will stay at that level. This automatically means they will appear to get smaller as they go further away, fulfilling the first rule.

For simple paintings of horses outdoors, remembering the above rules and using a little common sense should carry you through most of the time. However, if you embark on subjects involving special cases, such as where the ground is not flat, or with horses on different levels, a specialized book on perspective (such as Rex Vicat Cole's book, see Bibliography) can help.

If you wish to add a horse into a composition where there are other horses, a knowledge of perspective should help you to work out how tall it should be wherever you put it. However, if you do decide to do this, not only its size, but also its degree of foreshortening (see below) should be appropriate for its distance from you. Getting both of these things right is not easy. Potential problems that can arise when using mixed source materials in one composition are described in Chapter 7.

One last point: don't forget that the sky has perspective too. Clouds which are the same size and at the same height will gradually appear smaller and appear to drop down towards the horizon as they recede into the distance (because they are above your eye level).

Foreshortening

Foreshortening could be said to be another manifestation of perspective. When artists talk of foreshortening they usually mean the way perspective operates within an object.

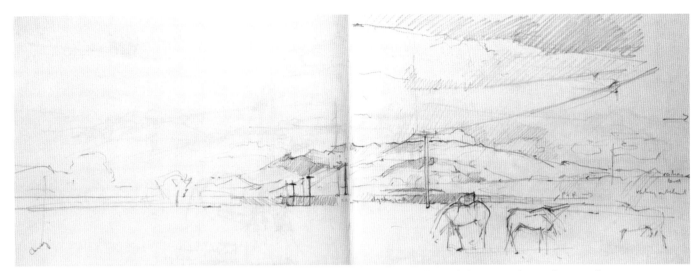

One of the classic cases of perspective – telegraph poles getting smaller and closer together as they recede, their tops dropping towards my eye level.

Foreshortening is most pronounced in an object's appearance when we are close to it, because it is determined by the relative distances from us of different parts of that object. If we are a long way from an object, no one part of it is significantly further away from us than any other part as a proportion of our distance from either of them. If we are very close to it, some parts may be as much as twice as far away from us as others, so they will appear half the size of their closer counterparts of the same actual size.

Excessive foreshortening can easily cause a beautifully proportioned, well-muscled Thoroughbred with a fine, delicate head to appear to have a huge, ill-proportioned head, terrible conformation, the forehand of a carthorse and the hindquarters of a goat. It happens. I have seen plenty of examples of it. No client commissioning a portrait will thank you for that.

There is no law that says you can't draw (or paint) very foreshortened horses. But if you do decide to, be careful to keep it consistent. Don't foreshorten one part of a horse and not others; if you do it will look even more like the horse has been assembled from a kit of parts that don't match. The trouble with extreme foreshortening is that even if you get it 'right' it can still look 'wrong', ugly, or even comical.

There is another disadvantage to extreme foreshortening. Because it only happens when we are very close to things, when the resulting work is on the wall it makes the viewer feel dragged as close to the subject as the artist was. This is acceptable for a gimmick occasionally, but such paintings can be very difficult to live with; they are unsettling and 'in your face', and it is in their nature that the main thing you see when you look at them is the foreshortening as it swamps all other impressions. If that's your aim, fine. But if you are trying to achieve other things, particularly anything elegant, subtle, restful, or complex, you will be fighting the dominance of the foreshortening all the time, a battle you're almost certainly doomed to lose.

Very foreshortened subjects can be fun to do for a change, and drawing them can be useful when trying to understand form and anatomy. They are an excellent, though demanding, exercise when learning to measure at an advanced level. But don't let foreshortening run away with you. In the words of W. Frank Calderon, 'By purposely adopting some peculiarity of manner, some trick of design or execution, which becomes a sort of trade-mark, an artist does himself no good, for, although it may procure him a certain amount of publicity for a time, as the novelty passes away this soon disappears.' This is a concept that can be applied to more things in painting and drawing than just excessive foreshortening.

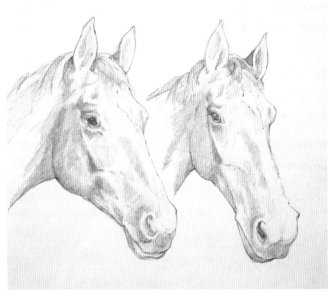

The same head, but from different distances. The example on the right is from so close that the head has become very foreshortened.

ABOUT DRAWING

100 feet (30m) from nearest leg.

33 feet (10m) from nearest leg.

13 feet (4m) from nearest leg.

The Effects of Foreshortening

The diagrams here show the effects of foreshortening and how its effects vary from different distances. For each pose, Flair's position didn't alter as I moved away to photograph her. We were on exactly the same level ground throughout. The distances measured are between me and her closest hoof.

At approximately 100 feet (30 metres) she appears to be broadly in proportion. Even on the back/front views, where any height differences would be most pronounced, the difference in height between fore hoof and withers, and hind hoof and croup (the same height on this horse), is only about 6 per cent – not very much. On the ¾ views the difference is barely noticeable.

At approximately 33 feet (10 metres) proportional changes are emerging in the ¾ poses and there are now clear height differences from the front to the back of the horse in the back and front views; a difference of around 12 per cent. Where her head is closest to us, it is beginning to look rather large, and when furthest away it is looking rather small. However, none of these poses look very strange or unnatural (though some are a trifle unflattering) and some are quite interesting in shape. Here, the foreshortening is interesting without being intrusive.

However, when we get to the closest views, from around 13 feet (4 metres) the foreshortening becomes much more pronounced. The maximum difference in height between her forequarters and hindquarters is around 30 per cent. Her head looks enormous when closest to us, and ridiculously tiny when furthest away. Even the side-on pose is showing significant differences – the legs on her right side are noticeably shorter than those on her left, and her right hind leg also looks shorter than her right foreleg. (I am standing on a line from her shoulder at 90 degrees to her spine, so the hind legs are further away from me than the forelegs. This slight difference is negligible when I am further away.) I'm also looking more down on her hooves. These poses might be interesting to draw or make studies of, but it is difficult to see them working well as part of a broader composition where everything else had to be foreshortened to match, and they would be likely to cause friction and disappointment with most clients wanting portraits.

When it comes to photography, because foreshortening is about relative distances, it is independent of the lens used. To maintain consistency between these poses, I used photography as a basis, but had I made drawings from similar positions, the results would have been the same. The only way to lessen the effects of foreshortening on a pose is to move further from the subject. To make the horse large enough in a photograph, that may also mean using a stronger magnifying lens. But it isn't the lens that is solving the foreshortening problem, it is the greater distance. Using a long lens too close will cause exactly the same trouble as any other normal lens at the same distance.

ABOUT DRAWING

100 feet (30m) from nearest leg.

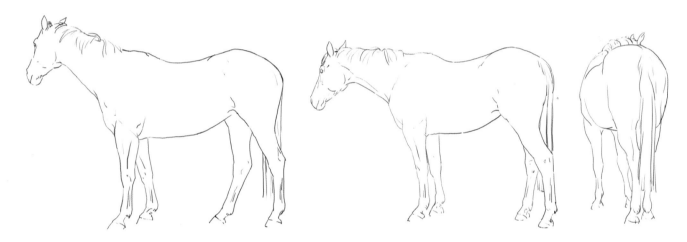

33 feet (10m) from nearest leg.

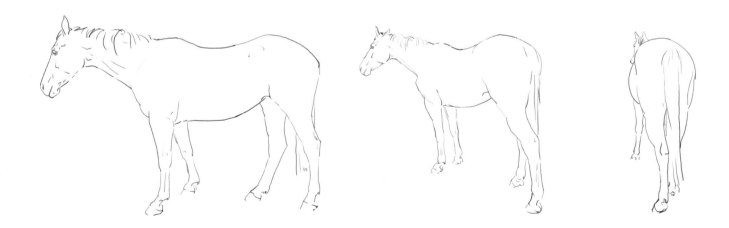

13 feet (4m) from nearest leg.

ABOUT DRAWING

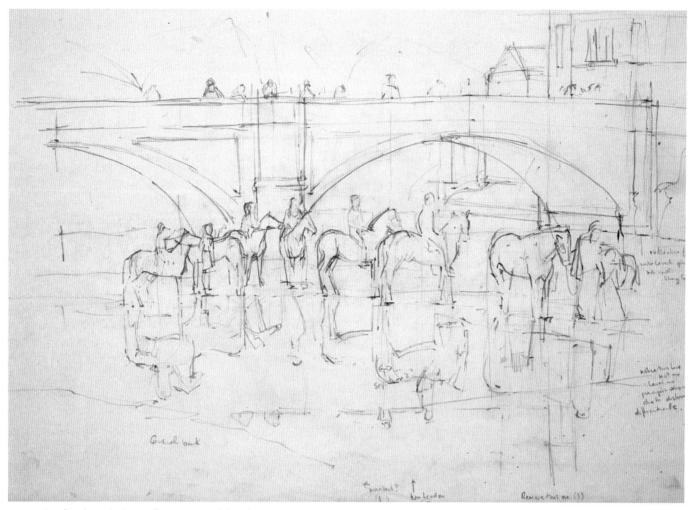

Drawing for the painting *Reflections, Appleby*, showing observations of the way horses and their surroundings are reflected in water (and also the way the horses and figures appear to get smaller as they go further away due to perspective). In this case my eye level was above the horses as I was sitting on the riverbank. Notice how the reflection of each object is as far below the water level as the object itself is above it at the point that the particular object touches the water. This is why, in the reflection, the head of one of the central riders appears to be at the same level as the bridge parapet – the bridge touches the water at a point much higher up the painting than the point at which the rider's horse's legs touch the water.

REFLECTIONS AND SHADOWS

In general, when it comes to reflections and shadows, I prefer to work more on observation than theory wherever possible, as it is all too easy to calculate such things incorrectly. Theory is all very well, but there are so many variables in real life that have to be taken into account that accurate observation at the time is always the most straightforward option.

When working from life outdoors there is one essential difference to remember between shadows and reflections – they may both appear and disappear as the light changes, but the shadows will move as well; the sun moves round at the rate of 15 degrees per hour, and also rises in the sky during the morning and falls during the afternoon. Shadows can move and change their shape a great deal in the space of an hour.

If you think you may be doing a lot of work involving reflections and/or shadows, or if you are interested in the optics/geometry involved, then I suggest that you study the relevant chapters in Rex Vicat Cole's book on perspective listed in the Bibliography, as he explains both reflections and shadows very well.

Reflections

Reflections of an object in water will appear to be the same distance below the water level as the object in the water is directly above it; in effect, the water acts like a plane mirror.

ABOUT DRAWING

This is easy to see in a simple example, such as when a vertical pole is standing out of the water; the reflection of the top of the pole will be directly underneath it, and exactly the same distance below the water level as the top of the pole itself is above it.

However, everything becomes far more complex when an object is beyond, rather than directly standing in, a body of water, such as a horse standing on a slope beyond the water, or clouds in the sky. In such cases, if the reflections have not been observed at the time, reconstructing them would require the application of a little geometry. In such a case I would again suggest referring to Rex Vicat Cole.

When colours are reflected in water, they usually lose some of their intensity (saturation) and their tones may change, they may be darker, and/or show less contrast.

Reflected shapes may break up if there are currents or wind and the water isn't still, and even on still water, the edges of objects may appear softer or more blurred than the edges of the objects themselves.

Reflections on shiny but curved surfaces, such as the sides of a car, will be distorted to follow the surface, and if that surface is coloured, then its colour will have an effect on the colours and tones of the reflections as well.

Shadows

Shadows can be calculated if you know the angle of the light and the exact three-dimensional shapes of whatever is creating the shadow and all the surfaces it is falling on. With a horse, that will be a very complex shape, so as with reflections, observation is the preferred method. If you didn't record, or couldn't see, the shadow cast by your horse when doing preliminary drawings, or you are constructing a painting from your imagination, then this is one situation where I would consider using a lay figure. Set the lay figure in the correct pose, place a sheet of white paper under the model horse's feet at the angle of the ground, and, using a strong light from the appropriate direction from as far away as possible (the sun is a long way off, which affects the shape of shadows), cast its shadow and observe it. Remember to place your eye at the same level as the eye level in your picture.

Both the sharpness of shadows and the contrast between the shadow areas and the light areas around them indicate the strength of the light; you would only expect to get high-contrast and sharp-edged shadows in very bright light.

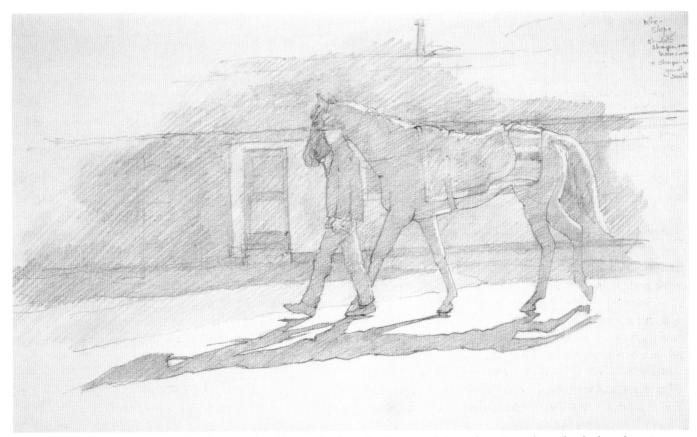

The shadow here is sharpest when closest to the object casting it, and as the ground slopes down towards us, the shadow elongates. Also note that when a hoof (or human foot) is lifted above the ground, there is a gap between the shadow and the object casting it.

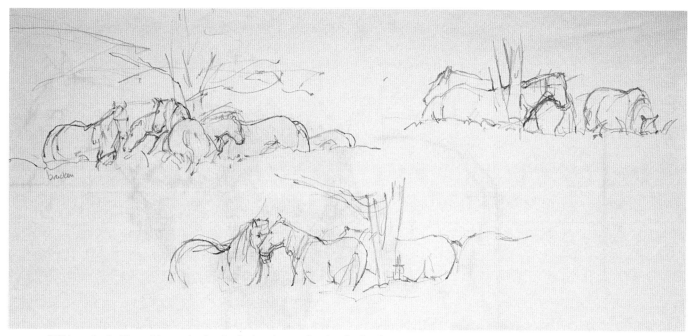

Wild ponies in Shropshire gathering in the bracken under the shade of a tree in hot weather (from slightly higher up the hill). Simple pencil line is a good medium for recording the way horses group and regroup.

MAKING CHOICES: PURPOSE AND SELECTION

The Need for a Purpose

Whenever we draw (or paint) we are setting ourselves a problem; the job of the drawing (or painting) is to solve it. If you don't know why you are drawing, you have nothing to guide you as you select your materials, or as you work on the drawing itself. Aimless drawing on autopilot tends to achieve very little except take up time that might be more constructively spent doing something else, like learning to play the banjo or clearing out the drains. It is necessary to have some idea at the outset what you are doing a drawing for, even if your purpose is just to 'play' with a new material or to 'loosen up' to get rid of stiffness in the wrist and focus your concentration at the start of a drawing session.

When you draw, always have some intention clear in your mind. It could be that you merely want to pick up a sketchbook and draw horses grazing, just for practice. It is still a good idea to have an end in view. Perhaps you could study how the horses group themselves. For that, it might be most effective to make a series of line drawings in pencil as the horses group and regroup.

If you were drawing a single horse in a similar situation but were more interested in how the light catches it as it stands under the trees as an idea for a possible future painting, then using soft, blocky shading to show the shafts of light on the horse's back might be more appropriate than a line drawing. Identifying the purpose of a drawing helps us focus on the best way to achieve it, in both materials and technique. The materials and techniques chosen for a drawing should always reflect the purpose of the drawing and help us to make the best possible job of it.

Selection and Simplicity

Drawing (and painting too for that matter) is not about recording every detail indiscriminately. It is a process of selection; selecting important things in, and unimportant things out. This brings us back to the concept of 'purpose' discussed above. Drawing is about selecting what to record according to the purpose of that drawing. If you are drawing motion from life in order to understand the movement of the shoulder within a stride, a simple drawing of a few lines may be enough to record the changes in the angle of the shoulder as the foreleg moves forwards and backwards at the walk. At the other extreme, a fully shaded drawing complete with background may be required if the drawing is a preliminary study to work out the balance of all the tones for a large and complicated painting.

The simplest drawing that will fulfil the purpose of a particular piece of work will always be the strongest one. If an artist is tempted to add eyelashes because, like Everest, 'they are there',

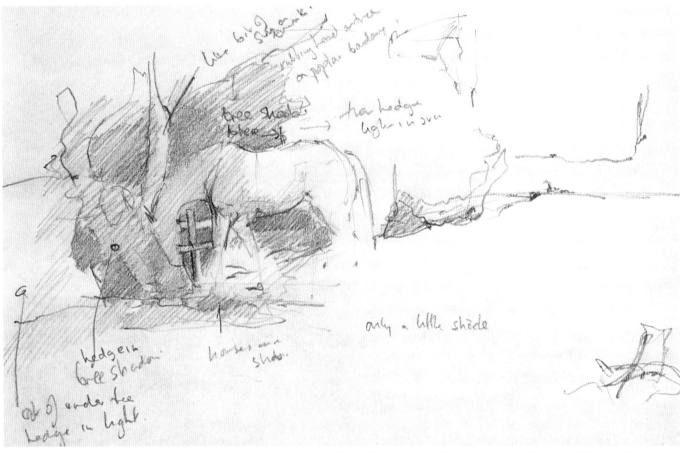

A quick drawing of a horse standing in the shade of a tree in a field, with blocky shading being used to show the fall of the light.

they need first to ask themselves this question: 'Will adding these eyelashes contribute directly to achieving the purpose of my drawing, or merely clutter and undermine it?'

It is necessary to distinguish clearly at the outset between detail and accuracy. Accuracy is about the quality of information in a drawing or painting; detail is about the quantity of that information. A drawing does not become more accurate just because more and more details are piled onto it. A simple drawing of a few lines may be very accurate, and a drawing stuffed with hundreds of different tones, with every hair individually drawn, can still be desperately inaccurate.

Detail is therefore, of itself, neither good nor bad. There are good detailed drawings, and good simple ones. The level of detail that is appropriate for a drawing depends entirely on the context of the work in question. However, we need to be sure that we genuinely do need all the details we record on a drawing and that we aren't merely adding them on 'just for the sake of it'. Far more drawings are spoiled by too much detail than by the lack of it. Take a look at the drawings of the old masters – they are often very simple. Even where they are detailed, all the details are there because they matter – they aren't mere decorative flourishes or stylistic tics. Master draughtsmen understood that crucial thing that is so hard to learn – when to stop. They recorded only the information genuinely necessary for the purpose of their drawings. That is what makes their drawings so strong.

I suspect that the modern problem of overworked drawings is a lot to do with photography. Working from photographs tempts artists to work in far greater detail than is either necessary or desirable. Some artists just stuff into their drawings everything they see in their photographs. A drawing isn't an expanding suitcase. Just because you can see something, whether in life or in a photograph, that doesn't mean it's important. In mathematics, the simplest solution to a problem is the most highly regarded, and is called the most 'elegant'. The same can be said of drawing.

THE DRAWING PROCESS

When we work from life, it can be a real challenge deciding what is important to record and what isn't. This challenge is made greater because what is in front of us isn't even static. Our horse is a living creature and will move, and the light is continually

changing, affecting colours, tones and shapes, and their relationships with each other. We may begin a drawing by thinking that the key to it is the light shape of a grey horse's back silhouetted against a dark hedge in shadow. As we work, we naturally see more, and understand more, of what we are drawing, making corrections if we need to. In addition, over time, the light changes, perhaps it catches the hedge, the shadow of a tree may cut into the light areas on the horse's back and break up that hard silhouette, indicating more of the roundness of the body, and we may realize that the white dog roses in the hedge make an important pattern, which echoes the dappled light on the horse and outlines the shape of the back. We retain the idea of the shape of the grey horse against a dark hedge, but that shape is becoming subtler, a mysterious shape, made more elusive by the now dappled light on the horse, and the roses in the hedge, and the drawing changes and develops to reflect this deeper understanding.

This is as it should be. A drawing should develop as we see more, and begin to understand more, of our subject.

We may even decide at some point that we need to begin a second drawing. It is often the case that it's only when you have been drawing for a while that you realize you need to extend your drawing to include more of the background, or that you have chosen the wrong place to draw from and need to move to get a more effective angle on the horse. To develop a drawing we must take time to look, think, and understand.

PLANNING A DRAWING

Let us take some things to consider in the simple case of a drawing of a single horse. In each case, decisions on how to deal with any aspect of a drawing should be made on the basis of the purpose of the work.

Light

Before you start, consider the light (and how it will change as you work). What lighting would be the best for your purpose? Might another time of day be better? If that's not possible, perhaps you could change the position of your horse? If your horse looks too flat, you might try standing the horse at a different angle to the light to bring out the form.

'Raking' light (light coming more from your right or your left than from directly behind or in front of you) is good for showing form. Don't forget to consider how the light will affect you too – if the sun is strong and is falling directly on your paper, you will be dazzled by the white paper and might find it difficult to draw. If the sun is directly in front of you, it may be difficult to see anything in the shadows.

Position

Think carefully about your position. Might the landscape behind your horse be less intrusive, or more interesting, if you moved a few yards to your right? Or a little further away? Or if you had the horse stand in a different place altogether? Watch out for any unfortunate conjunctions. You don't, for example, want your horse to look like it has a tree growing out of its head.

Eye Level and Sloping Ground

It's surprisingly easy not to notice that you are on higher or lower ground than your horse. Some drawings from unusual eye levels are interesting, but if you aren't careful they can just look like you can't draw; for instance, if you are significantly higher up than your horse, it may look like it has very short legs. If you do choose to use an unusual eye level, you may need to 'explain' it by the way you draw other things, such as the landscape, or buildings in the background. (See Chapter 3 for an example of two horses drawn from a low eye level.)

Is the horse itself standing on a slope? If it is, you may wish to have the horse moved onto level ground. In particular, if a horse not under saddle is standing in profile facing down a slope, it can appear to have a 'dipped' or 'hollow' back. This sort of thing can't be corrected by turning your drawing at an angle.

Avoiding Foreshortening

If you don't want a lot of foreshortening in your drawing of a horse, keep at a reasonable distance from it. The optimum distance for achieving this may be greater for some poses than for others (see the section earlier in this chapter).

If you want a flat profile pose of a horse to be as level and standardized in proportion as possible, both you and the horse need to be on the same level ground, and standing such that a line from you to the centre of the horse (at around the horse's elbow) would be at a right-angle to a centre line along its body. Otherwise the horse will be at an angle to the plane of your picture (the front of the horse will be either closer or further away from you than the tail end), making its proportions irregular.

This horse is standing on a slope, and its withers are considerably lower than its croup. As a result, the angles between the horse's body and its legs are not the same as they would be on level ground. A horse's body and legs are approximately bound by a square when standing level. When standing on a slope, that square is distorted, with one opposite pair of angles opening up to more than 90 degrees, and the other pair decreasing to less than 90 degrees. Tilting this new shape so that its base is horizontal won't make it square, just as turning this drawing won't make the horse look like it is standing on level ground.

Including All the Information You Need

There are few things more irritating than realizing when you're working later on in the studio that you want to extend your composition on one side but you have no idea what the buildings or landscape look like there because you stopped your drawing too short. Having to return to the original spot (and having to find a day of similar light and weather, just to complicate matters) is a nuisance, and in some circumstances it isn't even possible. Be sure to record everything you think you may need.

If for some reason it is only possible to take photographs, try to think about the same things you'd think about if you were drawing. Check your images regularly as you work for colour, focus, and exposure in case you are using the wrong settings. If you are using film, keep an eye on your settings in case a dial has been knocked to the wrong setting, or is wrongly set.

Turning the horse doesn't work, even in this drawing, where the horse's pasterns (whose angles would be a sure giveaway that the horse wasn't standing on level ground) are hidden. The angle between the rider and the horse's neck is too great and it looks like he is going to fall over backwards. The legs of the horse stick out forwards, making it look like it must be rocking back onto its heels, and horse and rider's combined centre of gravity is too far back for the horse's leg positions to be sustainable.

PHOTOGRAPHY

Horses were portrayed beautifully and, for the most part, accurately in paintings for hundreds of years before the camera was invented, so clearly it is not necessary to use photography to draw or paint horses, but, like any other technology, there is no reason not to use it – provided it is used appropriately. Many great artists have made good use of photography, Degas being an early and distinguished example. Nevertheless, if it is to be used it should be in addition to working directly from life, rather than as a substitute for it.

A drawing should be more than a mere slavish copy of a photograph. Otherwise you might just as well enlarge the photograph. A drawing (or indeed a painting) needs to be a fully developed work in its own right. For this to be possible, an artist must also be able to work without using photography in order to understand, and be able to compensate for, the inadequacies of photographs as source material.

There are many difficulties for the artist who depends too heavily on their camera. It becomes all to easy to confuse quantity of information with quality, whereas working from life teaches us how to select what's important, as there is never enough time to record everything. Photographs are already in two dimensions, hence the dead, flat quality of paintings and drawings indiscriminately copied from them. Photographs record colours and tones inaccurately, and copying perpetuates (and often exaggerates) these failings in drawings and paintings. It is often depressingly easy to see which paintings and drawings in an exhibition are just straight copies of photographs.

If you want to learn to swim, at some point you have to take courage and take your lifebelt off. Likewise, the longer an artist relies solely on photography, the more difficult it becomes to function without it and the scarier the idea of working from life becomes. But working from photographs all the time comes at a terrible price. It gets in the way of the development of an original style, restricts the choice of subjects possible, and, worst of all, limits an artist's development both as a draughtsman and as a painter. Quite apart from all the technical arguments, working from life is a real delight, so it's a pity to miss out on it. For anyone nervous about trying, there's lots of practical advice in Chapter 3 to get you going.

I can't emphasize enough that it is absolutely necessary to draw (and paint) directly from life – not only to learn how to draw, but, ironically, even to get the most out of working from photographs. However, even as I'm writing this I know that people who have only ever worked from photographs just aren't going to believe me. Resistance to the idea is positively phenomenal. However, put simply, it comes down to this: until a prospective artist makes a serious and sustained effort to learn to work from life, it's impossible for them to understand what information their photographs aren't giving them, so therefore it's impossible to make up the deficit.

Yesterday I was listening to two young and promising artists. They were both very open and honest about their initial resistance towards working from life when the idea was first put to them some years ago by more experienced artists. They genuinely hadn't been able to see what the problem was with working from photographs. However, they had been wise enough to be willing to trust their advisers' greater experience and to try working from life, and both now appreciate from direct experience how much is to be gained from it. The benefits are clearly evident to me in their current work. Indeed, they're now so conscious of the shortcomings of photographs as source material that they have serious misgivings about working from them at all, though in the long term, provided they continue to work from life, I am confident that they will use photography appropriately, as and when they need to.

Uses of Photography

There are many ways in which photography can be genuinely helpful. In conditions of changing light, photographs can record (at least to some extent) the lighting conditions across a whole scene at one moment in time, when it is impossible to draw or paint fast enough, especially in conditions of cloud and wind. A photograph can record details too fine to record in a small oil sketch, but which may be needed in a subsequent larger painting. Photography can also record a scene when it may be impossible to stop for long enough to draw it, such as in extremely cold weather (though earlier today I was painting in the snow – the key here is the right clothing and equipment).

For horses in particular, there are two additional practical reasons for using photography. One is that it helps when working on motion, especially fast motion. The other is that the pressure of time that now affects most of us also affects owners and stable staff. Whereas a hundred years ago a lad in a racing yard might have been looking after one or at most two horses, many staff now look after four. In other types of yard the staff-to-horse ratio is likely to be much worse than that. The days when a trainer or owner could spare a lad, lass or groom to hold a horse for an artist to draw and paint for days at a time are long gone. Yards are busy places, and even a short photo session can be an inconvenient break in their daily routine. We have to make the best of this and be grateful for such time as we can be spared by busy staff. In this situation, a camera is our mainstay. However, it is easy for things to go wrong; in order to get the most out of photography, it is important to understand its limitations.

ABOUT DRAWING

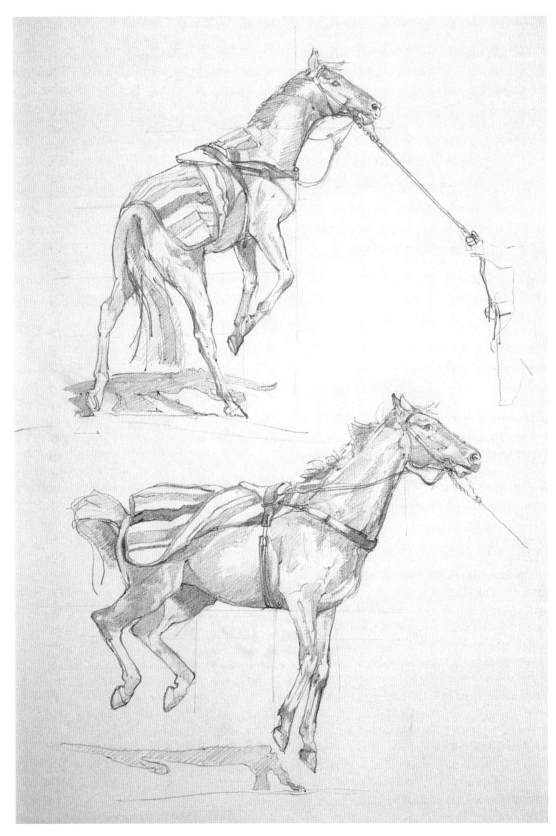

These are examples of the sort of pose which would be tricky to draw or paint without a little help from photography. It might be possible to retain in the memory a general idea of the overall pose of the horse, and the nature of the light, and a knowledge of anatomy might help fill in some gaps, but complex things like the way the stripes on the rug change as the rug lifts with the movement of the horse, or the precise shapes made by the tendons and muscles on the legs could well be another matter.

Taking Photographs

The cheapness per shot of digital photography is undoubtedly one of its charms, but the cost of film did have one good effect; it made people think carefully about what they were doing. There is a common view that if you 'go digital' it is so cheap to take pictures that it isn't necessary to think about exposure, shutter speed or aperture settings, what to take, or where to take it from; all you need to do is set the camera to automatic and take hundreds of pictures and some of them are bound to be usable. This is not the case. If you take photographs indiscriminately it is perfectly possible to end up with a computer hard drive full of unusable photographs. Whatever camera you use, to get the best out of it you need to understand your equipment and plan your shots so that you record as much of the information that you need as possible. This takes thought and practice. In particular, an artist should never be relying on luck when working on a commission.

Photography is a subject in its own right, and would take another book to explain. If you are struggling with photography, your camera manual should be your first port of call, and there may also be books available on your specific camera model. If you have Internet access, most of the higher-end camera ranges now have online communities run by knowledgeable users where detailed advice on equipment or technical difficulties can be sought. Most equestrian artists that I know use a DSLR (digital single lens reflex) camera with interchangeable lenses; they are not the easiest cameras to learn to use, but they are good at producing high quality images of fast motion, even in quite poor light.

I have listed here some common horse-related photography problems, and made suggestions for some rough and ready solutions that might help in an emergency. Your camera manual should explain the terminology. I'm assuming your camera has at least autofocus (AF) and auto exposure (people who use a manual camera generally already know what they're doing).

- Peculiar foreshortening is caused by getting too close (see earlier section on foreshortening); stand further away, and if necessary use a longer lens to magnify the image.
- A bleached-out ('overexposed') sky is often due to photographing into the sun; try taking pictures containing slightly more sky. If the sky is fine, but the horse and the surrounding landscape are too dark ('underexposed') include less sky. Photographs containing only sky tend to show too much contrast. Using 'exposure compensation' is a more sophisticated method of dealing with exposure problems, if your camera offers the option and you learn how to use it.
- If a standing horse is in focus, but the background is not, it is likely to be a depth-of-field ('DOF') problem. You could try setting a narrower aperture if possible, but generally the safest option is to take separate pictures of the background. (It's often useful to do this anyway in case you want to move a horse later on.)
- If you have an out-of-focus background because you have been swinging the camera to follow motion ('panning'), take separate pictures of the background.
- If a moving horse is blurred, but the background is sharp, your shutter speed is probably too slow. The larger a moving horse is within an image, the further it will move across the frame in the time it takes the shutter to operate, and the faster the shutter speed will need to be to 'stop' the movement. At worst it may need to be set to 1/1000th of a second or faster, and if there isn't much light that may not be possible. If the horse is smaller in the frame or is coming towards you, 1/500th or 1/250th might be sufficient. You might even get away with 1/60th if the horse isn't moving at all and you have a steady hand. Indoor shots are always a problem, as light levels are far lower than in daylight.
- If nothing is in focus, then your autofocus (AF) probably didn't operate quickly enough; check that you have used the AF settings advised in the manual for fast action. If the camera appears to have focused on the wrong thing, check that you have set the correct 'focus area' if applicable. See your camera manual for your options.
- If, after trying everything, you still get a lot of out-of-focus shots, seek advice from a photographer, preferably

COPYRIGHT

Copyright protection in Britain normally extends for seventy years after the original artist's or photographer's death. Within that period, if anyone uses a photograph, drawing, painting, or any other image from anywhere (including books, magazines, and the Internet) as direct source material without specific permission from the copyright holder, and makes any sort of financial gain from doing it, they are very likely to be breaking copyright law. Quite apart from the moral issues involved in making money from other people's work without their permission, and without paying them a fee where appropriate, it can have serious legal and financial consequences. Artists need to be aware of their local copyright laws, if only to protect their own work. (Copying for private study is usually regarded as acceptable.)

Bear in mind that even with written permission from a copyright holder, work that is substantially based on the work of others is increasingly ineligible for some open exhibitions, and reproduction of it may not be possible.

I couldn't expect two horses, three people and a falcon to stay still for long enough to record all the information I wanted to record in this drawing, so I took some photographs to work from later. In these situations, I take several photographs, moving around my subject a little, as this can help me to see the form and eliminate confusion about overlapping shapes. This is a substitute for being able to move around to check the form as I would when drawing directly from life. If you take only one photograph, there's also a risk that a horse will blink, squint into the sun, pull a horrible face, lay its ears back, or stick its tongue out at you, and you may not realize this until the opportunity to take a replacement photograph has gone for ever.

one who uses the same camera/lenses. Your camera/lenses may simply not be good at AF; some aren't. When you are photographing motion, some out-of-focus (OOF) shots are to be expected, as no equipment/operator combination is always 100 per cent perfect.

Never, ever use 'flash' around horses; a flash firing could cause a horse to shy, stumble or bolt. If your camera doesn't allow you to prevent your flash firing, get a camera that does, or even better, one that doesn't have an in-built flash at all (in-camera flash flattens form and affects colour so is best avoided anyway).

With photography, every choice we make of equipment or settings, whether we are aware of it or not, will result in the loss and/or alteration of a great deal of information. At worst, we may fail to record the very thing that attracted us to our subject. (Which of us has never looked at a photograph and wondered why we took it in the first place?) The eye, on the other hand, is very adaptable; if we work from life, we can choose to record detail in dark areas, or draw in dark situations where most cameras would struggle to cope. (I recall drawing in the desert before dawn, capturing figures outlined against a brazier when it was so dark that I couldn't even see my paper.)

When working from life, we can also stretch or compress individual sections of tone and colour ranges in whatever way we choose, and we can walk round a horse if we can't understand its form; nor are there any depth-of-field problems when working from life. If you need to take photographs for a particular project, take a selection of photographs from different angles, to record information on form. Make drawings and colour sketches as well, if you possibly can.

We should all draw and paint from life in general on a regular basis, partly because it is good practice, but even more importantly, because it is a very enjoyable thing to do, keeps us fresh and makes us observant. Photographs are a great supplement to drawing and sketching, but a poor substitute. A camera is a good tool, but a bad crutch.

LIFE DRAWING

I always recommend any artist who is serious about their work, whatever their subject matter may be in general, to attend a life class regularly, as I do myself. It is the single most important thing any artist can do to develop and improve their drawing (and painting). A good class should set both short poses for work on speed drawing, and long poses, over a full session or more, in order for students to be able to do sustained work on measurement and accuracy, and also to paint occasionally. Look for a class with a teacher who is both willing and able to teach measured drawing. If such a class isn't available, you may be able to find a group of artists who hire a room and a model and work independently; there are a number of such groups across the country.

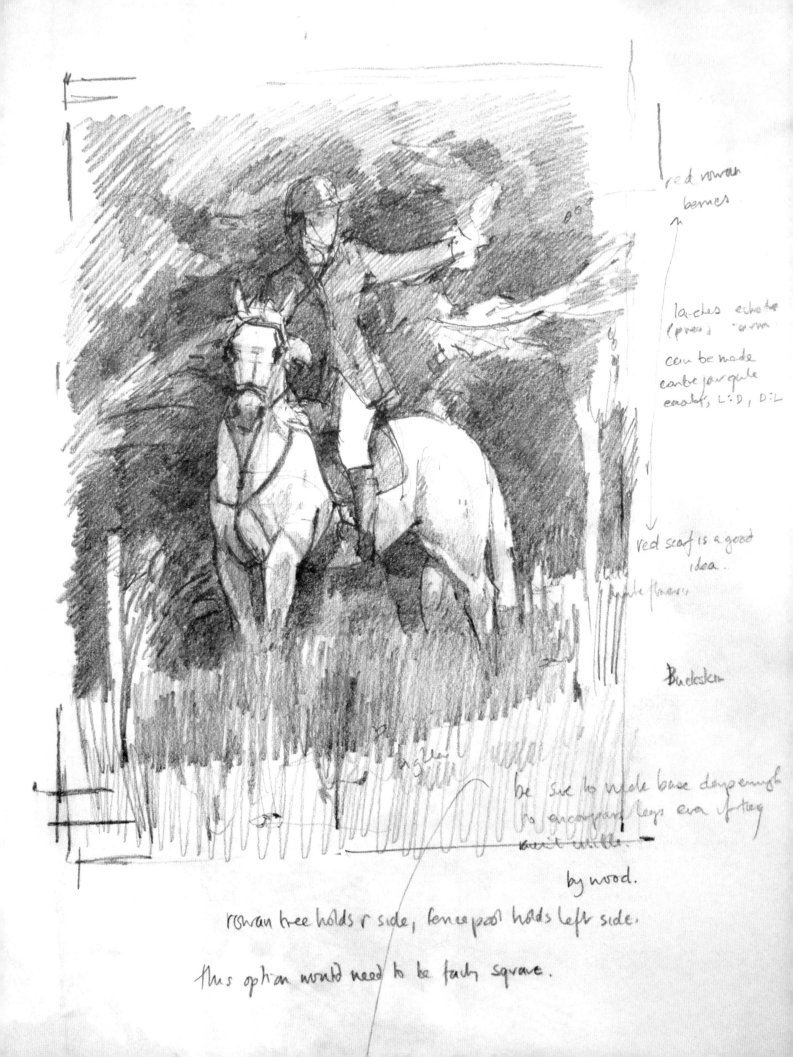

rowan tree holds r side, fencepost holds left side.

this option would need to be fairly square.

CHAPTER 3

PRACTICAL DRAWING

'The technique should grow out of the subject in hand.'
F.J. Glass, *Sketching From Nature* (1897)

SELECTING AND USING THE RIGHT MEDIA

Having the right equipment makes any job far easier. (You don't use a screwdriver to knock in a nail.) The materials chosen for a drawing should be able to produce the sort of mark that is suitable for the task in hand. For example, for free, large drawings of motion, the most suitable material would usually be one like charcoal, which produces a broad, dark line easily and fluently without needing much pressure. Fine detail might be best recorded using graphite pencil, but a drawing with large areas of dark tone might become unpleasantly shiny if done in graphite pencil and might work better in conté. Scale and practicality also need to be taken into account. For motion studies in a small sketchbook, charcoal lines might be too thick, and may smudge when the book is closed.

Ink is an unforgiving medium, as mistakes can't be hidden, but for illustration work it reproduces better than many other media, and, with a good nib which can give a flexible width of line according to pressure, can be a flowing and assertive medium. There will always be compromises when you are choosing your materials, so it is useful to master a range of different materials in order to give yourself maximum flexibility.

Where there is doubt as to which material would be the best one to use for a drawing, graphite pencil would be a very flexible choice. It is excellent for line drawing, whether delicate and fine or fluid and powerful, and responds well to variations in pressure. Tone can be indicated by flat shading, hatching and cross-hatching, and pencil marks can be blended with the finger or torchon. Once the pencil has been truly mastered by an artist, other materials should hold no terrors.

Whatever drawing materials you use, cultivate the capacity to make a controlled and sensitive line; one that you can vary in thickness and weight as you please, and which you can break

LEFT: **Working drawing in line and tone, with written tone notes and crop marks, showing the versatility of the simple graphite pencil.**

Head drawing from life in pencil, showing how variations in the 'weight' (thickness and blackness) of a line can be used to show form, emphasize change in line direction, make corrections, or indicate the dominant form where two or more lines join.

and pick up precisely where you need to. That makes the line interesting in itself, but, more importantly, those qualities of the line can be used to indicate three-dimensional form, or to explain structure. For example, where a line changes its angle, a little 'accent' (i.e. a small increase in the weight of the line by making it thicker and/or darker) points out the change and draws attention to the cause of it, whether it is a muscle or bone under the skin. Where one line meets another, you can also indicate by varying the weight of the lines which mass represented by your lines should dominate the other. Subtle effects like this can help an apparently simple drawing to hold a lot of interest and information.

EQUIPMENT

The simplest equipment list for drawing is a wood-cased pencil, scalpel, and paper. For non-permanent work, any paper that has a surface and colour suitable for your work is fine. However, if you are doing drawings you plan to sell, paper made from cotton ('rag') or linen is more appropriate, as paper made from wood pulp will usually become yellow and brittle over time.

'B' pencils are soft; the higher the number before the B the softer, and potentially blacker, they are. 'H' pencils are intended for engineering drawing and are too hard for most artists' uses. 'HB' pencils are for general use and sit between the two. I generally use either a B or a 2B. Because I work a great deal in sketchbooks, I don't care for very soft pencils, as they smudge too easily, but that is a purely personal choice. If you need to make a blacker mark, then just go softer.

When using a scalpel, first sharpen the point using a scooping cut, cutting away from you. I find it can help to rest the hand holding the pencil on something stable to do this. If you need a sharper end, then slide the blade along the lead sideways towards the point very delicately with a very small amount of pressure to make a smoothly tapering point. This takes practice, but is worth mastering.

Softer leads are usually thicker. Some manufacturers have special ranges with thinner leads which are intended for designers rather than artists. I prefer this type of lead, but that is a purely personal choice. Stick to a good brand, such as Derwent, Faber-Castell, or Staedtler, and bear in mind that pencil grading is inconsistent between brands; for instance, one manufacturer's B may be another's 2B. I find Derwent and Staedtler pencils feel softer and mark darker than Faber-Castells of the same grade. For measured drawing, a pencil with a plain coloured casing is preferable; jazzy ones can be distracting to measure with.

The most important thing when drawing in graphite is to have a good point. This may sound a little obvious, but it is surprising how many people who are otherwise very experienced struggle with some aspects of drawing purely because they are using badly sharpened pencils. Ideally the point should be long and straight, not chunky and angled like the points made by pencil sharpeners. A scalpel can be used to produce whatever shape of point you prefer. Sharpeners make points which go blunt almost at once, and are very wasteful of pencils. When I first went to art school, on the first morning our tutor came round with a waste basket for all our pencil sharpeners on the basis that it was the best place for them. I think he was right.

A properly sharpened point lasts a long time, and can be shaped either by the way you turn and use the point as you draw, or by the use of a sanding block or piece of fine sandpaper. A scalpel is the best kind of knife for producing a good point because its blade is narrow, so the necessary scooping cut can more easily be made, but care must be taken to use it safely. In particular, changing scalpel blades on traditional metal scalpel handles is a hazardous enterprise. In Britain, a company called Plasplugs make a plastic alternative; the blades can be lifted out, which is a far safer system. They still take standard scalpel blades, and have the added bonus of being retractable, which makes them safer to have in a pencil box. Putting your hand into a pencil box with a traditional scalpel in it is like putting your hand into a piranha tank – the wine corks that artists tend to stick onto blade points for protection fall off all too easily.

Blades should always be sharp (you are actually more likely to injure yourself with a blunt blade than with a sharp one, as blunt blades jag and jump) and when sharpening pencils all cuts must be made away from you – don't cut towards any part of your own anatomy, or anyone else's. Rest on something stable if you need support (but not on your leg!).

As you draw, shape the point so that it has a sloping, broad part for thick lines and shading and a narrower part for thinner, finer lines. A broader point picks up more of the texture of a paper, so if you want textured lines or shading, use the broad part. If you want more even lines or shading, turn the pencil and use a sharper area of the point. For very fine work, place a scalpel at right angles to the long point and carefully scrape it sideways along the lead to make a fine point like a needle. Great delicacy is needed here, otherwise you'll break the point off and have to start again.

There are few things more irritating than painstakingly sharpening all the pencils in your box and then finding when you come to use them that the points have broken off. Fortunately there are on the market some steel caps that you can use to protect your beautifully sharpened pencils from this fate. I wouldn't be without them. For the economical, there are also handles (extenders) you can buy which can prolong the life of pencils that have worn too short to use.

An alternative for those who are unhappy about using scalpels is a propelling pencil. A range of leads is available for these pencils in various thicknesses, including leads soft enough for

artists' drawing. Propelling pencils are handy in places where sharpening isn't practical, like art galleries. Keep them in a pencil case as the fine metal ends are easily damaged.

Some graphite pencils have been formulated to be water soluble. I find these pencils pleasant to use for ordinary drawing; the ones I use (sadly no longer available) feel slightly 'slippy' on paper so are good for fluent lines, though they smudge more easily than ordinary graphite pencils. If you plan to do a line-and-wash drawing and want to retain your lines, make sure you don't use a water-soluble pencil by accident.

Kneadable erasers ('putty rubbers'), if kneaded until soft before use, don't leave 'crumbs' and can be shaped to pick out highlights when shading in pencil, or used to clean areas of the paper that have become smudged. (Dusting off 'crumbs' from a conventional eraser frequently smudges a drawing and undoes all the good work.) Kneadable erasers can also be used with natural charcoal. However, for completely removing pencil lines, often a conventional soft eraser is better (a line usually rubs out more effectively if the eraser is rubbed across it rather than along its length). Erasers, especially the kneadable type, stick to some paper surfaces and leave dirty marks, so test on the edge of your paper before use.

Graphite sticks have a waxy texture and are heavy and awkward to hold compared to an ordinary wood-cased graphite pencil. I don't find they offer any particular advantages over graphite pencils.

Very soft materials, such as natural charcoal sticks (usually vine or willow), pastels/chalks, conté crayons etc., can be shaped with a sanding block, or worn into a useful shape as you draw. Compressed charcoal sticks and charcoal pencils are harder in texture and are more difficult to rub out than natural charcoal, which may matter if you're using an eraser to correct or to create highlights. With care, charcoal/pastel pencils can be sharpened like standard graphite pencils.

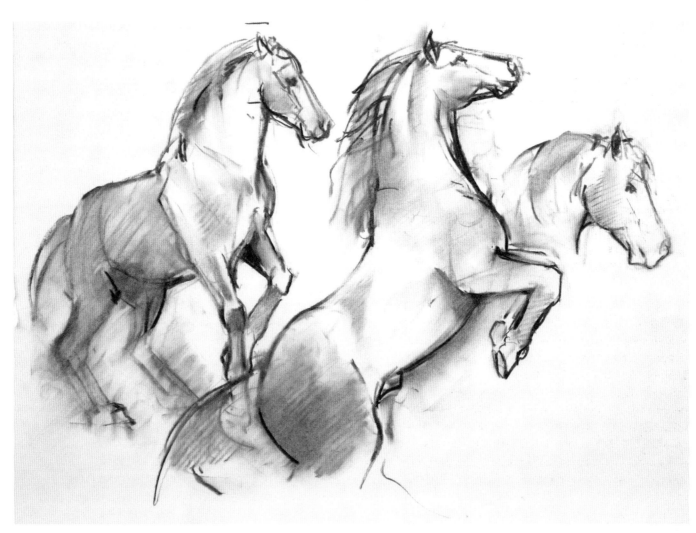

Natural charcoal is useful for fast, fluent work on a large scale, where bold dark lines are needed.

PRACTICAL DRAWING

Pen and ink is a demanding medium, and not easy to use out of the studio, though I have on occasion done so, but it is a good discipline to learn. I use a 'dip' nib that can give a thick-and-thin line as the pressure put on it varies; I don't use a reservoir. Indian ink is not water-soluble once dry, so if you use it, wash out your nib immediately afterwards before the ink dries on it. It is usually used for black line work that is to be reproduced without half-tones (greys). For general work, I prefer black 'Quink' ink: it flows quickly and you can dip a brush in water and use it to spread the ink and create interesting marks if you work on the line before it completely dries; the ink's component colours separate and create brown and blue areas.

WORKING FROM A LIVE HORSE

Please refer to the general safety advice in the Introduction before working from a live horse.

Finding Models

If, like me, you don't have your own horse, there are many horse events where drawing is possible, provided that you don't go anywhere the public is not allowed to go, and you keep your eyes open for loose horses (a companion can be useful for this). At horse shows there are often quiet areas where there aren't many spectators where you can stand to watch and draw. The collecting ring (where horses 'work in' before classes or competitions) can be a good place.

Choose an area where there is a good stout barrier between you and the horses – it keeps you safer and gives you something to lean on if you need it. It's unlikely anyone will come and watch you drawing if you choose a quiet place. If anyone does come and look at what you're doing, there is no need to be shy about it. They won't be expecting to see a Leonardo da Vinci; they are usually just fascinated by seeing someone draw – they may never have seen anyone drawing 'from life' before.

You could also look for someone local who would be willing to allow you to go along and draw their horse(s) occasionally. I have found horse owners to be very generous with their help to artists in this way, and the gift of a drawing of one of their horses in return is often appreciated.

If someone gets out a horse for you to draw and/or rides it for you, but you aren't confident enough to give them a drawing, at least let them have a good photograph if you have taken any. Horse owners like their horses to look their best in such circumstances, and though you may not realize it, they may have groomed or even bathed the horse especially for you, and you'll certainly have taken up a significant amount of their time.

Working from a live horse can be a challenge. Here are a few suggestions to make life a little easier.

Pen and ink, using 'Quink' ink and a dip-nib, with water applied with a brush before the ink had completely dried to create a line-and-wash effect.

If the Horse is Loose

Only work in the same area as a loose horse if you have permission, are experienced and confident with horses, and are absolutely sure that it is safe – and never if you are alone. Horse dribble all over your sketchbook is the least you can expect. Most horses will come and investigate you, and some can be very 'pushy', especially if they have been a bit 'spoiled' and are always barging for titbits. If there are several horses in a field, they may join together and 'play rough' with you, and you certainly don't want to get entangled in that sort of thing. Horses don't know their own strength, and can do you a lot of damage without in the least meaning to. It's generally best to have a fence between you and any loose horse, especially as your attention will be concentrated on your work. Even wild horses on the moors can get too close for comfort. I once needed a 'minder' to protect me from a particularly curious matriarch mare from a wild herd.

If you want a loose horse to stay in a specific place in a big field, like under some attractive trees, a bit of hay strategically placed can help if the owner is agreeable.

Posing a Horse

Consider temperature, wind, and the direction of the light before posing a horse. If it is hot, the horse will either have to stand in the shade or to have breaks in the shade to cool off. The horse may also appreciate being given water and hay occasionally if you are asking it to pose for a long time. If the weather is cool and windy, the horse will be happier posed tail-into-the-wind if possible. If it is cold, let the horse be led round regularly to warm up, and never keep it posing so long that it gets chilled (this is especially a problem if it is normally rugged up and you want it to stand for you with its rug off).

Remember that the sun moves round as well as up and down, so if you are looking at lighting effects, you will either have to work quickly, or have short sessions on different days at the same time of day. If a horse is posing fully tacked-up as if to race or hunt, it may become excited in anticipation and get very confused about why it is being kept hanging around. Make allowances, and don't keep a horse posing until it is boiling with frustration. Horses, like humans, tend to be much more restless and jumpy in windy weather.

If You Have a Handler to Hold the Horse

The owner/trainer of the horse should decide whether the horse needs to be bitted or can be held safely in just a headcollar. This is a matter of safety; they know the horse's temperament and you don't. If you are being commissioned to draw or paint a horse and your client wants the head without a bridle or headcollar, then you may have to arrange to see the unadorned head separately, either over the fence of a ménage or field with

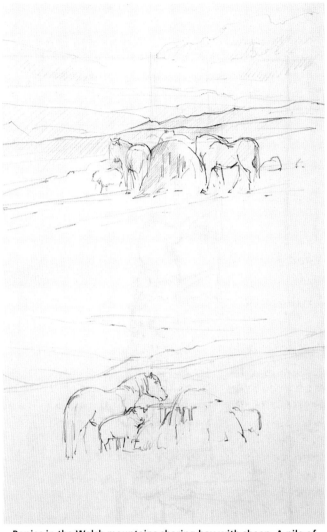

Ponies in the Welsh mountains sharing hay with sheep. A pile of hay can help keep loose horses in one location for sketching.

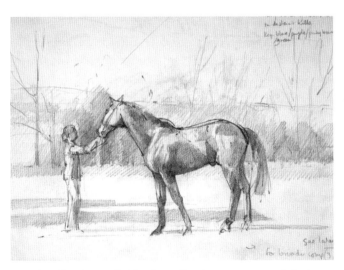

Some handlers have a habit of standing between you and the horse without realizing it, but here the handler is allowing a good clear view.

the horse loose, or over a stable door, in order to fill in the gaps in the information on your drawings or sketches.

When you have settled the pose to your satisfaction, mark the ground where you want the horse to stand, front and side. You could use sawdust, or if you are on concrete or stone, chalk or charcoal lines. This helps the handler to get the horse back in position when it has moved.

If the horse is getting very frustrated and fidgety each time it is returned to its position, let the handler take it for a short walk to release the tension. Don't do this too often, or the horse will learn that fidgeting gets it a nice walk. Titbits can only be given with the agreement of the owner of the horse. They should only be used sparingly, and as a reward for standing for a decent length of time. It's rare to find a horse that can't cope with posing at all, but you have to recognize and accept this if it happens, and call a halt for everyone's sake. It's also best not to ask too much of a horse the first time it poses.

Show horses can be good subjects, as they're used to standing around tacked up during the judging process. A handler used to showing horses is always a bonus, as they know how to get a horse to stand nicely in-hand for the judges and hold that pose. I have known a coloured show cob with an experienced showing handler stand perfectly happily in one pose for a couple of hours with only one 15-minute break. She had never posed before, but stood cheerfully watching tennis in the Village Hall courts while a group, including novices, drew her. Some horses are natural posers – but rarely are they as good as Rosie!

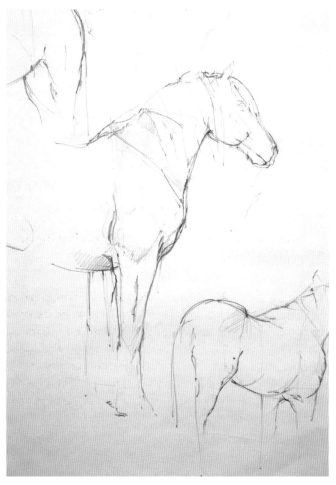

Rosie watching tennis.

If the Horse is Tied Up

In this situation you can't control the pose very much (other than going over and gently persuading the horse back to where you want it provided you have permission to do so, and know how to handle horses safely) but if the horse can have access to some hay, it can help. Think about where you want the hay – if it is on the ground, you will get a lot of 'grazing' positions. If the hay is in a net, it may be possible to tie it up higher; the horse will lift its head to get the hay, which could be useful if that's more the pose you want. Horses are less likely to get bored and fidgety if there is something nice for them to eat.

If a horse is tethered with a ring and chain for grazing, never get between the horse and the tethering ring. Tethering chains are heavy and can do both horse and artist a lot of damage.

Working from Life for the First Time

Ultimately, when working from life rather than photographs, your lines need to be clean, swift and direct, otherwise you will be too slow. However, at first you will need above all to take your time. Initially, accuracy is more important than speed, and simplicity is the key, not detail. Once you have trained your eye to see simply and accurately, speeding up is easy. Try to work too fast too soon and you'll only get quicker at making mistakes.

Begin by working purely in line in pencil. You can practise by drawing still-life indoors to get the hang of it. If you aren't used to working this way, don't be discouraged if at first your drawings appear rather flat, stiff and unattractive. That's entirely normal. When drawings are stripped of shading, 'furry' lines, and detail, any flaws in accuracy or proportions are exposed, lines can appear clumsy, and curves may lack flow. At this stage, non-artist 'friends' may add to your problems by telling you that your drawings don't look as pretty as they used to do. But the purpose of this line work is to get the basics right, and to make your line more accurate and responsive. Eventually your mark-making techniques should also improve, as should your proportions and structural analysis, and family and friends will see the improvement that experienced artists have been able to see all along. The key is to persevere.

Working Outside

If you haven't drawn outside before, start with landscapes until you are confident you can record things cleanly and accurately. Take your time, try different measurement systems and see if you can find one that suits you (see Chapter 5). As horses generally live in landscapes, you aren't wasting any time; you are learning useful things for later.

Once you feel you're in control of your forms and proportions, try speeding up a bit. Then try using some simple tones to show light and/or form. Keep any shading simple and light, and only use it where you feel certain that you need it. When working directly from living animals later on there will rarely be time for complicated work in tone.

To get used to subjects that move, if you have dogs or cats at home, try drawing them when they're asleep. (They'll still move around quite a bit, surprisingly enough.) Cattle out in the fields are also good subjects, on a similar scale to horses in terms of the

Measured drawing in line of Styhead Tarn, Cumbria, showing a little tone – only where it clarifies the light or the form. Note the clouds, and the reflections of the mountainside in the tarn.

landscape, and with comparable anatomy, and they aren't very athletic so they often keep a pose for a while, especially when lying down. In Britain we are fortunate in being able to see them well enough to draw them by looking over gates on many country lanes.

All you need now is a lot of practice.

TIPS ON DRAWING HORSES FROM LIFE

It is best not work very close to a horse when you first draw from life, as this will cause abrupt foreshortening. As we have already seen, extreme variations on actual comparative proportions make drawing difficult, unnecessarily so at this stage.

It is a good idea to start a drawing with something that is likely to change the least over time. I generally suggest the withers and then the bulk of the torso if working from the side (the easiest pose to start with). Positions and angles of legs often change a great deal, the head and neck move most of all.

Standing horses will change their leg positions fairly regularly. They may also rest their hind legs alternately by picking up a hoof and resting the front tip of the hoof on the ground (they usually only rest a foreleg due to injury or disease). The topline of the back will change slightly if the horse alters its leg position. If a horse lowers its head to graze, the topline of the back will change even more, and if a foreleg moves forward or back the whole shoulder area will change. It's rare for one part of a horse to move without changing the appearance of something else. Watching for those changes is a good thing to be doing as you draw. In fact, developing the capacity to notice them is one of the reasons for drawing.

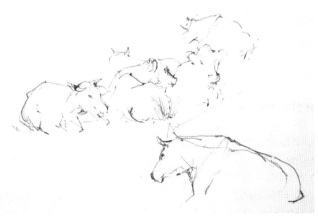

Quick sketches of cattle.

Horses often return to a previous pose, so it is useful to keep more than one drawing 'on the go' at the same time. For example, for the horse that tends to rest a hind leg, I might have one drawing with the right hind resting, and another with the left hind resting, changing between the drawings as the horse moves. That makes it easier to notice how other things (like the hindquarters and back) change as the weight shifts from one hind leg to the other, as I can compare my drawings. Occasionally I'll record these differences on one drawing, but it can get messy and hard to follow afterwards.

Weight Distribution

Understanding weight distribution is very important if you want your horses to look convincing. Horses weigh about half a ton, as anyone who has had their foot trodden on by a horse will tell you. Even the smallest horses are heavy, powerful and solid, however graceful they may be, and need to look so. Weight only looks 'right' if your drawing is accurate (and I mean accurate, not detailed, as detail tends to undermine weight and substance, rather than add to it). In fact, a drawing or painting has to be even more accurate to show weight than it does to show movement. If we return to our example of a standing horse resting a hind leg, we will observe that the hip that is carrying the weight will be higher than the hip on the 'resting' leg side, and more subtly, the weight of the quarters also has to shift sideways slightly towards the weight-bearing side so that the centre of gravity of the hindquarters is directly above the weight-bearing hoof. Always think about where the weight is.

Drawing the Head

Most people instinctively start with the head. The trouble with that is that the head has a large range of movement even in a standing pose, and it will move a lot. If you are doing drawings specifically of the head alone, then work on several drawings at once, and be ready to move around the horse if necessary. You'll need to start a new drawing on your sheet each time the head moves to another position, and to move between your drawings as the horse returns the head to a previous position. Don't forget that as the head drops lower, the neck changes substantially in shape and angle as well as in position; you can't stick any head onto any neck. Almost any change in the stance of a horse will affect more than one area.

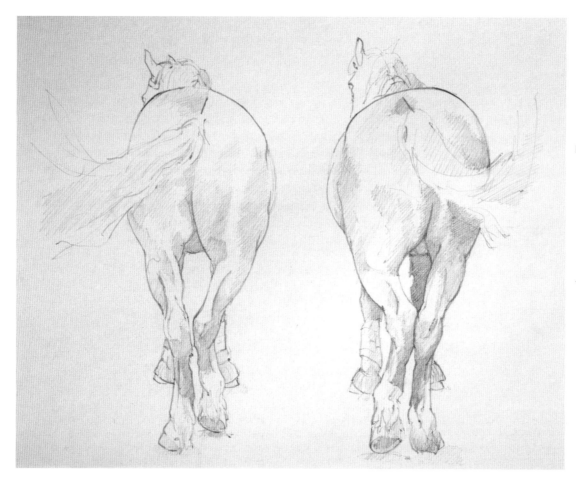

When a horse rests a hind leg, the pelvis tilts and the hip on the resting leg side drops, leaving the hip carrying the weight higher. The bulk of the quarters also shifts across towards the weight-bearing leg so that its centre of gravity is above the hoof carrying the weight. If you find this difficult to see, watch a horse with a rug on. Provided the centre of the rug is running along the horse's spine, you will see that when the horse rests a leg, the rug will hang lower on that side as the hip drops.

Size, Scale, Position

With any drawing, all these three things need to be considered before you start. Consider how large your drawing needs to be to record what you wish to record, including any background, and also the scale within that drawing that the horse needs to be. Start too small and you won't have much space to record anything, start too large and it may be difficult to keep the drawing together as a whole.

When you make the first marks on your paper, be sure you have started in the right position; on a side view, for example, there is a lot of horse in front of the front legs, and it's surprising how easy it is not to leave enough space for it. Surprisingly, on a side view, the horse's elbow is fairly central; there is as much horse in front of it as there is behind it. Measurement (see Chapter 5) can help with this.

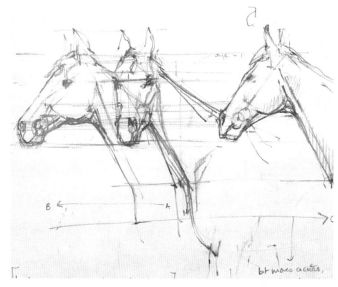

Head drawings: preparatory work for a portrait of a racehorse.

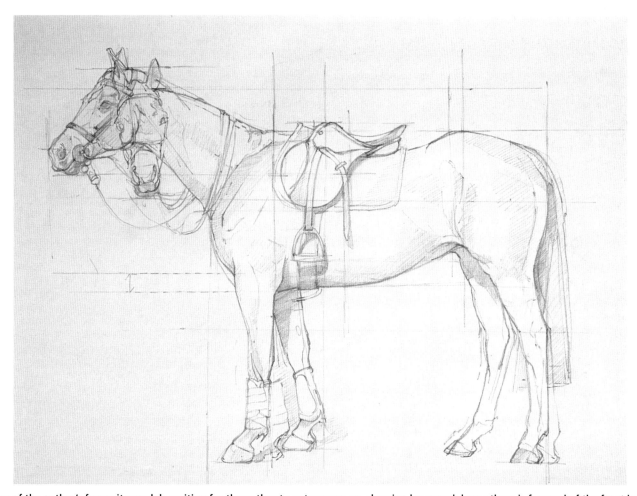

One of the author's favourite models waiting for the author to get a move on, showing how much horse there is forward of the front legs, and how the position of the head affects how much space on the paper needs to be allowed for it. Flair is a small but well-proportioned warmblood; note that her body is slightly longer than her height to withers; this is usual for a warmblood. Note also the changes in leg position and the horizontal and vertical lines I've used to check alignments (see later in this chapter).

Negative Spaces

This is a very useful concept to consider when trying to observe and draw objectively. It works on the principle that everyone thinks they know what a head, or a horse, or indeed any other thing looks like, but nobody knows what a space looks like...

As we saw in Chapter 2, one of the barriers to accurate observed drawing is that we all have our own ideas about the appearances of things, whether this is due to our personal taste, knowledge of anatomy, or whatever. These ideas get in our way when we try to observe objectively.

If instead of drawing, say, the horse in front of us, we only look for and draw the shapes of the spaces between our horse and other objects in its surroundings, we are not going to be inhibited by our previous prejudices about the shapes we are drawing, therefore the drawing we do is likely to be a good deal more accurate. For example, instead of trying to draw the angles of an individual leg, we could observe and draw the shapes *between* the legs, and between them and other things in the background. This has another advantage, in that it encourages us to relate our subjects to their surroundings.

It is surprising how often in the ordinary course of a drawing, when we check our negative spaces, we find we have made quite big mistakes in our drawing. Always keep an eye on those helpful negative spaces.

Horizontals and Verticals

You'll see horizontal and vertical lines on many of the drawings in this book, because I make a habit of checking horizontals and verticals as I draw. I hold my pencil vertically, or horizontally, in front of me and find out which parts of my subject line up with each other. I might use this to check whether, for example, the front of the left hind hoof is directly under the point of the hip, or whether the highest point of the withers is level with that of the croup (it often is). When checking horizontals and verticals, sometimes it helps to use a long ruler. Being longer than a pencil, it gives you a wider horizontal to use, and you can hold it in both hands to keep it steady. You can also make a hole in one end and hang it from a pencil to get a true vertical.

You can also use horizontals and verticals to check lines as well as points. For example, you may think that the back of a hind leg from the point of hock to the fetlock is vertical, but check it – it may not be. This sort of information is quick to find and easy to use. Horizontals and verticals, if checked as you draw, can prevent drawings becoming skewed or distorted, and will help you to look objectively at your subject.

Simple Relative Proportions

Proportion is very important when trying to make a drawing of a horse look like a horse – and a particular horse at that. If you haven't time to measure, even a few simple checks on relative proportion can save a lot of trouble. Using the pencil at arm's length as described in the Measurement section in Chapter 5, you can measure one part of the horse in front of you and see how it compares with another, and then make sure you have the same relative relationship in your drawing. For example, you could compare the length of the body to the height of the horse at the withers to find which is the longer, and by how much. If you ensure these proportions are also the same in your drawing, then your horse shouldn't end up looking too tall, or too long in the body.

The negative spaces here between the horse's legs and the stones in the wall, and between the lower legs and the pattern of soapsuds on the floor, help us see the positions and shapes of the legs, making it easier to see the foreshortening (this drawing was done from very close to the horse). Drawing the shape under the neck rather than the neck and head helps to establish the angles and shapes made by the neck and the head, which might otherwise be difficult to see objectively. The key to using negative spaces is to draw the shape you are observing without thinking about what is making it, thinking only of the proportions and angles of the shape as if you were drawing it on a flat piece of card that was to be cut along your lines to cover the shape.

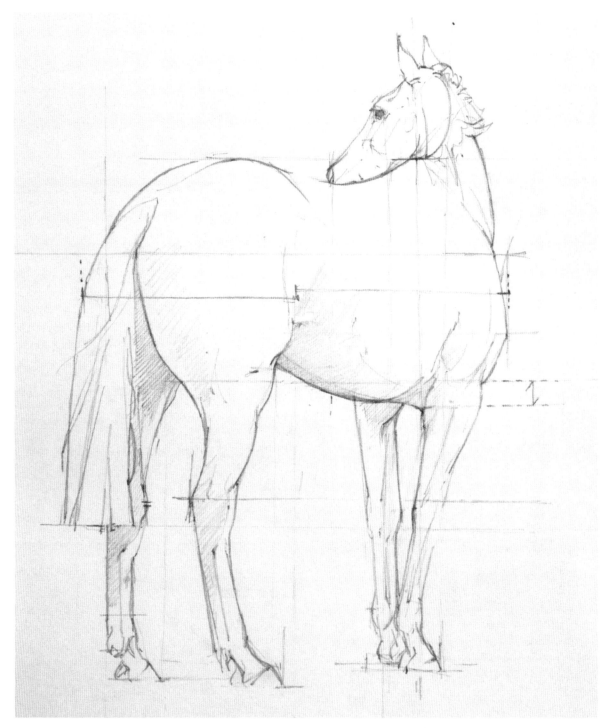

Horizontals, verticals, proportion, and negative spaces applied.
In this case, checking verticals showed that the front of the right hind hoof was directly below the stifle, the nostril was only slightly further to the right, and the poll was above the back of the upper right foreleg. Checking a horizontal revealed that the point of the right hock was slightly above the level of the change in direction on the back of the leg caused by the accessory carpal (pisiform) on the right fore, and the bottom of the tail was level with the underside of the knees. The withers were level with the top of the hindquarters (they often are, as they are usually close to our eye level and at the same absolute height). Where the chest emerged from the front of the right fore was substantially higher than the point where the back of the leg leaves the chest (this is often the case).
Looking at the drawing, and knowing the actual proportions of the horse from a side view, it may be surprising, but due to the angle of the body, the distance from the point of shoulder to the stifle here is exactly the same as the distance from the stifle to the back of the tail. Checking relative proportions established this. That's exactly why using relative proportions is so useful; it can prevent us making erroneous assumptions. Note also the shape of the negative spaces, for example, the one between the front legs. If you can get that shape and its angles right, then the legs will automatically be in the correct alignment with respect to each other.

PRACTICAL DRAWING

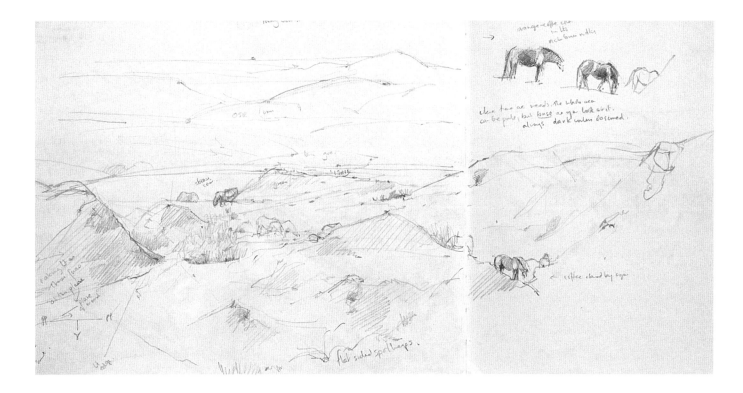

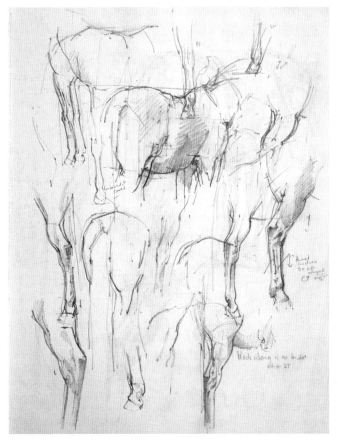

Studies of hocks and hindquarters. As I drew, I moved around the horse to obtain different views in order to better appreciate the structure of the leg.

Ponies on the Clee hills in Shropshire, showing them in the context of the scenery, the distant Welsh mountains, and the sky. (The horses at the top right weren't floating in the sky, they are enlarged details.) This drawing was done from further up the hillside, so all the horses are drawn from above.

Background and Surroundings

All too often, people neglect their horses' surroundings, which is a pity for two reasons: one is that horses don't exist in isolation suspended in mid-air and it is a bad idea to get into the habit of drawing them as if they did; the other is that backgrounds can actually offer a lot of help. A vertical post, such as a telegraph pole (provided it really is vertical), can be a good reference point for your verticals. Buildings and people can give your horse and your drawing scale (an isolated horse could be any size). People also give interest as well as scale to a drawing, as does landscape, and drawing all of these things is good practice if you want to paint 'real' pictures, rather than just studies of horses.

Angles of View and Eye Levels

It isn't a good idea always to draw horses from the side, and from the same eye level. Horses aren't flat, and drawing them from other angles, and from other heights, even if only for practice, helps you understand their volume and judge how

PRACTICAL DRAWING

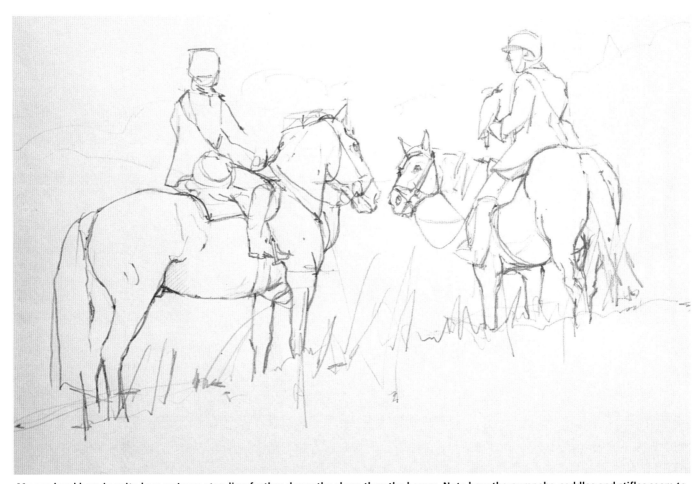

My eye level here is quite low, as I was standing further down the slope than the horses. Note how the numnahs, saddles and stifles seem to be much higher up the horses' sides than when seen from the eye level of an average human on level ground, and how much more of the underbelly of both horses is visible. Also note the effect of the lower eye level on the appearance of the heads, necks and shoulders, both human and equine.

their weight is balanced and distributed. You will also develop a better understanding of anatomy if you habitually draw from lots of different angles. Try changing your eye level occasionally, by standing on a bank, or sitting on the floor where it is safe to do so (i.e. well out of the horse's reach and not in places where other horses might be led past you).

Be wary of angles of view that suggest that a horse has only three, or even two, legs, due to one leg masking another. For a portrait in particular you might wish to check with your client that such a view would be acceptable.

Studying Individual Parts

You don't have to draw the whole horse every time. If you are struggling to understand the structure of the hock, then draw hind legs; if you have problems with hooves, draw hooves; just don't lose sight of the need to draw and understand the interactions those parts have with the rest of the body as well.

Studies of hooves and fetlocks (on the corner of a landscape drawing).

49

PRACTICAL DRAWING

Standing Back and Walking Around the Subject

Standing in one place to draw is fine, and if you are measuring formally you have no other option, but even if you're measuring it is a good idea to stand back and look at your drawing from a distance occasionally. This helps us to see mistakes. It is also beneficial to step away from your work completely and take a walk round the horse from time to time, to check that you are not misunderstanding the form. That's another area where photography scores a blank. If you are finding it difficult to understand what you are seeing, you can't step aside and get another angle to see what is really going on if you only have a photograph to work from. That accounts for the flatness seen in some drawings done from photographs – as well as the occasional anatomical howler due to misunderstanding the form, such as muddling up the legs of two different horses.

Skies

Skies are very interesting in shape and tone, but are often forgotten by artists when drawing, creating a problem that feeds through into paintings as well. This is a pity, as skies should not be regarded as a nuisance or as a blank space we have somehow to fill in, but rather as an opportunity for making a positive contribution to the purpose of the drawing or painting as a whole.

Perspective applies to skies just as much as it does to objects on the ground, and in a flat landscape (and horse painters see a lot of these, as for obvious reasons most racecourses are in flat areas) perspective as expressed by clouds in the sky can be used to create distance and depth where it might be difficult to establish these things in other ways. If the clouds in the sky are in reality approximately the same size, then as we go down from the top of a picture towards the horizon the clouds we are seeing will be further and further away, so they should gradually appear smaller.

Even when doing a measured drawing (see Chapter 5) many people don't bother to measure clouds at all but just draw them in any old how. Clouds can be extremely deceptive in size and position and require careful observation. Next time there is a day with a reasonable number of individual clouds and not too much wind (clouds can both move and change shape at a great rate in windy weather) go out and draw some, measuring their size and heights above the horizon. If you haven't done this before you may be in for a surprise.

Drawing showing measurements of cloud sizes and how their heights decrease as the clouds become closer to the horizon, where the clouds are at far greater distances. This would be a rather boring drawing without the sky, and would feel far less spacious.

PRACTICAL DRAWING

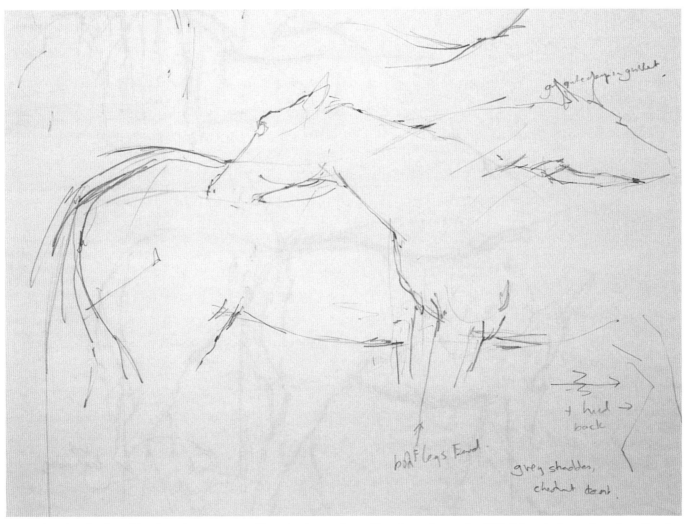

Large, fast drawing from life of two horses engaged in mutual grooming, with notes on leg angles. With this sort of pose there is no time for detail – the main angles and masses have to be established as quickly as possible as the pose may change at any second.

Fleeting Poses

Sometimes horses make sudden movements into a pose you know they won't hold for long; a horse may bend its neck right round to scratch its quarters, spreading out its legs for support, or perhaps two horses will indulge in a little mutual grooming. Capturing these gestures is one of the most interesting and enjoyable challenges of working from life, and watching for them teaches us a lot about how horses behave. However, no carefully measured drawing will catch those moments before they're gone. That's where speed drawing comes in – the most important shapes, lines and curves have to be identified and recorded quickly before the pose has gone.

To record two horses grooming, the lines along the horses' backs and the angles and curves of their necks and heads would be the most important lines to make, followed by perhaps a few lines to indicate the chest and quarters and the overall angles of the legs. There is no point trying to draw details such as elaborate contours on the legs and fetlock joints in a drawing of this sort, as the pose may have gone for ever before you can record even one leg in that level of detail. Work simply and quickly, but as accurately as you can (see Chapter 5 for an exercise to help develop these skills).

This all comes back to the idea of purpose described in the previous chapter. Learning to select what to draw and what to leave out is, as always, the key, but for a good drawing of a short-term pose it is vital, as there is no time for making unimportant marks. If the horse does, by some chance, resume the pose, there may be time then to refine the drawing, or make another more detailed drawing of some specific area, but don't count on it. Get the crucial lines down first, as you may never see that horse adopt that particular pose again.

KEEPING A SKETCHBOOK

Artists have used sketchbooks in one form or another for hundreds of years. In Italy, artists were keeping early versions of the sketchbook as long ago as 1400. At that time, they belonged more to studios than to individuals, and all the artists working in a studio would use them. They contained drawings of people, animals, plants, and birds, some in colour, which would be used for reference when the studio produced paintings for clients. These 'modelbooks', as they are called, were made from parchment or vellum, the finest materials available at the time, and were greatly valued. The work in them was executed with such great skill and care that, over six hundred years later, many still survive. As studio practice changed and paper became cheaper and more widely available, modelbooks evolved into the personal sketchbooks we use today.

Sketchbooks have been widely used by artists of many schools over the centuries. Though many will have been lost or destroyed, a surprising number survive, including notable examples by Constable, Delacroix, and Géricault; nearly three hundred of Turner's sketchbooks alone are still in existence. Sketchbooks are sometimes included in exhibitions, and are always a treat to see, though of course you can only see one set of pages. A select few have been printed in facsimile, and the Victoria and Albert Museum even has some drawings from one of Constable's sketchbooks online.

It is always interesting to look through the sketchbooks of fellow artists (though do ask before looking, as some artists prefer to keep their sketchbooks private). Sketchbooks show the sort of work artists do to maintain and develop their skills, and if you are lucky you may even be able to find preparatory work for paintings, which can give a lot of insight into how an artist works.

I fear that not everyone these days realizes how beneficial keeping a sketchbook can be. I kept sketchbooks as a student, but for some years afterwards I only used them for drawing in galleries and out of doors, and did most of my studio drawings and preparatory work on loose sheets. The main disadvantage of this is that loose sheets of paper can easily get lost or damaged. In sketchbooks, drawings are protected and sequences of work can be kept together and found more easily if required for reference. When I began to teach students how to use sketchbooks, I went back to doing all but my largest life or landscape drawings in sketchbooks, and have never regretted doing so.

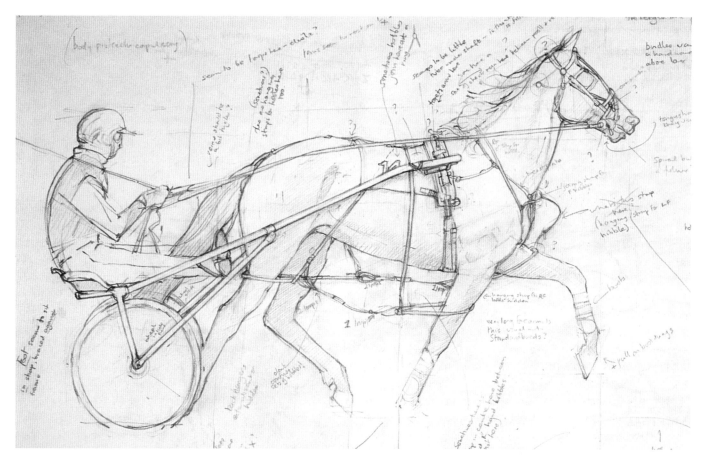

Sketchbook study made for reference of a pacing horse in harness. The straps on the legs are called hopples (or hobbles).

PRACTICAL DRAWING

Studies for Reference

A sketchbook can be used to record specific notes from life for future reference; for example, a farrier shoeing a horse, or detailed drawing of some tack. It is also a good place for drawing when you're studying things like perspective, movement, or anatomy.

Drawing from Observation

Many artists make a point of drawing from observation in a sketchbook every day, just as musicians practise every day. It doesn't have to be a spectacular subject, it can be anything: a landscape, a chair, the view from a window, a sleeping cat, a horse scratching its tail on a rail – it's all practice.

To stop the wind catching my paper when working outdoors I use a couple of bulldog or 'foldback' clips. Broad rubber bands can be used for small books, and tape, ribbon or ¼-inch elastic for larger ones. Some expensive books have cloth tapes bound into their backboards to keep them open or shut.

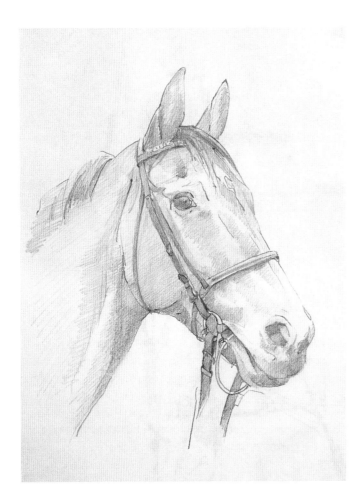

Sketchbook study of a special bit for a commissioned portrait. This Thoroughbred races in an unusual bit, called a 'Dexter'. It's especially important with commissions to be sure the horse is wearing the tack your client wants it to be wearing.

It is a good thing to have a sketchbook handy at all times. Its presence reminds us to draw, and the more drawing we do the better. A well-chosen large hardback sketchbook does away with the need for carrying about the paraphernalia of drawing board and paper, and a small one can be kept in the pocket so that there's never an excuse for being without the means to draw. (We all know that if we see something interesting by chance and the means are to hand, we're more likely to draw it than if we have to go and hunt for pencil and paper. On occasion I've been reduced to drawing on a paper table napkin when nothing else was available, which is not ideal.)

These days, sketchbooks are my most fundamental working tool; in addition to transcription, life drawing, and drawings of horses, hawks, landscapes, and so on, from life, my sketchbooks are full of ideas for paintings. I rarely start a painting without doing some preparatory work in one.

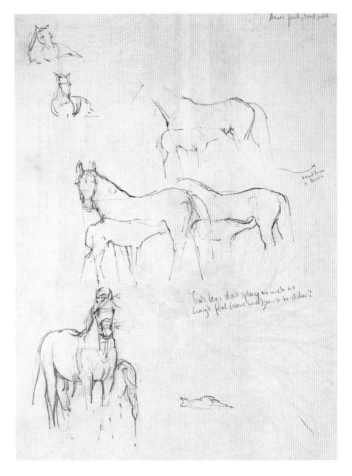

Observed drawing from life of a mare and her foal.

PRACTICAL DRAWING

Quick sketches in line using a brush and watercolour.

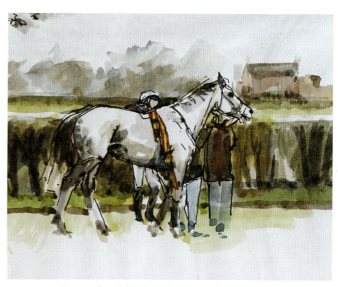

Pen and Quink ink with watercolour washes.

Experimenting with Materials and Techniques

Sketchbooks are a good place for testing out equipment and materials, like a new pencil, or a new technique, like drawing onto a page tinted with watercolour, or drawing into a chalk base. For example, if I were to be trying out a new nib, as well as drawing with it, I'd make lots of curved and straight marks with it, varying the pressure, noting things like how flexible it was and whether it could be used at more than one angle.

Sketchbooks are also good places for doing exercises to practise shading, colour mixing, and the like. You could draw a grid and fill each square with a different colour, in coloured pencil, watercolour, gouache or acrylic, or just fill each square with very even shading, or smoothly graded shading in different tones for each square, taking care to be precise with all the corners. Or you could draw random lines over the page and do the same – an even more demanding exercise as you'd have to work with more difficult, tapering shapes.

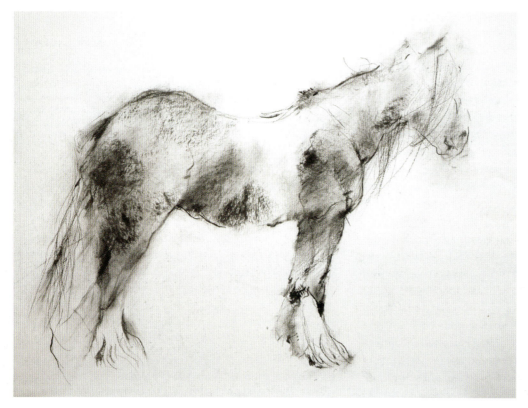

Rosie, by John Beresford. Large drawing (A2) showing the use of a fluid, dynamic technique.

PRACTICAL DRAWING

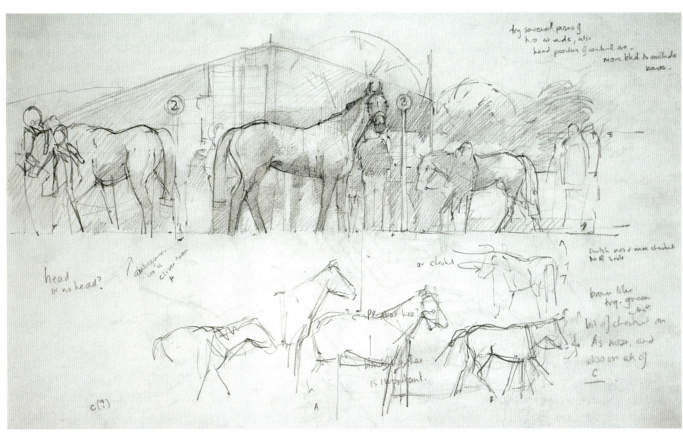

A working drawing for a possible future painting, including alternative poses and notes. My sketchbooks contain a lot of written notes as well as drawings, as can be seen here. As I draw, I makes notes of ideas, potential problems that I may forsee, colours, and things that the drawing has made me realize are important. In a sketchbook, I'm not concerned with tidiness or a slick appearance; as long as I can read my own notes, that's the only concession I make to neatness. The next step was an oil sketch in colour.

Recording Ideas

A sketchbook is an excellent place to record an idea for a painting safely before you forget it. (Scraps of paper and backs of envelopes tend to get lost.) It doesn't have to be a detailed idea, it could just be a scrappy sketch, or even a quick note in words.

Preparatory Drawings and Sketches

Sketchbooks can be used for preparatory work for an individual painting or a larger project. This could include options for compositions, tone plans, notes and instructions. Work for a particular project can be kept together in one book in order to avoid losing anything important, so that it can be referred to easily later on, or shown to clients for approval.

RIGHT: **Test record in sketchbook of different pencil types for reference.**

Transcription

Working directly from master paintings, drawings, prints and sculptures can be very instructive; the masters become your teachers. Sketchbooks are great for this, as they are ideal for use in art galleries. For a more detailed explanation of transcription, please see Chapter 5.

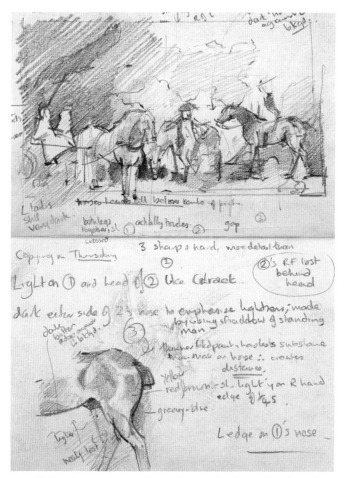

Small drawings and notes in an A6 sketchbook. Studies from the George Stubbs painting *The Milbanke and Melbourne Families* in the National Gallery, London.

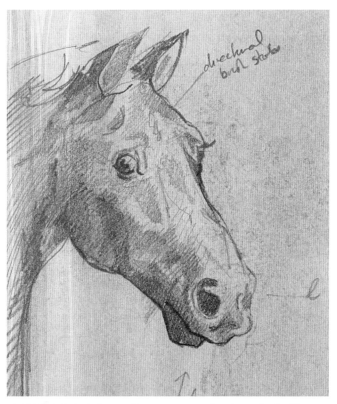

A head study in pencil on a page previously washed with watercolour in a small (A6) sketchbook, which I made in the National Gallery, London, from George Stubbs' famous painting, *Whistlejacket*.

Sketchbook as Scrapbook

If you look at other artists' sketchbooks, you may find a wide assortment of oddments inside, either loose or stuck in: postcards of paintings that have impressed them on a visit to a gallery, photos relating to a specific job, reviews of exhibitions they plan to visit, all sorts of things.

Some artists use their books as a visual or work diary, some write in useful advice they have been given, names of suppliers, poetry they like, clients' instructions, shopping lists, colleagues' phone numbers, just about anything. There are no rules, your sketchbook is your own, and you can do whatever you like in it. Make it part of you.

CHOOSING A SKETCHBOOK

Sketchbooks don't have to be kept pristine; they are for working drawings. We have to be able to feel free to take risks and make a mess in them if necessary, without worrying that they will disintegrate on us. Because of this, sketchbooks need to be strong, hard-wearing and functional, containing paper that is suitable for the materials and techniques we plan to use. Buying poor quality, flimsy sketchbooks is a false economy; they are awkward to use, their bindings fall apart (which is irritating) and the paper is usually horrible, deterring us from working in them (which is worse).

Paper

Soft media, such as pastel, need paper with a rough surface, fine work of any sort requires a smooth surface, and water-based materials require a heavier weight of paper with appropriate surface 'sizing'. Some books have tissue interleaving between

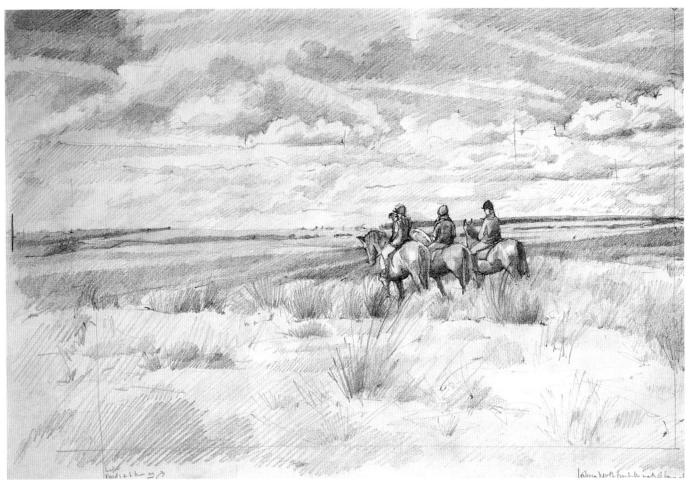
Fully worked out sketchbook study in tone for a painting of horses and riders on the Northumberland moors. Note the lines at the sides and base indicating possible options for cropping the image.

the pages to protect drawings from each other; this is especially useful for pastel and charcoal drawings. As I work mostly in pencil, I prefer thin paper because it keeps books lighter and less bulky to carry around, but if you tend to be a wee bit heavy-handed, you may need thick paper, especially if you plan to work double-sided.

I sometimes pre-stain a few pages with a watercolour wash in pale blue, grey or brown. This gives a mid-toned base to the paper and roughens it a little, making a pencil line blacker, and highlights can be added using white chalk (Turner did this in his books).

If you can't find sketchbooks made from a type of paper that is a good compromise for all the materials you use, you may need a selection of books with different papers.

Expensively bound books can still contain very nasty acidic cartridge paper that bleeds and wrinkles like mad if wetted, and yellows and embrittles with age like the pages in cheap paperbacks. It is unsafe to rely on a sketchbook's price as a guide to its paper quality. You can only be sure what a paper is like by trying it. Some books are made from a specific named paper which is also available in sheet form, so you could 'test' it by buying a sheet first. If you can't find a book you like, ask other artists about the ones they use. If you still can't find what you want, get papers you do like and make your own books up (or have them bound for you by a bookbinder). This also means you could potentially have a mix of papers in one book, or even have tissue interleaving, which could be useful. But don't allow making sketchbooks to take up so much time that it becomes a substitute for drawing in them.

Bindings

One of my pet hates is spiral-bound books, especially where the front cover is only thick paper. About the only thing you can say for them is that the covers fold round easily, but even that isn't without its drawbacks; because of the rings and holes you can't draw across a double page if you need to. The paper is often thick and coarse (it has to be thick to take the strain of the binding), pages get dog-eared because they flop outside the covers, the holes enlarge and the pages fall out, the pages skate

PRACTICAL DRAWING

Drawing from sculpture can be as useful to painters as it is to sculptors. This was drawn from the Apollo Fountain at Versailles. To get this view, I had to perch on the edge of the pool. I remained a little concerned throughout the drawing that both I and my sketchbook might end up in the drink...

One of a set of drawings made from the *Assyrian Lion Hunt* bas-reliefs at the British Museum. (I was looking up at the sculptures, so foreshortening makes the legs look too long.)

about when you're drawing, and the looseness of the binding allows the pages to slide and rub against each other. In these circumstances, even pencil drawings smudge very badly very quickly, and if they are precise drawings for reference they can end up too badly rubbed to be of use.

Spiral-bound books with perforated pages have to be the most frustrating of the lot. If you have no alternative but to use a spiral-bound book, use clips, tape, ribbon or elastic to prevent the pages slithering around or falling out.

Glued-in pages fall out. That sort of binding, found in tear-off pads, isn't suitable for working sketchbooks, it is only intended to be a tidy way of holding sheet paper in one place until it's needed. Incidentally, watercolour blocks aren't sketchbooks; they are glued almost all round so that the paper can be used without stretching. They are used one sheet at a time; each sheet being removed with a blade after use. The used sheets then have to be stored elsewhere, in a portfolio or plan chest.

Stapled bindings may rust if they get damp, either with rain or water-based media, so it is best to choose books with stitched bindings wherever possible.

Used properly, especially by painters who, like ourselves, sometimes have to work out of doors in difficult conditions, a sketchbook has a hard life, so it needs to be tough. It may have to cope with anything from a horse sneezing on it or a dog sitting on it to being dropped in muck.

The Roberson 'Bushey' books that I use (see the list of Suppliers at the end of this book) have strong, hard covers and thin but strong leaves. The paper is smooth, which permits fine detail if I want it, and is a good white, which allows me to use a wide range of tones.

I like to be able to use a full double-page spread, but also to be able to fold and clip a book right back on itself when working on a single page, so I look for a strong but flexible spine and sewn-in pages. I have several in use at any one time, from pocket-sized A6 to others that are larger than A3, some bound on the long edge, others on the short (I use those mostly for wide landscapes) and they are all used indoors and out.

It's definitely worth saving up for a good strong one; it will be a pleasure to use and you'll do more work in it.

Make a habit of keeping a sketchbook, even if only a tiny one, about your person. You never know when you will get an idea, or see something interesting that you want to record (I usually keep one sketchbook in the car, and another in my rucksack/bike bag, so that I can't inadvertently go out without one).

Two appropriate quotes to round off this chapter:

'Do not fail, as you go on, to draw something every day, for no matter how little it is, it will be well worth while, and it will do you a world of good.'
Cennino Cennini, *Il Libro dell'Arte (Italy, c. 1390)*

'The student of Nature should never be without a sketchbook.'
F.J. Glass, *Sketching From Nature (1897)*

More drawings from the *Assyrian* bas-reliefs at The British Museum.

Hyp
Legs seem thicker
than Eclipse
head finer

note eclipse's
fused backbone.
Hyp **not** fused

Eclipse's 1st tooth
fine lower jaw

getting bigger a(bit)
as I go down

LH (cont'd)

RH

RH LH LF

CHAPTER 4

ACQUIRING SPECIFIC KNOWLEDGE

'It is often said that Leonardo drew so well because he knew about things; it is truer to say that he knew about things because he drew so well.'
Sir Kenneth Clark, Director of the National Gallery, London 1932–45

ANATOMY

Using Anatomy to Help Us See

My own art school training was almost entirely in life drawing and painting. Although it is taken for granted that it's important to know about human anatomy to do this, it's rare that it is actually taught, and rarer still that anyone is taught how that knowledge can actually be used in practice. Many years' observation of both students and fully fledged artists suggests to me that many buy anatomy books, slightly fewer look at the contents more than once, many fewer read the text, and fewer still of those make any significant use of the knowledge they have acquired. Nevertheless, I do believe that there is a place for anatomy in our armoury, albeit one that is often overestimated.

You don't need to be a mountaineer or a geologist to paint mountains, and you don't need to ride or to be a horse physiologist to paint horses. But just as knowing about rock formations could help stop us making a careless mistake when painting a rock face, and mountaineering might suggest subjects to us that we wouldn't have seen or thought of otherwise and help us get there, riding may help us understand how a horse moves, and judicious use of horse anatomy and physiology can help us see what's there and prevent us making mistakes.

Skeletons, Lay Figures and Écorché Figures

A particular difficulty for us as artists when it comes to studying anatomy is that the appearance of any structure, bone or muscle we draw will be different depending on the particular horse in question, the angle from which we are observing it, and the way it is standing or moving. Anatomy books, even those written specifically for artists, are only able to show a limited number of fairly standardized 2D views.

Horse skeletons are somewhat large to have in one's studio, but you may be able to find somewhere with a complete horse skeleton and go and draw from it from a variety of angles. There are small-scale plastic 'kit' skeletons available, some of which are rather too simplified to be of use to artists, but if you can find a good one it can be useful to have if you want to study the skeleton from angles other than those shown in books.

Lay figures (jointed figures, usually in wood) are even more variable in quality. Small ones are usually too crude and badly proportioned to be of any practical use. The best ones can occasionally be useful, as has been mentioned earlier with regard to shadows, but you need to have a good understanding of horse movement to be able to use one, as it is perfectly possible to set them into perfectly *im*possible positions.

Écorché figures are models, usually in plaster or wood, without the skin, showing the superficial muscles and those parts of bones, ligaments and tendons that lie directly under the skin. They are curious things, once common in art schools but hard to find now. Attempting to sculpt one for yourself might be instructive, albeit very time-consuming.

Dissection

Dissection, though interesting if you have the stomach for it, is not of any great practical value to most artists when there are so many books available on anatomy. Dead horses aren't much like live ones in appearance, still less so when they are in pieces. (An exception to this might be if you wished to paint a dead or dismembered horse, in a battle scene, for example.) I found that in practice, however interesting in itself, dissection merely confirmed that the internal structures were, indeed, as the anatomy books said they were, so no surprises there. If you are interested in dissection, but can't find a veterinary or agricultural

LEFT: **Drawing from the skeleton of** *Hyperion*, **at the National Horseracing Museum, Newmarket.**

college that will allow you to participate or observe, there is a book listed in the bibliography that gives a detailed photographic record in colour of a professional dissection.

Dissection should not be done by amateurs without professional supervision due to the risk of infection. (Stubbs wasn't an amateur in dissection. When he did the dissections for *The Anatomy of the Horse*, he had previously worked on human subjects under the instruction of a York hospital surgeon.)

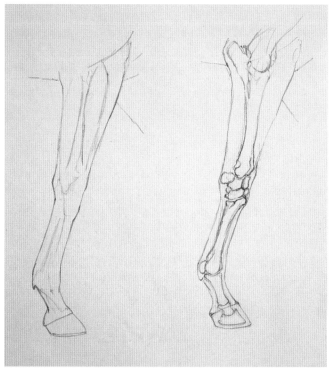

Right foreleg showing how underlying bone structure can affect the surface appearance of the limb.

Using Anatomical Knowledge

When drawing or painting from life, anatomy's most useful function is in preventing us making mistakes by making us doubt, look again and check. It isn't a substitute for looking, only an aid to it.

Let us consider how this might work using an example of an important bone close to the surface, the accessory carpal bone (called the pisiform bone in older books). This projects backwards behind a horse's fore 'knee'. It has a significant effect on the appearance of the contour of the back of the leg from a number of angles, so it is important to us; its visible manifestation needs to be the right shape and correctly placed.

A person knowing no anatomy might easily ignore it altogether (possibly even thinking it was a swelling) or be a bit casual about its location and put it too high or low compared to the changes in contour due to the other carpal bones at the front of the knee. An artist who was aware of this bone ought to be less likely to make such errors; they would expect to see it, have some idea of what it does and therefore how other structures like nearby tendons and ligaments fit to and/or around it, and what its spatial relationship with the other bones in the leg should be, and would be prompted to check by looking again at their model if their knowledge suggested that what they had drawn might be wrong.

The diagrams in this chapter indicate those aspects of anatomy that are most obvious from the outside when drawing or painting. If you wish to know more, or to understand how the mechanical structures of the horse operate, then please refer to the detailed bibliography.

Terminology

It isn't necessary for an artist to know the name of every bone, muscle and ligament. I would suggest that an artist who is working a lot with horses would find it useful to know the terms for all the 'points' of the horse (this helps when talking to clients and other artists), what the basic structure of the skeleton looks like, and to have a simple but clear idea of the way the skeleton works mechanically.

I have used common names for the points of the horse, and modern veterinary terminology for the skeleton and muscle diagrams. Other books, especially older ones, may use different names for the same things. If you wish to go more deeply into the mechanics of movement, textbooks will assume you know the terminology for the muscles etc. so at that point you will either have to get to grips with it, or spend a lot of time referring back to diagrams as you read.

Connecting Theory with the Live Animal

If you can find a horse and owner who are both happy about the idea, and provided you are competent at handling horses safely, you could try drawing the muscles and bones that are discernible through the skin onto a horse using a soft, non-toxic chalk that will brush off easily. This is a good exercise, as you can also feel where the bones or other structures are close under the skin and consolidate your learning. If that isn't possible, you might take some good photographs of a race-fit Thoroughbred (i.e. a model with a fine coat whose subcutaneous muscles, tendons and bones can be easily seen) in good raking light (strong light from the side that brings out the lumps and bumps in the form). Tape clear acetate sheets over your photographs and try to construct the skeleton on one sheet, and the muscles on another, using your anatomy books. If you use spirit-based pens, you can usually correct mistakes with methylated spirit.

These are all good ways to connect theory with practice; without that connection, theory is just a pointless distraction.

ACQUIRING SPECIFIC KNOWLEDGE

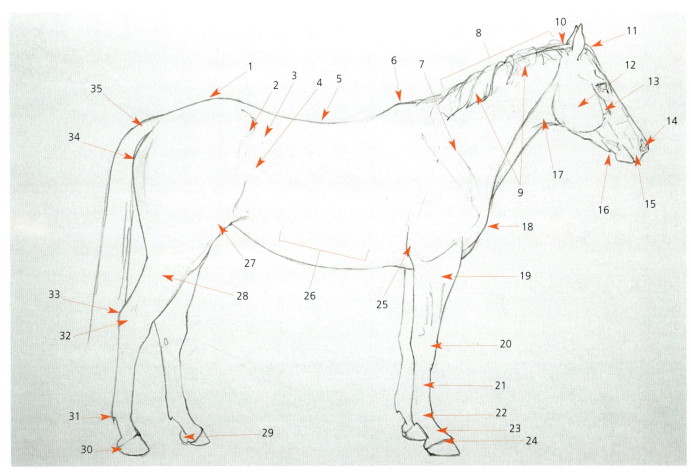

The Points of the Horse

The part of the horse's body between the flanks and the tail as far down as the gaskin is known as the hindquarters. The whole of the horse from the withers forward, including the forelegs, is known as the forehand. The part of the mane that falls forward on the forehead is called the forelock.

1	croup	19	forearm
2	point of hip	20	foreknee
3	loins	21	cannon bone
4	flank	22	fetlock joint
5	back	23	pastern
6	withers	24	coronet
7	shoulder	25	elbow
8	crest (upper part of neck)	26	ribs
9	mane	27	stifle
10	poll	28	gaskin or 'second thigh'
11	forelock	29	heel
12	cheek	30	hoof
13	cheekbone	31	ergot
14	nostril	32	hock
15	muzzle	33	point of hock
16	chin groove	34	point of buttocks
17	throat	35	dock
18	point of shoulder		

■ ACQUIRING SPECIFIC KNOWLEDGE

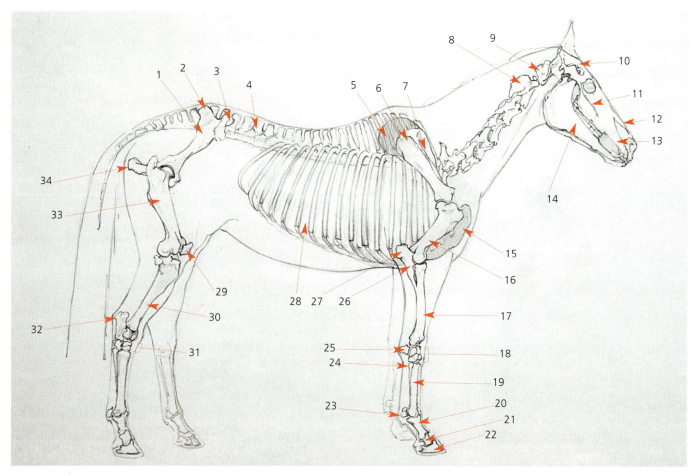

The Skeleton of the Horse

For clarity, I have only included the limbs on the horse's right (off) side, the right half of the pelvis (ischium and ilium) and the right ribs. The accessory carpal bones, sesamoid bones, patella, and the calcaneus are there to provide leverage for the muscular system. There is another sesamoid bone, the distal sesamoid or 'navicular' bone, which is inside the hoof and therefore not visible in this view. Note the large natural gap between the front teeth and the back teeth. This area is known as the 'bars' of the mouth, and is where the bit rests. Below the knee/hock the bones have the same names in both fore and hind limbs.

1	ilium	18	carpus/carpal bones (equivalent to human wrist)
2	tuber sacrale	19	cannon bone
3	tuber coxae	20	proximal phalanx
4	spine	21	middle phalanx
5	cartilage	22	distal phalanx (coffin bone/pedal bone)
6	scapula (shoulder blade)	23	proximal sesamoid bone (one of two)
7	scapular spine	24	splint bone (one of two)
8	axis	25	accessory carpal bone (pisiform in old books)
9	atlas	26	ulna
10	cranium	27	olecranon (elbow)
11	facial crest	28	ribs
12	nasal bone	29	patella (equivalent of human kneecap)
13	maxilla (upper jaw)	30	tibia
14	mandible (lower jaw)	31	tarsus/tarsal bones
15	manubrium of sternum (cartilage, rather than bone)	32	calcaneus/os calcis (equivalent to human heel)
16	humerus	33	femur
17	radius	34	ischium (tuber ischii)

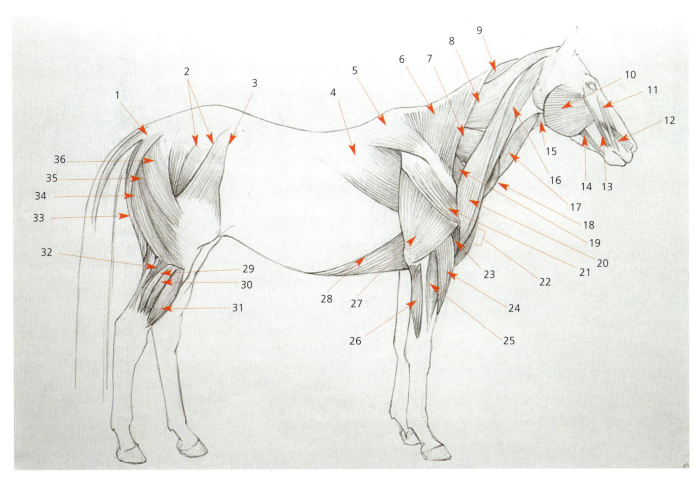

The Superficial Muscles of the Horse

1. levator muscles of tail (lift tail)
2. gluteus superficialis (flexes hip)
3. tensor fasciae latae (flexes hip joint, extends stifle)
4. latissimus dorsi (pulls foreleg back, flexes shoulder)
5, 6. trapezius (lift shoulder, move shoulder back/forward)
7. serratus ventris
8. splenius (in sections, can lift neck, extend neck, bend neck to side)
9. rhomboideus (pulls shoulder forward and up, lifts neck)
10. masseter (chews)
11. levator nasolabialis (lifts upper lip, enlarges nostril)
12. caninus (lifts upper lip, widens nostril)
13. zygomaticus (pulls mouth backwards)
14. depressor labii (pulls lower lip backwards and downwards)
15. omohyoideus
16, 20. brachiocephalicus (flexes neck ventrally and bends neck to the side, advances the limb)
17. sternocephalicus (flexes neck)
18. cuteneus colli (moves the skin on the neck)
19. subclavius (suspends body, stabilizes shoulder)
21. deltoidius (flexes shoulder joint)
22. superficial pectorals (connect foreleg to body, pull back foreleg) and biceps brachii (flexes elbow)
23. brachialis (flexes elbow)
24. extensor carpi radialis (extends carpus)
25. common digital extensor (extends carpus and lower foreleg)
26. ulnaris lateralis (extends carpus)
27. triceps (extends elbow, flexes shoulder)
28. caudal deep pectoral (suspends body from between forelegs, pulls foreleg back, stabilizes shoulder)
29. deep digital flexor (flexes joints below hock)
30. lateral digital extensor (extends joints below hock)
31. long digital extensor (extends joints below hock)
32. biceps femoris (extends hip)
33. semitendinosus (flexes and extends stifle, extends hock)
34, 35, 36. biceps femoris (in more than one part, so can extend the hip and stifle, flex the stifle, extend the hock joint)

(Note that 16 and 17 form the jugular groove.)

ACQUIRING SPECIFIC KNOWLEDGE

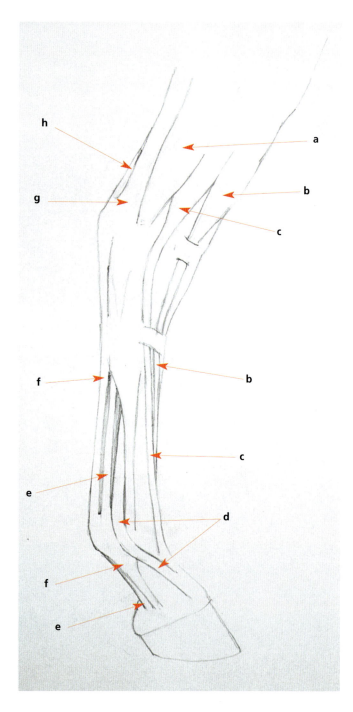

Hind leg

a	deep digital flexor
b	common digital extensor
c	lateral digital extensor
d	suspensory ligament
e	deep digital flexor (perforans)
f	superficial digital flexor (perforatus)
g	gastrocnemius
h	superficial digital flexor

Comparative Anatomy

When looking at the muscles of a moving animal, bear in mind that when a muscle is working it is contracting in length, and therefore getting fatter. Muscles also develop more bulk according to the work they have to do. Some muscles in common between horses and humans which are bulky in humans are much less so in horses, and vice versa. It can be interesting to find these differences, and think about why that is so; for example, a muscle that might be very important in two-legged motion might need to be less powerful if its host had four legs.

A human leg at the level of the calf muscle is generally larger in circumference than a horse's leg around the cannon bone, despite a human being far smaller and lighter than a horse. That's because the horse's leg below the hock or the carpus is the equivalent of our hand or foot. The bulk of the muscles which act on our hands and fingers are further up our arms, just as the muscles that act on our feet and toes are above our ankles – the force is transmitted to where it is needed via tendons. You can feel this by curling and uncurling one hand with your other hand held lightly around your forearm – you'll feel the muscles working. It is the same in the horse. The horse's lower limbs can be as thin as they are because the bulkiest parts of the muscles which power them are further up the leg. The tendons on the horse's lower limbs which transmit the actions of the muscles stand out clearly on horses with delicate legs and fine hair.

It can be helpful when considering the bones and muscles to think about the equivalent in humans, but there are some significant differences. For example, horses don't have collarbones (if they did, they could easily break them if they jumped a big fence at speed, just as we can break ours if we fall and put out our arm to break our fall), and unlike humans, who can flex and extend their ankle without doing the same at the knee, a horse can only flex its hock if it also flexes at the stifle. (This could be useful to know if you were drawing a horse without a model.)

GAITS AND MOTION

Before photography, some aspects of the motion of the horse were imperfectly understood. Eadweard Muybridge's book *Animals in Motion* was published in the 1890s, containing many sets of photographs of horses in motion. This became the first point of reference for artists and animators on animal locomotion, and remains in print to this day (though not all of the captions are accurate). Since Muybridge, artists have been expected to get the phases of gaits 'right' rather than working on their impression of motion, so we need to know how the gaits work. For example, the traditional but incorrect 'rocking

ACQUIRING SPECIFIC KNOWLEDGE

horse gallop' with the moment of suspension (the moment when all the legs are off the ground) shown with both forelegs outstretched forward and both hind legs stretched out to the rear is no longer regarded as acceptable, even though in some ways it expresses a feeling of movement better than many if not most of the 'accurate' phases of the gallop do.

It is worth bearing in mind that photography has also revealed to us many phases of all the gaits that are ugly and/or appear static. Just because a phase of a gait is 'correct' that doesn't mean it's a good one to use if you wish to express motion in a painting. Simply saying, 'but the photo looked like that' isn't good enough.

In particular, some phases of all the gaits have a leg completely vertical which can stop the illusion of movement dead; if we wish to create an impression of movement and also use one of these phases, we may need to 'lose' the vertical leg by, for example, keeping it a similar tone to the background so that it doesn't stand out.

There are a few specialized gaits that are peculiar to certain breeds of horse, and there are also movements which are the results of special training for dressage or other pursuits, but the most common gaits are walk, trot, pace, canter, and gallop.

When talking of horses, the left side of the horse is called the 'near' side, and the right side of the horse is called the 'off' side.

THE MOST COMMON GAITS

I find it is useful to think of the gaits in terms of hoof beats and leg sequences. When drawing, I listen for the rhythm of the hoofbeats as well as looking. The canter and the gallop are 'handed' gaits (there are two possible leg sequences rather than just one) but the other gaits listed here are not.

It is especially important when working from photographs that you don't make a mistake about which side of the horse a leg is attached to; this is easier to do than you might think, especially when a number of horses are together in a group. Some knowledge of gaits should help prevent that sort of mistake. (With groups, count horses, multiply by four, and if you have more legs than that in your picture you've mistaken something else, such as a post, for a leg.)

There are several versions of the common gaits (except for the gallop). A gait might be 'extended', 'medium', 'working' or 'collected' according to the precise way the horse moves within the gait. This will affect the appearance of the horse from our point of view. For example, in an extended version of a gait the horse would have a longer stride and therefore 'cover more ground' in a stride, its forelegs and neck would stretch more forward, and its hind legs would stretch out more behind. In a collected version of the same gait the horse's legs would be more underneath its body and the head would be carried higher

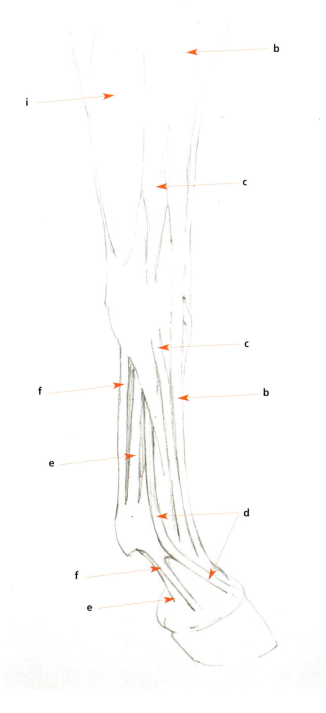

Foreleg

b	common digital extensor
c	lateral digital extensor
d	suspensory ligament
e	deep digital flexor (perforans)
f	superficial digital flexor (perforatus)
i	ulnus lateralis

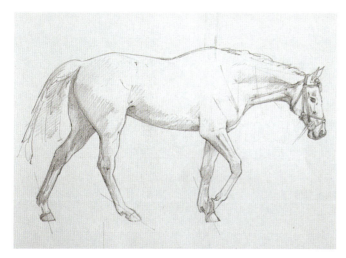

The Walk 1: Right hind hits the ground bringing right stifle forward and upwards, left fore taking the weight with withers above at their highest point.

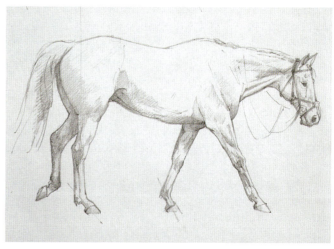

The Walk 2: Right fore about to touch the ground, right elbow forward and low, right hind taking the weight and right quarters above at their highest point.

and more tucked in towards the chest, making the horse appear more compact, the knees and hocks would be lifted higher, and the stride length would be shorter, covering less ground per stride. (In dressage, a horse can even be trained to trot 'on the spot', this movement is called the 'piaffe'.)

As the hoof touches down, a leg's first task is to stabilize and support the weight of the horse. A limb only begins to propel the horse forward when it has passed beyond the vertical. Energy is stored as the fetlock joint moves downwards after the foot makes contact with the ground, and this energy is released again as the fetlock rises and the leg passes beyond the vertical, aiding propulsion. The main propulsive force comes from the hindquarters.

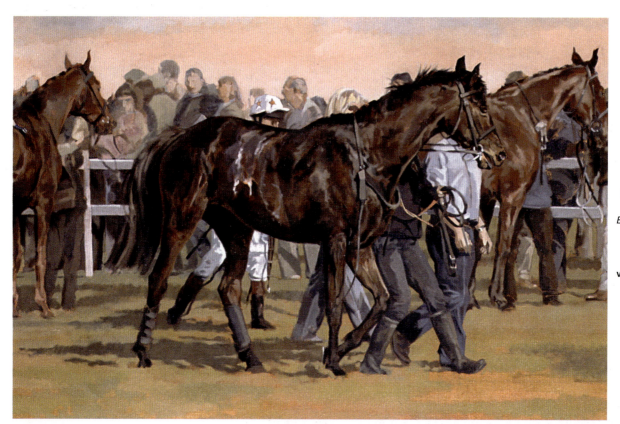

Detail of *The Paddock, Easingwold*, 30 × 43 in (76 × 109 cm), showing walking horse.

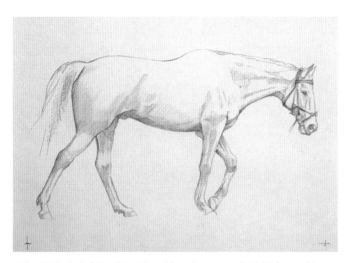

The Walk 3: Left hind just touching the ground, right fore taking the weight with the withers above back to their highest point. Note that with the right hind leg at its furthest back position, the stifle has also moved much further back than in the first drawing where the leg was at its furthest forward.

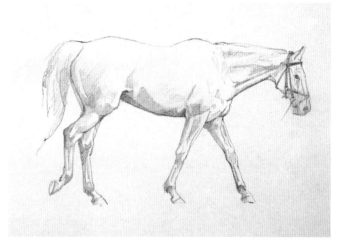

The Walk 4: Left fore about to strike the ground, left hind taking the weight, pushing the quarters on that side to their highest point (also tilting the pelvis slightly down on the right side). The right elbow is now a long way further back than it was in the second drawing, and is also higher.

Legs don't just pivot from the point they appear to leave the profile of the body, they swing from a point much higher up – the hip joint in the hind legs, and the shoulder in the forelegs, so with all the gaits, look carefully at the elbow and the stifle. They swing forwards and backwards a lot, even at walk, more so in the faster gaits, and in the extended versions of any specific gait. Refer back to the skeleton and think about how all the joints have to open and close to make the legs swing forward and back, and you will see why this is so.

In all the faster gaits, a horse moving on a curved path tends to 'motorbike', or lean towards the inside. The angle of this lean from the vertical can be remarkably large when a horse is galloping or participating in mounted games.

Walk

The walk is a four-time beat, with four evenly spaced beats. In the illustrations here it starts with the right hind, and follows the pattern, right hind, right fore, left hind, then left fore.

At the walk, there are usually at least two, if not three, feet on the ground at any one time. The head and neck, if not restrained, are usually held low (the 'free walk'). A horse would normally walk at approximately 4 miles an hour (for comparison, humans walk at more like 3 miles an hour).

The body doesn't rise or fall significantly as a whole, but it rocks slightly from side to side and front to back as each leg takes the weight. Readers who ride will be familiar with the feel of this motion, especially if they have ever ridden bareback (i.e. without a saddle).

At the walk, as a leg becomes vertical under the body, the part of the body above that leg will be at its highest point. You can follow this through on the drawings: in the first, the left fore is only just beyond the vertical, and the withers above it are at their highest point. In the second drawing, the right hind is taking the weight and so the horse's hindquarters on that side are at their highest point.

Watch for how the angle of the fetlock alters as the hoof reaches forward, hits the ground, takes the weight, propels the horse, and leaves the ground. As the hoof reaches forward, prior to making contact with the floor the fetlock lines up with the angle of the leg. Once on the ground, the hoof begins to take the weight of the horse, the fetlock becomes more horizontal, then, as the leg passes into the 'propulsive phase' (after it has passed the vertical) the fetlock again becomes more vertical, and finally when the foot leaves the ground it flicks backwards. At faster speeds, such as the gallop, on softer ground the fetlock may even touch the ground.

At this angle of view, when the right foreleg is forward, the elbow is under the withers, but when the leg is back, the elbow is significantly behind the withers. The right stifle in the first drawing is significantly in front of the highest point of the croup when that leg is forward, but when the right hind leg is back (here in the third drawing) the stifle is almost directly underneath the highest point of the croup (and is also lower than in drawing 1).

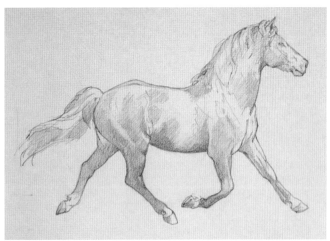

The Trot 1: Right hind plus left fore going forward to contact. As at walk, the elbow and stifle swing forward and back a significant distance during each phase of the gait. The drawings show the moments of suspension before the hooves make contact with the ground.

The Trot 2: Left hind plus right fore going forward to contact. On the previous drawing, the left hip is still higher than the right as the left leg has only just passed through the propulsion phase, but here, after the right hind has taken the weight, the right hip is now higher.

Trot

The trot is a two-time 'diagonal' gait, with two even beats; a hind leg plus the foreleg on the opposite side hitting the ground together, then the other hind leg plus the other fore. In a good active trot there is a 'moment of suspension' just before each pair hit the ground when all four legs are off the floor. If you hear more than two beats per stride, then the diagonal pairs of legs are not going down precisely together. This is fairly common, and would be termed an 'impure' gait.

The horse holds its head and neck high and fairly still during a natural unrestrained trot, and its body rises and falls as a whole more than in the walk, but stays fairly level from withers to croup. Under saddle, the speed of the trot would normally be between 6 and 8 miles an hour, but if being driven in a trotting race, the horse might go as fast as 30 miles an hour. The approximate stride length of an ordinary trot can vary between 3 and 5 feet, depending on the size of the animal and its conformation.

When a horse is under saddle at the trot, the rider will usually rise (or 'post') out of the saddle on one diagonal and sit back into it on the other, this is called the 'rising trot' as opposed to the 'sitting trot' where the rider doesn't rise. (A rising trot is usually more comfortable for horse and rider.) When a horse is travelling on a curved path, the rider should sit when the horse's shoulder on the outside of the curve is moving backwards. If the horse changes direction onto the opposite curve, the rider will sit for two beats to 'change the diagonal'. It is generally more flattering to a horse and rider combination to draw or paint the rider in the sitting phase than when the rider is rising, especially with less experienced riders who tend to rise out of the saddle more than is strictly necessary.

Pace

In Britain this gait is primarily seen in harness racing. It is similar to the trot but is a 'lateral' gait, with the pairs of legs on the same side operating together: the hind plus the fore on one side, then the hind plus the fore on the other side. Technically, though the legs move in pairs when pacing, it is a four-time beat, as the hind foot of each pair tends to strike the ground fractionally before the forefoot, as in the case in the illustrations here. Horses being driven in a pacing race can reach speeds of as much as 30 miles an hour. (The pace is generally slightly faster than the trot when it comes to harness racing.)

The head and neck don't move a great deal (in racing the head is actually restrained by the tack), the body rises and falls as at the trot, but also sways as a whole from side to side as the weight shifts completely from the legs on one side of the horse to the other. If seen from the front, and if the horse is pacing in a straight line, the legs will be seen to angle more centrally under the body, in order for the horse's centre of gravity to be between the feet that are in contact with the ground.

In racing, pacing is achieved and maintained using 'hopples' (sometimes known as 'hobbles') which prevent the horse 'breaking' (changing to a normal trot). I have omitted the hopples and much of the other tack here in order to show the legs more clearly. See Chapter 4 in the sketchbook section for a detailed drawing showing hopples in use.

I find pacing on the racecourse a rather elegant gait to watch, with a pleasant relaxed 'swing' to it. It is surprisingly fast, given its flowing and smooth appearance.

ACQUIRING SPECIFIC KNOWLEDGE

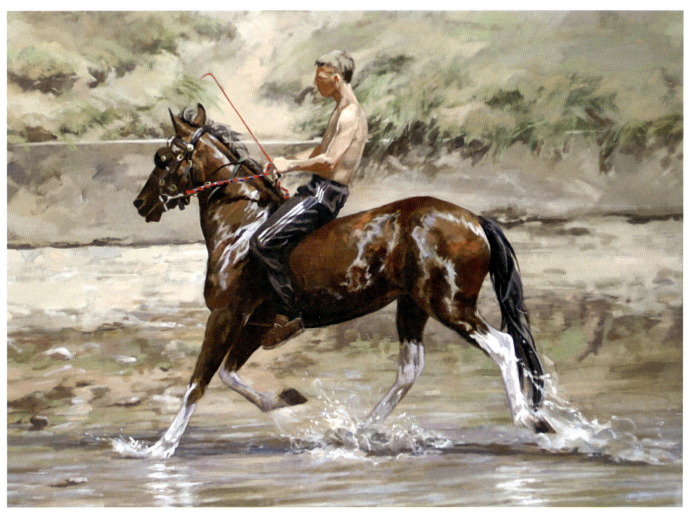

Trotter in the Shallows, 32 × 42 in (81 × 107 cm).

The Pace 1: Left hind plus left fore, with hind leg making contact with the ground slightly before foreleg.

The Pace 2: Right hind plus right fore, with hind leg making contact with the ground slightly before foreleg.

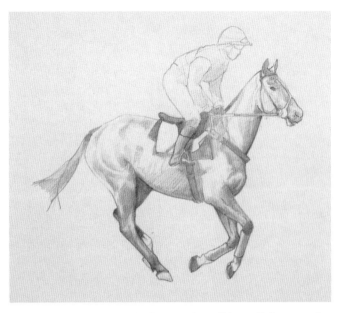

The Canter 1: The moment of suspension, all legs off the ground.

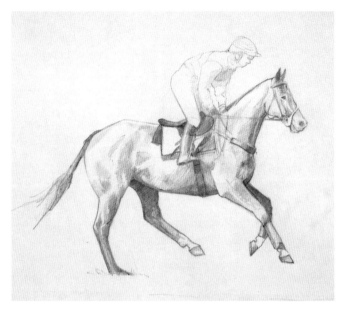

The Canter 2: The right hind leg hits the ground first, and propels the horse forward (this is 'canter left'). At the canter, the forehand is significantly higher than the hindquarters at this point.

Canter

This is a three-time beat, with a gap between each set of three beats where all the horse's legs are off the ground, known as the moment of suspension. A canter is a 'handed' gait and can occur in either of the following sequences:

1. Right hind forward, followed by left hind plus right fore, then left fore (as illustrated here). This is known as 'canter left' as a horse normally prefers this sequence when cantering 'on the left rein' (on a left hand curve/anticlockwise).
2. Left hind, followed by right hind plus left fore, then right fore. This is known as 'canter right', as a horse normally prefers this sequence when cantering 'on the right rein' (on a right hand curve/clockwise).

A horse moving from a left hand curve to a right hand one needs to change sequence. The horse will either drop back into trot and then up again into correct canter 'lead' to 'change leg', or do a 'flying change' at canter, which produces an irregular sequence for one stride, almost like a skip. You are most likely to see this in dressage, or showjumping.

If a horse is using the leg sequence for the opposite curve to the path it is following, the horse is described as being 'on the wrong leg' ('wrong' because it can make a horse very unbalanced). An exception to this is where it is being intentionally done as an exercise in dressage, the horse is then described as being 'in counter-canter'. Counter-canter requires a significant level of strength and balance on the part of the horse.

In the canter, the head and neck (if unrestrained) move more than at the trot, with the head falling as the forelegs reach forward, and rising as the forelegs pass the vertical and thrust the forehand upwards. The body as a whole rises and falls relative to the ground and also rocks from front to back.

A horse would normally canter at between 10 and 17 miles an hour, and a normal canter stride might be approximately 9 to 12 feet in length.

As a horse moves faster, it brings its legs more inwards towards the midline of its body. You can't see this from the side, but you may see it from the front. If you look at hoofprints, the faster a horse is going, the more the hoofprints of all four feet will tend towards being in a single line.

It is not uncommon at a canter for the two legs that should be hitting the ground together to be slightly out of time. A horse that isn't moving energetically may put the hind foot of the pair down very slightly before the forefoot. This doesn't mean that the horse is galloping; a gallop would have four fairly evenly spaced beats to it. Sometimes it is the forefoot of the pair that touches down slightly in advance; this occurs in horses who are not well balanced and/or which don't bring their hind legs sufficiently under their body when cantering.

The illustration of racehorses cantering down to the start shows several different phases of the canter, and it can be observed that those phases of the canter which have one leg vertical (shown in the horse to the right of the tree and the horse on the far left) have less of a feeling of forward movement.

ACQUIRING SPECIFIC KNOWLEDGE

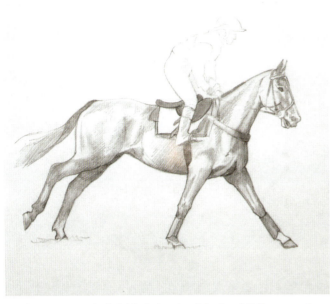

The Canter 3: The left hind plus the right fore hit the ground together, and move backwards together at the same angle. The forehand has lowered as the front legs come into play.

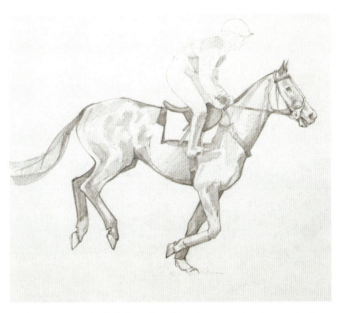

The Canter 4: The left fore then hits the ground and propels the horse forward, the hindquarters curling up to bring the hind legs back under the horse.

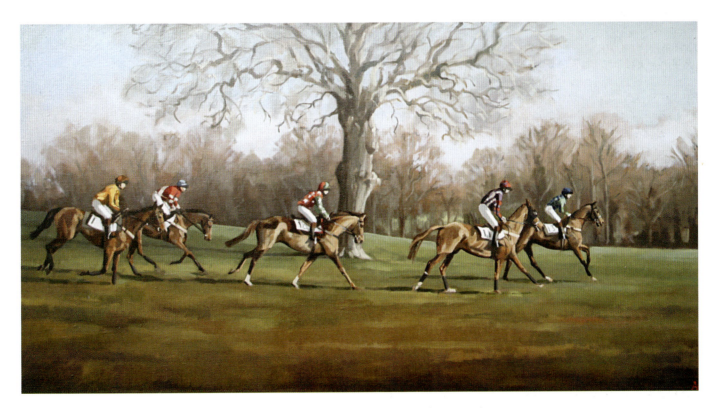

Whitwick Point to Point Races, 18 × 34 in (46 × 86 cm).
In this picture, several phases of the canter can be seen, and as the horses are travelling in a straight line, some are cantering 'right' and some are cantering 'left'.

ACQUIRING SPECIFIC KNOWLEDGE

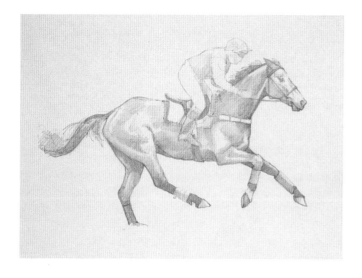

The Gallop 1: Left hind, having touched down, is moving into the propulsive phase.

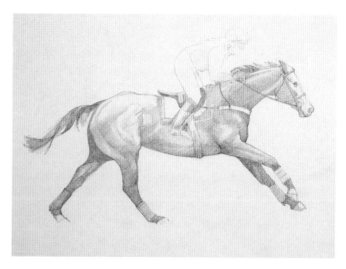

The Gallop 2: The second (right hind) foot touches down, the head is lowering and extending. In a true 'side on' pose like this one, the forefoot won't go further forward than the nose.

The Gallop 4: The fourth foot (the right fore) has now touched down, the third foot has already lifted off. Note the angle of the fetlock joint on the foot in contact with the ground, the pastern is almost horizontal.

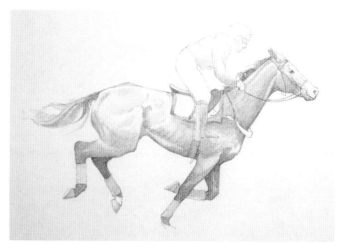

The Gallop 5: The fourth foot is now towards the end of its propulsive phase and is about to lift off. The body is being pushed strongly upwards as a result of the actions of the two front legs, enabling the hind legs to curl under the body for the next stride. The fetlock of the right fore is springing back, aiding propulsion.

Gallop

This is a four beat gait, essentially similar to the canter, but the two diagonally opposite legs (which move together in the canter) move separately; usually this only happens at speed. The four beats are even, followed by a gap during the moment of suspension.

In the case of the horse, the two sets of sequences at the gallop are either left hind, right hind, left fore, right fore, or right hind, left hind, right fore, left fore. This is known as a 'transverse' gallop, and not all four-footed animals gallop in this sequence. The dog, for instance, has a 'rotatory' gallop. When drawing or painting other animals, never assume they will move in the same way as the horse.

At the gallop, the head is generally carried lower than at the canter with the neck extending and contracting more with each stride. The head stretches forward and down as the forelegs stretch forward, and swings upwards as the forelegs thrust backwards. The body rises and falls during each stride, rocks front to back, and there is a 'moment of suspension' between each stride when all four feet are off the ground and tucked under the horse. At the gallop, the foot is already on its way backwards before it hits the ground. The forefoot will hit the ground heel first; at fast speeds the hind foot may not.

The main difference between the canter and the gallop is that the second hind leg to touch down will be leaving the ground when the first forefoot, which touched down much later, is still entering the propulsive phase (as can be seen in the third drawing). This differentiates the gallop from a faulty canter. (Note that not all languages have a different word for the canter and the gallop.)

A galloping horse, under saddle, might be travelling at a steady speed of about 18 miles an hour when hunting, little faster than a canter, but on the racecourse might reach speeds of well over 40 miles an hour. A Thoroughbred racehorse would have a gallop stride of approximately 20 feet or more in length.

This huge stride length creates a difficulty for us when studying our own photographs of the faster gaits. You can see in these illustrations that the horse is passing where I was standing, changing the angle presented to me (in fact, the horse had to pass me twice for me to capture all the phases here). The advantage of studying the photographs in Muybridge's book *Animals in Motion* is that they were taken directly from the side of the horse, using many cameras, all being 'tripped' as the horse passed them, in some sections at the equivalent of up to thirty frames a second (which is faster than cine film). The grid backgrounds in his photographs also make it easier to assess which parts of the body are rising and falling at each point in the movement.

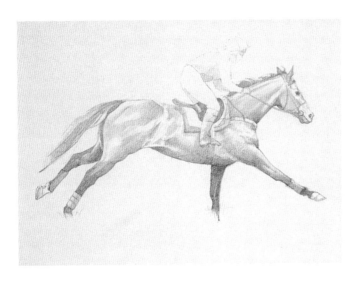

The Gallop 3: The third foot is now moving into the propulsive phase, the first foot has left the ground, the second is already at the point of leaving the ground. The fourth foot is reaching forward, the neck extends forward to its full stretch, and the head swings to its lowest position. (It is only the angle of view being slightly from behind that makes the right fore appear to be in front of the nose.)

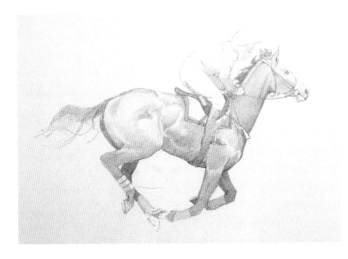

The Gallop 6: The moment of suspension. Unlike the traditional portrayal of the moment of suspension, which shows all four legs stretched out to their full extent, we can see that the legs are, in fact, all tucked up under the body of the horse. The head is also brought back towards the body and lifted up to its highest point. If this illustration is compared with the one above, we can see the two extremes of the movement.

ACQUIRING SPECIFIC KNOWLEDGE

TACK

This is the term for horse equipment. If you are drawing or painting any sort of tack, whether for riding, ploughing or driving, be very careful to note not only its structure but where and how it is attached, whether straps, chains or ropes pass through, over, or under others, and whether each part is fitted tightly for security, or loosely to allow for movement. You will find horse-loving clients are particularly unforgiving of mistakes when it comes to tack, so a little time spent at a friendly riding school is very helpful if you aren't a rider yourself.

You could ask for a lesson or two in tacking up, which would give you the opportunity to learn how tack ought to be fitted as well as get you used to handling a horse safely. (If you are spending a lot of time around horses you never know when you may have to handle one in an emergency.) A school that teaches to BHS Stage 1 and 2 exams should certainly be able to give you such a lesson, as tack is on the syllabus. Time spent drawing in a tack room might be time well spent, especially if you can ask what the things you find are used for, and how.

An extra caveat for those who use photography: if you are tempted to 'flip' an image of a horse horizontally to get it pointing in the opposite way, beware! Tack isn't necessarily symmetrical; in particular, there are sometimes buckles on one side, usually the left, that don't have an equivalent on the other. (Horses are usually led, mounted, dismounted, tacked up and untacked from the left.) Tack is a vast and complicated subject, and new items come onto the market every year, so it is worth collecting a few reference books on the subject. Don't assume that all horses you see are correctly tacked up.

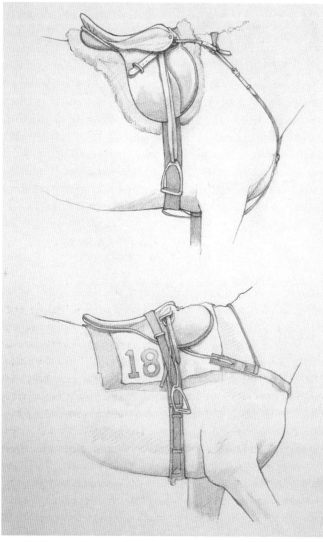

TOP: **'GP' (general purpose) saddle with a sheepskin numnah, and a breastplate to prevent the saddle slipping backwards. This saddle is designed to be comfortable for both horse and rider for long periods of time, possibly all day, both on the flat and when jumping.**

BOTTOM: **Racing saddle with surcingle and breast girth. This is much smaller and lighter than a GP saddle, and flatter in profile. They can be even smaller than this. The stirrup leathers are shorter, as jockeys ride with their knees more tucked up. Under the number cloth there is a weight cloth with pockets in to carry the lead weights that are added to adjust the weight the horse will carry in a race.**

Saddles

Saddles have an air gap underneath them running centrally from front to back to keep the weight of the rider off the horse's spine; the rider's weight rests on the ribs each side. The high point at the back of the saddle is called the cantle, and the high point at the front is called the pommel. The artist is most likely to encounter the following: the 'GP' (general purpose) type with a 'forward cut' (curved front) and padded 'knee-rolls' to help maintain the rider's leg in position when jumping; the 'straight-cut' dressage type, which has less of a knee-roll and a vertical front edge to the saddle flaps (to allow freer shoulder movement); the showing saddle, which is also straight cut (to show off the horse's shoulder) but usually doesn't have knee-rolls; and the racing saddle which is as small and light as possible. There are many other types of saddle, including Western saddles, and side-saddles (which have extra pommels to give security when jumping, as a lady riding side-saddle has only one stirrup).

Stirrup irons (or 'irons') hang from stirrup leathers. The girth is buckled under the flaps of the saddle on each side and goes around the body to keep the saddle in place. There are many different kinds of girth, but one particularly of note for artists is the surcingle – an additional girth that goes over the top of a saddle for extra security. Numnahs are cloths or pads that go under the saddle. Some saddles have additional attachments, such as breast girths, breastplates and cruppers, to keep them in place, which go round the horse's chest or tail.

Snaffle bridle designed for one bit, with stitched cavesson noseband and a running martingale with 'stops' on the reins to prevent the martingale rings interfering with the bit. Compare the ears here with the ears on the drawing of the double bridle; they are very mobile.

Double bridle (for two bits) with plain cavesson noseband.

Bridles

The bridles illustrated are versions of the two that you will see the most: the bridle used with the snaffle bit (but also many other bits) and the double bridle. There are also many different bridles with specialized bits for particular purposes, and some bridles which have no bit in the mouth at all.

In the bridles illustrated, the cheekpieces hold the bit at the correct height in the mouth and therefore sit closely against the head, but the throatlash (the strap that hangs across the cheek) is intentionally loose; it should be possible to put the width of the palm between it and the horse's cheek. (As mentioned above, as well as positioning tack correctly, it is very important not to show a strap as loose that should be tight, or vice versa.) Nosebands have a range of styles and functions. The traditional plain cavesson noseband is often seen on hunters. The cavesson should be (but often isn't) placed two fingers' width below the end of the cheekbone, and should also be closely buckled, not hanging loose. Some nosebands have sections that go below the bit and are firmly buckled under the chin to keep the mouth closed. Racehorses often don't wear a noseband at all, or may wear one with a sheepskin cover. There's more than one way to hold reins, so take note how a rider holds them if you are working on a commission.

The double bridle is mostly used in advanced dressage and showing, though traditionalists hunt with one, and the military also use it. Traditionally it has two bits, a Weymouth and a bradoon, and two sets of reins. The Weymouth has a flat chain attached to it that goes under the chin, in this example the chain is partly sleeved in leather, and has a further leather strap to keep it in place. (There is a bit called a Pelham which also has two sets of reins, but has only one bit.) It is common to see leather straps running from the noseband or from rings through the reins, down the chest, between the legs, and to the girth. These are usually 'martingales' of one sort or another, and are primarily used to prevent the horse throwing its head up and avoiding the action of the bit (and possibly also knocking out the rider's front teeth).

You are also likely to see horses wearing headcollars; these are similar to bridles, but less complicated. They have thicker straps, no bit, and incorporate a sort of noseband. They are normally made either from coloured nylon webbing or thick broad leather, and have an attachment ring on the underside for a lead rope. They are used for tying horses up, travelling, and leading them in situations where the extra control of the bit is not necessary. Traditional halters, made of rope, or rope and white tape, perform the same function. For foals, there is a smaller and simpler version of the headcollar called a 'foal slip'.

PROPORTIONS

Though all horses are different, there are some general proportional relationships that are approximately the same for most horses. The ones I've found most useful are those illustrated here that can be expressed in terms of the length of the horse's head. Such 'rule-of-thumb' proportions (for example, a horse's body is, very approximately, two and a half heads long) can be useful when drawing from life, as they can be used to see if and/or how the horse deviates from them, helping to establish that horse's characteristic proportions. They may also be helpful if it is necessary to construct parts of a horse that couldn't be seen, or which weren't recorded in preparatory work.

Most 'standard' proportional diagrams assume that a horse's body and legs, when seen from the side, will fit into a square, the horse being as high at the withers as it is long in the body. With the exception of Thoroughbreds, I find that most horses are usually a bit shorter in the leg than that. Just as with anatomy, don't let any theoretical proportions distract you from seeing what's really there when you are in front of a living horse. If I had to sum up my approach to all the specific knowledge in this chapter, it would be this – it can be useful to know it, but you have to be able to forget it when faced with the real thing.

For the two examples here I have measured the head from the side and applied that distance to different parts of the horse's body that would normally be approximately a head in length, in order to show where the part of the horse is smaller or larger than average. These are:

- Wing of atlas to base of neck (in front of shoulder blade)
- Point of shoulder to withers
- Elbow to withers
- Breast bone to just above fetlock
- Ilium (point of hip) to back of shoulder blade
- Depth of body at the lowest point of the back
- Point of hock to stifle
- Height of the point of the hock from the ground
- Point of croup to patella

The cob is a type rather than a breed. His mane has been 'hogged' (cut short) as is usual with this type of cob. Cobs are stockily built, and were traditionally a farmer's horse; tough, with strength and stamina that could take the farmer round his land all day and do general work round the farm including in harness, but also able to carry a reasonably stout farmer out hunting over fences, albeit a little more slowly than a conventional Thoroughbred hunter would. We can see that the height of this cob's hocks and the length from his stifle to his hock are shorter than the length of his head, and his forelegs are also rather short, just as I'd expect from a cob.

Thoroughbreds like the lower example are bred for speed before everything, and this is reflected in their proportions. This horse is longer in the leg than the cob, being slightly higher at the withers than it is long in the back (long legs = a longer stride, hence greater speed). It's also more slender, which would be more obvious if seen from the front or from behind, and has a more sloping shoulder (the shoulder here has a similar slope as the cob's, even though the leg is further back, so at rest it would slope more), but otherwise differs less in proportion from the cob than at first sight one might imagine. It often surprises me how little the proportions actually vary between horses that superficially appear to be very different.

Though these are two specific examples, they are both reasonably representative of their respective sorts. Over the years, a number of people have measured examples of horses in order to find their average proportions, and compare the relative proportions between breeds. Some of these statistics were collected in a book, *Growth And Nutrition In The Horse*, by David P. Willoughby. Working from these statistics (which are expressed in terms of a comparison of height-to-withers rather than in heads) the two extremes in terms of build and proportion of those compared appear to be the Thoroughbred and the draught horse. Unsurprisingly, given that Thoroughbreds are descended from Arab horses, Arabs are fairly close to Thoroughbreds in most proportions, except that the Arab is slightly shorter in the head, and significantly shorter in the neck and back (in fact it has one vertebra less than other horses). In these two respects the Arab is closer in its proportions to a draught horse or a Shetland pony.

Draught horses and Shetlands, despite the great difference in size between them (the average height to withers of the male draught horses measured was just under 65 inches, whereas the average measurement for the Shetlands was just under 40 inches) are remarkably similar in their proportions. Both tend to be slightly higher in the croup than the withers (Thoroughbreds and Arabs are, on average, higher in the withers than the croup). The two heavier breeds are also proportionally much longer in the back than Thoroughbreds or Arabs, and have a proportionally longer head, and a deeper chest. They have proportionally shorter cannon bones and thicker legs, and are wider between the shoulders and across the hips. Their necks are also proportionally shorter than those of the Thoroughbred (though similar to the neck length of the Arab).

RIGHT: **Proportions of a Cob (top) and a Thoroughbred (bottom). Though very different in type, their basic proportions as compared to their head lengths are surprisingly similar. In each case, the superimposed lines are exactly the length of that horse's head. (We can't see the height of the hock in the lower drawing; in this case it would be at, or above, a head's height from the ground.)**

ACQUIRING SPECIFIC KNOWLEDGE

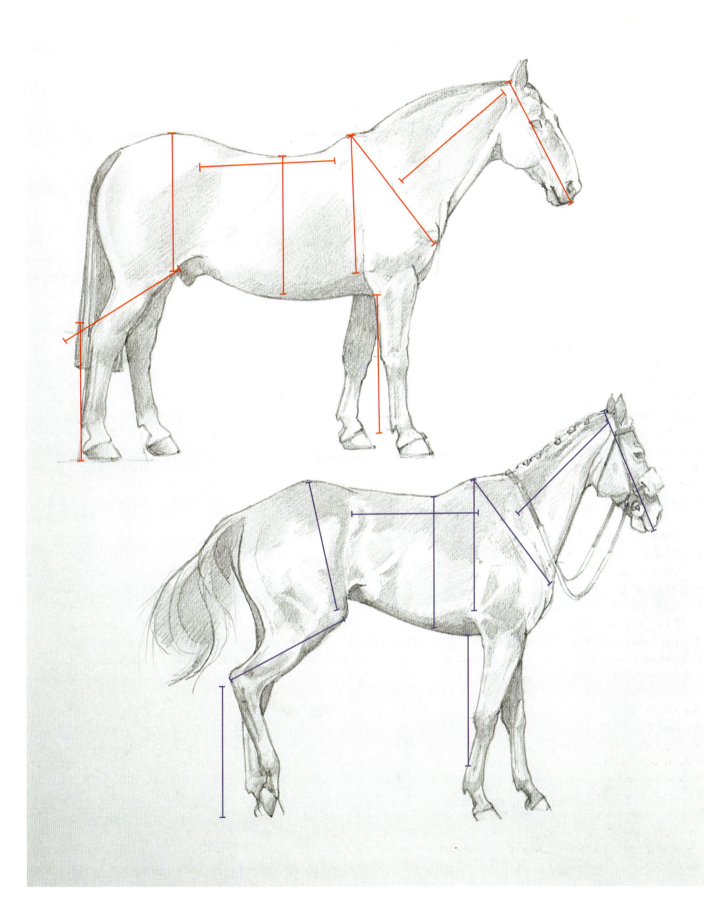

ACQUIRING SPECIFIC KNOWLEDGE

Foals of any breed are very different, and have to be observed very carefully. When a foal is young it is very much taller than its body is long, it is long in the leg but not deep in the chest. Its neck is also much shorter in proportion than the neck of an adult horse (so much so that they can't just bend their neck to reach the grass, they have to bend and/or splay their forelegs as well). The foal is also proportionally much narrower in the body from side to side than a fully grown horse or pony.

There are many breeds of horse, and they all have their specific characteristics and variations from 'standard' proportions. Individual breeds have their own proportions and peculiarities; for example, some breeds are restricted to certain colours only.

The proportions of all breeds should be within healthy limits, but will nevertheless vary to reflect the work they do, the environments they have traditionally lived in, and also, to some extent, taste and fashion.

The racehorse has long slender legs and sloping shoulders to give a long stride, a delicate head, medium-sized feet, long neck, and a fine silky coat. The Shire, which needs to be able to pull weight, has short thick cannon bones, a long back, upright shoulders, a short, thick neck, a big heavy head, big feet (to spread its weight when ploughing so it doesn't sink into the soft ground), and a coarser, hairier coat with 'feathers' (long hair) around its fetlocks. Arab horses and Welsh cobs, amongst others, tend to have 'dished' faces (a concave profile). Thoroughbreds tend to have a straight profile, and the heavier breeds are inclined to have 'Roman' noses (a convex profile).

You will always be able to find individuals who don't fit the theoretical shape their breed or type is supposed to be in every respect. Never make assumptions, especially when doing portraits.

CONFORMATION

Conformation is the subject concerned with the 'correctness' of all the shapes, angles, sizes and proportions of the parts of a horse's body, and how they all fit and work together. 'Good' conformation is consistent with soundness and good performance. There is fairly general agreement about what good conformation is, though the ideal conformation for a specific job may vary a little from the general norm. There are specific terms for deviations from good conformation, particularly those which make a horse prone to lameness. This is a very large subject, and is outside the remit of a book for artists, but for those who are interested I have listed some books in the Bibliography which go into conformation in more detail.

Horses, like people, are not usually perfect, and part of what gives them individuality and character is the way they deviate from a single idea of 'perfect' conformation. However, if a horse has an exceptionally glaring defect, like a crooked leg or one eye higher than the other (one horse of my acquaintance had one eye so much higher than the other that hoods for him had to be specially made, or he couldn't see out of both of the eyeholes at once), for a commission it might be worth considering the possibility of posing it in such a way that it wasn't more obvious than necessary.

Horses show most faults less plainly when moving than when standing. A standing horse that is badly 'back at the knee' (the leg below the knee being angled forward rather than straight down) might be more flattered by a pose from the front than the side, as it wouldn't show that particular defect so plainly. A horse with a dipped back (where the downward curve of the back is too deep, something common in older horses) might

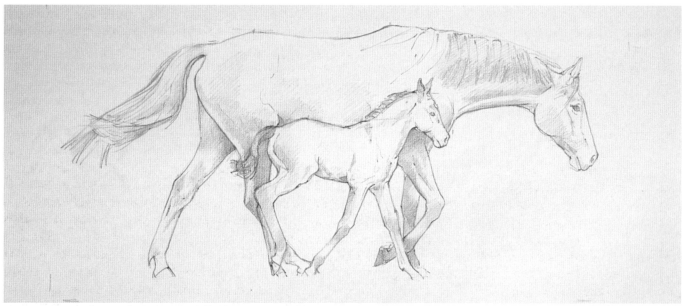

Mare and young foal, showing differences in proportion. The foal's legs are about two-thirds of the mare's in length, but his body is less the half the length of hers, as is his neck.

ACQUIRING SPECIFIC KNOWLEDGE

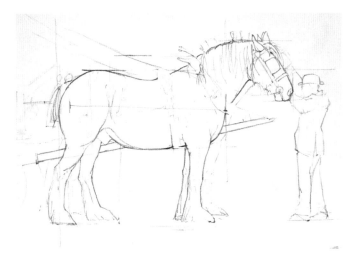

Shire horse, showing its proportions – longer in the back than it is tall, with thick legs and a short, powerful neck. This Shire has the typical 'Roman nose' (convex curve to the face) of the breed.

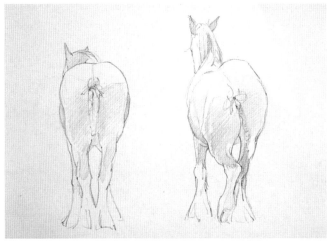

Two Shire horses, showing how wide their quarters are relative to their height.

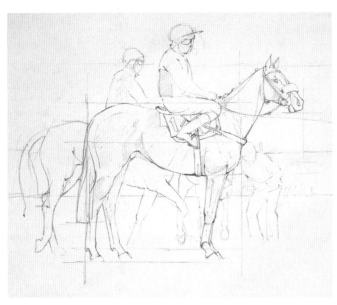

A typical Thoroughbred, taller than it is long, with a long, thin neck and slender legs. Notice also the straight profile of the face. (This isn't an ideal pose for a portrait, as the horse appears to have only three legs.)

A Thoroughbred from behind. Despite its muscular development, it is narrower between the hips in proportion to its height than the Shire.

look better with a saddle on, possibly with a saddle cloth as well, and it would certainly be a bad idea to pose it with its quarters higher up a slope than its forehand, which would make it appear worse. Even a horse with a 'good' back can look hollow-backed in such a pose. Personally, I won't actually alter a horse's appearance for a commission, but I am happy to show it to its best advantage, if the client wishes me to do so. This is a matter that has to be handled tactfully, however.

If I'm painting a horse I can't pose, for example one standing in a group in the river at Appleby, that has 'sickle hocks', (a conformation fault where the hind legs are too bent) then I'll paint it as I see it – complete with sickle hocks. That's how it is, and I see nothing wrong with painting the truth of what I see. In fact, I think it shows more respect to the horse to do so. Speaking as someone with a beaky nose, I would not be pleased if someone painted it cute and retroussé – my beaky nose is part of what I am. I don't change stone-roofed houses into sweet little thatched cottages when painting in the rugged Pennine moors either. But how far you want to 'prettify' or standardize things is, of course, always up to you.

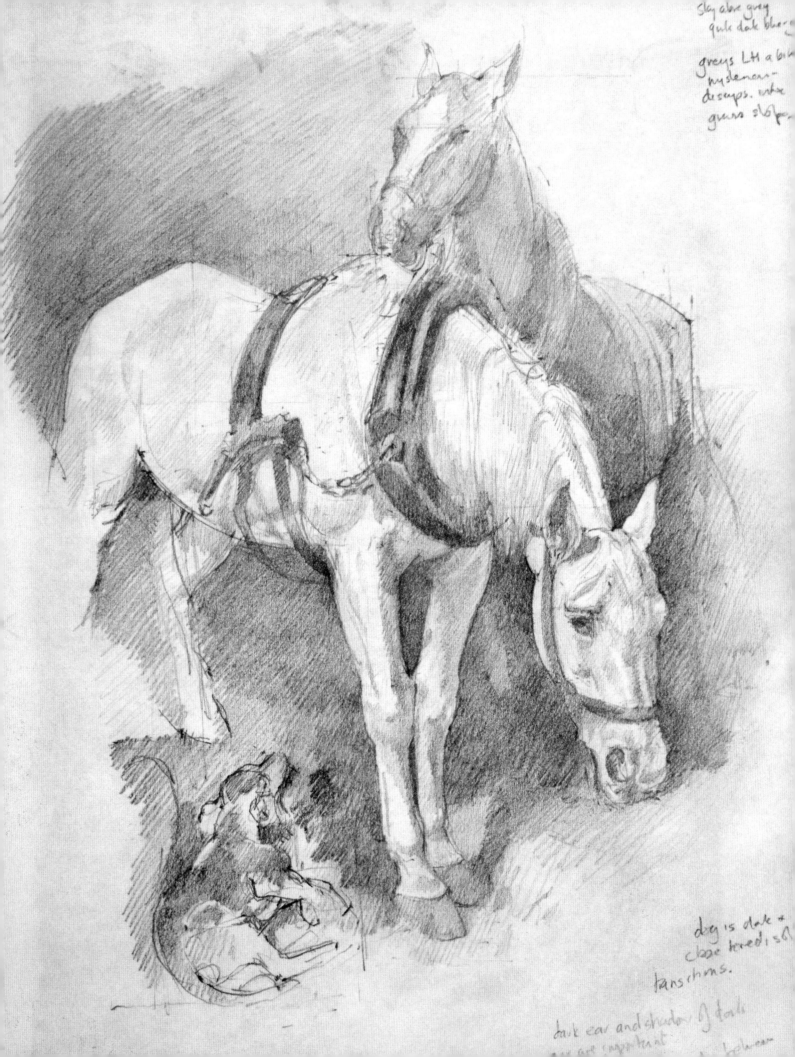

CHAPTER 5

MORE DRAWING

'Accuracy ought to be learned before despatch in the execution.'
Leonardo da Vinci, *On Painting*

MEASURED DRAWING

Why do artists measure? The most common reason for artists to measure is because measurement helps with the observation of proportion and foreshortening. It can also be used as an objectve way of checking a drawing for mistakes. Some artists measure a lot; others may use it only occasionally, or in a simplified way. Try it and see, but do give it a fair chance. It does take a little while to learn.

No measurement system is perfect, and it can be hard to predict the appropriate system to use for a particular situation until you have built up some experience. Begin with static subjects, like landscape, still life, or life drawing, and work slowly and carefully, double-checking everything until you have thoroughly grasped the system before you attempt a subject that isn't completely still. For preference, draw standing up, with your board vertical on an easel. If you sit, slant your board or sketchbook to face you at a right angle to your line of sight. Face your subject directly when measuring, don't stick your easel in front of you and peer round it to measure or sit where you have to twist your body to see the model. Measurement becomes difficult if you use it very close to a subject. The larger your subject is, the further away from it you need to be.

The most efficient way to learn measurement is in a taught life class, where the teacher can see when you may be going wrong and correct you; sadly such classes are not always available. Here I will explain the two main methods of measurement; for brevity I'll call them 'direct' (the simplest and quickest system) and 'modular' (the most flexible, and the most accurate if your subject is still). There are some absolute requirements that apply to both:

- The artist and subject must stay in exactly the same place, and the pose must stay the same.
- Measurements must be made with the elbow and wrist locked straight.
- If you don't believe a measurement, check it; don't ignore it or guess.
- Measurements are more accurate if they are done either horizontally or vertically.
- Measurements at an angle are useful for checking but are unreliable on their own as even if the measurement is correct, it is difficult to transfer an angle correctly to a drawing. If you want to measure to a point that is neither directly under, nor level with, an existing mark on your drawing, then you will need to make two measurements: one to establish its height, and another to establish how far 'across' it is.

A few simple measurements might be all you need for a small or not very detailed drawing, just to keep it in the right general proportions, but if you wish to and your model is still enough, you can measure in as much detail as you like. In a life class you can measure even small distances, like finger joints, and can potentially work to a very high degree of accuracy. It is good practice to do this from time to time, but with live horses you'll need to keep it simpler. To keep the drawing together, I would advise, as always, to keep working over the whole drawing rather than working on one part of the drawing much more than the rest. You'll catch any mistakes sooner.

Using the Background

Don't patch backgrounds in afterwards or ignore them; it isn't only a horse's volume that's important but also the spatial relationships between it and the objects around it. Backgrounds can also offer a lot of help when measuring, such as by providing vertical posts or walls as reference points. Negative spaces are as important when measuring as when doing any other sort of drawing – watch out for them.

LEFT: **Transcription done in York Art Gallery: detail from J.F. Herring's** *Barney, Leave the Girls Alone.*

MORE DRAWING

To measure, the elbow must be locked straight, with the wrist in line with the arm.
I keep my little finger on the thumb side of the pencil, as I find it helps me keep the pencil still, and accurately vertical or horizontal. It also makes it much easier to slide the thumbnail accurately, and without dropping the pencil. This grip can also be used for drawing, as it enables very precise mark making, though it feels strange at first if you are used to holding your pencil like a pen. For it to be possible to make fluent curves using this grip, you usually need to stand to work in order to keep the arm, wrist, and shoulder free.

To Measure

Hold the pencil upright at arm's length, with the elbow locked straight, and close one eye. Place the tip of the pencil in front of one end of the length which you wish to measure, hold the pencil still, and slide your thumbnail down the pencil until your thumb lines up with the other end of the length to be measured. If you have difficulty holding a pencil still, support your arm at the elbow using your other arm with its elbow resting against your body.

Direct Measurement

I've taken a horse standing sideways-on as an example. Before I started to draw, I measured the height and length of the horse to fix the position of the drawing to make sure it would fit on the paper.

I always begin a drawing by measuring something that won't change much if the horse changes its stance slightly; in this case I chose the distance from the withers to the underbelly directly below, and then transferred that distance to the paper. I then knew exactly how deep the chest was, and could make a horizontal mark to indicate the height of underbelly there. Next, I measured the height from the withers to the pastern of the nearest foreleg, then from the withers to a point level with the shoe. That established the height of the horse.

Next I measured the distance from the withers to the croup, and transferred that to the paper. I could then draw the curve of the back between the two points, knowing that it wouldn't be either too long, or too short. I could even measure the amount of dip in the line of the back to be sure I didn't make the back too flat, or too curved.

I then measured from the withers to a point directly above the point of buttock, and from the withers to a point above the front of the chest at the point of shoulder. That gave me the length of the body. I could check this by measuring the overall body length. Each measurement I made helped me find where a part of the horse should be; in the illustrations you can see the scaffolding for my drawing developing. A drawing built on a secure scaffolding can be developed with confidence, in the knowledge that the proportions should be correct. However, look carefully at the shapes and curves of the horse as you place lines between the measurements – this isn't a 'join the dots with straight lines' exercise.

Make just a few simple measurements at first. Keep an eye on the negative spaces, and check horizontals and verticals, just as you would when drawing without measurement.

With this system, a measurement is made and transferred directly to the paper. Unless you move closer to, or further away from, your subject, the only way you can vary the size of your drawing is to scale those measurements; for instance, if you wanted a larger drawing, you could double up each measurement. Direct measurement is difficult if you are close to a subject, because taking the measurements becomes awkward. It is also less consistently accurate than modular measurement (due to optical factors too complicated to go into here), but it is much quicker to use, and easier to learn.

Early stages in a measured drawing using the direct method. Major features of the form and the positions of the extremities have been found first.

A slightly later stage in the same drawing showing more development of shape and form within the established proportions.

Modular Measurement

Modular measurement uses one part of your subject to measure everything else. This has a number of advantages. It is easy to work to any scale you like. You are continually referring one part of your drawing to another so it is easier to catch an error than when using direct measurement, and you should be continually thinking of the drawing as a whole. For geometric and optical reasons it is fundamentally more accurate than direct measurement, because the unit you use to measure everything with is always the same length.

For my basic unit here I used the distance between the top of the withers and the underbelly below the point of the elbow. I have chosen this distance as I will have to keep referring back to it and I need something that won't change if the horse alters its position slightly. I also find it easier to use a vertical unit.

Holding the arm locked as before, I measured the distance as described above. (This unit will be used throughout the drawing to measure everything else.) I then measured the length of the horse in front of me from nose to tail in 'units', in this case, that came to three.

Then I had to decide on the scale of the drawing. First I decided how wide I wanted the drawing of the horse to be (unlike with direct measurement, this could have been any size I liked) and marked that width on my paper with two vertical lines. I then divided that distance into the number of units long my horse was – three in this case. Finally, I measured the length of one unit and made a vertical line that length at one side of my paper. That's the length of the module on my drawing; it represents one unit.

I then found the unit on the horse again, and used it to measure how many units high the horse was at its highest point (in my case the ears). I then used the same number of modules on the drawing to find the height of the horse in the drawing. (Had the drawing been too tall for the paper, I'd have had to reduce the length of my module and start again.)

In theory, it is now quite straightforward. Make every measurement in 'horse' units, and mark it down in the same number of 'drawing' modules. You can measure large distances by counting how many units long they are, and smaller distances by measuring them first and then seeing how many times they will 'go into' your unit – on your drawing, that distance will 'go into' your module the same number of times.

It's even more important with modular measurement to measure only horizontally and vertically. Measuring at an angle using a module is very tricky indeed.

I find it works best to do all measurements from one original point, as far as possible. The highest point of the withers, which is nice and central on this pose and won't move about much, is often a good place to start. In this case, having fixed the withers and the underbelly at the elbow, I measured forward from the withers to a point directly above the front of the chest. That was about half a unit. I then made a mark on my drawing half a module to the left of the elbow; I now knew that the horse's chest couldn't go further forward than that. I then measured from the withers across to the highest point of the croup (1⅓ units) and marked that distance on my drawing at 1⅓ modules to the right of the withers. As ever, I was checking horizontals – was the top of the croup higher or lower than the withers? Normally it will be the same height with this pose, and indeed it was here. So now I know exactly where the croup is.

I then measured from the withers to a point exactly above the point of buttock; the horse's body in my drawing had to end at that line. I then held my pencil horizontally and found a point underneath the withers that was level with the point of buttock, measured down to that point from the withers in units, (about ⅔ of a unit) and used that to determine exactly how far in modules below the withers the 'point of buttock' should be (⅔ of a module). I then found all the major points of the horse by the same method, developing the drawing of the horse using the measurement points as I worked.

I'd also measure things in the background or tack on the horse if I felt that would be useful. In this drawing, the numnah, saddle, and stirrups are useful reference points; the bottom of the saddle flap is level with the point where the neck emerges from the chest, and it is much easier to measure from the withers to the saddle flap than to the chest, so I measured to the saddle flap and took a horizontal from there to find the base of the neck.

Because this is not a direct measurement method it takes longer, especially at first, but once you're used to it, it is very flexible. The direct method can become a severe exercise in mental arithmetic if you wish to enlarge or reduce by multiples like 17¾ or ⅝; but with this system it is equally easy to work at any size.

MEASUREMENT TROUBLES

If things are going wrong, check that you haven't slipped into the following common errors:

- Not keeping the pencil at arm's length when measuring. This is the most common fault. The pencil must always be at the same distance from your eye. The drill is, locked elbow, wrist in line with the arm.
- Moving around. You must keep that measuring eye (and your subject) still. Mark where you stand in some way; perhaps by a twig on the ground.
- Not trusting your measurements. Check them by all means, but you must trust them, even (perhaps especially) if they are not what you expect. Don't just ignore or overrule any that you don't like.

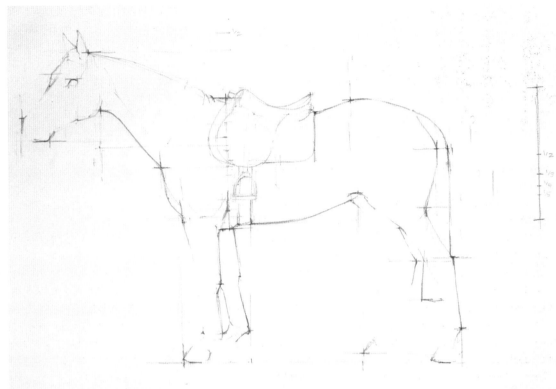

Here, the basic scaffolding of the drawing has been established by measurement. From this point I could go on to build in as much or as little detail as I liked, knowing that the horse was in proportion. If I wanted to 'tidy up' the drawing, I could remove the measurement marks, but unless I really needed to, I'd leave them there, as they fix important positions very clearly. On my 'module' I have marked off a half, a third, a quarter, and a fifth, for when I'm transferring measurements that were not whole numbers of units. This saves time, and makes for fewer marks on the drawing itself.

- Not measuring from your first reference point. If you measure from any other point, and you happen to have got that one wrong, things will go from bad to worse. If you measure from your first reference point wherever possible, you'll catch most of your own mistakes without any help.
- Not assessing the horizontals and verticals correctly. Check with a plumb-line or spirit level if your drawing seems to be leaning or distorted. In any drawing, measured or not, horizontal and vertical alignments are the structural tiebars which hold a drawing together. If you suffer from uncorrected 'astigmatism' (a structural problem of the eye), I'm afraid these alignments may be difficult to get right.
- Trying to do a 'neat' drawing. Don't. Measurement and alignment marks are part of the drawing, and should help you notice important things about your subject. Unless you have a specific reason for removing them, leave them – there is no need to rub them out. Corrections are a record of what you've learned, so leave them in too. Start with light lines, correct with heavier ones, so you don't confuse your marks.
- Attempting a subject that is too difficult. Avoid tricky subjects at first (e.g. architecture from odd angles and very foreshortened subjects).
- Squeezing the drawing to fit your paper. If your paper is too small, or you started in the wrong place, too bad! Either extend your paper with another sheet, or let the drawing run off the sheet. The worst thing you can do is to squeeze things up; the drawing becomes worthless as a reference and confusing to work on. Plan your drawing with a few careful measurements before you start next time.
- Overdoing it. Your eyes will find this difficult at first. Don't strain your eyes by doing very long sessions before they are used to it; an hour would be enough for the first time. Good light helps – measured drawing is much more difficult in poor light conditions.

MEASURING AS A CHECKING EXERCISE

You can use measuring to track down problems or bad habits in your freehand drawing. Set a scale on your paper using whichever measurement system you prefer, then draw freehand. Then go back and carefully and honestly check all your freehand marks using measurement. This should help you find any problems with your drawing. It is especially helpful to do this when drawing foreshortened subjects. Most of us have a few pet errors which we make without realizing it, such as placing pasterns too low, or making heads too small. Measurement can help us find these faults, and, more importantly, help us eliminate them.

MORE DRAWING

DRAWING EXERCISES

Developing Memory

To some extent, even with static subjects, we are always drawing from memory. We look, see a curve, assess its nature (is it an even curve, or does it perhaps tighten along its length?), carefully place it in our mind, turn to our paper, and draw it. However, if we are to draw something that isn't completely still, then we have to be able to memorize shapes faster, and hold more information in our mind for longer – not easy things to do. The following exercise works on developing visual memory. Initially most people find it hard, but it is worth persevering with it. It does get easier with practice.

For this exercise, I would suggest working from photographs, at least at first. The subject won't move in the 'observation' time, and it is also easier to check afterwards how accurately you have remembered the original, and therefore how effective the exercise has been.

If you don't want to waste expensive paper on this exercise, you could use layout paper, which is thin, white, and smooth. I find it pleasant to draw on, though of course it is not archival. I'd use a soft pencil, 2B at the very least, or charcoal. You could even use ink if you were feeling brave. You don't need to work very large; in fact, you might find it easier if you work quite small at first – maybe even as small as A5 if you are using pencil.

Take one photograph of a horse, and look at it for two minutes. (Time it.) Turn it face down. Then draw it, just very simply in line. Don't panic, just draw everything you can remember; take your time, and, when you are sure you can't remember anything more, turn the photograph back over and compare it to your drawing. The chances are that the first time you do this you won't have recorded much information, and what you have recorded won't be terribly accurate. This is because it is difficult at first to decide what we might need to remember when looking at the original image, so we try to remember too many things. As a result we get muddled and end up not remembering very much, and we find that, when we come to draw, we can't remember whether the legs were straight or not, let alone which legs were forward and which back or what the shape of the neck was.

Of course, we'll never remember every detail, but we can train ourselves to look for and remember the big, important things, like the curve along the top of the back and whether it is level or not, the angles of the legs (even if we just remember them as sticks at this stage), the angles and shapes of head and neck.

Try again with a fresh photograph. Now you have more of an idea what to look for it should be a little easier. When you've drawn what you can, turn the photograph over and compare again. Hopefully your drawing should have a few more things in it this time, and they should be more accurate.

Always keep in mind as you work that this exercise is about identifying what is important as quickly as possible and storing it in the memory; it's about speed and accuracy, rather than detail, and quality of information, rather than quantity. (It's more important to remember things like the angles of the legs than how many buttons there are on the jockey's jacket.)

You may find that you end up muttering to yourself about things to remember; that's fine. As long as you're looking and remembering, it doesn't matter how you do it. When I'm doing this exercise with human models, I find that in the 'looking'

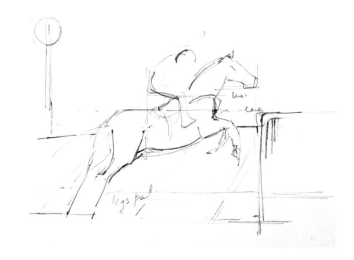

I used the fence and the post here to help me remember things – the top of the wing of the fence is level with the horse's back, and the top of the actual fence is a little below it, and is not horizontal, but falls a little to the left. The line along the bottom of the fence is rising up to the left, and the two hind legs are parallel from the hocks down. The lowest point of the disc on the post is level with the top of the jockey's head.

phase I sometimes take up the pose of the model briefly in order to get the 'feel' of the pose and work out where the weight is, as that helps me remember it. You can't do that with a horse in quite the same way, but trying to think of yourself as the horse and imagining how the pose might feel could help you remember. You will find ways of your own to fix things in your mind; you must do whatever works for you. I have found the following things work for me:

- Are there any things that are vertical or horizontal? If you can remember them, they can make a framework for everything else.
- Which things are level with, or directly underneath, which other things?

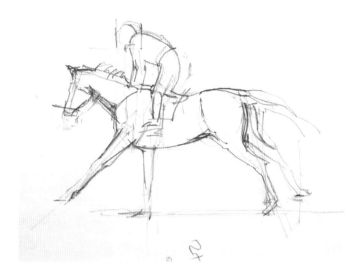
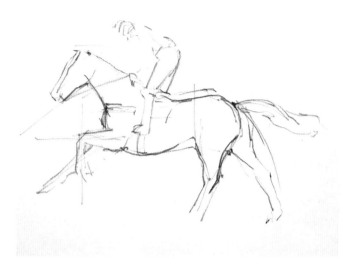

I found it useful with this pose to remember that the off-fore was vertical, and the jockey's calf was also vertical and slightly to the right of it. I also noted that the front of the jockey's head was above the horse's chest, and the back of the head was above the horse's elbow.

Here I noted that the underside of the horse's head was parallel to the off-fore, and the horse's left forearm was approximately horizontal. I noted the triangular shape between the two hind legs, and the very small triangular gap between the nearside knee and the off-foreleg. I also noticed that the breast girth was not quite horizontal.

- Look for any helpful horizontals or verticals in the background, like telegraph poles or walls (these things aren't always vertical, so it pays to check).
- One way of assessing and/or remembering an angle of a line is to think of it like the hand of a clock – what number would it be pointing to? (Some artists might find it easier to think of angles in terms of points on a compass.)
- Look for the shapes of any important negative spaces; are they square, oblong, triangular, tapering, slanted, tall, wide?
- Can you see any things that are parallel to each other (for example, a leg that's parallel to the angle of the horse's head.)
- It can be useful to try to remember the angle of the front of the head, and how high the horse's poll and chin are compared to the rest of the body.
- Is there anything useful in the background, like a tree or a building? Drawing it could make it easier to remember other angles and shapes.

You may find yourself 'filling in' the things you don't remember by calling on previous experience of drawing horses and your knowledge of anatomy. If you find yourself doing this, when you turn the photograph back over, check to see if you were right when you used that information. If you were, then you're using your knowledge usefully (although when you are supplementing your memory with your knowledge you do need to be aware that you are doing it – it's not a good idea to be doing it without realizing it). If your 'knowledge' has led you into error, attempt to work out why you got it wrong, and you will be learning something useful for the future.

When you have done the exercise a few times, stop. You should find that each time you improve, but don't overdo it. This exercise takes a lot of concentration if done properly, and three or four goes at once is probably enough. Have another try on another day. If you find that it is helping with your drawing, do it whenever you feel you will benefit. Keep it simple. It's about developing skills for drawing at speed, especially when working from life from both standing and moving horses. It should help you learn to work out quickly what's important, to discard what isn't, and to remember and record those important things.

If you are struggling, try extending the time you allow yourself for the observation stage. If it starts feeling easy, push yourself a little, try to remember more, and/or try cutting down the observation time. When you are confident, try the exercise from a real horse/horses. Of course, if you go to a life drawing class, you can do this exercise there too. Look for a set time, then turn away and draw without looking back to the model.

Memory develops with practice, and a better visual memory should help with all the drawing that you do.

MORE DRAWING

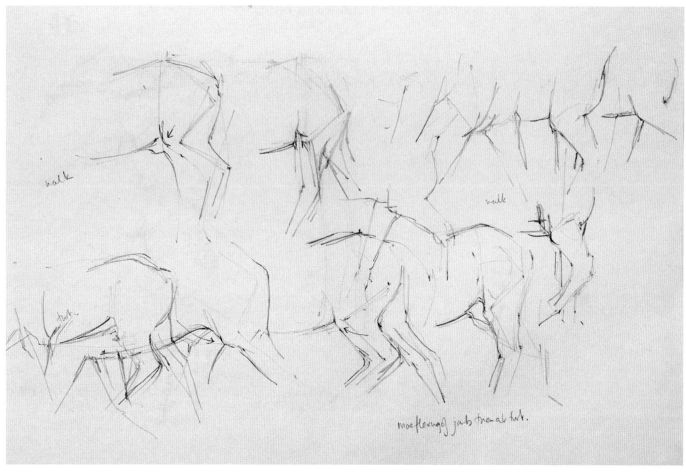

Notes on the extent of movement of the hind legs and forelegs at the walk, and the hind legs at the trot.

Studying Movement

This will be much easier if you have done some work with the exercise in memory drawing first, as you will need to be able to see things quickly, and then remember and record as much of what you saw as you can.

Start with a horse walking. You might be able to watch a horse being lunged, or a lesson in a school. If all else fails, take a video. Provided it is only for private study, you could use television footage of horses walking round in the paddock at the races (see notes elsewhere on copyright). Avoid footage shot from strange angles; much racing coverage in particular is now taken from high viewpoints which makes horses' legs look too short.

Thinking about your knowledge of the stride at walk, pick a phase of the stride, and look specifically for it. Each time your horse is in that position and at that same angle to you, fix something in your mind about it, hold it, then draw what you have observed. I find it can be helpful to snap my eyes shut for a second as the horse moves out of the phase, as I can retain the image for a tiny bit longer.

You might choose the point where the off (right) forefoot is forward. Each time the horse is in that position, look and see what else is happening. You could count the stride out loud, 'one-two-three-four' for the four beats, and then at the right number, in this case two, look and ask yourself – is the head up or down? The next time, you could ask, where is the left hind leg, is it bent or straight? Or what angle is the shoulder at as that leg comes forward? Each time you see the horse, you add a little more information to the drawing.

You can begin with little more than sticks for the legs, and then develop them as you see more, until you have enough information for your purpose. Don't expect too much. You won't be able to do complex drawings. They will just be simple ones, even just a few angles of legs and no more, but the exercise will be forcing you to really look, which is the point of doing it. Write things down in words as well, if it helps.

Drawing motion from life is very, very difficult. Some people never get the hang of it, so if you find it is beyond you, don't get worked up about it. Even the fact you are trying reflects well on you, as many people never even try. If you are really stuck, have a go at drawing a grazing horse. When horses graze, they move

MORE DRAWING

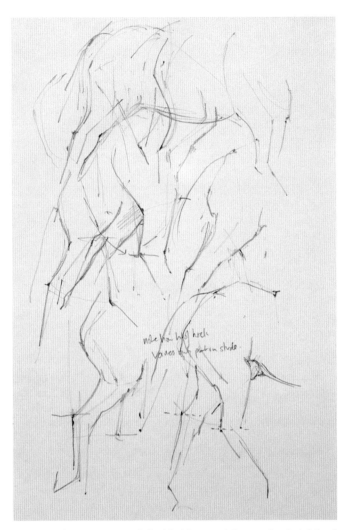

Notes on the movement of the hind legs and the varying heights of the hocks at different points in a stride.

Things to Look for in a Phase of a Motion Pose

Look for leg positions, overall angle of leg, is the knee or hock flexed/straight, is the pastern flexed/straight? How far forward/backward is each hoof? Where is the top of the leg? (Remember, for example, that we have seen in Chapter 4 that as a foreleg moves forward, the shoulder swings forward, so the leg appears to 'come out of the body' further forward as well.)

Is the body rocking up at the front, or down, or is it level? (Use a pencil held horizontally to check.) Is the shoulder swung forwards or is it more towards the vertical at this point in the stride?

Where is the stifle (kneecap)? Is it above the underline of the body or below it, is it forward or back? (It moves a lot in a stride.)

Is the head held high or low, what angle is the front of the face at? Is the upper line of the neck straight or curved?

You can probably do useful work from walk and even trot if you take some time over it, but at even at the slowest canter you'll be lucky to get very much drawn other than the body and head. But all the same, it's worth a try, as it will still make you look.

At the faster paces, even if you end up drawing very little and all you succeed in doing is getting a better understanding of how the body rocks up and down within a stride, that's still an achievement, and will hopefully prove helpful in the future.

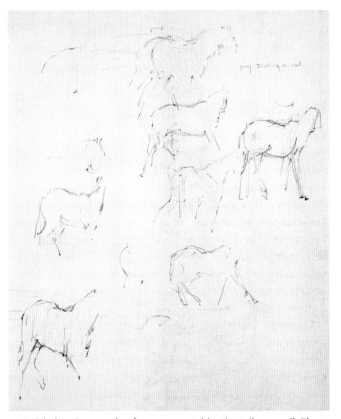

Quick drawings made of a pony scratching its tail on a rail. The horse was moving all the time, so getting anything other than the basic angles of the legs was difficult.

between poses that are often similar to phases of the walk, holding each pose for a little time whilst they eat. You could either make several drawings of different poses and move from one to another as the horse moves, or to simplify things even more, concentrate on just one pose, taking a break when the horse is in a different pose. Each time the horse stops with its legs in the right place for you, do a little more observing and drawing.

If you get plenty of practice at this, you might eventually feel able to attempt a walking horse again. Just work at it calmly, don't expect miracles, and don't panic and give up. Like most things in drawing, it all takes time and practice.

Some life classes have sessions on motion. As they are using a human model, it is possible to ask the model to pose mid-stride for a few moments, then move on to another phase and stop there for a few moments. The time for each pose can be decreased gradually as the students speed up, until the model is actually walking, though slowly.

MORE DRAWING

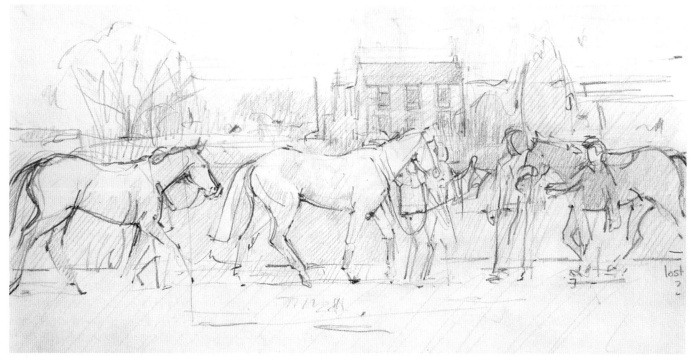

In this example, a little tone is being used to indicate the form of the central horse, and the tone relationship between it and its surroundings.

General Drawing Exercises to Try

Here are a few exercises that are commonly used in drawing classes which you could try if you feel that your drawing is getting stale and that you need a change to loosen it up:

- Drawing without looking at the paper.
- Drawing without taking the pen/pencil off the paper.
- Drawing with only straight lines.
- Drawing *without* any straight lines.
- Drawing with the non-dominant hand (the left if you're right-handed, and vice versa).
- Covering the paper completely with pencil or natural charcoal and drawing into it with an eraser (don't use compressed charcoal or charcoal pencil as neither rub out well).
- Drawing from a photograph turned upside down (drawings done this way are usually more accurate as you will observe more objectively).
- Drawing with a brush, using ink or paint (this should produce more flowing lines, and is a good exercise for brush control).

One last tip: whenever you draw, always spend more time looking than drawing

TONE IN DRAWING

Ideally, shading or other types of tone should integrate the subject and the paper, creating volume and space, rather than being confined to completely 'filling in' isolated hard outlines on an otherwise empty paper. If shading is open and dynamic, and plenty of plain unshaded paper is left within an object, then the object will 'read' as part of the paper and any background around it, even if there is no shading elsewhere. (However a main subject is treated, it helps if the background is treated in the same way.)

If any object, in our case a horse, is shaded all over within a hard contour and in an almost infinite variety of tones surrounded by paper with either no shading at all, or only a sort of apologetic shadow next to each hoof, it looks cut out and stuck on, and it will appear flat and stiff. The only time I'd consider doing this sort of drawing would be for commissions where that style was specified by the client, studies, or drawings for illustration purposes that are really more diagrams than drawings, such as those in Chapter 4.

The most important thing in tone work is getting the relative values of the tones you apply marshalled in the right order. I would start by lightly shading or blocking-in the darkest areas. If, and only if, I still felt I needed some mid tones, I would then place them, darkening the darker areas to fit, working across the whole drawing each time. It is a false assumption that finer and

finer gradations of tone create more volume – a few simple tones accurately and thoughtfully placed can be far more effective in this respect. As is often the case in both drawing and painting, 'less is more'.

If you haven't studied a lot of master drawings, now is definitely the time to do so. They are generally reproduced well in art books, so it isn't as necessary to travel to see the originals as it is with paintings (though it is still good to do so if you can).

Here is a drawing that shows a record of both colour and tone. Note that some of the lights on the black patches on the horses are lighter than the shadows on the white parts. This can easily be the case with a shiny black coat in strong sunlight.

Note particularly how the masters treated tone. Drawings by Raphael are beautiful and light, showing much clear paper within his figures. Rembrandt's superb drawings and etchings might help those who wish to do denser all-over tone work, and watercolour painters and illustrators should enjoy the work of the Tiepolo family, who were masters of line and wash (and seem to be able to draw horses at just about any angle, even from underneath).

When working from life, often there is little time for tone work as well as line, so it is even more necessary to keep shading simple and work out your priorities. Consider which areas of tone would, if you recorded them, be most effective in making the drawing say what you want it to say.

Tone can be used to show volume, and/or describe light. It isn't only about local colour; I find that often it isn't about colour at all. One doesn't 'shade in' a black horse black all over. With tone as with line, what you select to record will depend on what the drawing is trying to do. If the purpose of your drawing is to study structure and volume, then you could use tone to indicate such things as the lights and shadows that show the form of a horse, like the structure of its head and jaw. If the drawing is about light, you would look for the darkest darks in your overall subject, making them the darkest part of your drawing; that might mean shading a hedge in shadow behind a horse where it makes a strong contrast with the horse's back, and shading the horse's shadow, but having little or no shading on the horse itself, even if it was not a very light colour. Sometimes the two approaches overlap, sometimes they don't; it is more a question of emphasis than anything.

For general drawing purposes, I prefer simple tone work, leaving plenty of 'open' paper, but there are instances where I might do a densely shaded drawing with quite finely spaced tones. I might do this in a free-standing drawing intended to be exhibited in its own right if the purpose of the drawing made it necessary. I might also do a densely shaded drawing as a 'tone study' for a painting in order to work out the tone distribution and see if a composition, originally developed in line, still held together when the tones were taken into account. (This sort of drawing allows me to see if I might need to change the colour of a horse from dark to light, or move something in the background to produce less contrast between the background and some part of a horse that I didn't wish to draw attention to.) Whatever the reason for using tone, I would still keep working across the drawing as a whole, rather than shading in one bit completely and then moving on to another area.

Tone can also be used as a simple tool to show texture, to separate objects, to show which objects are behind or in front of others, and to avoid visual confusion (as in the landscape drawing in Chapter 3 on page 57).

Teabreak. **Aquatint etching, 4 × 6 in (10 × 15 cm), by Glynis Mills. This shows how tone can be used to produce form and space. Note the importance of the sky in the composition.**

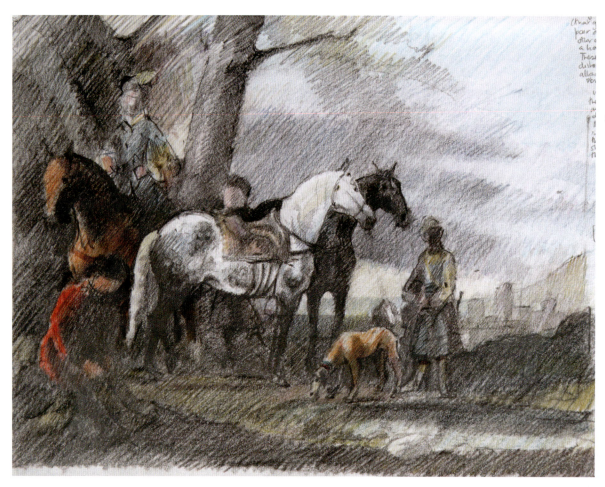

Copy in coloured pencil from *Huntsmen Halted*, an oil by Aelbert Cuyp at the Barber Institute, Birmingham University.

TRANSCRIPTION: LEARNING FROM THE MASTERS

Transcription is the modern term for making copies of the work of other artists, a practice which has been part of the training of artists for centuries: Leonardo da Vinci was an advocate of copying; Michelangelo did it; Rubens made copies of the work of many artists, particularly Titian; Gainsborough copied Van Dyck; Cézanne spent hours copying paintings in the Louvre; and Degas made many copies, including a drawing of *The Battle of San Romano* by Uccello (c. 1456) with particular reference to the horses.

This isn't about making facsimile copies; copying as I mean it here is the use of practical techniques to learn from and understand the work of our predecessors. Copies are usually executed in the style of the artist doing the copy, and are seldom very detailed; the artist needs only to record enough information to achieve the intended purpose of the copy. Some copies vary substantially in technique and style from the originals.

Art students used to have to be able to do accurate drawings from casts before they were allowed to draw from the life model or paint, and copying drawings and paintings was also common practice amongst both students and practising artists. It was still being done in some art schools when I was a student. In spite of the disappearance of formal copying from the syllabus of most art schools, many contemporary artists routinely make copies.

Copies can be in paint and even full size, but they are now most commonly drawings in sketchbooks. The source is usually a painting, but could be a print, drawing or sculpture. Painters as well as sculptors can benefit from drawing sculpture; a sculpture of a horse can be a useful model if you have no access to a live horse, with the added bonus that it won't fidget and you can study exactly the same pose from several different angles.

It is possible to copy from reproductions, but it is preferable to work from originals where possible, as reproductions are frequently inaccurate in colour, and often fail to reproduce some parts of an image altogether, especially in very light or dark areas. All the work shown here was done from the originals.

Sculptures are obviously best studied from the original work. Drawings reproduce better than paintings; those of Holbein, Tiepolo, Degas, Constable, Rembrandt and Raphael are always worth studying. Copying cartoons can also sharpen drawing skills, since if your copy of a cartoon is only slightly wrong it will be obvious, but stick to the best cartoonists. Never waste time copying any but the very best draughtsmen in any discipline.

Two tone studies in pencil from *Cavalry Making a Sortie from a Fort on a Hill*, **an oil by Philips Wouwermans, at the National Gallery, London.**
LEFT: a study of one section showing the interlinking of several horses and riders in more detail.
RIGHT: A study of the whole painting, looking at composition in general and tone distribution.

For purely private study, there are normally no problems with copyright. However, if you wish to sell copies or use them for financial gain, you must check the copyright status of the work concerned.

Why Copy?

Intelligent, questioning and thoughtful copying is the best way to learn from our predecessors because drawing forces us to look and think in the same language. It should help us to see the decisions that the original artist made about composition, space, tone and light, and begin to ask ourselves why they might have decided to do what they did. That is a great way to learn, especially for artists for whom more formal teaching isn't available. In specific cases where a problem has been identified in our own work, copying the work of artists who are strong in that aspect of painting or drawing in which we are weak can help us find solutions to our own difficulties. I have found copying to be a very effective tool, both for myself and my students.

In addition, working in galleries exposes us to a wide range of works and can give us ideas for paintings of our own, it can help with research for a historical painting or illustration, and it brings art history alive. Drawing from sculpture helps to develop our understanding of three-dimensional form. It isn't necessary to be a great draughtsman to copy: I've had primary school children doing it, and they loved it. You can do it at whatever stage you're at. If your drawing is weak, it should help you improve, and, even for the best draughtsmen, copying is still challenging and useful.

Materials and Methods

Accurate full-scale copies in paint are seldom made these days except by restorers in training (though there is no reason not to make one if you want to). A copy can be as loose as you like. It can be anything from a rapid series of lines exploring isolated parts of a painting, to a large and detailed study of an entire work. There are no rules. You just record the information you need in whatever way makes most sense to you. You can make written notes on your drawings if that's helpful to you (it is particularly useful to make notes about colour if you aren't using coloured materials).

The most common materials currently used for transcription are pencil and charcoal, but you can use any materials that are appropriate for what you're trying to do and the constraints of your working space. To study composition, pencil or charcoal line would normally be sufficient. If you are studying colour, paint would normally be the best choice, but if you are working in a gallery directly from the original, coloured pencil may be the only option available to you. In that case you may have to blend and layer and will have to work on relative, rather than absolute, colours and tones.

■ MORE DRAWING

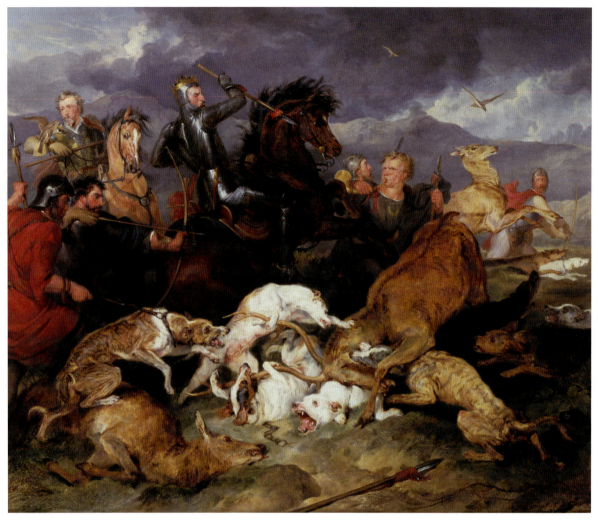

The Hunting of Chevy Chase. **Oil, 56 × 67 in (143 × 171 cm) by Edwin Landseer, 1826. © Birmingham Museums (reproduced by courtesy of Birmingham Museum and Art Gallery).**

Choosing a Work to Study

You might choose to copy a work simply because you like it. As long as you are asking yourself intelligent questions as you work that's as good a reason as any. Provided the painting is a good one, you should be learning things from it. (It is useful to bear in mind that one may like a bad painting, as well as dislike a good one.)

Listed below are some examples of more specific reasons for copying a work:

- Complicated compositions are a problem for you, so you find a Rubens with a superb and complex composition and explore it in line to learn about composition and perspective.
- You are struggling with light in a painting of your own, you find a Munnings which has the effect you are looking for and you decide to do a simplified tone study of it to find out why it works and yours doesn't.
- You feel your own work looks 'flat' and you find a Cuyp which has created an illusion of vast space, and you want to find out what visual tools he used to do it.
- The horses in the Gilpin painting you have just noticed are very well integrated with the landscape, and yours always seem to look 'stuck-on', so you want to find out how the artist did it.
- You want to do some drawings of isolated details of a painting by Landseer from areas that don't reproduce well, so that you can refer to your drawings when studying the painting at home.
- You want to sharpen up your drawing, so you make a careful copy of a master drawing of a horse by Van Dyck from a reproduction in a book.
- You are short of a live model, so you draw casts or statues of horses in the local museum, or a local equestrian war memorial.

A painting need not include a horse to make it useful for an equestrian artist to study. Your choice of painting will depend on the problem you're trying to solve. My equestrian work has

MORE DRAWING

Copy of *The Hunting of Chevy Chase* **using line and, where necessary, tone, to explore composition and rhythm. Note the connections between elements of the picture and where things line up with each other vertically and horizontally.**

benefited from copying paintings with many other subjects, from classical landscapes to portraits of humans. However, when it comes to horses specifically, I have found the following artists, examples of whose horse work is in public collections, particularly helpful: Stubbs, Sawrey Gilpin, John Ward, Cuyp, the Herrings, Ben Marshall, Landseer, Munnings, Gainsborough and Rubens.

Working in Galleries

Opportunities to work in private collections are rare, and commercial galleries don't expect an artist to turn up with a sketchbook wanting to draw their paintings. However, state-funded galleries are usually supportive of artists who want to work from paintings in their collections. There may be guidance for artists on galleries' official websites; alternatively, you could phone before your visit to check that drawing is allowed and under what conditions. It usually is, though sometimes you may have to sign a form on arrival. The only time in over thirty years that I have not been allowed to draw in a public gallery was in a provincial museum in a special one-off exhibition. In that case I was told that it was a condition imposed by lenders to the exhibition, but drawing from the same gallery's own permanent collection was still fine. (Big 'blockbuster' exhibitions are usually far too crowded for copying to be possible.)

If you want to study a specific work, it is always a good idea to confirm in advance that it will be on display. Some galleries have up to four-fifths of their holdings in store, and even a famous work normally on display all the time can be temporarily out for conservation, or on loan elsewhere.

When working in galleries, use clean materials and don't leave any sticky or otherwise unpleasantly lingering evidence of your visit. No gallery wants pastel dust on their floors, paint on their door handles or grubby charcoal finger marks on goods in their bookshop. Many galleries won't allow the use of charcoal or pastel, and in some places this is due to the inconsiderate behaviour of artists in the past.

All the galleries I know have a general ban on the use of liquids or any kind of paint, although it is sometimes possible by prior arrangement in special circumstances or if you are on one of their own courses. Pencil and/or coloured pencil is usually fine, and is

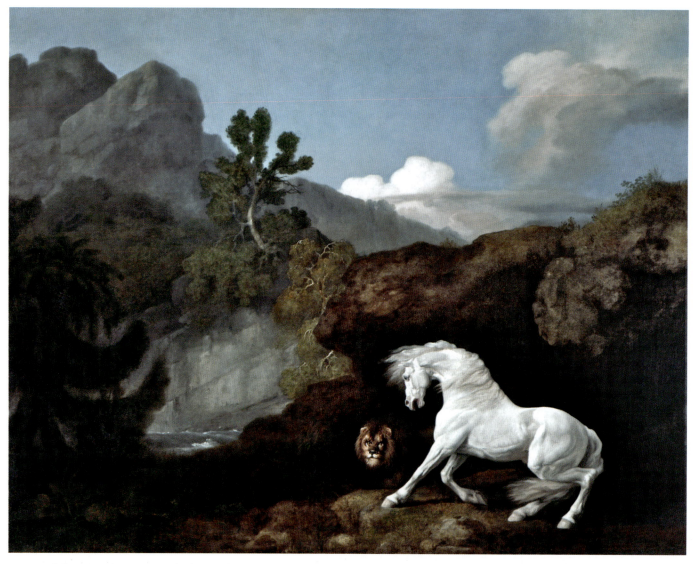

Horse Frightened by a Lion. **Oil, 40 × 50 in (102 × 127 cm) by George Stubbs, 1770. (Reproduced by courtesy of National Museums Liverpool, the Walker Art Gallery.)**

far more convenient to use anyway. Check in advance of your visit what materials are allowed if you want to use anything else.

Drawing boards are unwieldy and impractical. A sketchbook is best. It needn't be a large one, just as big as you are comfortable with. If you're a bit shy, you can use a small one so that people can't see what you're doing as easily. Fold-back or bulldog clips can be used to fix books open at the right pages, which makes them easier to hold.

If possible, try to position yourself opposite the centre of the painting. Drawing at a shallow angle to a painting plays havoc with the shapes and perspective in it. Also bear in mind that if you get too close to a painting it may appear distorted; for sculpture that's even more of a problem. If you can't stand for long periods and there is no convenient seating, it's worth asking a guard if there are any folding stools available that you could borrow. Some galleries have a stash of them for lectures. Guards are generally very helpful provided you don't make a mess or cause an obstruction. If other visitors approach the painting you are copying, note your position, and step aside to let them have a good view. They'll soon move on.

Inevitably, some people will get curious about what you're doing. Children in particular love watching people doing things, and should be encouraged. Let them watch and don't be put off, you'll soon get used to it. Be friendly and explain what you're doing. Were it not for members of the public being interested in art, and guards to take care of it, there would be no collections for us to visit. In return, you could ask for their opinions of the work you're studying — people's spontaneous reactions to paintings can be both interesting and surprising.

MORE DRAWING

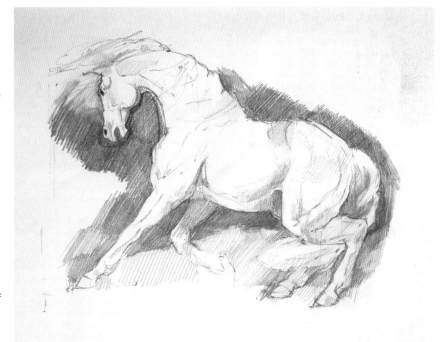

RIGHT: **Study of the horse in *Horse Frightened by a Lion* in line and tone showing the form of the horse and the tone transitions around it.**

BELOW: **Smaller study with notes showing more of the painting and the shapes of some of the tonal areas surrounding the horse.**

Working on a Copy

Copying should involve you in a very intimate and concentrated study of a work. To make the most of your time, you need to ask yourself questions as you work, about why and how the original artist did what they did, such as:

- Where/which objects/shapes line up with each other vertically or horizontally (these relationships hold a painting together).
- What is the tone pattern across the painting?
- How much detail is there, and where is there the greatest level of it? Detail is often used to draw the eye to a particular place. In dark areas there is often less detail than you might expect.
- Where are the major points of interest to which your eye is drawn, and how has the artist drawn your eye there – by shape, colour, line or other means?
- How has the artist used perspective, aerial perspective, line, tone and colour to create depth, 3D form or space between objects?
- Where do you find the important things (e.g. strong verticals/horizontals, major objects)? Do they lie on significant points, like the diagonals? Or on the golden section? Or a third of the way in from the sides, base or top?
- Where is the centre line, and what is happening there? Where is the horizon – is it low or high, and what effect is that having?
- What techniques has the artist used to indicate the textures of objects?
- How has the artist created the illusion of space (for example, a vast landscape in a tiny painting)?

You could spend a whole day in a gallery studying just one painting, making many different drawings exploring different aspects of it at different scales, or you could make a single large and very detailed drawing of that one painting. Alternatively, you might study several paintings, possibly comparing the differing approaches of several artists from different periods or schools to similar subjects or problems. The final challenge is to go home and put what you have learned into practice in your own work.

■ MORE DRAWING

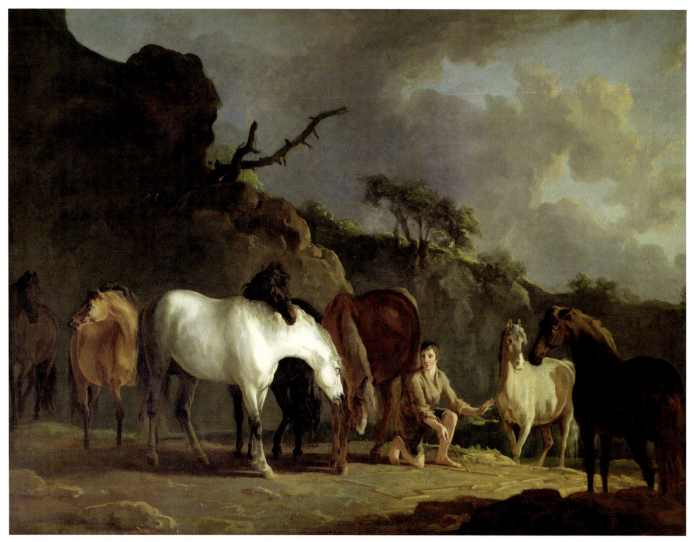

Gulliver Reprimanded And Silenced By His Master When Describing The Horrors Of War. **Oil on canvas, 41 × 55 in (104 × 140 cm) by Sawrey Gilpin, c. 1805. (Reproduced by courtesy of York Museums Trust, York Art Gallery.)**

When we visit art galleries, we can easily be overwhelmed by the number of paintings. Large national galleries may have literally thousands of paintings on display. There is a great temptation to try to see everything – and if we have travelled a long way and may not be likely to visit the gallery again, this temptation can be overwhelming. However, even in such a case as this, I always try to select a few paintings on my way round to return to and spend some time with, preferably drawing them, before I leave. Otherwise, a whole visit can become a blur, and though it has been an enjoyable day, we may not remember anything that will be useful to us.

I was fortunate at art school to be taught methods and materials by the National Gallery's first Chief Restorer. He asked us if we would go to the best French restaurant in town and order everything on the menu. Of course, we wouldn't. So why then, he asked, would we try to see every painting in a great art gallery in one visit?

I occasionally find that when I get inside a gallery, I'm not 'in the mood' and can't concentrate. Perhaps the journey has been a bad one and I'm still distracted by it, or the light is bad, and the paintings seem to have receded into the dark to sulk and have become very inaccessible. Again, I find drawing brings me back into contact with the paintings. I find one, any one, that looks vaguely interesting, and force myself to concentrate on it by drawing. I soon settle down and feel comfortable again, the paintings start to look friendly and accessible once more, and I go on to look, enjoy the paintings, and draw when I want to, for the rest of my time there.

If you aren't used to big art galleries, the idea of walking into a huge room and drawing in public may seem a bit intimidating. But galleries are our natural home as artists, and we shouldn't let ourselves be frightened of being, or working, there. Once you have done some quiet work in a gallery a few times, it should feel as natural as working in your own studio.

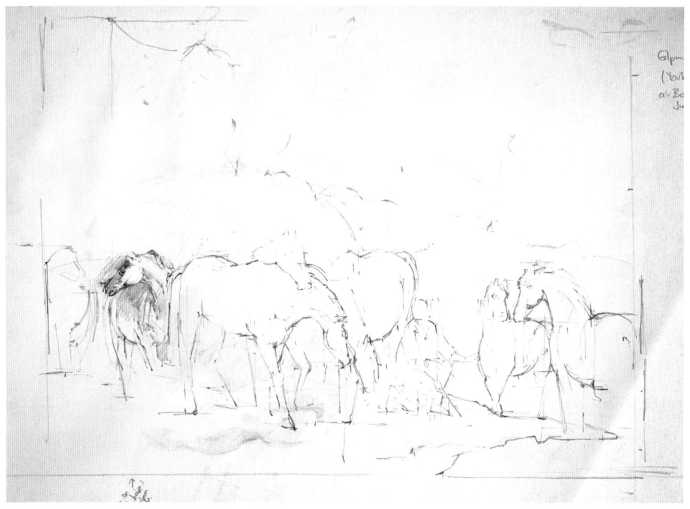

Drawing from *Gulliver Reprimanded And Silenced By His Master When Describing The Horrors Of War*, **exploring rhythms and composition, with one head in more detail exploring form and light.**

The time you spend with a painting should be 'quality time'. The quantity of time you spend staring at it isn't a guide to how much you're learning. It would be better to study a painting hard for ten minutes than stare at it without thinking for an hour. I find that the very act of drawing concentrates the mind. It is, of course, impossible to know for certain by looking at a picture, or even by drawing it, why the artist painted it the way they did. But we can think about the options they may have had, and whether we would have made the same choices about composition and so on. This does bring us closer to the painting as well as teach us things about technique.

There are paintings in some galleries that I have worked from more than once. Each time I get to know it better, and it becomes like meeting an old friend and having a chat. And as the paintings I go back to are the very best ones, each time I learn something more. If I visit the gallery to work elsewhere, I often drop in to see any old friends before I leave.

Those who are fortunate to live conveniently close to a good gallery and visit it often will know that on different occasions, different paintings catch their eye. This may be due to the light on that day being more favourable to some paintings than others, or the artist's own mood, or the problems they may be having in their own work causing them to be attracted to the work of artists who may help them with it. Even one's own personal taste changes with time and experience. This is why most galleries are worth repeat visits, the more so as they often hold a lot of work in store, and generally try to rotate at least some of their collection from storage, so you may see something new each time.

Gallery websites are increasingly likely to include a partial or complete catalogue of works, sometimes indicating which works are on show (though I'd still check in advance if I wanted to see anything specific). Websites also help us keep up to date with special exhibitions we might not want to miss.

CHAPTER 6

PAINTING THEORY

'The art of painting is to surround a touch of Venetian red so that it looks like vermilion.'
Edgar Degas

OBSERVED COLOUR

The crucial thing to keep in mind when working with colour is that if the aim of a painting is to depict space, light and volume, the colours you mix have to do more than imitate 'local' colour (the colour objects would appear to be if seen under full spectrum white light). They have to describe the colours as they would appear in the particular lighting conditions in your painting.

Natural light varies greatly according to the time of day, the weather, and the time of year. It tends to be cooler (bluer) in summer and in the middle of the day, and warmer (more orangey) in the winter, the early morning, and the late evening. The backlit white tail of a grey horse may, in evening light, look almost orange; at midday in midsummer, it may appear blue grey, or even nearly white. This is why it is impossible to give colour 'recipes' for horses of particular colours. (Auto white balance on digital cameras can cause such interesting effects to be lost.) Observing colour accurately is a skill that takes time to develop. There is an exercise on this subject in Chapter 7.

REFLECTED COLOUR

Reflected colour also enters the equation, particularly when light is strong. In the example above of a grey horse in the sun, if the light is strong enough, it might be possible to see some green light on the underside of the horse's belly. This comes from sunlight being reflected up from the green grass. If the horse is standing on sand, the reflections on the underbelly could be a warm brown; if it is standing on brick, the reflections might be orange-red. (Reflected colour is one of many things we need to be very careful about when mixing elements in a composition when they were not observed together at the same time.)

Blue shadows on grass are usually the result of light from the sun being reflected from a blue sky. This blue light is there in the sunlit areas of the grass too, but you can't see it there because it is overwhelmed by the stronger direct light from the sun.

If you find reflected colours difficult to see, try painting a simple still life with some very strongly coloured objects, like a deep blue silk drape and a pile of oranges, in very strong light. You should, if you set it up carefully, be able to see orange light reflected in the shadows on the silk, and blue colours reflected onto the oranges where they too are in shadow. If you are still struggling to see reflected colours, the square-painting exercise in Chapter 7 may be helpful to you.

Look out for reflected colour as you go about your daily business. You'll see it in all sorts of situations once you know it is there to be seen. One of the joys of being an artist is that you see lots of interesting things that you wouldn't otherwise have noticed. After the first lesson I had in 'negative spaces' I saw them everywhere I looked, and I still do.

Once you are tuned in to reflected colour, it is easy to understand why automatically darkening a colour mixed for the light side of an object with brown or black to make the colour for the shadow side of it, as beginners often do, isn't a good idea. Reflected colour is an additional reason why you can't have formulae for the shadows on a bay horse – the colour of any shadow will always depend on where it is, and what surrounds it. A horse may pick up colour from another horse standing next to it, the sky, a handler's shirt – anything.

LEFT: **Detail from** *Unsaddling, Llanfrynach*. **The small areas of red in the horse's girth are picked up by the tiny amount of red in the groom's hair ribbon. Without those reds, the painting would be restricted mostly to greens, blues and a neutral warmish brown, which could make it appear flat. However, the reds bring the picture alive.**

You have to observe closely to see reflected colour. It can be very subtle and elusive, and often fails to register in photographs, but it adds a surprising amount to the solidity and unity of a painting if correctly placed; it helps paintings look 'real'. If you are using photography to record source material, it may be useful to make written notes in your sketchbook of any reflected colours you observe at the time as well.

RELATIVE TONE

Every mark you make in colour also has a tone. Identifying the darkest and lightest areas in a painting and placing other tones in the right relative relationships between them is very important. It is easiest to see this when painting in monochrome (one colour). If the lightest area in a painting is darker than white, but all the other tones are much darker, that light tone may appear to be completely white. However, if you then add a white area, the area that was originally the lightest will suddenly look darker, and the darker areas will look darker still. All the previous tones will also seem closer together in tone as you have expanded the tone range with the new, lighter, tone. All tones interact with each other. It is important to place tones in the right relationships with each other if we want to create space, form and light. (See the tone painting exercise in Chapter 7.)

RELATIVE COLOUR

It is possible, though difficult, to 'match' colours one by one by copying the colours in front of you. However, painting, like drawing, is more about relationships than absolutes. To quote Henri Matisse, '… it is the relation between the colours in your picture which are the equivalent of the relation between the colours in your model which must be considered'.

Just as a dark area will appear darker next to white than it would next to black, a square of plain flat colour will appear completely different according to any colours and tones that surround it. When we paint we are dealing with many colours and tones, and the practical manifestations of the way colours and tones are modified by each other can rapidly become exceedingly complicated to manage.

We have seen in the drawing chapters that tones don't exist in isolation, and that their effectiveness depends on their relationships with the other tones. It's the same with colours. As we work, we need to keep checking all the tone and colour relationships within the painting. Just as making one area too light can make others appear too dark, making one area greener can make its complementaries (reds) elsewhere in the painting appear too red. As if that wasn't enough, just to make it even more complicated, adding a little red in one area where there are no reds at all can actually boost a larger area of red elsewhere (as an echo draws attention to a sound).

Whenever a colour is added or altered it will subtly change the appearance of all the others, and their relationships with each other. Within a painting, colours generally form too complex a set of relationships to be able to predict exactly in advance in every instance what will happen when we change or add a colour; all we can do is to be aware of the basic theory in order to suggest possibilities, and check the actual relationships between colours we are building as we work.

Managing all those relationships is one of the things that makes painting difficult. It can help to get these relationships correctly balanced if you do a small, simplified colour sketch before starting on a painting. On a small scale, it is possible to make adjustments to tone and colour relationships quickly and judge their effectiveness. Once the most important relationships of colour, tone and saturation (the intensity of a colour) have been worked out in a sketch, they can usually be established on the final painting without needing any major adjustments or corrections, and intermediate variations in small areas can be judged and placed in-between the major areas of colour in their proper relationships as the painting progresses.

I like to set the ranges of the various tones and colours very early in a painting. If there is an important area of red, as in the painting that starts this chapter, I work out its colour in terms of tone (how light/dark it is), hue (is it a violet-red, like alizarin crimson, or an orange-red, like a medium cadmium red?), and saturation (how intense the colour will be). Any other reds, or other colours, have to maintain their correct relationships with it; for example, if another red elsewhere was yellower, then it would be painted yellower.

Particularly important colours for a painting should be introduced at an early stage. One colour may be important because there is a lot of it (like greens in a landscape with a lot of green). In that case, I'd fix several 'sample' green points in different areas of the picture and make sure they were in the correct relationships to each other (greens in the distance are often bluer and lighter; in the foreground they are often yellower and darker). Other colours may cover less of the area of a painting, but may be important for other reasons (like a bright orange along the horizon in an otherwise dark painting, where that patch of light was actually the whole focus of the painting).

Once all the major colours have been established, other colours and tones slot in between them. Of course, we must always be willing to change anything at any point in a painting if it becomes necessary, so sometimes you may have to change even those first key colours, but if sufficient thought is given to them at the start they usually remain good solid reference points and rarely need to change.

Restricted Palettes

Some artists always work with a restricted palette (only a few different pigments). Though it doesn't suit everyone, it is particularly useful for beginners, as when you have only five or six pigments from which to mix all your colours, you learn the ins and outs of colour mixing very thoroughly from the start.

If you wish to try limiting your colours, but still want to be able to mix a fairly wide range of colours (including bright, highly saturated ones), I would recommend the following: cadmium yellow, cadmium red, alizarin crimson, ultramarine blue, and titanium white (omit white if using transparent media). I used this palette as a student, and found it was possible to mix most colours with it. I gradually added other colours as I found I needed them, some in order to be able to vary the transparency of my mixes, and others because I was mixing a similar colour very often from my existing colours so using it saved time. My current studio palette includes some earth colours (such as the umbers) and various cobalt-based blues. However, my studio palette is a large marble one on a movable worktop. I still use a limited palette when working with a small sketchbox.

Although a lot of my work involves landscapes, I almost never put out a green when using oils, as the stable green pigments (e.g. phthalocyanine and viridian) are already very blue. I simply find I don't use greens even if they are there, so though I keep a space for them and one or two other colours such as madder, I only put them out on the rare occasions when I need them. Some artists, especially those who teach, are opposed in principle to the use of black, particularly as it tempts beginners to mix black with a colour to make a shadow. I do use black, but sparingly. Blacks can make interesting browns with some reds, and rather good greens with some yellows.

Whilst I don't always put out all my colours, they all have a place of their own on the palette, whether they are there or not. Most artists will always keep their colours in the same place on their palette, though the actual places they put each colour varies from artist to artist: some use the order of the spectrum; others work light to dark, or dark to light; there are lots of ways to do it. It doesn't matter what order you choose as long as it works for you and you stick to it.

Use good quality paint. It goes much further and so doesn't cost as much more in the long run as people think. Cheap paint is often just filler (bulking agents) stained with fugitive dyes.

You can explore the possibilities of the pigments you are using by painting a square grid. Paint all of them, one to each square, across the top of the grid, and then again down one side. Then complete the grid, mixing the colour for each square from the colour on the side of the grid level with the square with the one at the top above it. Each mix will appear twice, so make sure you vary the proportions of the mix each time to gain more information about what your colours can do. Painting the squares precisely will help with brush control. Save your brushes, and keep the mixes clean, by using a small painting knife to mix the paint (in watercolours, you could use an old brush to mix paint rather than wear out a new one with a good point).

Put your colours out before you start, not as you need them. If you are using tube colours, don't be mean when setting out your palette either, be generous. You'll be tempted to work too thinly if you don't put out enough of each colour.

HOW MUCH COLOUR?

Surprisingly, paintings often appear most rich in colour, and are most successful in creating depth, when the range of colours in them is not very great, the saturation of the colours isn't very high, and the tones are generally fairly low (i.e. dark). Rembrandt and Velázquez are fine examples. The use of a lot of highly saturated colours in a painting may make the colour relationships so extreme and jarring that the colours merely fight each other, cancelling each other out, so that despite all the colours used, a deep, rich effect is not produced.

If a painting is predominately high-toned (light in tone), it can appear chalky even if it has strong, saturated colours. Too much contrast, and/or a lot of highly saturated colour, can create a crude appearance; and it destroys any illusion of depth, partly because it won't establish any aerial perspective (see below). Of course, what is right for an individual painting depends on your intentions. If you are aiming for a flat effect, then a large range of saturated colours could be exactly what you wanted. But in general, I'm expecting readers of this book to be aiming for a less graphic and more representational 'look'.

The painters of the Venetian Renaissance are rightly known as great colourists, but the richness of colour in their paintings is primarily due to their understanding of tone, and their restraint in the use of colour, not because they used every colour in the box. In this instance, once again, 'less is more'.

If you find the management of colour difficult, simplifying and narrowing down the range of colours within a painting, and avoiding the use of high contrasts in tone, can make colour difficulties significantly more manageable, and often makes a painting more effective. A traditional practice was to avoid having a big contrast of tone as well as a big contrast of colour between areas that touch each other. For example, if you want to put a yellow next to a purple, at least make them the same tone, and if you want to have a big tone contrast on an edge, keep the colours similar. This helps to keep a painting unified.

■ PAINTING THEORY

Fell Ponies on High Street, Cumbria. **16 × 23 in (41 × 58 cm).** An example showing the effects of aerial perspective. The landscape changes in colour from oranges, yellows and greens in the foreground to purples and ultimately blue in the distance. The contrast between the darks and lights in the foreground is great; it lessens to almost no contrast at all in the distance. This lessening of contrast is due to moisture in the atmosphere.

Aerial Perspective

Aerial perspective is an effect that has been known to artists for centuries; Leonardo da Vinci (1452–1519) mentions it in his book *On Painting*. It is particularly important for an artist looking to create depth and space. Aerial perspective is most evident in damp climates, dusty locations, and at long distances, but can occur anywhere, even indoors. It is due to dust particles and/or moisture in the air coming between the viewer and the object. The strength of its effect depends on the degree of dust or dampness in the atmosphere. On a clear, dry, sunny day it may be barely evident over a distance of many miles (making distant hills look deceptively close) but on a foggy day or in a smoky atmosphere it can be very obvious over a distance of only a few feet. Distance also tends to soften the appearance of the 'edges' of things.

The effect of aerial perspective is to make things look lower in contrast, often paler, and lower in saturation (greyer) the further they are away from the viewer. It can make grass gradually bluer with distance, and a more distant pony lower in contrast and greyer in colour than one the same colour that is closer to you. The darkest darks on the distant pony will be lighter than those on the nearer one, its edges will be softer, its colours will be more muted and quite possibly bluer, and any highlights in the distance will not be as light.

If a painting is looking washed-out and flat, some crisp, strong colour in the foreground can help. Alternatively, if the landscape behind a portrait of a horse is distracting, it may be that the colours you have used for the distant parts of the landscape are too strong and dark, or the edges of your trees and fields are too sharp, making your landscape 'sit forward'. You could try using aerial perspective to solve this problem. For instance, you could repaint the more distant parts of the landscape bluer, lower in contrast and saturation, and use softer edges. Alternatively, if the paint is dry, you could use a 'scumble' (a very thin layer of opaque pigment, as opposed to a glaze which uses transparent colour) of grey. A scumble needs careful handling as it is easily overdone. In oils, it is important not to use turpentine or other volatile solvent alone for this, as if you do the layer may crack or dust off when dry. A mixture of 50 per cent turpentine and 50 per cent linseed stand oil would probably be a better choice.

Manchester City Art Gallery's paintings of cab horses in fog by Adolphe Valette are good examples of aerial perspective.

Textures

If you wish to paint textures well, observe how sharp or soft the transitions of the tones and colours on surfaces are, and the way they take and reflect light, rather than looking for a special brush with which to lay on the paint.

Colour Recipes

There are no shortcuts to anything worthwhile, and painting is no exception. Colours have to be observed and structured with great care. There are no magic formulae. Practice is everything. The more you practise by drawing and painting from life, the more things you will see, the more accurately you will see those things, the easier you will find it to see colour, and the better your work will be. If you are struggling to see colour, try the squares exercise in Chapter 7.

PLANNING A PAINTING

Think of a painting you have in mind. I will assume you have a general idea already of what you want in your picture, even if you only have a rough sketch of it in line on a scrap of paper. Next, on the principle that if you know where you're trying to get to, you're more likely to arrive, it's useful to work out the answers to a few simple questions about your proposed painting before you begin.

Sketch of a horse and rider in the desert, 8 × 10 in (20 × 25 cm). Due to the dry atmosphere, there is only a little change in colour over a very long distance, merely from a warm brown to a cooler, greyer brown. Such changes in colour and contrast as there are here are due to dust being blown into the atmosphere by the desert winds. This dust also makes the very blue sky appear quite grey at the level of the horizon.

- What is the painting about? (It might be about an abstract idea, like an effect of light, or you might be aiming to tell a story, or describe a specific event, or it may be a portrait.)
- What effect do you want the painting to have? (For example, do you want the painting to be dynamic, or disturbing, or restful to look at?)
- Where do you want the viewer's eye to go, and linger?

Painting, like drawing, is all about decision-making and problem-solving; therefore every painting, whether a major exhibition piece or small sketch from life, needs an identified purpose, however simple that purpose may be. Knowing what we want to achieve in a painting helps us to make the right decisions about composition, colour, tone and so on. When in doubt about what to do, we can refer to our original idea and apply this test – will the various options I am considering add to, do nothing for, or even undermine, what I am trying to do in this painting?

Size and Scale

How big do you want your painting to be? If you hope to sell it, there may be purely commercial considerations about what size you (or your gallery or agent) may think might most easily sell. If it is a commission, then your client will need to be consulted about the size; in my experience clients often have in mind a specific location for a commissioned work. (Don't forget to add an adequate allowance to accommodate an appropriate width of frame, or, for works on paper, a frame and mount.)

Beyond such considerations, it is a question of what size of painting will give the effects you wish to achieve. Bigger isn't always better, or even more eye-catching. A simple, small painting which has been carefully composed can have a bigger impact than a large and elaborate one where the idea for the painting has got lost.

For equestrian paintings in particular I work out how large the individual horses in the painting will be, and roughly draw one out at that size to decide whether I am happy with the scale. If the horses come out too small for my idea for the painting to work, or they would have to be simplified more than I wish to do, then the canvas is too small. For commissions, a client may expect a level of detail that dictates that I work to at least a certain size. On the other hand, I may not wish to enlarge a preparatory sketch beyond a workable size, given the information I have recorded. If in doubt, think back to your original aims for the painting and use that as a guide for your decision-making.

Cropping and Format

It might improve your painting and help you focus your composition on your objectives if you were to crop it. For example, you might cut off a tree at one side which is distracting. Conversely, you could extend the composition by adding more space above for sky. (You could experiment using L-shaped pieces

Painting Theory

of card to 'frame' your image.) It is generally not a good idea to crop a painting so close to a horse's nose that it has no space to move into, especially if it is moving. When completed and framed, close cropping might create the impression that the poor creature is about to bash its nose on the frame, especially as framing usually covers some of the edge of the image under the mount or the frame rebate.

This is not an absolute rule; I can think of notable highly successful exceptions where horses have been cut off mid-body, in paintings by Degas, for example. In the great *Hambletonian, Rubbing Down* by Stubbs, much of the power of the image comes precisely from the fact that the horse is 'cramped' into a canvas that seems too small for him. However, if you do decide to crop an image very close, or slice your horses in half, be careful. Stubbs knew exactly what he was doing with his superb painting, many other aspects of which appear to me to have been subtly manipulated with great finesse to make it work (and I suspect it also 'works' partly because of the huge size of the canvas). Not all of us can bring that sort of thing off.

It's surprising how many people don't think about format but automatically use a landscape (horizontal) format. Might your painting work better with a portrait (vertical) format? You could experiment with a preliminary drawing or sketch by using the L-shaped pieces of card again to 'frame' it.

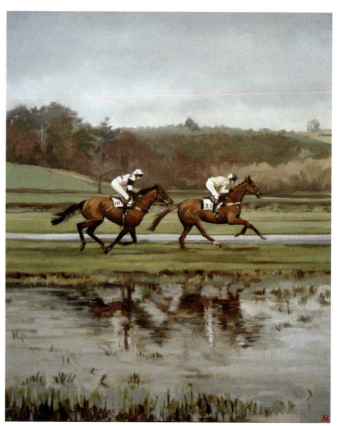

Flooding, Eyton-on-Severn. **30 × 24 in (76 × 61 cm). Cropped to a vertical format.**

Sizes and Proportions

If you make up your own canvases then you can have whatever sizes and proportions you like. Otherwise, you are restricted to what's available, and it is wise to be aware of those proportions and sizes before you begin – there's no point carefully calculating a composition based on a canvas of a size or proportions which you can't buy. It is possible to cut a canvas (or a board) down after you have started if you change your mind about the composition at a later stage, but it's better not to have to, and adding bits round the edges, though technically possible in both cases, is difficult and definitely to be avoided. Paper is also very difficult to add to successfully, so if you work on paper make sure your sheet is large enough to allow for at least some changes. It is easy to trim it later if necessary.

Ovals and circular shapes are also sometimes used for paintings, though in my experience framers don't like them much and frames for them tend to be expensive. At the very least, if you plan to use shapes with curved edges (or other than 90-degree corners) and want to use an off-the-shelf frame, check what sizes are available first, as the range of sizes manufactured is quite limited.

Artists who work on paper can leave decisions about proportion until their work is completed, provided that they ensure that they have sufficient paper all around their image.

Most oblong canvases have a ratio of short side to long of between 1:1.2 and 1:1.6, and it's easy just to accept that without thinking about it, but might your painting look better on a long thin canvas, or a square one? There can be advantages and

Drawing for *Flooding, Eyton-on-Severn*.
As the idea was about the horses and their reflections, I later decided that the painting didn't need the landscape to either side.

PAINTING THEORY

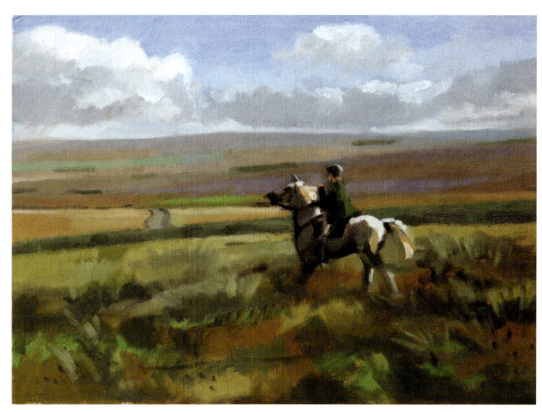

This sketch, 8 × 12 in (20 × 30 cm), unlike the painting of Eyton-on-Severn, needs the breadth of the landscape, as that's what the picture is about.

The drawing could have been cropped almost anywhere, depending on the intention for the painting. Cropped to be vertical, it might have been more of a portrait; cropped to be horizontal, it becomes more about the space the figure is in.

disadvantages attached to these less common proportions. If the format you are using is landscape, a squarer canvas can help include more sky, which can be useful in building atmosphere in a painting. I find that making a landscape format painting taller and squarer tends to make it more restful, all other things being equal, but it can make paintings more difficult to sell if they are already large, as that extra vertical height requires them to be hung in a room with a high ceiling – and most modern houses have low ceilings. Canvases that are an exact square have to be composed very carefully; in practice they usually have some major element(s) dividing them into unequal oblong sections. At the other extreme, long, narrow canvases, whether in portrait or landscape format, can be difficult to manage in terms of composition, especially if they are a 'double square' (the shape of two squares side by side) or longer. Compositions of such paintings tend to break up into sections and become somewhat incoherent unless the painting is fairly small. If you have a group of horses on such a canvas, especially if they are all in profile, it can end up appearing like a frieze – great if that's what you want, but a problem if it isn't.

Don't rule out unusually proportioned canvases. There will always be some circumstances where the effects may be exactly what you are looking for. Just be aware that there can be difficulties associated with certain proportions. Preparatory drawings can help a lot here.

COMPOSITION

Poor composition has spoiled many an otherwise good painting. Every painting, including the smallest and simplest, benefits from a little forethought on how it is arranged. Indeed, smaller paintings often benefit most.

Some artists don't consciously think about composition, others think about it at every stage in their work, but every artist takes decisions about composition, either consciously or by default. If an artist's work is simple in subject, especially if it is mostly studies of horses without backgrounds, then provided they choose a canvas to work on that is the right size and don't leave ugly negative shapes around their horse, then there isn't much for them to consider. Artists who have spent many years studying master paintings will have subconsciously absorbed a lot of the conventions of composition and can often work very effectively almost by instinct. At the other end of the scale, some artists are deeply interested in things like geometry and the theories of visual perception.

Even if you work solely from life and your only aim is to record what you see as objectively as possible, changing nothing, you will still be making some decisions that fall within the definition of 'composition', such as what parts of the world in front of you to include in your work, where you choose as your viewpoint, the size of the canvas, board, or paper you work on, and its shape and proportions. If you are taking more charge of the elements of your composition, whether making minor adjustments to the positions of horses and figures, or constructing an imagined scene of something that never actually happened, then even more decisions have to be made.

For most artists there will be times when they need to plan a specific composition. It may be one of their own choosing, or it may be for a client who wishes a number of different elements to be included in a painting that can't all be assembled together. These are the times when a little theory can be helpful.

Linear Layout

This is useful to establish in an initial drawing, even if it is only a very rough drawing. If any problems emerge, further drawings can be made to sort things out before taking the idea into paint. Here are some points to consider in terms of the linear layout.

Where is the major point of interest? If you have placed it slap bang in the centre of the painting, you may wish to consider moving it, as things tend to look more interesting if they are at least a little off-centre. Photographers, who to our shame think more about composition than a lot of artists do, tend to place their main point(s) of interest according to the 'rule of thirds', so they might place a simple isolated tree in a flat landscape a third of the way in from one side, for example.

I find that in some cases the rule of thirds can place important items a little too far from the centre, especially in paintings that are very wide compared to their height. A more traditional way of dividing a painting is by placing objects using the 'golden section'. This is a ratio; the basic idea of it is that a line can be divided into two in such a way that the ratio of the length of the smaller part to the larger is the same as the ratio of the larger part to the whole. If you want to divide a distance, such as the width of a canvas, into these two parts, you can do it using geometry, or you can do it by multiplying the total distance by 0.62 (not a precisely accurate number for the golden section, but a good enough approximation for our purposes). If you then mark that distance along your line, it works out slightly closer to the centre than a third.

'Thirds' or the golden section can also be applied to the vertical edges of a painting. This might suggest possible positions for strong horizontals like the horizon.

Look at your groupings of objects – is there too much going on in a subsidiary area of a painting that is taking your eye away from your main subject?

For some reason, things tend to be more interesting to look at

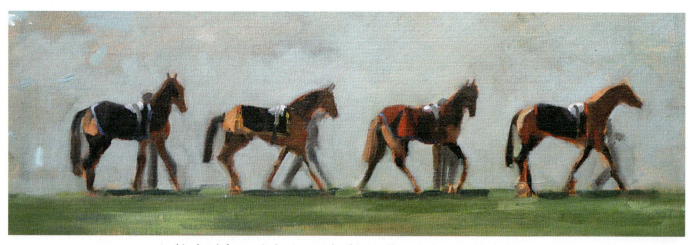

In this sketch for a painting I wanted a 'frieze' effect, so chose a wide format.

PAINTING THEORY

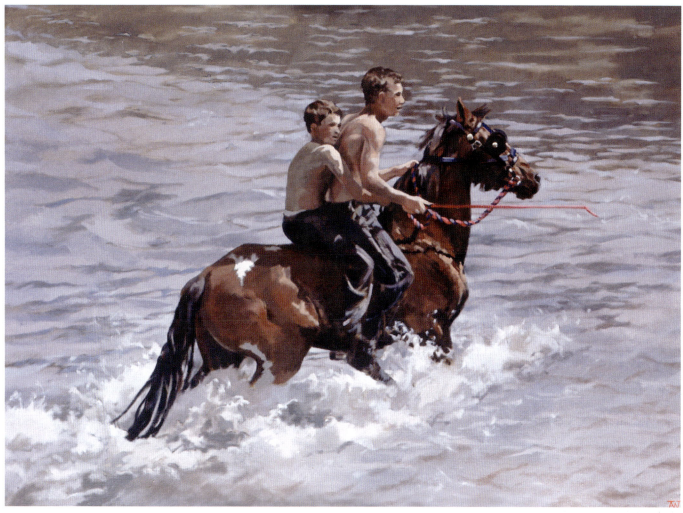

Appleby Fair, Two Lads. 26 × 36 in (66 × 91 cm). This painting is about diagonals and angles. It is important that the main diagonal thrust of the composition lies along the diagonal of the canvas from bottom left to top right.

if they don't appear in even numbers. Thus three or five horses in a group tend to look more interesting than two or four. If you have to include even numbers of things, there are at least two common ways of dealing with the problem – shape and subdivision. If the things in question are horses, you can ensure that the shapes of the horses aren't all the same, for example by having the horses at different angles to the plane of the canvas, letting their contours overlap each other in an irregular way, or overlapping their shapes with handlers. If the number overall is large enough, try subdividing the horses into odd-numbered groups. If there are enough, make those odd-numbered groups different in number. If there were eight horses, you could divide them into uneven groups and make them a five and a three.

Unless the whole point of a picture is that it is a symmetrical image, I'd avoid making it symmetrical. (Symmetrical things tend to look boring, and when looking at them, the eye often doesn't know where to settle, and can end up bouncing from one side to the other as if it were watching a tennis match.)

It can be helpful to locate the diagonals on the canvas/board. If a sloping line or angled edge of an object is lying just off a diagonal, try moving it onto the diagonal.

Never forget the sky; clouds have shape, colour and tone too, and are part of the overall composition. As Constable once wrote, 'That landscape painter who does not make his skies a very material part of his composition, neglects to avail himself of one of his greatest aids.'

Horizontals and Verticals

We naturally 'read' paintings from left to right, or, in some cases, right to left, but rarely up and down. This means that horizontal and vertical lines have different effects. Verticals interrupt this

movement of the eye. That can be very useful – for instance, a vertical formed by a tree at the right-hand side of a painting can send the viewer's eye back towards the centre and stop the eye 'falling out of the picture' on the right.

By the same token, a strong vertical can also stop the flow of movement across a painting dead in its tracks. This raises a problem for us when painting racehorses actually racing, as professional racecourses in particular have a lot of vertical posts holding up their running rails.

Worse still, these posts are usually white and therefore very difficult to 'play down' tonally against their background (usually grass or spectators' clothing) which is likely to be considerably darker in tone. Leaving the posts out is seldom an option, so their placement needs to be carefully considered if the illusion of movement is a primary objective.

If they can't be moved to harmless places like behind a group of horses where they are broken up by legs at many angles, it may help to paint them as dark as possible, or if that isn't feasible, painting the background surrounding them lighter and therefore closer in tone to the posts. Those phases in the gaits mentioned in Chapter 4 which have one leg completely vertical present similar problems. Again, minimizing the degree of contrast in tone between the leg and the background by whatever means available may help.

Balance and Rhythm

When planning a composition, consider the balance of it across the painting. If you wish to create a harmonious whole, and you find that all the interest in the painting is on, say, the left-hand side, you may have to find a discreet way of balancing that out on the right. That doesn't mean that you need to add lots of interest on that side – an appropriate balance could be created using a very simple object, like a tree or a pole. The paintings of Cuyp are good examples of compositions which are beautifully balanced, even though often asymmetrical.

Look for the angles, patterns and shapes that the edges of your tones and contours make within the painting. They may make, or be able to be arranged to make, many different rhythms, for example, dynamic zig-zag shapes, spirals pulling in towards a particular place on the canvas, or restful, undulating curves flowing across it. These things can be used to contribute to your original idea for the painting. Conversely, if you create them by accident, they could be subtly undermining it.

Rhythm is a difficult concept to explain in print. To understand it, the artist must develop a sensitivity to the way the edges of tones and shapes across a painting link and interact. Transcription of master paintings can help to develop an 'eye' for it. The painting by Landseer *The Hunting of Chevy Chase*, illustrated in Chapter 5, is a painting rich in internal rhythms.

Shapes

Some shapes have particular associations. All things in paintings, in our case especially horses and groups of horses with or without people, will make shapes in themselves and create shapes between them (negative spaces). Triangular or tapering shapes set on their bases appear fairly static, especially if they have sides of equal length. Similar shapes standing on their points look far less static, and if they are elongated, irregular in shape or slightly angled from the vertical, the effect is even greater. In particular look for the shapes made by the gaps between horses' legs. They can be important in your efforts to create either a peaceful and quiet painting, or a dynamic and exciting one. If a shape created within your composition is a problem, and you can't change it, downplay it by reducing the contrast between it and its surroundings, or break it up (run a shadow or a shaft of light across it, for instance).

Tone Plan

Historically, artists were well aware of the importance of the surface pattern of light and dark in a painting. In my experience, in contemporary painting, compositions fall apart more because of a poor tone distribution over their surface than any other single failing. To assess the tone distribution in a painting, make a tonal drawing or sketch of it, simplified into just a few tones. Some areas of tone will include parts of several objects, even cutting across them.

If this simple 'tone plan' proves to be a scattering of small dark areas and small light areas spread evenly over the canvas like confetti, your painting will, in tonal terms, be 'bitty'. That will tend to make it both confused and flat. If you can group the tones into larger areas (which may mean changing or darkening some colours, casting shadows in different places, or moving/eliminating some objects altogether) the painting will gain in both simplicity and strength.

If your tone plan reveals very large unrelieved areas of tone, whether light or dark, it may appear dull and flat. In that case, introducing a small area of light tone into one of the large dark areas, or vice versa, can make the painting more interesting and give it depth.

If you want a particular part of a painting to draw the eye, take a tip from the great masters. They knew that a dark shape will stand out most against a light background, and a light one will stand out most against a dark one.

Where a part of an object, let's say a horse, was light in tone, the artist might place it against a dark tree, but if another part of the same horse was in shadow, they might place that part of the horse against the sky, or a lighter bit of foliage. Done too crudely, it can be noticeable and jarring, but done subtly and in

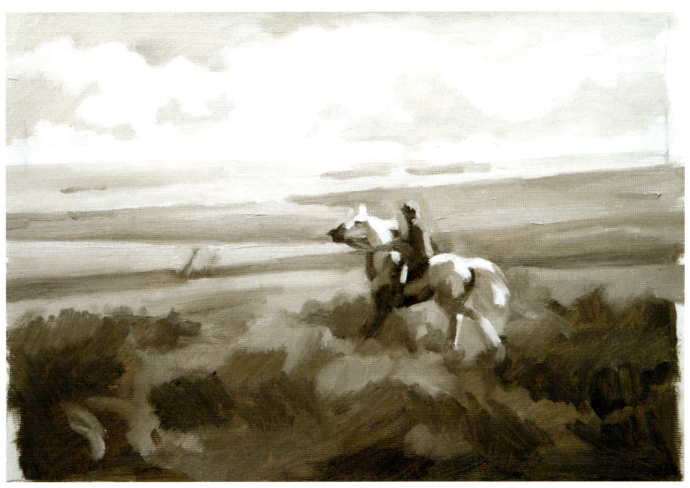

Tone plan for the sketch earlier in this chapter.

moderation it is very effective. Earlier I suggested disguising a post by making it close in tone to its background. This is exactly the opposite – emphasizing the shape of the horse by increasing the contrast in tone between it and its background (see the section on transcription in Chapter 5, for an example of this in George Stubbs' painting, *Horse Frightened by a Lion*).

Sharp edges between tones emphasize their tone differences; soft edges between them make tones look more similar to each other. We can use this to manipulate our tonal effects as well.

Doing simple tone work from master paintings is an excellent exercise. We can also do this to analyse our own work. I often do tone studies of a painting that I'm planning, in order to help me spot and resolve any potential tone or compositional problems before I start.

Softness of Edge and Detail

Edges between colours have qualities of their own; they may be soft, or hard. As we have seen in the section on aerial perspective, soft edges tend to recede, and underplay tone differences. Hard, sharp edges tend to come forward and emphasize tone differences; they also attract the eye, as does detail. Because both quality of edge and detail can be used to direct the viewer's eye to where you want it to go, in that sense they are compositional tools.

Some artists, especially beginners, use hard edges all over their paintings; this can make it difficult to control where the viewer's eye goes using other means. Generally, hard edges are best confined to foregrounds and/or your main focus of interest. Indiscriminate, hard-edged detail all over a painting leaves the eye wandering around all over the place, undermining the composition and weakening the impact of the painting. Focus your detail carefully and don't overdo it. The human eye only sees detail in a small proportion of its field of view; paintings can often be most effective if they do likewise.

Reminding ourselves of our original aim should help us decide the degree of detail necessary. For example, if a painting is 'about' the power of a rearing horse, will painting its eyelashes add to the impression of power, be merely ornamental and do nothing to contribute to the original idea, or at worst, be distracting, and make the horse look cute and weedy, which could distract the viewer and totally undermine the whole idea?

PAINTING THEORY

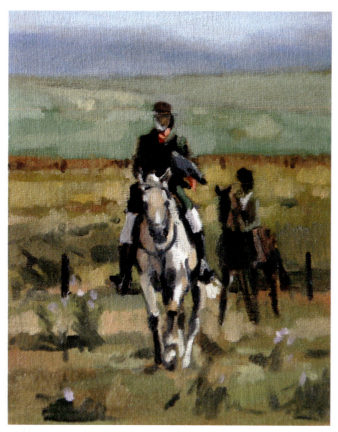

Falconry on Horseback. **10 × 8 in (25 × 20 cm). A painting without a lot of detail.**

The Effect of Colour on Composition

In a composition, just as a small light area can 'balance' a large dark one, and a small object appropriately placed on one side of a painting can balance a large group on the other, a small area of one colour can balance a large area of its complementary. For example, equestrian paintings, like landscapes, often include a lot of grass. All that green may be overpowering, or even dingy, depending on other factors, so it's worth remembering the classical landscape painter's trick – include a little red (green's complementary) somewhere in the painting to 'balance' the green. It could be any bit of red – a man's shirt or a red tiled roof. Red collars, traditional for draught horses in Suffolk, perform this function in some of Constable's paintings.

Colour will always affect composition, which is another reason for doing preparatory sketches.

The Need for Ruthlessness

It can be tempting to add something to a painting merely because we think it will be fun to paint, or it would be an impressive bit of 'flash'. Unfortunately, if we fall into this temptation, we may risk compromising the painting as a whole. In that case, it might be better to save it for a painting where it would be more appropriate, or to make a painting just 'about' that one thing.

The same principle applies when deciding whether to alter something we have already painted. As Arthur Quiller-Couch told his students when advising them to remove sections of their writing which were merely what he called 'extraneous ornament', 'Murder your darlings'.

It is easy to become reluctant to change, move, or remove altogether, a good bit of painting we're rather attached to. In my experience, once it is clear that something isn't working or that it is interfering with the purpose of the painting, however good it may be in its own right, there is no point resisting the inevitable. At such times we must be ruthless. If it needs to go, it must go, and the sooner the better. If it is allowed to linger on, all that will happen is that we will struggle harder and harder to work round it, damaging more and more of the rest of the painting trying to make a round peg fit into a square hole. The more we delay, the more difficult it becomes to deal with it, and the more time we will have wasted.

KNOWING WHEN TO STOP

This is always a difficult one. There is, of course, a large element of personal style involved when it comes to the level of detail you choose to work in, but fundamentally, as with drawing, the level of detail should be driven primarily by the idea behind a particular work. When the idea is achieved, that's it, and it's time to stop fiddling about with it.

The best way to produce good, serious work is to continually question whether what you are doing is contributing to your aim for the work in hand or undermining it. Resist the urge to include detail without considering whether you really need it, however tempting it may be, particularly if you are using photographs.

It is all too easy to overwork paintings. This is less of a temptation when working from life, when your horse has the fidgets, rain clouds are sweeping in relentlessly towards you, and you are losing all circulation in your fingers which are staring to resemble frozen chips in temperature and colour. Cold weather in particular concentrates the mind wonderfully.

Curiously enough, provided the marks you make are accurate, they will imply far more detail than they record, and the viewer's eye will fill in the gaps – which is actually something most viewers find rather satisfying, even when they don't know it's happening. Landseer is an example. People who know his work only from reproduction often persist in stating he painted in a lot of detail. In fact, some of his canvases, particularly the large ones, have large areas of very loose, fluid painting (so much so that the ground layer can easily be seen) but because the marks he makes are so perfectly judged, the viewer's eye completes the image and

PAINTING THEORY

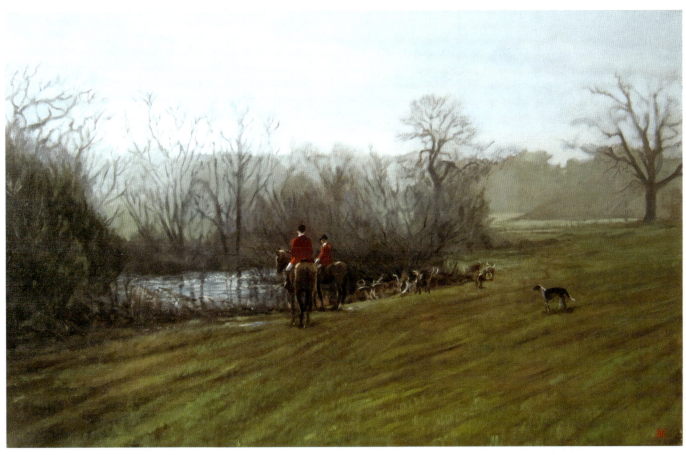

The Lake, Doddington. 25 × 40 in (64 × 102 cm). This painting shows the effect of colour on composition. It is painted mostly in blues, greys and greens, with not a lot of contrast, but this is relieved by a little red, most of which is also close in tone to its surroundings. Without the red, some other compositional device would have been needed to hold the eye in the centre.

creates the impression of great detail and wonderful textures.

Detail is fundamentally related to scale, and reproductions in books don't give much feel for scale. A painting that in a book appears detailed can, in reality, be quite simply painted, but very large. When studying paintings from books, it is a good idea to check their actual sizes; they can be quite surprising. Constable is a famous example whose work suffers badly in reproduction. His enormous canvases are incredibly loosely painted, with thick paint standing out all over. Unfortunately, when badly reproduced at a tiny fraction of their size in books or on objects such as table mats, they look flat and fussy, and are therefore often misjudged.

Conversely, some small paintings with lots of tiny details can, when reproduced, create the impression of being quite large; it can be a shock to find how small they are in real life (yet another reason for studying from originals wherever possible).

As a general rule, impact is undermined by detail. A small but simple painting can have great strength and make the artist's intention plain, and a big painting groaning under every possible detail can be a fussy mess saying nothing.

Including excessive detail is as detrimental to a painting as it is to a drawing, but we all overdo it from time to time. A stage designer friend once taught me the design principle referred to earlier in this chapter, 'less is more'. It's a good rule to remember. In my own work, the level of detail I use depends on the requirements of the painting in question, but within that premise I do try to achieve my ends by using the simplest means possible.

CHAPTER 7

PRACTICAL PAINTING

'Stormy day, noon.'
Note on the back of one of John Constable's watercolours done 'on the spot', high up in the Cumbrian mountains. (Any artist familiar with outdoor work can fill in the grim gaps in that brief narrative.)

EQUIPMENT FOR WORKING OUT OF DOORS

If you don't have to carry your kit far, you might not need special equipment. Paints and the like can be transported in a satchel, a wet oil palette can be covered with clingfilm, a wet board or canvas can be carried, and if you drive, easels up to the size of a radial easel can fit in most cars. However, there are specific pieces of equipment that make working outside much easier.

Transporting Canvases and Boards

Canvas pins are plastic or wooden blocks with metal spikes which are put into the corners of canvases or boards to keep two facing surfaces apart. A strap round the backs of the two boards/canvases can help prevent pins dropping out (hard-surfaced boards like MDF won't take pins). A metal tube longer than the spikes can be used to push the pins into the first board rather than back into you, if you prefer your digits unperforated.

Metal canvas clamps come in pairs (fixed to opposite ends of boards or canvases) or in fours (one for the centre of each side). Some have a carrying handle. They clamp a pair of boards or canvases together face-to-face with a gap between them. They are fiddly to use, but at least they don't spike you.

Both pins and clamps need to be used with pairs of boards or canvases that are the same size, as each one protects the face of the other. They all leave holes or dents on the painted sides.

For transporting boards, many painters make their own wooden boxes with internal slots. Each slot takes two boards back-to-back. As long as the boards share the dimension between the slots, you can transport different sized boards in the same box. (Too many slots and you'll never lift it when full, so if you make your own, don't get carried away and make it too big.) Slotted boxes are also useful for storing wet boards at home.

LEFT: *Morning, The New Forest*. **Detail**.

Sketching and Box Easels

Sketching easels (wood or metal) are light and easy to transport. However, they are unstable in wind, can do the splits on smooth surfaces, and you still need some way of transporting everything else. Box easels are a better option, though more expensive. It's possible to carry everything needed for painting in the box, including a wet palette, and a small canvas/board can be secured to/carried on the outside. You only have to pick it up, and you're ready to go. Box easels are made more stable than sketching easels by the weight of the contents of the box and the fact that the legs have set angles and don't all come from one point. They come in 'full' or 'half' size; half-size ones have folding palettes.

If you can only have one easel, a box easel is a good all-round choice. If you're short of space, it packs up small and can store a lot of equipment; a full-size one can take a large canvas or board, and it can even be used as a table easel. Unless you only plan to use it indoors, buy a good strong one from a reputable manufacturer (I use a Mabef M22). All good easels are expensive, but last a lifetime if they are well cared for. Wooden ones can usually be repaired if they have accidents. Inferior ones will fall apart if used in the challenging outdoor environment and are difficult if not impossible to repair, so cost more in the long run as well as being frustrating to use.

Someone once said to me that sketching easels were so complicated that putting one up was a creative act in itself; box easels are worse. It's worth practising at home with the box empty before using a fully loaded-up one outdoors (especially in front of other people) if you don't want to end up with one of its legs in your eye and the box's contents on the floor.

Instability can be reduced by securing an easel with a bit of strong cord passing from the top of the legs of a sketching easel (or from the box on a box easel) to a weight on the ground

PRACTICAL PAINTING

between the easel's legs. A bucket of water would do; most places that have horses have a bucket and a water supply. Put the weight on the floor and tie the easel down to it so it can't take off in the wind, rather than suspending the weight. Suspending it can put unnecessary strain on thin-legged easels. I use thin guy rope and a tensioner. For sketching easels, the splits can be prevented by tying a cord all round the legs at a fixed height.

Sketchboxes

When you have to carry your equipment miles rather than yards, compactness and light weight are everything. The solution is the sketchbox (or 'pochade'). Sketchboxes are normally used on the lap, though some are fitted with tripod mounts. They have space for the basic necessities, and include storage for a wet palette and at least one wet board. The box lid opens up to form an easel.

I take mine up into the mountains so they have to fit in a rucksack. The commercially made ones aren't compact or light enough for this, so I make my own. Mine are designed to fit the size(s) of board I use and to hold exactly what I need and no more. My box for 8 × 12in boards weighs about 3 pounds (1.4 kg) empty (but including the palette) and is only fractionally longer and wider than the boards.

If you buy one, examine it first. Some are flimsy and break easily; others are unnecessarily complicated and clumpy, making them heavy. Drawers in particular add a lot of weight. If you want to stand to work but a full-size box easel is too heavy for you, a half-size box easel is generally a more compact and stable option than a pochade + tripod combination.

Some people spend a fortune on lightweight easels or boxes and then travel festooned with bags which contain everything but the kitchen sink. The best way to keep things light is to strip your kit down, possibly even use a restricted palette, and take only the things you absolutely need. If I want to travel very light, I'll even lay out my colours on the palette and leave the tubes at home.

CHECKLISTS

If you're inclined to forget things when you go on painting trips, keep a list in your box of the things you need as a reminder. For oils in a sketchbox I'd take: board(s), a basic range of paint (I save part-used tubes for the sketchbox), brushes, dipper containing turpentine ('turps') or turps and oil, palette, rags (to clean hands, wipe off mistakes and wrap wet brushes), palette knife, sketchbook and pencil (some artists prefer charcoal).

In a box easel, I'd take all of the above but a larger range of paint and brushes, a bigger sketchbook, an apron, and small bottle of turps. If away painting for a few days, I'd also take in my general luggage spare brushes, white spirit and hard soap for brush cleaning, a full 'board box', and large tube of titanium white. If I might be painting in company, I'd add an odourless solvent (some people can't cope with the smell of turps).

For acrylics I'd take the same things, but I might consider using a palette designed to prevent acrylic paint drying out. I'd substitute water for turps and add a large water bottle and pot for washing brushes as I worked. With oils, the brushes can wait a few hours until you get home; with acrylics, they can't.

There are many useful and compact sketching kits available for watercolourists, but I just stuff the following into a rucksack or satchel: watercolour block, pencil, scalpel for removing pages from the block, paintbox, brushes, rags, water bottle and pot. There are some useful lightweight collapsible pots available, but I generally prefer glass pots for stability.

Box easel folded up, and set up for working.

CLEANING AND MAINTENANCE

There's no point in having all the right kit if it's not ready for use when you need it. When I first started work as a painter's assistant in the theatre, my boss insisted that all our kit was thoroughly cleaned after use, without exception, and put back where it lived. It's a good habit to get into. Keep your brushes and palette clean, your equipment in good order, your pencils and blades sharp, and see to it that you don't run out of essential supplies. With just a little forethought, you'll always be ready to seize the moment and make the best of any opportunities that come your way. Contrary to popular opinion, there is nothing creative about mess. Mess is just mess. For anyone who thinks there is something very restrictive and old-fashioned about this approach, a small story.

You have been wanting to paint the horse in the field just down the road as the sun is setting, casting golden shafts through the trees. For the last week, there has been heavy cloud. Tonight, to your surprise, the clouds lift just at the right time, you are inspired, you'll go and do that horse! You grab your paintbox and rush down to the field. But wait – you didn't clean and restock it when you got back last night from the life class, did you? Most of your brushes are standing hair-down in a pot of white spirit (I suppose that at least you didn't let them dry out, but the hairs are already curling), you didn't replace the empty tube of white, and the palette is covered in half-dried reds from the drape you were painting.

You forgot yet again to tighten that loose screw, so the handle of the box is getting ominously loose – you can only hope it won't drop off before you get back. You're lucky that your box contains two boards, because you didn't replace the one you used last night. But with no white, and only a few brushes, none of them the ideal size for this enterprise, your artistic spontaneity is going to be a wee bit cramped. You also realize when you get some paint on your hands that you have no rags, and your dipper is nearly empty. It's going to be difficult to make much of an attempt at your elusive subject. An artist who had kept their kit in good order could have been as spontaneous as they liked – they'd have got that sunset, for example.

The moral is, clean your kit and replenish your boxes when you get home, however tired you are, and however disinclined you are to do it, just as all good horsemen and horsewomen attend to their horse's comfort before their own after a ride. This applies to the end of the day in the studio too. Cleaning up is quicker when the paint is freshest, and your brushes will keep their shape better, and last longer too, which is a saving in these expensive times.

Just as a good groom checks tack for broken stitches, check your equipment regularly all round for loose bolts and screws, and, if you find any, tighten them up. Wooden sketching and box easels in particular are plagued with this problem, probably

Home-made sketchbox. This has grooves for two boards in the lid. The palette slides across to hold the contents of the box in place and closes the end to prevent the boards sliding out, and it slides out completely for cleaning. There are compartments under the palette for tubes of paint, brushes, a dipper, and a small sketchbook.
The webbing strap contains a compression snap with a quick-release buckle (like those used on rucksacks) so that the strap can either be fastened round my back and adjusted to length to prevent the box sliding down my lap as I work, or pulled tight around the box to prevent the palette sliding out in transit. There's also a carrying handle on one end, and an adjustable cord to set the angle of the lid.

because wood expands and contracts as humidity changes. Working outdoors puts a fair bit of strain on an easel from wind and weather and being carted about from one location to another doesn't help matters.

If fittings become loose, joints can 'work' which in turn can cause splits in the wood which can be difficult to repair. If a piece of wood on your easel does start to develop a split, glue and clamp it and leave it clamped long enough for the glue to set. If you aren't handy with wood, ask a carpenter to do it, but either way, do it at once. A small split can become a big break if not dealt with quickly. If a screw gets loose so often that the hole in the wood enlarges and the screw won't 'bite', the hole will need to be plugged and the screw refitted.

If you maintain your equipment carefully, it will repay you by being reliable and lasting a long time. Some wooden easels benefit from a light oiling of the wood with raw linseed oil, but check with the manufacturer's instructions first, and avoid oiling surfaces that might stick together.

PRACTICAL PAINTING

DEALING WITH THE WEATHER

In cold weather, a warm hat and gloves (without awkward chunky seams) are a must; sometimes fingerless gloves may be sufficient. You can get very cold working outside, and may even damage your hands if you don't protect them. On a bright winter day, ordinary clothes and a fleece may be warm enough to walk around in, but you may require long johns, thermals, a couple more fleeces and a heavy windproof jacket as well if you are standing or sitting still to paint for an hour or two.

Some people like to stand on a folded up sack to keep the cold from their feet. I've learned the hard way to take a foam mat if I'll be sitting down. An hour or more perched on wet grass or sharp rocks (and they get sharper by the minute) is dampening to the enthusiasm and detrimental to the concentration.

It is difficult to judge tones if you are dazzled by the sun, and even when the sun isn't very strong, glare from the sky can be unpleasant; a hat with a wide brim may help. Keep direct sun off the surface of your board or canvas as you work, or when you take the painting indoors it will look too dark (box easels can lean a painting slightly forward, which helps). If possible, I align my small sketchbox so light doesn't fall directly on my board. I use an umbrella for my box easel to shade my board/canvas if necessary. In the past, artists like Sargent and Millais used big white cotton umbrellas. (Don't wave brollies around close to horses, they really hate it.)

STAINED GROUNDS AND THEIR ADVANTAGES

When painting in oils, I usually take a selection of pre-stained boards of different colours with me to use when sketching outside, and in the studio, when I have decided on a canvas to use for a painting, I stain it a suitable colour for the painting in question. Partly this is because it prevents me being dazzled by a white ground if working outside, but more importantly, it is because working directly on a white ground makes it very difficult to judge the correct tone for a colour, especially in the early stages, as it is being seen against lots of white when there will be little if any white in the completed painting.

Artists who start on a white ground often have to stop part way through their painting and repaint all their colours darker, because when the white primer that provided so much contrast has been covered up, the other colours no longer seem dark enough. As explained in the previous chapter, it is the relationship between tones that is important.

I usually stain canvases/boards with raw umber thinned to a wash with turpentine, washed on with a large brush or wiped on with a rag. I might perhaps add some ultramarine blue for colder tints or a little burnt sienna for warmer ones.

In oils, as a stain like this takes at least twenty-four hours to dry, I stain boards for sketching in batches with a variety of tints so I always have a choice of boards that are dry and ready to use. Staining would also work for acrylics.

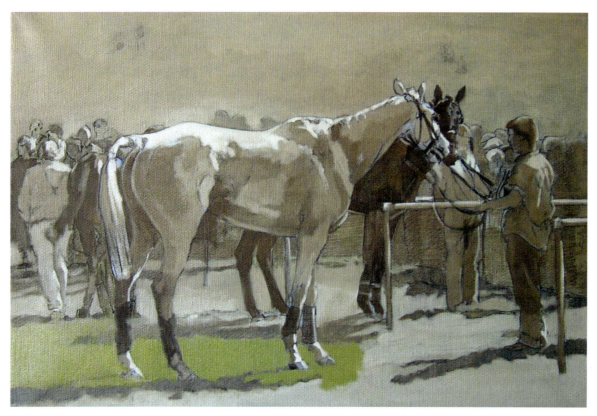

Bredwardine, a Grey and a Bay. **18 × 26 in (46 × 66 cm). This painting is still in the very early stages, and the blue-grey stained ground can clearly be seen.**

PRACTICAL PAINTING

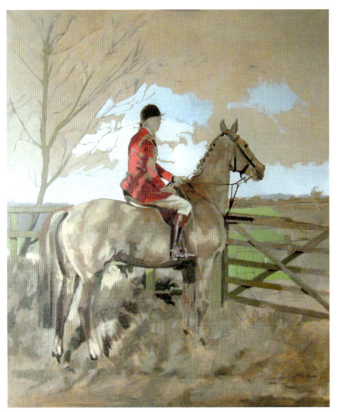

This painting, 32 × 27 (81 × 69 cm), is still being blocked in, and the warm brown stained ground is still visible in places.

change its rug colour from red to blue, then as soon as you make the change, you immediately see the effect of it on the painting as a whole. If half the painting is still a blank white canvas and in another area it is painted in full detail right down to the buckles on the bridle, when you make a change it simply isn't possible to make any useful judgement as to whether it has worked or not, as too many other major variables still exist. If the progress you're making across a painting is very uneven, you may also fail to notice that changes need to be made until you have done a lot of work that will need to be redone.

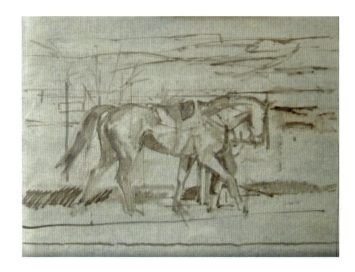

Sketch for *Leading Up, Sheriff Hutton*, 23 × 32.5 in (58 × 83 cm) with the stain and the underdrawing only.

It wouldn't be a suitable technique in those special cases where the paint is used thinly and relies on light being reflected back through the paint layer from the white priming for its effects, or for transparent media such as watercolours where the white paper showing through the paint is part of the way the painting works.

WORKING ACROSS THE WHOLE PAINTING

Whether you stain or not, the key to keeping in control of any painting, however simple or complex the composition may be, is to work across the whole painting all the time, regularly checking that the appropriate relationships between all the different parts are working, and not allowing any part or parts to get too far ahead of any others. If this sounds horribly formal and restrictive, it isn't – it's quite the reverse. If you are in control of a painting, it is actually easier to experiment and take risks with it than if the whole thing is in chaos.

If you were to decide, after broadly establishing the basic tones and colours, to move a horse to a different position, or

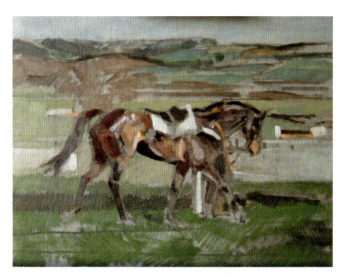

A later stage in the sketch for *Leading Up, Sheriff Hutton*, showing how the sketch was worked on all over very simply before any area was allowed to become detailed.

121

PRACTICAL PAINTING

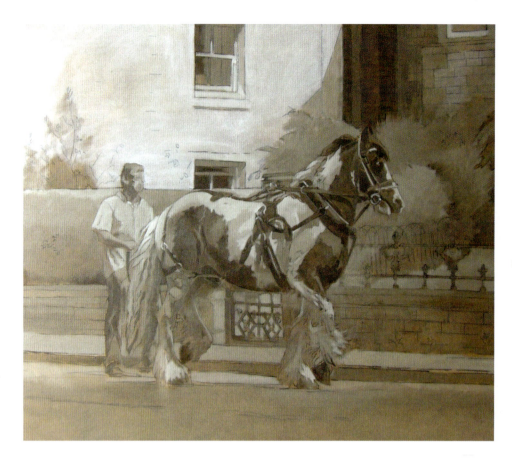

1. After being drawn up, the painting has been 'blocked in' with tone, using raw umber and titanium white.

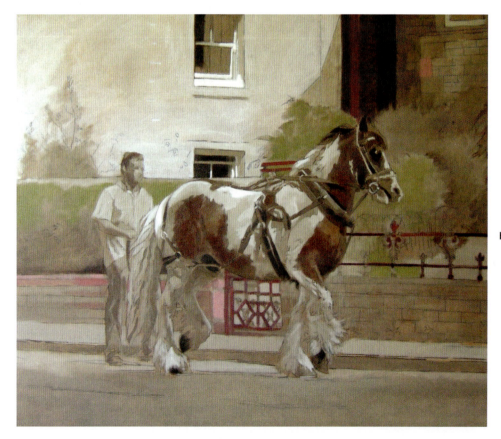

2. The most important colours have been added – they are spaced across the whole painting.

PRACTICAL PAINTING

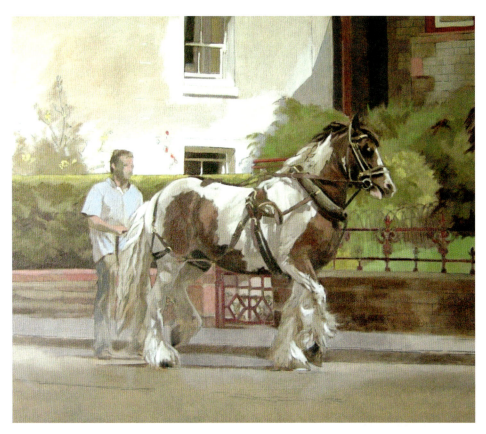

3. More colours are added, such as the blue shirt, and again, the whole painting is worked on without getting into too much detail anywhere.

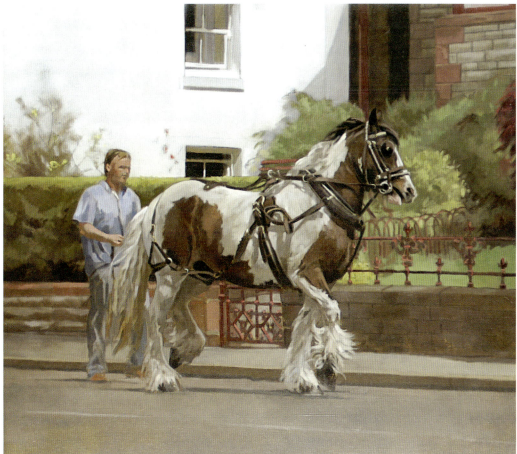

4. *Long-reining, Appleby*. 30 × 34 in (76 × 86 cm). The painting is now complete.

PAINTING IN TONE

Tone is easily the most consistently weak area in modern representational painting. Artists used to do a great deal of tone work in their early training, and developed very good judgement in tone relationships. Today, tone is now almost totally neglected in teaching except as a rather crude, mechanical way of describing the volume of a single object. In fact, tone is about the relative relationships between tones all over a drawing, or painting. Basically, it's relative tone that creates space, rather than absolute colour.

Tone is important when painting for two reasons: one, because if artists want to create space convincingly in their paintings they have to be able to handle complex tone relationships with considerable delicacy; and two, because where tones are badly structured, colours will appear either chalky, crude or dull.

I referred earlier to Velázquez and the colourists of the Venetian school. Their work is not 'colourful' in the modern sense of having a wide selection of very high-toned and highly saturated colours splashed around everywhere. They achieved a sensation of great richness of colour through careful limiting of colour, but mastery of tone. Many later artists abandoned this traditional use of tone, being more interested in theoretical ideologies of colour.

A lot of contemporary paintings are high toned (light in tone) all over. This can result in chalkiness and a lack of depth. Attempts to compensate for this chalkiness by using more saturated colours will only make a painting look even flatter. Of course, not all paintings are concerned with establishing volume, depth or the space between objects; they may have other priorities. However, if you do wish to create depth, subtlety, and/or richness of colour in your work, you will need to master your tone relationships.

Traditional ways to achieve correctly functioning tone relationships in a painting included the making of preliminary studies in tone, and starting actual paintings using an underpainting in tone alone (which would then be glazed with thin washes of colour to achieve the colour desired). Students would be encouraged to do exercises in tone. Here's one to try.

An Exercise in Tone

Prepare a board or paper in advance with a thin stain of raw umber (see section on 'stained grounds' earlier in this chapter). You will also need at least six or seven brushes, preferably flat ones, and a palette knife. Knives allow you to mix colour very evenly, which this exercise requires, and brushes are damaged by mixing paint in bulk. A rag is useful for wiping out any mistakes.

If you are using oils and acrylics, I suggest using raw umber and titanium white. In oils, titanium white does dry slowly, but raw umber is such a fast drier that a mix of the two dries pretty quickly. A professional quality white is better for this job as it should be stiffer and more opaque.

You could do this exercise in gouache, though the changes in tone as it dries may be annoying. If you wish to use watercolours, I suggest working on tinted paper in body colour using Chinese white. If you prefer to work transparently you will have to work on white paper rather than tinted paper, which makes the exercise a lot more difficult.

Set up a simple still life. You could include a piece of unpatterned crockery or glassware, a vegetable or piece of fruit, and possibly a plain jug or kettle. Skulls are great to paint or draw if you can find one, as are casts. Place the objects on a white cloth, and fix up a plain-coloured drape in the background with some folds in it. A strong artificial light directed onto your subjects will make the lights and shadows easier to see, but be careful to protect your set-up from any light source that may change while you work.

Stick to working from life. This is an exercise in seeing and recording tone, and in translating three-dimensional space into two dimensions, so working from a two-dimensional photograph defeats a lot of the point of the exercise. Photography can also be inconsistent in the way it records the tone values of different colours, and may not record some tone differences at all. I photographed the set-up I used for this example, and some of the tone differences I saw and recorded in paint simply aren't identifiable in the photographs.

Using paint thinned to a watery consistency (with oils use turps for faster drying), establish in line where the principal objects and tone patterns are. You can use any colour you like for this as the lines will be covered up as you paint.

Detailed drawing-up is not necessary, but make your marks accurate as well as simple. There is no pressure of time for this exercise. Time spent plotting out the painting will be time well spent; if you place your objects correctly at the start you won't be fighting problems with shapes or tones not fitting together properly later on.

If working in oils or acrylics, using the umber and white, mix five piles of paint (with a palette knife to keep the tones evenly mixed and save on brush wear). Make them evenly spaced in tone from light to dark. Your darkest tone will need almost no white, just enough to give the mix some 'body'. Your lightest tone should not be completely white, but should be tinted with a little raw umber. Raw umber doesn't have much tinting strength, so except for the lightest tone, start with umber each time and add very small amounts of white until you get the various tones you need. (Tip: if you add strong colours very gradually to weak ones, it makes it less likely that you will end up having to mix too much paint in order to get the colour you want.) If you aren't using a slow-drying medium such as oils or

1. Still life drawn up in ultramarine blue on a raw umber stain.

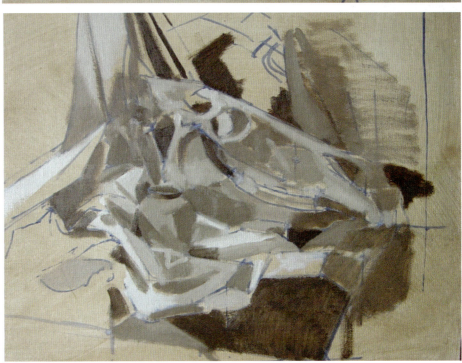

2. The tone range is established.

alkyds, you'll have to make provision for this paint not to dry out as you work. If you are working in transparent watercolour, mix five washes of evenly spaced tones.

First find the darkest general area of your still life and paint this simply and flat with your darkest mix. Take a fresh brush and find the lightest area (not including any highlights) and again 'block in' with your lightest mix. Find an area that you think is midway in tone between them, and block that in with your middle tone with another brush. Some areas of tone will cross contours of objects; paint them as one, losing the contour between them and thereby 'losing' the edges of those objects in places. This will prevent the objects in your painting looking as if they have been cut out and stuck on. Place your tones directly next to each other, without leaving gaps, covering the drawing-up lines. Relationships between adjoining tones can't be judged properly if they are separated by lines or gaps.

PRACTICAL PAINTING

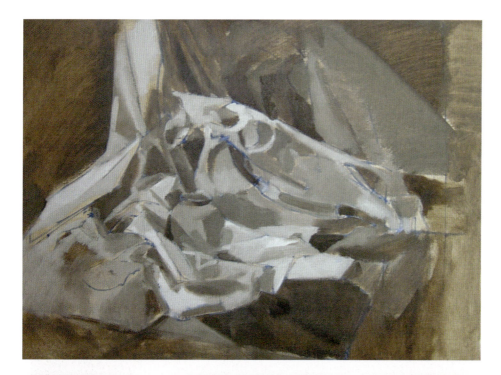

3. Most of the board is now covered.

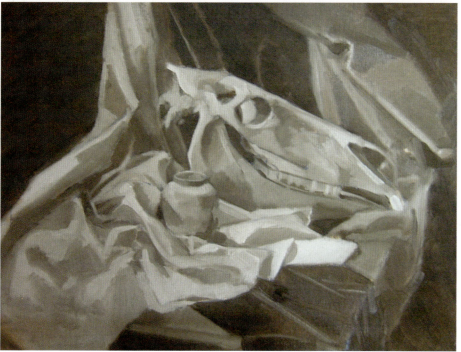

4. Smaller areas of tone are added, and others adjusted.

Using all the tones you mixed at the start, complete the painting. Keep a separate brush for each tone, and don't thin the paint. Paint solidly and flat. As you work, check that the relationships between all the tones are as they should be. For example, you might be painting a shadow on a white cloth. Though it is a shadow, it may still actually be the same tone as the mid-tone on a dark jug elsewhere, and not nearly as dark as the shadow on the dark jug. Look at your set-up and find areas that are the same tone as the area you are painting. They need to be the same on your picture. Be sure that if you paint an area darker than the area next to it, that it really is so on your set-up. Make any necessary adjustments as you work to get the tone relationships as close as possible to those on your set-up. Deliberately defocusing your eyes can simplify what you are seeing, making it easier to judge the relative tones.

The object of this exercise is to organize all the tones in front of

5. The completed study, 16 × 20 in (41 × 51 cm). The highlights have been added last. Note how the texture of the surfaces can be indicated by how crisp or soft the edges of the tones are; the fabric has soft edges and the glazed ceramic pot has sharp, clear edges, making the fabric appear soft and matt, and the ceramic smooth and hard.

you in the right order. There's no need for detail. Look for shadows and reflections. Observe how the light describes the volume of objects (this is easiest to see on simple forms, like cubes and spheres; oranges are great for this). Take a break every now and then; when you come back with a fresh eye, you'll see any errors more easily.

When you have got to the point where you have adjusted all your tones as accurately as you can, drop in any highlights with white. If there are any very dark shadows, block them in with straight raw umber.

This is a time-consuming exercise when done well, especially the first time. It needs to be done carefully, checking all the time that no tones are falling out of line with others. The more accurate your tone relationships, the more 'real' the sketch will look, in spite of it being in monochrome. This exercise is worth repeating with other still life set-ups or landscapes; when you have got to the point where you can work quickly enough, try it with a horse in a landscape. Just keep it simple, and think all the time about how light or dark each tone you place needs to be compared to the ones you have already recorded.

The final step is to put into practice what you have learned when painting in colour. The reason for doing this kind of tone work is to get so much into the habit of thinking about tone relationships that when you go on to work in colour, not only the colour relationships but also the tone relationships you make across the painting will function properly.

When working on a painting in general, rather than doing an exercise like this, you can manipulate your tones somewhat. You might decide to stretch a part of a tone range or compress it, or to have all your tones very light, or very dark. Those are legitimate stylistic choices. But if you go further and displace something from its place in the tone 'pecking order' (i.e. make one thing lighter than another when it fact it was darker), don't do it without good reason, and be sure it really has the effect you want it to have.

Tone sketches can be used as underpaintings for oils and acrylics. When sufficiently dry, they can be overpainted with transparent glazes of colour. If you intend to do this, keep your overall tones a little lighter than you would otherwise do, and your contrasts a little greater, as glazing darkens tones and reduces contrasts. Alternatively, tone sketches can be overpainted in solid opaque colour (matching the tones of the colours to the underpainting). I find that this technique makes managing the colours on a complex painting much easier. It is a traditional way to work, although it is no longer widely used. If you find it difficult to get both colour and tone right at one go, this way of working divides one complicated task into two more manageable ones.

PRACTICAL PAINTING

A SIMPLE EXERCISE IN SEEING COLOUR

Seeing colour is not as easy as it sounds. Just as we make assumptions about shape when drawing, we make assumptions about colour when we paint. We may *think* we know what colour a chestnut horse is, but we may be completely wrong if it is standing in coloured light. We may think a numnah is red, but the parts of it that are in shadow may be brown, or blue. We may think that a horse is black, but a strong shaft of warm sunlight could make it look brown, or even bring out a dapple in its coat. As we saw in Chapter 6, reflected colour from other objects adds to the complexity, and when we paint things in three-dimensional space we also have to paint not only the objects, but also the air between them, complete with dust and moisture, or even mist and fog (aerial perspective). The intrinsic colours of objects are profoundly affected by all these things.

Representational painters have to learn to see the colours that are the result of all these phenomena. This exercise is designed to help us isolate colour from other considerations and look at it as objectively as we can. Just as we might use negative shapes to circumvent our preconceptions about shape, here we are using squares to help us be similarly objective about colour.

Bright, steady light makes this exercise easier, as would a grey (white) horse. For anyone who has trouble finding horses to pose for them, it is possible to work from a photograph if your camera is good enough to record subtle differences in colour. The difficulty with using a photograph is that unless you use a very high quality film, or a digital sensor of high quality carefully set up to pick up subtle colour variations, the exercise may not be very effective. If you have to use a photograph, pick one you have taken on a day with good strong sunlight.

You might choose to use a pre-stained board if you don't plan to work in transparent media. Using your usual painting equipment plus a long ruler, draw the horse and its surroundings very simply. Square up the paper or board (as shown) with squares that are no smaller relative to the horse than those shown here (i.e. about the size of the width of the foreleg just above the knee or larger). Now paint each whole square the colour of the largest part of that square. If the square is half one thing and half another, you may divide it. The overall effect is rather like what is now known as a 'pixelated' image, the contours being lost (that's why there is no need for complicated drawing-up).

In this example I started by painting the darkest square and the lightest. Then I placed the more 'extreme' ends of each colour range, which here were the oranges in the coat of the horse, the brightest greens, the brightest blues of the sky and the handler's jeans. Next were important reference points, like the most distant grass, and the darker tones in the coat. Then, just as in the tone exercise, I placed the other colours in between, each time I painted a square asking myself, 'How does

First stage of squares exercise, with the main tones and colours established.

Most of the main areas have now been developed between the original colours.

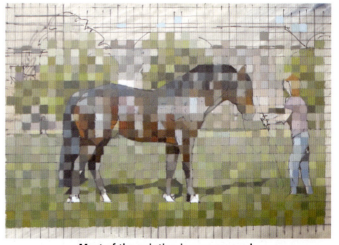

Most of the painting is now covered.

PRACTICAL PAINTING

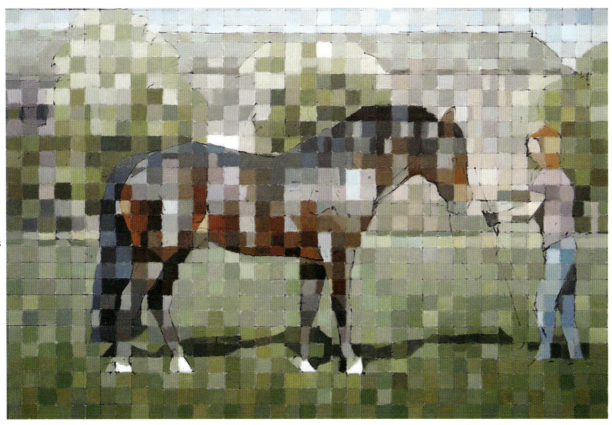

The completed exercise. Note the reflections of the green grass on the cob's white 'feathers' (long hair around the fetlocks) and the green tinge the grass gives to the colours of the underbelly in places.

the colour and tone of this square compare to the tones and colours in the ones already painted?' Try not to paint two squares next to each other the same colour, even if you think at first they are. Look more closely and try to see differences.

If it becomes clear that one already done is the wrong colour, repaint it. Look for as many different colours as you can. When the exercise goes well, some of the colours can be quite surprising. For example, here I found pale blues, very dark midnight blues and pale mauves on the horse's back and flanks, oranges and red browns on the horse's quarters and lower body, and even dark and pale greens on the underbelly and the feathers (due to reflections from the grass). In the grass there were greys and yellows, blues and turquoises.

At first it may be difficult to see these colours. If so, exaggerate the colours you can see just a little. Try to see the differences in colour between two adjoining squares – is one, perhaps, bluer, yellower, or redder than the one next to it? Then paint it so. Working with comparisons like that is helpful to people who can only see the obvious local colours that they 'know' things are, and are getting frustrated because they can't see the colours other people seem to be seeing. Not everyone sees absolute colours as the same, but most of us do see colour relationships in the same way. (I might call something orange which you might call red, but we should both agree as to which of any two colours is more red, or more yellow, than the other.)

This exercise can be done to good effect from other subjects too: still life, landscape, or the figure in the life room (the most challenging subject of all for this exercise due to the subtle colours of human flesh). It is all good training for the eye and the judgement. If you are working from a horse, as the exercise is a slow one, you may have to work on a smaller section of the horse and background than I have done here, and/or use larger squares. I always advise including some background, as it is the tone and colour relationships between a background and main subject that give depth and are hardest to get 'right' from photographs if you haven't studied them from life.

You don't have to fill every square for this exercise to be useful. If you have seen colours you haven't seen before, it has done its job. It can be quite exciting to realize that you can see colours you'd never have dreamed were there, and would never have seen otherwise. Once you have started to see colour in this more subtle and sophisticated way, it should be much easier to see it when painting without the squares, but it will be tempting to revert to 'local' colour. If you find you are reverting (as most students do to some degree when they return to painting normally), just do the squares exercise again.

COMBINING SOURCE MATERIAL FROM MULTIPLE SOURCES

Most painters will at some point wish to attempt a composition using a combination of source materials from different places and/or occasions. This opens up a lot of interesting and exciting possibilities, but is not without its drawbacks. Consistency is required when merging such references, otherwise the resulting painting can appear peculiar and its space unconvincing. There are several potential problem areas that need careful consideration.

Artist's Eye Level and Ground Levels

Your eye level needs to be consistent. If you put horses on the same level in the painting when your original eye level compared to the horses was not the same (for example, if one of your horses was originally on a slope and you were looking up at it, and another of the horses was on ground at the same level as you) then those horses won't look right together if you paint them as if they were on the same level. Nor will it work if you take horses that were standing on a slope and paint them into a landscape that is flat, or slopes in a different way. As we saw in Chapter 2, you can't just tilt them to fit.

Scale and Foreshortening

Horses at different distances and of different sizes need to be appropriately scaled. The surroundings need to be consistently scaled too. All too often one sees a horse that has been 'stuck on' to an unrelated landscape without proper consideration of scale, and the horse appears either enormous or far too small.

Even if the horses are correctly scaled with respect to each other, and were drawn from the same eye level, they shouldn't be put standing next to each other if the horses were originally at different distances from you. As we saw in Chapter 2, the closer we get to an object, the more pronounced the foreshortening, so a magnified image of a distant horse is less foreshortened than an image of one the same height seen from a closer distance.

Light and Shadow Direction

Always be aware of where any light in the picture is coming from. For example, it destroys the unity of a picture if sunlight appears to be coming from more than one direction. Be careful to extend your attention on this point to the landscape. Having shadows going to the left from your horses but to the right from your trees isn't a good idea. The sun moves round us at fifteen degrees an hour, therefore shadow direction can change a lot even during an hour-long painting session.

Don't forget that shadows change in length and shape as well as direction during the day. In the evenings and early mornings, shadows are longer; in the middle of the day they are shorter. Keep the shadow lengths consistent across your picture. (Shadow length can also be affected a lot by the slope of the ground). If you choose to get round all this by working at the same time of day on different days, don't let those days get too far apart; remember that the sun is higher at the same time of day in the summer than it would be in the winter, so the shadows won't be the same.

Shadows don't only fall on the ground, they fall across any surfaces in their way, including other horses, so if you add anything into a shadow area, the shadows have to be modified accordingly. Whatever surface a shadow falls on, the shadow will change in shape as it follows the form of that surface.

Reflections

Again, consistency is the key. For example, if you add a horse to a group of horses standing in the water which are reflected in the water, don't forget to add the new horse's reflection as well.

Contrast

On sunny days, the edges of shadows and objects will be sharp and clear, and the tonal range between the lightest and darkest tones in your picture will be large. On dull and/or cloudy days, the light will be more diffused, edges of objects and any shadows visible will be softer, and the overall tone range across the painting will be narrower. If you are combining reference materials from days where the light was significantly different, or even on the same day when the light has changed between your sketches, you will have to decide what sort of light you want and apply it to the whole picture in a consistent way.

Colour Temperature

Information from sketches made at different times of day will have to be adjusted to compensate for any differences in colour temperature. For example, sunlight at the start and end of the day tends to be warmer and more orange in colour, whereas midday light tends to be colder and bluer. The light should be consistent within a painting, and also should be consistent with any sky you paint. For example, it wouldn't look right to have beautifully consistent cold blue midday light on all your horses and landscape but a raging red-hot sunset right behind them.

PRACTICAL PAINTING

Scale and foreshortening. Using examples from Chapter 2, we can see that the two horses on the left, originally at the same distance, fit very well together side by side, whereas the third horse, which was much closer, can't be put in the same place even if it is scaled to be the same size. Not only does it look ridiculous, it doesn't appear to be standing on the same surface as the others. It would be possible to use the three horses in the same painting, but only if the two on the left were placed as much further away from us in the picture as they were in 'real life' – i.e. far further away than the one on the right.

Reflected Colour

If you move a horse (or anything else) from one place to another, don't forget to change any reflected colours appropriately. For example, if you take a horse standing on grass and move it into a picture where it is standing on a concrete yard, don't forget to change those colours on the horse which have been affected by reflections from the green grass. It's surprising how many people forget this one.

Maintaining Consistency

Where visual contradictions do appear in a painting, viewers will subconsciously know that something is wrong even if they don't know why. In essence, due to the lack of consistency within the painting, the illusion of consistent space and light has been lost, and the picture looks artificial and flat.

An artist needs to be systematic, consistent and logical in order to achieve a united piece of work when working from multiple sources. Preliminary drawings and sketches can help a great deal in this respect. In the past, this was all part of an artist's training, and many great artists such as Rubens and Titian appear to achieve remarkably 'real' results with incredibly complex subjects almost without effort, but, of course, they had spent many years learning how to do it.

There are many great subjects that would be difficult if not impossible to attempt if we restricted ourselves to only working directly from life, so we mustn't allow ourselves to be put off trying. Begin with something simple, and when you are used to putting everything together in a methodical way, you should be able to expand your horizons and tackle any subject you like.

WHEN THINGS SEEM TO BE GOING WRONG

As we paint, quite often doubts arise as to whether something is working or not. If we get stuck, looking at the painting in a mirror, or even upside down, can help to identify where the problem lies. If a change is being considered, sometimes it is possible to paint a potential correction on paper (oil painting paper in the case of oils), and place it on the painting to see if it works better. If it proves impossible to locate the source of the problem, or you know what it is but aren't sure what to do about it, you may be getting too close to the problem to see it clearly – this can be a good time to leave the painting for a few days, or even weeks, and not look at it. When you come back to it with a fresh eye, both the problem and its solution may be easier to see.

You can also ask other people to look at the painting without telling them first what you think the problem is, and see how they react. Non-painters can often spot a problem even if they can't help you find a solution. (The hardest part can be identifying what the problem actually is, so if they can pinpoint the problem, you may be able to find the solution yourself.)

Having another artist look at your work can be very helpful indeed, but bear in mind that not every artist is good at helping other artists with their work, however good their own work may be, especially if the two artists' styles are very different. Some artists really don't like giving opinions on other people's work. They find it embarrassing. In that case, don't press them into doing it.

Even if another artist can spot a problem, their own solution to it may not work for you; it's more than likely that you may still have to find your own way out of it. If you are lucky enough to find a fellow artist who is both willing and able to help you, be very thankful.

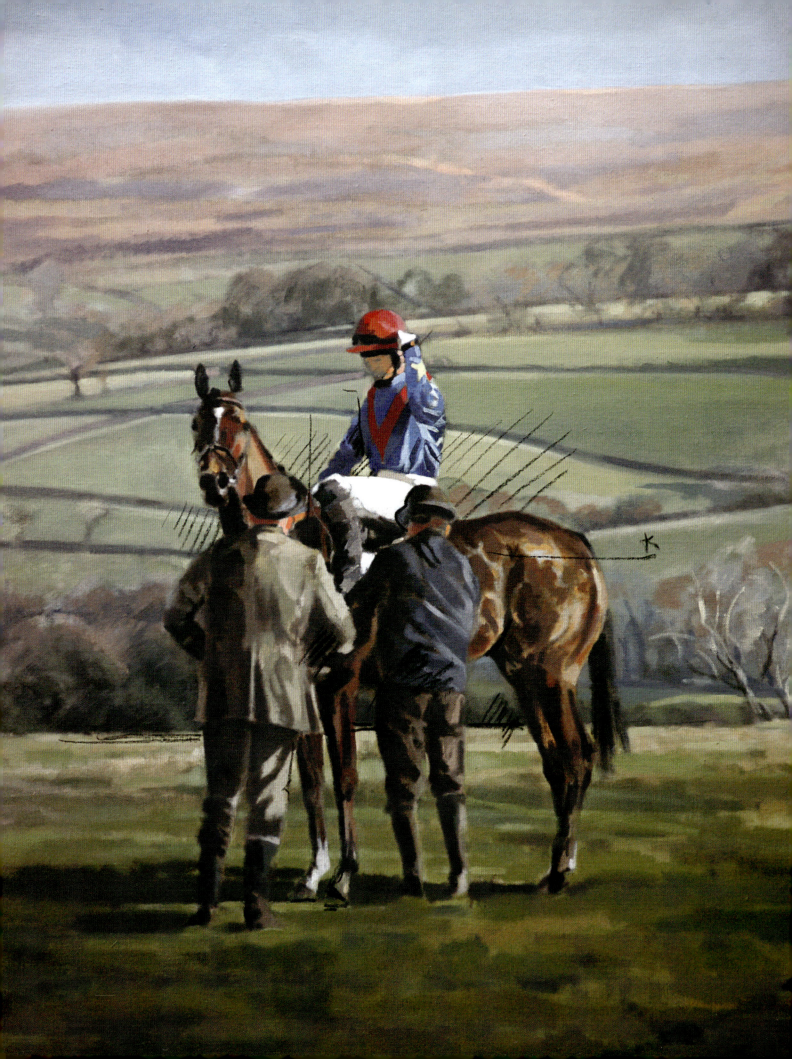

CHAPTER 8

DEVELOPING A COMPOSITION

'It is not bright colours but good drawing that makes figures beautiful.'
Titian (1488–1576)

CHOOSING A SUBJECT

A good choice of subject is the first step towards a good painting. As painting is a complex process which may carry on over several days, or even weeks, unless you have a clear idea of what a painting is about it is easy to become distracted by minor things, causing the painting as a whole to fragment and lose that unity which is necessary in all good paintings. Making decisions about what to do becomes challenging as there is no context in which to do it, and the painting will tend to drift. The clearer an original idea is, the less likely it is that a painting will end up mired in indecision and failure. The purpose of a painting is its driving force, and without such a driving force the painting process can easily descend into copying, or 'filling in' a drawing, especially where photography is involved.

Aside from direct commissions, there are many possible reasons for an artist's choice of subject. Some we might describe as responsive, such as wanting to capture a specific lighting effect we have seen; some may be quite theoretical, like wanting to capture speed or use a particular geometric layout; others may be narrative, illustrating a particular event. It doesn't much matter what the reason is for painting something, so long as you are clear about it in your own mind, and it interests you enough to sustain you through any difficulties later on. Here are some examples:

- An interesting lighting effect on a misty afternoon
 (a painting about light).
- A view from the eye level of someone on horseback
 (a painting about creating a feeling of 'being there').
- An interlocking composition of carefully grouped horses, jockeys and connections in a paddock
 (a painting about formal composition and space).
- A painting about a historical event, or illustrating a scene from literature (a painting about reconstructing time and place).
- A landscape with horses, rather than horses in a landscape (a painting predominantly about landscape where the horses are secondary).
- A painting to commemorate a special occasion (this would usually be a commission, and the artist's decision-making may be restricted by their client's instructions).

Some of these ideas are technical, some are telling a story, and some are more to do with creating an atmosphere. Several of the above ideas could come from the same afternoon at the races, and if ten artists went to the same race meeting, they should all come out if it with different ideas.

Let's take an example and see how having a purpose can help in practice. You're out on the racecourse on a rainy and windy day. Suddenly, the rain stops, the sun comes out, and the horses pass in front of you, the sunlight is behind them and it catches their manes and tails, lighting them up like fire. Wonderful. So you note in your sketchbook a reminder, maybe with some rough drawings or even written notes, that you want to do a painting 'about' that lighting effect. How you go about it in terms of the practicalities will vary from person to person. You might rely on photographs taken at the meeting and/or drawings done at the time; you might reconstruct it using anatomical knowledge, or organize a 'set up' with other horses in similar light to get the source material you needed.

However you go about it, as you work on the painting (whether that work includes preparatory drawings or not) you will be taking decisions all the time, such as: Do I include that detail? Should I make that number cloth lighter? Do I leave out that horse at the back, as its legs look funny? It is easy to get bogged down in such decisions. The key to making every decision on this painting

LEFT: **Detail of** Checking The Girth, Erw Lon **in progress, showing charcoal corrections marked for the next stage.**

DEVELOPING A COMPOSITION

is, 'Will this help focus the painting on the effect of light that made me want to paint this picture, or not?'

If you get to a point where piling on more detail will do nothing to help create that lighting effect, or might even detract from it, then remembering your initial idea will help you decide not to include that extra detail. If making the number cloth lighter would draw attention away from the contrast between the manes and tails and the dark forms of the horses' bodies, then referring back to the main idea will tell you what to do; leave it darker. If you need the horse at the back because it is part of the flickering pattern of light along the horses' backs that keeps the pattern of movement in the painting despite its ugly leg position, you'll need to keep the horse in – you'll just have to find a way to conceal or play down the legs. Knowing what you're trying to do makes actually doing it a lot easier.

When choosing a subject, there is also the purely commercial aspect – put bluntly, will this subject sell? This is a difficult issue. With original drawings and paintings we are selling just the one item, so we have only to please the one client; it is not like trying to sell a product like baked beans to thousands of people, where it might be necessary to consider whether 'most people' would like it. The constraints of a commission can stimulate artists to do good work, but most artists usually do their best work when they have chosen a subject that they are committed to for artistic reasons, and have then executed it to the best of their ability. In my experience it's certainly easier to sustain an idea and do a high quality piece of work when I'm being driven by an artistic idea than if I am continually looking over my shoulder at possible sales. I think the quality of the work is more important than the subject. I have painted pictures that I felt I had to paint because the idea meant a lot to me, though I thought no one else would like them, but they have consistently sold faster and for higher prices than other pictures I have painted that I had felt sure would be popular. So now I try not to think of the market.

I have, however, heard artists and/or dealers say the following (all other things being equal, of course):

- Paintings with vertical formats are generally harder to sell than horizontal ones (probably true).
- Lighter paintings are currently easier to sell than darker

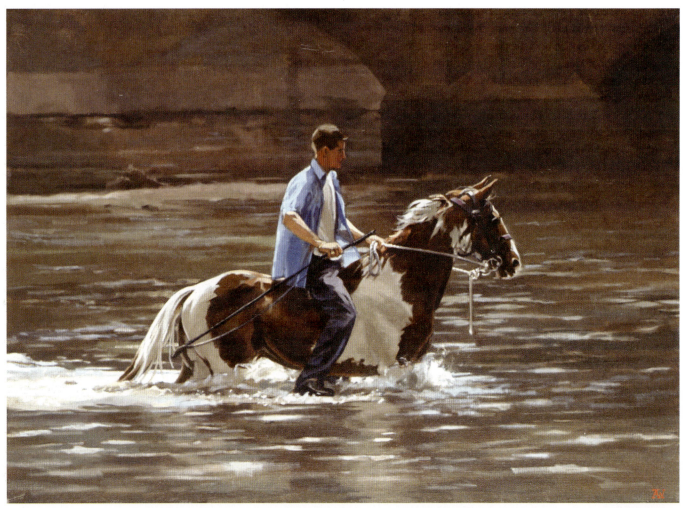

Appleby Fair: The Blue Shirt. **26 × 36 in (66 × 91 cm), a painting of a subject seen by chance.**

ones (this may be just a current fashion).
- Colourful paintings sell better (again, at present) than more monochromatic ones (they certainly stand out more in exhibitions hung on conventional off-white walls).
- High-contrast paintings are easier to sell than more subtly toned ones (possibly a passing fashion, but subtle works certainly don't stand out as much on gallery walls, though they are usually easier to live with).
- Paintings of famous horses are easier to sell than paintings of unnamed horses (probably true, especially for portraits).
- It helps, particularly with hunting and racing scenes, to identify the location/hunt/racecourse (certainly true).
- Cute titles aid sales (depressingly, probably true).

How applicable these might be would depend a great deal on where you plan to sell and at what prices, and they shouldn't be thought of as cast in stone. Fashions change over time.

SOURCES

Artists are often asked where they get their ideas for paintings from. Of course, the answer isn't the same for all artists, but, talking to colleagues and considering my own experience, I'd say there are three common types of source (aside from commissions, where the basic idea will be the client's).

Reacting to the Moment

The most obvious source is something observed. An artist could be standing by the paddock at the races, or just doing some general sketchbook drawings of mares and foals under a tree, the light catches the scene in a particularly beautiful way, and they suddenly 'see' a painting.

It is vital that the particular aspect of the scene that has captured the artist's imagination is remembered or recorded clearly at the time, whether in drawings, sketches, or words, and if necessary photographs as well. (Photography can miss out the

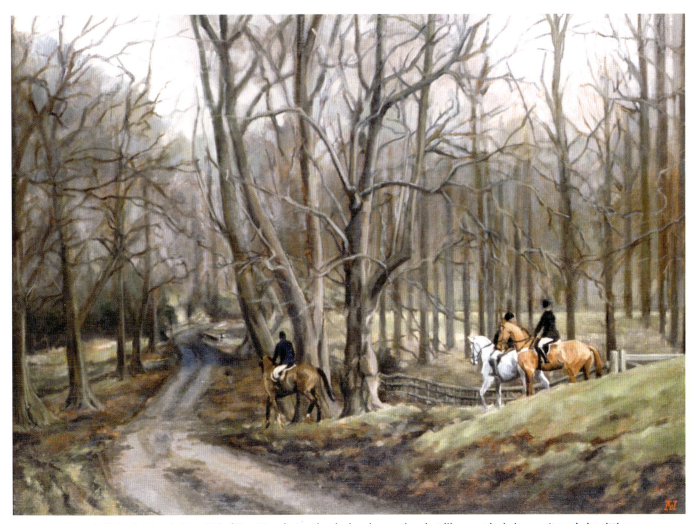

Eccleshall Castle Woods. **26 × 36 in (66 × 91 cm).** Another lucky observation, but like most luck, it wasn't made by sitting in the studio waiting for inspiration.

■ DEVELOPING A COMPOSITION

Sketchbook work for *Roman Cavalry on High Street, Cumbria*, **showing differences between them. Various features of the landscape were moved during the drawing process to places I felt would contribute better to the overall design on the painting. This was definitely an 'idea first' painting: I had wanted to paint this picture for years, even since I first walked over parts of this old Roman road.**

very things we need to record, so it's not good as a single source of information.)

This sort of idea comes when an artist is in a situation and is observing and reacting to it. The problem with a reactive approach like this is that a certain amount of luck is involved in whether you are 'inspired' or not. All you can do to improve your luck is put yourself in the right sort of places, keep alert, and hope.

Collecting References

Sometimes artists go out and collect images, such as drawings, sketches, and/or photographs, and make a large reference collection, with the idea of sorting through them at a later stage and selecting things to paint. This can also be a chancy process, as it is perfectly possible to spend a lot of time and effort collecting and filing vast quantities of material and then find none of it sparks off an idea at all. That failure can be due to poor choice of the original subject(s), or not enough thought having

gone into the information when it was originally collected, leading to shortcomings in the quality of that information. Poor photographic technique can render photographs unusable, and in the absence of supporting notes or drawings can make us wonder, when we review them afterwards, why on earth we took the photographs in the first place.

Collecting references in the hope of later inspiration needs to be done with thought, and some planning, if it is to be effective.

Idea First

Another way for an artist to come up with a subject is for the artist to think of an idea first, and then either paint it from their imagination ('out of their own head'), or set up the scene – or parts of the scene – to fit the idea and work from that.

This sort of idea might be anything at all: an elaborate mythological story, a scene describing an event from history, an illustration of an event in a work of fiction, or a simple scene with horses in a landscape. The idea might arise from the artist reading a book, watching a film, or even finding out about the history of a place or an equestrian event from the past.

This sort of approach to painting was much more common in the past, particularly before photography, but now, due to a combination of changing markets for paintings and the loss of skills and techniques within the profession, it is more seldom seen. It can be very challenging, but it can also be good fun to attempt a subject of this sort. Occasionally having to use skills that we don't usually use is good for us all.

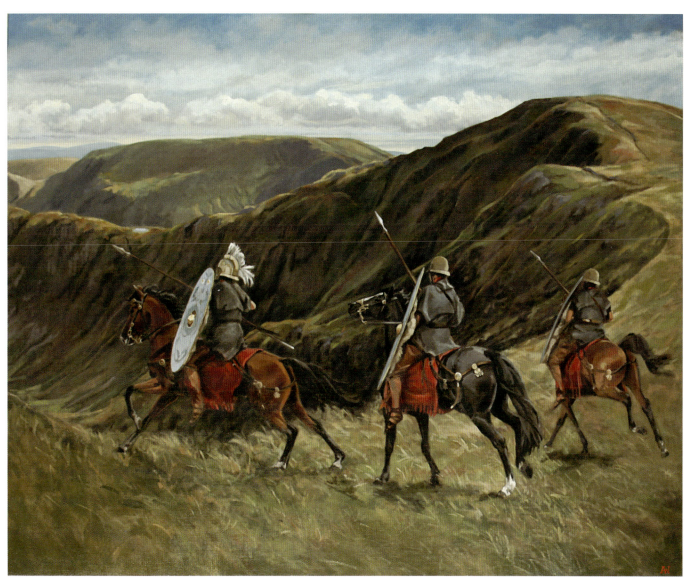

Roman Cavalry on High Street, Cumbria. **40 × 50 in (102 × 127 cm).**

DEVELOPING A COMPOSITION

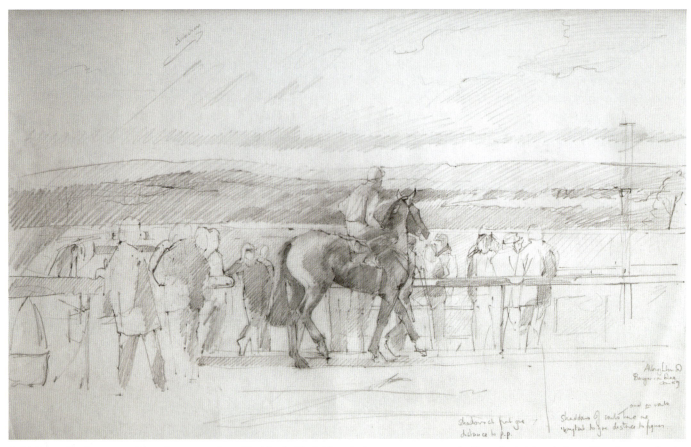

Initial drawing for *January Sun, Bangor-on-Dee*. **The idea behind this painting was to create a feeling of a brisk, windy, cold and sunny day in a big open space. When drawing, I became particularly interested in how the spectators grouped themselves, and how the depth I needed was created by the decreasing height of the figures in the middle ground, and the deeper distance created by the recession in the racecourse rails and fences.**

PREPARATORY DRAWINGS AND COLOUR SKETCHES

I find preparatory drawings and sketches very useful. It is, of course, entirely possible to start a painting directly on the canvas with no preparatory work at all, and many artists do, but even when working directly from life I usually do at least one quick drawing in a sketchbook before I pick up a brush, just to explore my subject a little, to get me thinking and looking, and to help me consider the options I have. The larger and more complex the painting, the more preparatory work I do.

The purpose of preparatory work is to plan and develop a painting. It may be sufficient to do one drawing on which all the ideas are worked out through a series of corrections, or it may take several drawings and/or colour sketches. There are many types of preparatory work, from back-of-the-envelope drawings of tentative ideas for painting, which are little more than an idea in a few lines, to detailed studies of particular parts of paintings (such as an unusual piece of tack or the structure of a hock). I often do drawings in a sketchbook to explore possible

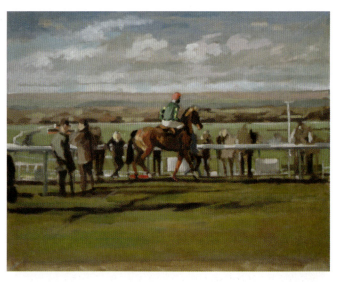

Oil sketch for *January Sun, Bangor-on-Dee*. **16 × 20 in (41 × 51 cm). In a sketch like this it is possible to try out options and to experiment without wasting materials and time. The effects of any changes can be seen quickly and if they don't 'work' can just as quickly be repainted back to the original colours.**

DEVELOPING A COMPOSITION

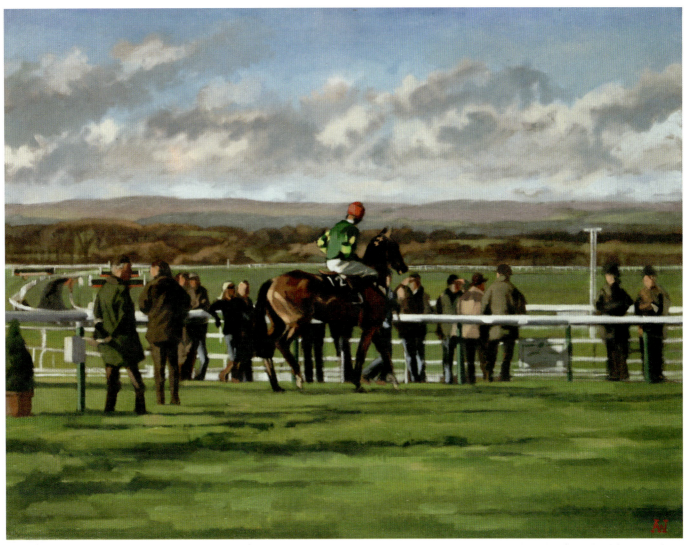

January Sun, Bangor-on-Dee. **20 × 26 in (51 × 66 cm).** Unusually, the horse and jockey are bang in the centre, but I have used other shapes around them and an asymmetrical ground plan to destroy any feeling of symmetry between the two sides of the painting.

compositions for a painting. In terms of detail, preparatory drawings can be loose drawings exploring rhythm, right through to highly finished tonal or line drawings, maybe even at full size.

Much time and trouble can be saved by exploring the options for a painting in drawings and sketches first. If this initial work reveals a serious problem, the painting can be changed, postponed, or even abandoned, avoiding wasted time and materials. It also prevents an artist's confidence being damaged by failure due to an intrinsic fault in the original idea. I find that I take fewer than half of my original ideas forward to paintings.

Preparatory drawings and oil sketches are an excellent filtering system. The animal painter Anton Mauve (1838–88) would do a colour sketch on the spot when he found a subject he wanted to paint, and would only return to the spot to draw tones and details. He would then put the whole project to one side for at least three months, ensuring that only the most essential things remained in his memory (this is recorded in Adrian Stokes' book *Landscape Painting*).

Rather than doing a lot of separate drawings which are easy to lose, I prefer to do my preparatory work in sketchbooks. I often do everything on one drawing, correcting it as I go, first working on the composition in line, moving horses and/or other elements of a composition around, possibly changing their scale, as I work. (This is one sort of drawing for which I do use an eraser.) Doing all this on one drawing can be confusing if you aren't used to working this way. An abandoned option can be difficult to remember if you want to return to it, so you have to be sure of your decisions.

It can be easier to work on several different compositional drawings so that they can be compared and the best solutions chosen. If you get to a point in a drawing where you want to

DEVELOPING A COMPOSITION

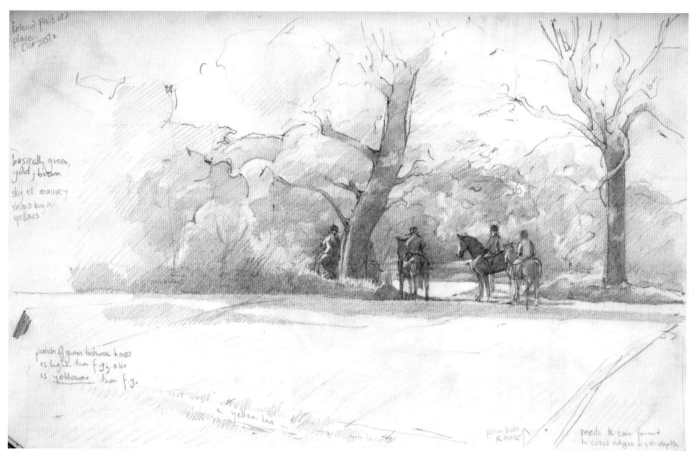

The initial drawing for *Evening, Oncote Covert*.

work on several different options for the next stage, consider photocopying (or scanning and printing) your drawing several times and then developing the different options on different copies; that way, you can compare the options as you work on them without losing your original drawing, provided you use paper and ink that will take pencil or whatever other media you are using. There's nothing wrong with using technology where it can offer practical help.

I also use preparatory drawings to decide, in conjunction with the composition, where the edges of the painting need to be. In some of the drawings illustrated here it is possible to see lines indicating several options for where the edges of a final canvas might be. As you can also see, I often make written notes on the drawing to remind me of anything useful I have worked out during the drawing process.

Once I'm happy with a composition in line, I often work over the same drawing in tone, planning broadly where the darks and lights will go. Occasionally I'll do an additional tone drawing. Sometimes I do drawings of small sections of the painting to explore or clarify other options.

I always do a preparatory sketch in paint for a studio-based painting (see later in this chapter) in order to work out whether the idea I have in mind will work in colour. If I conclude that it

won't, the painting will be abandoned, or postponed until I can think of a different way to do it. Sometimes this sketch is done before I draw, sometimes after; there are also times when I will draw, then paint a colour sketch, then return to drawings again to work out how to get over a difficulty that emerged in the colour sketch.

Evening, Oncote Covert, a Work in Progress

This is a 'live', ongoing project which is a good example of a fairly simple idea and the processes I use to develop a painting. The large drawing is of the whole composition, and is a drawing begun on the spot and worked on in the studio afterwards. It includes written notes of any thoughts that emerged as I was working, about things I might need to remember, or consider, later on. I do a lot of note-writing, as sometimes there may be a considerable gap in time between the original drawings and the later stages of a composition and it is easy to forget important points. It is often a matter of months before I will return to an idea if I have a lot of other work in hand; on occasion, such as in the case of the Roman cavalry painting earlier in this chapter, I have even come back to an idea after several years.

I don't work solely on one painting from the first thought of it

DEVELOPING A COMPOSITION

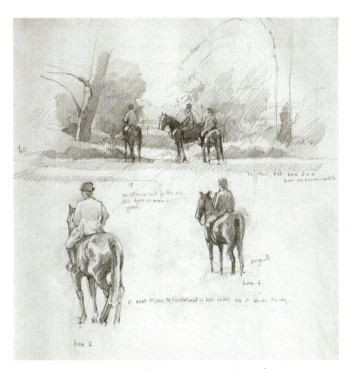

Alternative horse and rider poses and positions for *Evening, Oncote Covert.*

Sketch in progress for *Evening, Oncote Covert.* **8 × 10 in (20 × 25 cm). Rough drawn lines and first colour.**

More colour ….

Fully blocked-out in colour.

until it is complete and then look around for another to do. At any point in time, I have many paintings at various stages of development. I usually have dozens of ideas at sketchbook stage, a significant number at colour sketch stage, and at least two or three final paintings in progress. As an oil painter, I sometimes have to wait for paint layers to dry, and I may also want a little break to think about a painting before I carry on with it. Working on only one at once would waste a lot of time.

In this case, after the first drawing, I decided that I needed to consider alternative poses for the horses and riders, so I did some larger-scale drawings, again in my sketchbook, exploring different possibilities. That satisfied me that it was worth going on with the idea, so I progressed to a small oil colour sketch on board to explore the possible tones and colours for a final picture. This sketch was sufficiently small that I could alter anything in it quickly. When I wanted to change the colour of the whole sky, it took a matter of minutes to do it. I could work simply in broad masses of tone and colour, to work out how best to achieve my original aim, which in this case was to describe the saturated colours and sharp long shadows that come from a sunny evening, which nevertheless has a dark, threatening sky.

My first attempt at the sky was the wrong blue, making it look like a sunny midday sky, so I pushed it more to the violet blue of a coming storm. The field beyond the horses started out as pale green, but although its lightness gave it some distance, it didn't

141

DEVELOPING A COMPOSITION

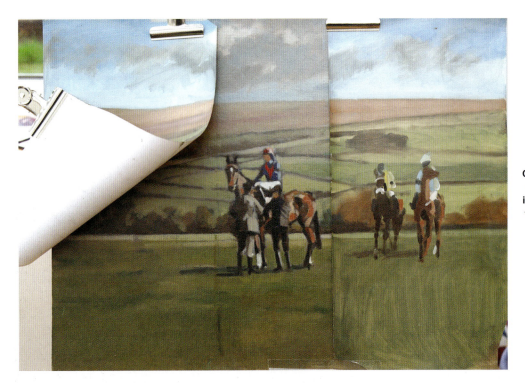

Oil painting paper has been painted to match the colours and positions in the landscape. It is possible using this method to try combinations of options on one sketch; here just one is in place.

create the effect of light beyond my figures which I wanted, so I added a bluer green patch beyond it and made the original colour a little yellower. This created a good focal point in the centre of the painting, drawing the eye to the group of horses and riders on the headland.

As I worked, following the drawing, I concentrated the biggest contrasts in tone in that central section, again to encourage the eye to linger there, and to explore the deep blues in the distant trees. The large tree to the left of the central group is a dark mass in the sketch, and its canopy holds up the roof of the painting. This wasn't evident from the drawing, where my preoccupation was the complex shapes in the trees, something which doesn't show in a small sketch, although this information will be needed for the final painting provided the canvas is large enough.

At this stage I'm happy about the way the painting is going, and intend to take it further, but it remains a work in progress. I always try to keep an open mind about the possibilities, so if ever this sees the light of day as a painting, there could still be a number of changes. It is possible that I may return to the colour sketch and work further on it. At the very least, I still have to decide on the size and boundaries of the painting and its format. But that is for another day.

TRYING OUT OPTIONS

If you are unsure about a decision on a painting, but don't want to work on the originals of sketches in order to see if something works or not, as with drawing, you could make a photocopy (or print a scan) of a sketch and work on that. However, to get a high-quality comparison, you do need to work in the same media. This isn't very practical when it comes to paint.

In the case of the painting *Erw Lon*, my painting was 'about' a particular place – the start at a point-to-point racecourse in South Wales, sadly now no longer used. It is a particularly beautiful place, spacious and quiet, and I wanted to show this. I had some doubts about whether to stick to my original idea of achieving this by showing one horse having its girth checked in a wide open space (which also makes this painting a 'pair' with another painting – part of my original idea) or to include other horses walking round as well. Given that the size of the painting was to be 40 × 50 in (102 × 127 cm), I didn't particularly want to experiment on the painting itself.

I did a number of drawings (with paper additions of a range of options), and also a small oil sketch, without coming to a decision, so decided to see what difference colour would make. I made a second sketch of the whole composition on a larger scale (16 × 20 in; 41 × 51 cm) and then painted my other options on pieces of oil sketching paper at the same scale. That gave me the opportunity to see more clearly the effects of using the different options. You can use the same method to check a colour before applying it to a painting, but be careful if you use oils, as the paper may have a different absorbency to your canvas or board and as a result the colour may 'sink' (become very matt in surface) and therefore appear tonally different, until it is varnished.

For the final example in this chapter, I will make a detailed description of a large and complex painting from the first idea through preparatory drawings to the finished colour sketch.

DEVELOPING A COMPOSITION

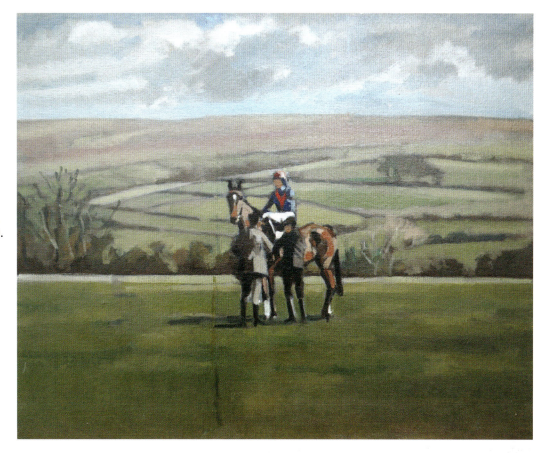

Checking The Girth, Erw Lon sketch. 16 × 20 in (41 × 51 cm).

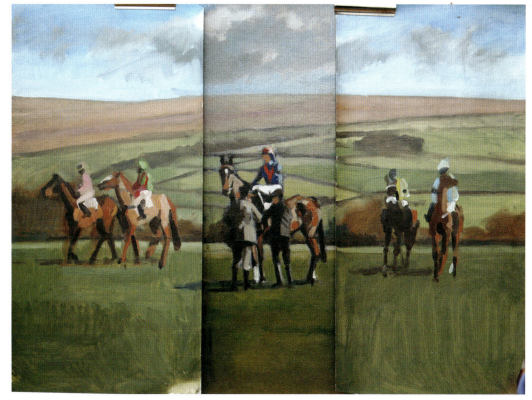

Additional horses painted onto two pieces of oil sketching paper. Here they have both been clipped to the original sketch on board. The same method could be used to extend a sketch beyond the dimensions of the board.

143

DEVELOPING A COMPOSITION

THE PADDOCK, SANDON

Preliminary Drawings

The original idea for this painting evolved over a period of years. I know this point-to-point racecourse well, and for some time I had wanted to make a painting about the feeling of space and atmosphere that is a very particular characteristic of Sandon, and which is created by the relationship between the horses in the paddock and the panoramic views of the surrounding landscape that the location of the paddock gives. That was my primary purpose for the painting, and, as we will see, was the driving force behind everything I did when working on it.

I have chosen this painting to include here as it also contains many of the elements covered earlier in the book: horses (moving, standing, side-on, facing, and three-quarters), tack, people, trees, landscape, aerial perspective, sky, and linear perspective. It also has a story-telling element: one groom receiving her number from the steward whilst the huntsman and spectators look on, another horse being led round, one standing whilst its tack is checked; all in all, it is a very characteristic paddock scene. Such a complex and large painting (40 × 50 in; 102 × 127 cm) generally needs a lot of planning, so it is ideal for showing the way a painting might evolve and develop. I did in fact make quite a lot of changes during the progress of this painting.

I wanted the horses in the paddock to be placed to give the 'feel' of a paddock at the races, so before going to the next meeting, I did some rough line drawings to work out where I'd need to be to see this. I wanted a particular landscape backdrop, the light in the right place, and the right relative scale of the horses to the landscape. (Had I got too close to the horses, they would have dwarfed the landscape.)

I also made a ground plan of places I'd like my horses to be, as well as the sort of poses I was looking for. It is often worth doing a ground plan of a proposed picture. If it shows lots of horses all in the foreground at the same distance from you and facing the same way, with no objects in the middle ground, then maybe you need to think again. A ground plan shows you how much

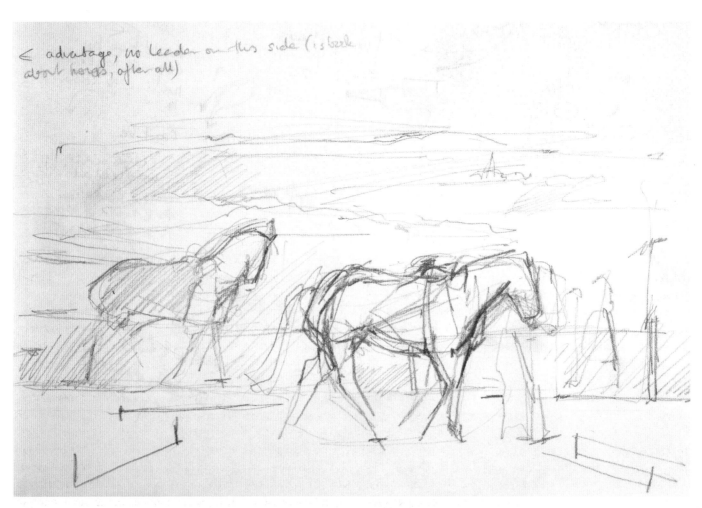

The first scribble of my initial thoughts for *The Paddock, Sandon*.

DEVELOPING A COMPOSITION

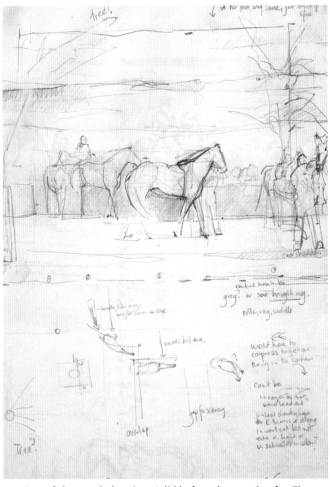

One of the rough drawings I did before the meeting for *The Paddock, Sandon*, to work out where I might need to stand and what drawings I might need to make on the day. This drawing has a 'ground plan'.

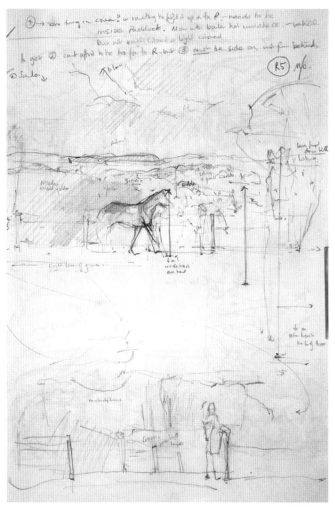

Drawings made from life during a race meeting for *The Paddock, Sandon*. The upper drawing shows vertical lines indicating the heights of horses as they pass particular points. The lower one shows a rapid drawing of a huntsman by the paddock entrance.

depth you are building into your painting and how your subjects are interacting spatially within it. You can also record the directions in which horses and people are looking; those angles of view are also important. The more interesting your ground plan looks, the more interesting your painting is likely to be. Theatre directors call this sort of planning 'blocking'; they may be making moving pictures, but the principle is the same.

At the meeting, I took photographs and made drawings. It is possible to see in one of the drawings some vertical marks with arrowheads. These represent the height that a horse was when in each particular place. It is difficult to do detailed drawings when horses are moving around, but I find that it is useful at the very least to note heights at various points, then if later on I find that I need to place a horse there, I know how big it should be. Height-to-withers is a useful measurement, because it isn't dependent on a horse's head carriage, but this can be more difficult to judge with horses moving towards you or at odd angles, so here I measured height-to-ears when the horses' heads were up.

I wrote notes on the drawings of any thoughts I had at the time about what might be important, or might be difficult and therefore need addressing in studies before I painted. At the bottom of one of the drawings there is also a rough sketch of a huntsman beside the paddock entrance, including some colour notes. I hadn't thought of having a huntsman in the painting I was planning; that was something I only began to consider on the day when I saw him take up that position and saw how effective the red of his coat was at bringing out the blues and greens of the landscape (red being the complementary of green, of course). I had to draw the pose as quickly as I could before he could move. It may be almost a scribble, but it was enough to record my thought for later consideration, so the drawing

DEVELOPING A COMPOSITION

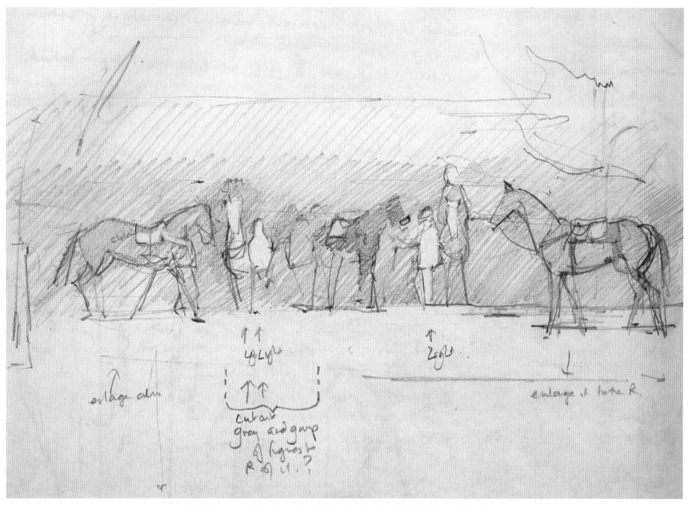

First composition drawing in the studio for *The Paddock, Sandon*.

fulfilled its purpose. It's important, however much you plan, to be flexible enough to take advantage of the good things that happen by pure chance. I am reminded of the famous saying by Moltke, that 'no battle plan survives contact with the enemy' (he didn't mean by this that people shouldn't plan; more that a single rigid plan will never be flexible enough). It's also important, if your ultimate aim is a painting, to be thinking in colour even if you're drawing in black and white.

I find that it is useful to include the landscape in some of my drawings, even if the horses in it can only be drawn very simply with a body and 'stick' legs just to give scale. It all helps to record the 'feel' of the space and the relative scale of the various elements in the picture. If the drawing isn't working, you still have the opportunity to change your position and try again. I find that my drawings record a feeling of space that for some reason my photographs don't. As this painting is about space, it was more than usually necessary to draw on the spot. Note that some rough cloud formations have also been recorded.

Back home, using my drawings and photographs, I made some composition drawings. (As this is a painting of a place, rather than of a particular race, I have used horses from more than one race, though they weren't all in the paddock at the same time.) The original idea of the horse entering the paddock is still there, but the horse on the right which was facing to the right is now facing left. I felt this would work better in terms of preventing the eye 'falling out' to the right, as it would bring the eye back to the central group of figures and the distant landscape behind them – fulfilling the painting's purpose. (Viewers tend to look where the people and horses in the painting are looking.)

DEVELOPING A COMPOSITION

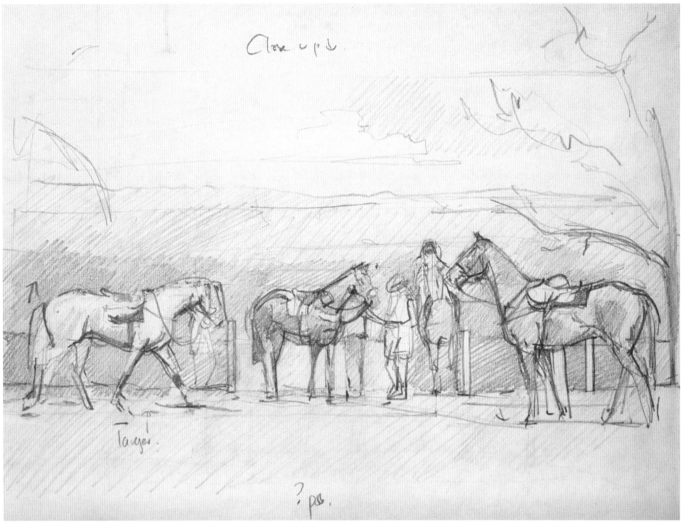

Second composition drawing for *The Paddock, Sandon.*

My first composition drawing had a mid-toned horse on the left, which I intended to be a chestnut. However, when I started to draw, I felt this would not be likely to be able to hold its own tonally against a background of similarly mid-toned trees in the middle distance, which I didn't want to change. The drawing suggested to me that the painting would end up too tonally even on the left and therefore the horse wouldn't direct the eye back into my main focus of interest, the central space between the paddock and the distant landscape. I experimented with a grey horse in a second drawing, which I thought worked better. The horse on the right was fine, as its head and lower legs stood out tonally against the lighter grass and slightly lighter middle ground quite naturally.

The first drawing also had a grey horse in the centre facing directly towards the viewer. I felt that as I was now adding a grey immediately to the left of it, it might be too repetitive in tone and colour. More importantly, it was too similar to the huntsman in pose, and as I needed the red of the huntsman's coat, that grey horse had to go.

Between the two drawings I also removed a figure with its back to me walking down the chute to the left of the central horse. I didn't particularly object to the figure, and it did lead into the landscape rather well, but removing him helped 'compact' the composition, which I felt was starting to sprawl too wide and becoming 'bitty'. Removing the retreating figure also exposed the quarters of the bay horse in the centre, which I liked, as it emphasized their rounded form. The last drawing at this point was a summary of the other drawings to date. It was larger and more precise, as it was to be used to work from when moving into colour.

147

DEVELOPING A COMPOSITION

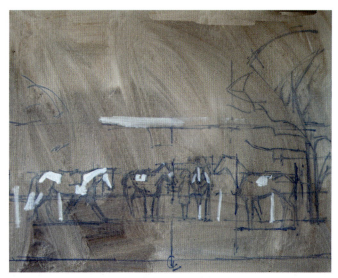

Simple drawing-up sketch (16 × 20 in) for the painting of the paddock at Sandon.

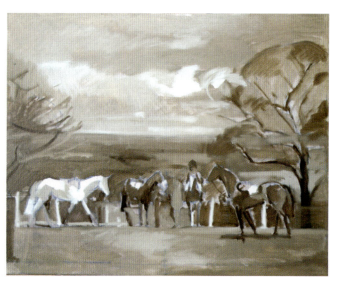

Tonal underpainting for sketch.

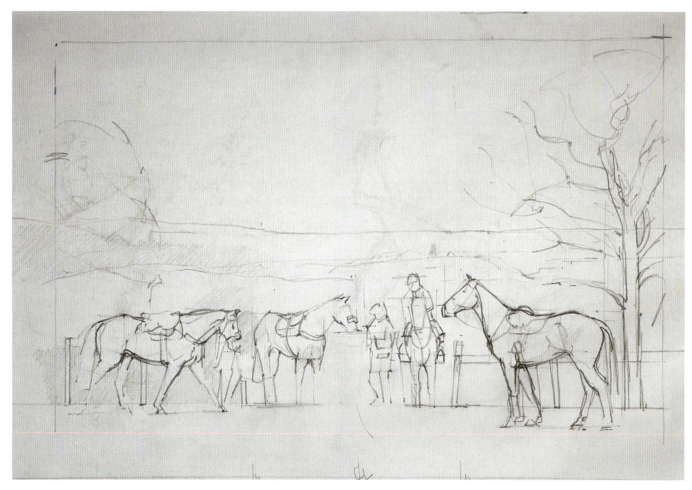

Third composition drawing, used as a guide for the colour sketch. On this drawing, possible marks for the edges of the colour sketch can be seen. In fact, the colour sketch has more sky and more foreground than I had originally planned. I prefer a colour sketch to have a little extra space around the subject in case I decide to alter the composition when the colours make their contribution to it.

DEVELOPING A COMPOSITION

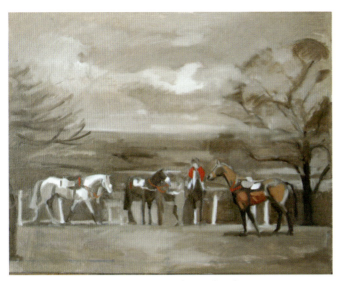

Colour introduced into sketch.

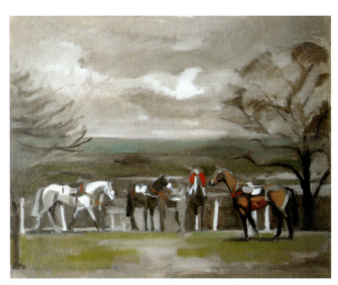

Most important colours now evident.

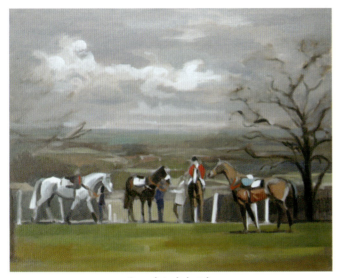

Completed sketch.

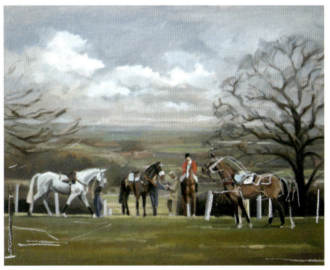

Chalk and charcoal corrections on sketch.

The Colour Sketch

The next stage was a small colour sketch, starting with a simple drawing in paint on a stained ground. It is possible to see in the illustrations how the sketch was developed. Firstly I worked over the whole sketch following the same procedure as described in the tone exercise in Chapter 7. Then I introduced colour, starting with the most important ones and then adjusting the others in between.

As I worked, I adjusted contrast and tone as well as colour, keeping a special eye on the white posts, which can easily stand out too much in racecourse scenes, and on whether the sketch was producing the effect of aerial perspective I wanted. As a result I made small changes to the colour of the distant hills, which were at first too green and too dark to recede properly.

At this point, I decided that the horse on the far right was not 'working'. I considered changing it to a horse of a different colour, or even a different pose altogether, but eventually decided that the source of the trouble might not be colour, tone or even shape, but might be simply because the horse was too close to the huntsman. It was certainly true, when I considered the matter, that the area between them was very small, and not a very pleasant shape (remember those negative spaces?). I tried a new position in chalk and charcoal directly on the sketch, and

149

DEVELOPING A COMPOSITION

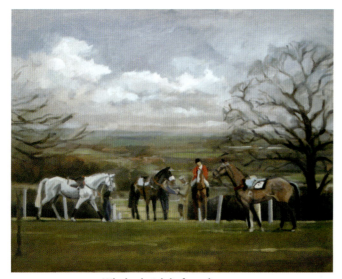

Whole sketch before change.

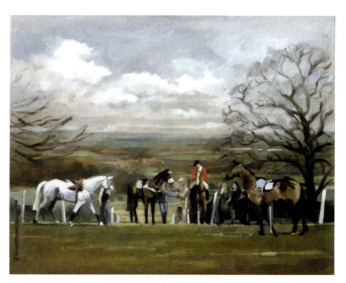

Whole sketch after change.

Detail before change.

Detail after change.

that confirmed my suspicions, which were borne out when I referred back to the third compositional drawing. In fact, this space had become compressed between the first and second compositional drawings when I had been trying to make the composition more compact, and at that point I hadn't foreseen the trouble it would cause.

So it was back to the drawing board. I made a new drawing, creating more space by moving the horse to the right. In that space, I was able to add some spectators, which not only made the space a more interesting shape, but also helped me explain the fall of the ground beyond the rail – an extra bonus. I also felt that the bay horse wasn't crowding the huntsman's chestnut horse any more. Before I moved the bay horse, its head was in close proximity to the huntsman's arm and this related them too closely to each other, making it seem like they were the same distance away and flattening the space in the paddock.

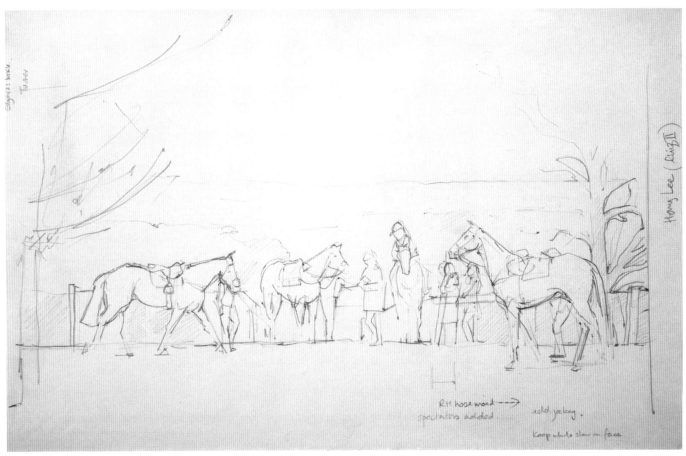

The fourth and last composition drawing, showing changes in spacing on the right of the picture, and the addition of a post.

The small size of the additional spectators also helped to create space between them and the bay horse, adding more depth to the composition. The bay horse looked much happier to me. I now realized that on the previous drawing it had looked cramped and hemmed in with no space to move forward into. (Never be afraid to go back and do more drawing if things aren't going well; it rarely wastes time in the long run.)

My original placing had the bay horse standing with a thin vertical gap between his tail and the tree, and I had felt at the time that this was a good idea, as the tree would then 'hold in' the composition on the right. With the bay horse in its new position, however, unless I made the painting wider (which I didn't wish to do) and moved the tree, his tail overlapped the tree.

When I saw how this worked out in practice, I decided I preferred it. The tree still proved to be a strong enough vertical, and the thin gap had, in fact, been rather distracting, and was undermining my desire to keep the point of interest in the centre with the distant landscape.

I then returned to the colour sketch, and made the alterations, repainting the bay horse, as you can see, in its new position. This did appear to have solved the problem. The new gap also allowed for a horizontal strip of grass in the distant landscape to become wider, which again added to the width and feeling of space, this time in the landscape. This just shows how altering one thing can have effects elsewhere which you hadn't thought of. It is at times like this I really appreciate having a colour sketch and some drawings to work with. Had I begun the final painting directly after my drawings, I might not have realized the problem with the bay horse until I had put in a great deal of work on it – and after all, until I moved it on the sketch, I couldn't be certain whether I had correctly diagnosed the problem. Had I been wrong, I might have had to change it again, or worse still, change it back, which on a painting this size doesn't even bear thinking about.

After a few more small changes, including adding a white post on the far right to hold the composition in, it was time to proceed to the final painting, of which more in the next chapter.

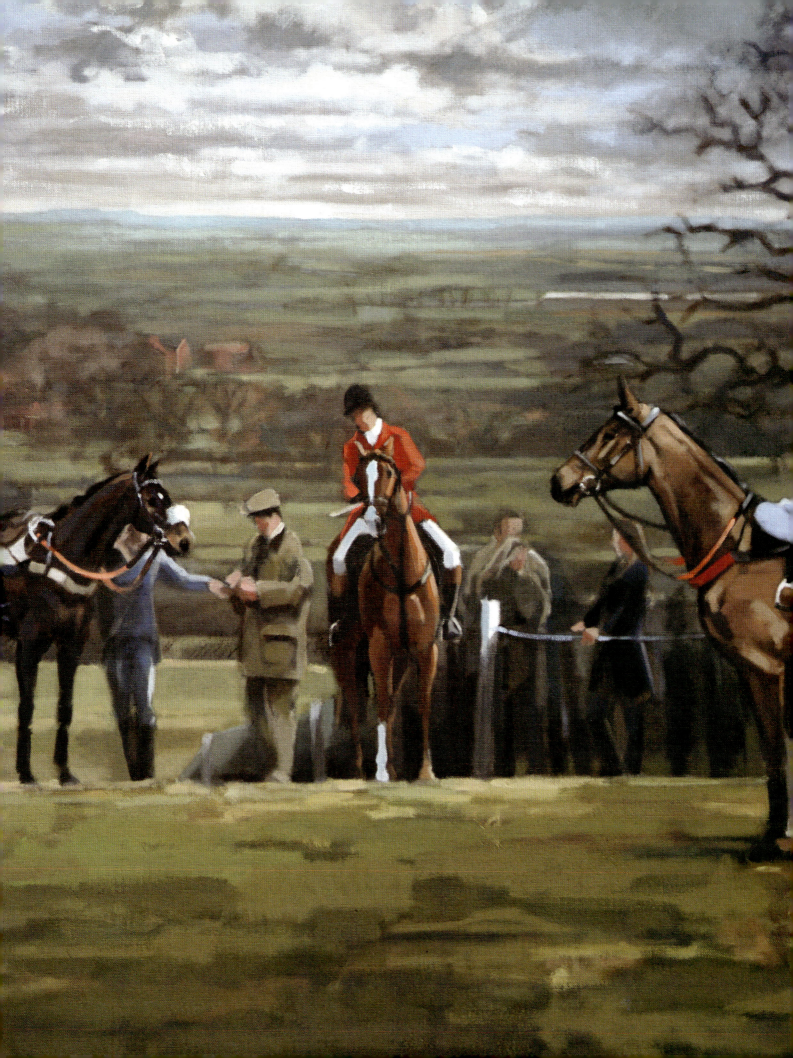

CHAPTER 9

THE PAINTING

'Painting is easy when you don't know how, but very difficult when you do.'
Edgar Degas

This chapter begins with a continuation of the painting from Chapter 8, and ends with a number of examples of other paintings, some showing them in progress, and others comparing paintings in pairs.

STEP ONE: THE SUPPORT

Watercolour painters have a selection of papers to choose from, and except for the need to stretch lightweight papers, surface preparation is not usually necessary if the right paper is chosen. In the case of oils or acrylics, the support might be canvas, wood, board or paper. For acrylics, the surface should be primed with an acrylic primer compatible with the surface. The colour and texture of the primer can be whatever the artist prefers so long as it is made from permanent materials if permanence is required.

For oils, it is a little more complicated. The surface needs to be sized (primarily to prevent the oil in the paint rotting the support) and then primed with an oil-based primer which will provide a surface of the required absorbency. My own preference when using oils is linen canvas, sized with rabbit skin glue and then oil-primed (linen is stronger and has more 'spring' than cotton). For more detailed information on suitable materials for supports and their preparation, see the books listed in the 'painting and drawing methods and materials' section of the bibliography.

With opaque materials, as a final check before starting, the placing of the major elements can first be 'roughed in' very loosely in charcoal to check the scale. It can be useful to do this, because if the subjects of the painting come out too small or too large, another canvas can be selected before a lot of drawing-up is done. (This rough drawing would be dusted off before staining and/or more complicated drawing-up.)

Some artists work on a white ground, but many others prefer to stain or otherwise break up the flat white surface. (The advantages of staining are described in Chapter 7.) I find staining helpful not only when working on preparatory sketches in oils, but also when working on a final painting.

I usually use a stain of raw umber thinned with turpentine, adding ultramarine blue for a cooler ground, or a little burnt sienna for a warmer one. If working in the studio, I would begin the drawing-up in charcoal, line it (redraw over the charcoal in thin paint), and then dust the charcoal off. Working directly from life I would draw up very simply in paint.

TO DRAW UP, OR NOT TO DRAW UP?

Drawing-up/underdrawing can be quite loose. Some artists even dispense with it altogether; they begin by establishing large areas of tone and gradually work towards more colour, detail and definition as they work, which is a good sound way of working if it suits you. The main advantage of that way of working is that the painting doesn't get bogged down in detail in one area when the rest of the painting is still untouched, which can be a temptation if drawing-up is done first.

I draw up in order to place the various elements where I want them, as I often do fairly complex compositions which if not drawn up tend to need a lot of corrections. I dislike making extensive corrections as I prefer the paint to be uniform in thickness across a painting, and not very thick, for technical reasons. (In oils, using thick paint can lead to cracking.) The disadvantage to using thinner layers is that as oils become

LEFT: *The Paddock, Sandon Point-to-Point Races*. **Detail.**

transparent with age, significant corrections can start to emerge from thinner paint films almost like ghosts and spoil the painting; hence I try to avoid having to make more corrections than absolutely necessary. The more complicated the subject, and the larger the painting is in scale, the more drawing-up I tend to do.

When I work directly from life, I will usually do some very simple drawing-up in paint just to decide on the scale and where things are to be placed – often just a few lines. Occasionally I don't draw up first at all, but that's a rare occurrence for me, though I do it sometimes for practice on principle. (We should never get so fixed in one way of working that it is our only option, as one day we'll end up in circumstances where our own pet methods or materials won't do the job, and then we really are up the proverbial creek without a paddle.)

MATERIALS AND TECHNIQUES FOR DRAWING-UP

When I first started painting and used a white ground I did use pencil for drawing-up, but I don't use it any more. Pencil is an awkward medium to use for drawing-up on primed surfaces for a number of reasons. Compared to using charcoal or a paintbrush, significantly more pressure is needed to draw with pencil, especially on a springy canvas with its rough texture. This pressure makes lines stiff and unshapely, and scratches into the priming layer. Pencil lacks the fluidity of drawing with a brush when working large, particularly with curves, and on stained canvases pencil shows up poorly; also, pencil marks can be difficult to correct on primed surfaces.

Pencil is also more likely than charcoal or paint to tempt an artist to include more details than are necessary at this stage, or indeed, at all. Most of these details will be lost when painting begins, so excessive detail in drawing-up is a waste of time, whatever drawing medium you use.

Even worse, putting too much detail in at an early stage can fossilize an image. This discourages the artist from making necessary changes later on for fear of losing the carefully drawn detail, and/or turns the painting process into a form of painting by numbers, where patches of paint are butted up to each other with no flexibility for correction or improvement. One of the keys to good painting is that whatever part of the process is being engaged in – from first drawings in a sketchbook, to studies, to drawing-up, to underpainting, and then to any and all of the subsequent layers – every decision taken, and every mark made, should be trying to improve on the corresponding one at the previous stage. That can't be done if an artist is sticking slavishly to an earlier decision about where a colour or mark is to go.

On every paint layer the drawing will tend to 'drift', and if the artist leans too much on an underdrawing, some very peculiar things can happen, especially with tack and legs. Every mark on a painting is a drawn mark, even in paint, and needs to be made with thought. You don't do all the drawing first and all the painting after. Painting is drawing too. Painting isn't about 'filling in' a drawing.

Unless a painting is very large in scale, I'd expect to see no more drawn on an underdrawing than is drawn on the example reproduced here at actual size. As long as the marks made are correct, a few will suffice. There isn't much point doing an elaborate drawing of tack, as the horse can't very well be painted round the shapes of the tack without losing the form of the horse, and if you try to do this, the painting will just become stiff and flat.

Even if the horse in a painting is 2 feet (60 cm) high, a simple indication of things like how far down the face the noseband is, the angle of the cheekpiece, and the height and position of the eye, is quite sufficient. Drawing details of buckles and so on at this stage is a waste of time even at that scale. Every time we make a mark or paint we should be drawing; if details end up being needed they will come in naturally at a later stage. The drawing-up phase is just a scaffolding. It needs to be accurate and strong, but simple.

For an artist who is a little lacking in confidence, doing a complex drawing at this stage may feel 'safer' but trust me, it really is best to try to get into the habit of keeping it as simple (though accurate) as possible, and then only build in more detail when, or indeed if, it becomes necessary as the painting develops. If you keep it simple at the outset, you make it easier to keep overall control of the painting. Once a painting becomes complicated by detail, it is all too easy to allow one part of it to get too far ahead of the rest, or to become resistant to making necessary changes because a pretty bit of detail on which much time has been spent would have to be repainted.

The advantage of drawing-up with charcoal and/or a brush is that using these methods doesn't encourage detail. I often use a long-handled rigger for drawing-up in order to make fluent curves; this also discourages the inclusion of too much detail.

For oil and acrylic painting, it is a good idea to use long-handled brushes for everything, and to hold them well away from the ferrule, as this stops us getting too close and fiddling about with details. If your hand isn't steady enough, don't go to short handled brushes; stick with long ones and learn how to use a mahlstick.

The usual rule in any medium, including watercolour, is to use the largest brush that can make the mark you want. The more experienced and skilled artists get, the larger the brushes they are able to use to make the same marks.

Corrections in acrylics are not usually a problem, as paint can be wiped off or can be removed with a knife if wet, or by overpainting if dry. In oils, corrections can also be made by

THE PAINTING

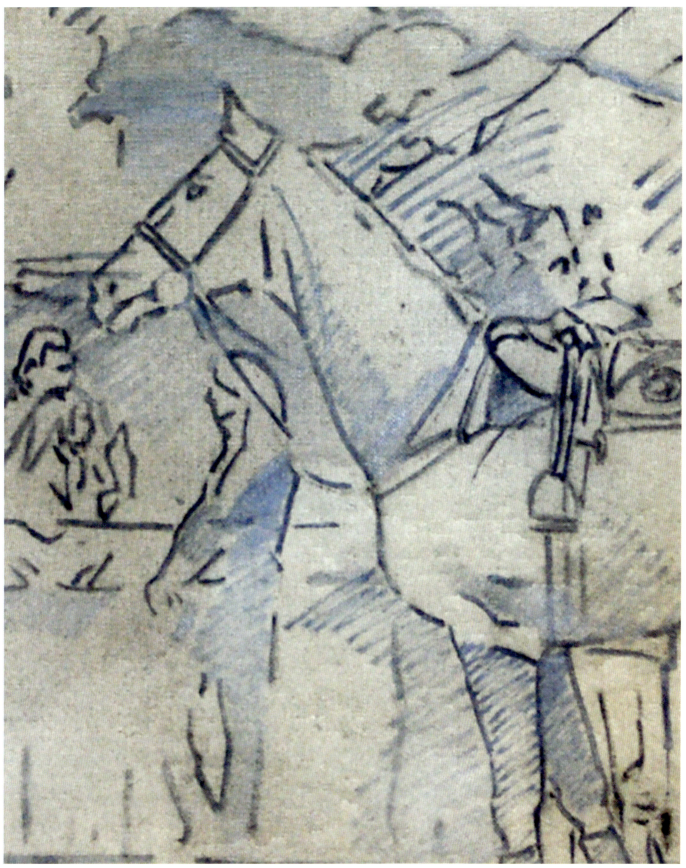

Section of drawing-up for *Sandon* at approximately actual size.

■ THE PAINTING

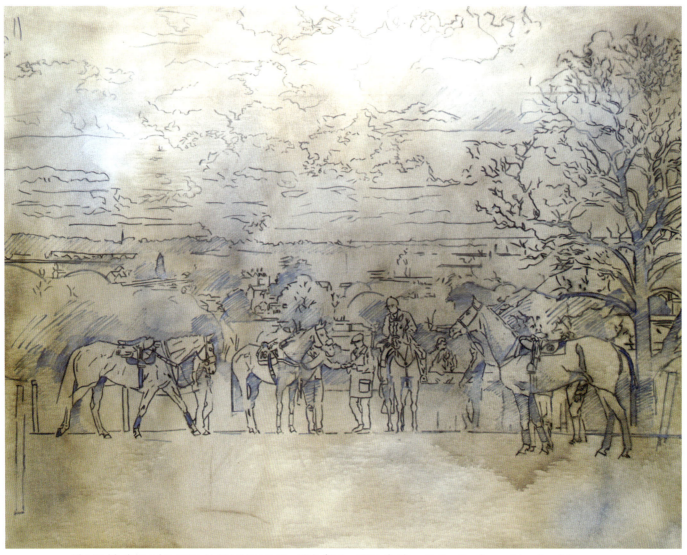

The Paddock, Sandon Point-to-Point Races. **40 × 50 in (102 × 127 cm). The painting has been stained and drawn up.**

scraping or by wiping off, if necessary using a little turpentine. Corrections in charcoal can easily be made, as charcoal can be dusted off a primed surface with a dry rag or brush. The drawback of charcoal as a drawing-up medium is that it can be picked up in the paint layer. If I draw up in charcoal, in order to be able to move things about and correct more easily, I usually reline the drawing in paint with a rigger or other similar brush, and dust any charcoal off when the painted lines are dry.

If you draw up solely in charcoal, tap the canvas hard a few times to remove the excess charcoal before starting to paint, or even lightly dust it (being very careful not to lose too much of your drawing.) When drawing-up from a preparatory drawing, be careful not to draw your painting up on a slant. Check that your verticals and horizontals line up with the edges of the canvas or board.

If you make up your own canvases, then you can take the trouble to be sure that they are square. Bought-in canvases, however, are not always square, so it is worth checking before you start drawing-up to avoid frustration later.

THE PAINTING

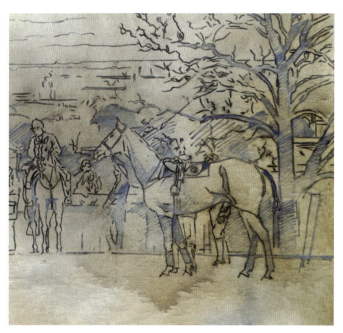

The horse on the right was still too close to the huntsman …

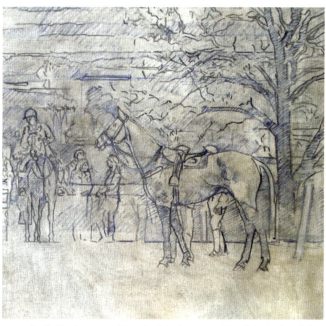

… so both the horse and tree had to be moved further to the right.

DRAWING-UP IN WATERCOLOURS AND GOUACHE

For watercolours and gouache, pencil works well for a lot of artists as a drawing-up medium if one is needed, provided the line isn't too heavy. Rather than being obliterated as is usual in oils and acrylics, this drawing often remains part of the appearance of the final image, particularly where body colour is not used and the paint layers remain transparent. That means it needs to be done with accuracy, character and sensitivity, just as it would be in a finished drawing, unlike in opaque oils and acrylics where drawing-up is primarily about the positioning of objects and where, although the curves need to be flexible, the drawing doesn't normally have to be particularly stylish as it will soon be lost under the paint.

A lot of pencils which are fine to use for dry drawing and look and feel just like ordinary pencils are specifically made to be water soluble. Caution is, therefore, required as to whether the pencils you decide to use for this process are water soluble or not if you wish to retain your lines. Work out how soft the grade of pencil needs to be by testing on the paper you plan to use.

Corrections to pencil underdrawings on paper have to be done with care, especially if transparent watercolour will be used on top. It is easy for an eraser to damage the surface of a paper and make it impossible to get even washes over the corrected area. Some papers are more forgiving than others; unfortunately the better quality papers are often the least forgiving of all.

As in oils and acrylics, some watercolour painters draw up with a brush, or dispense with drawing-up altogether. Others use ink and nib to make line and wash, where the ink line isn't so much an underdrawing as the main medium, with the colour washes subordinate to it. Again, in that case, the style of the drawn line is very important, as is how soluble the ink used is – or isn't – in water.

MONOCHROME UNDERPAINTING

Not all artists use this technique, but many do, and I certainly find it helpful. If you have never tried it, but find that you can sometimes get bogged down in a painting due to problems with tone versus colour – or if you are tempted to work in too much detail in one part of a painting when the rest of your picture surface is still blank – I suggest you try using an underpainting.

This technique is suitable for opaque media where it will be covered with subsequent layers as the painting develops. It isn't easy to adapt it for use in true watercolours or other transparent media, or in media like gouache which remains soluble when dry, and therefore a subsequent layer can 'lift' it.

I use a fairly simple monochrome underpainting to establish the tone range across my paintings. This gets rid of the drawing-up lines, and once the tones are established, it is easier to see whether the tones of the colours that I subsequently use are sitting in the right part of the overall tone range. An

■ THE PAINTING

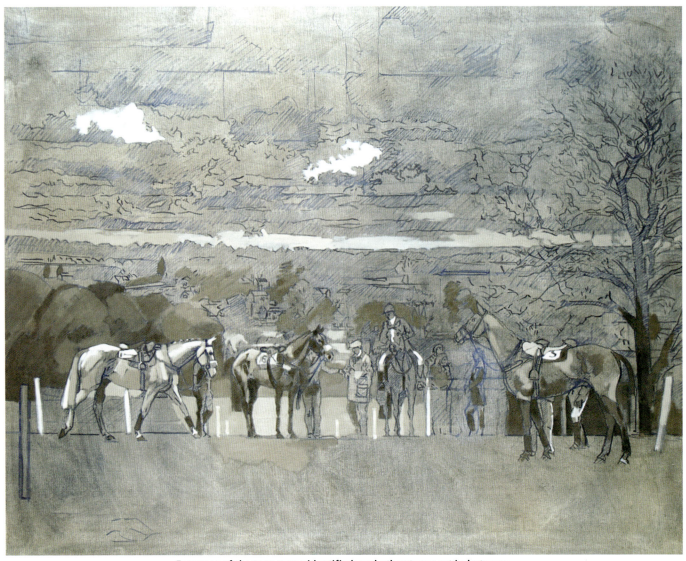

Extremes of the tone range identified, and other tones set in-between.

underpainting in monochrome does to some extent separate decisions about tone and colour, making them a little easier to manage.

Another benefit of a solid monochrome underpainting which makes a complete layer is that it is possible to work more freely over it in colour, as any small gaps in subsequent layers are accepted by the eye. That helps the 'painterly' feel of a painting. If there is no underpainting, and two colours are not perfectly butted together, the gap between them showing the stained ground, or even worse, a white ground, can spoil the logical continuity of the painting's surface and flatten any illusion of depth or solidity of form that might otherwise have been created. There is historical precedent for tonal underpainting in oils. Some artists would paint an entire picture in grey (a grisaille), and then glaze their colours over the top. In the

Metropolitan Museum of Art in New York there is an example of a work, thought to be by a follower of Ingres, where the glazes have not been added and the grisaille can be seen complete.

Few artists today use the colour glazing technique in its entirety, but many still make a tonal underpainting and work on top of it, though with opaque paint. The process of establishing a tonal underpainting can be seen in this painting of Sandon, and in some of the examples of paintings in progress later in this chapter.

In the illustrations showing the underpainting for *The Paddock, Sandon*, first the lightest light (except highlights) has been placed, then the darkest dark. I'd normally expect to find the lightest and darkest areas in the foreground, given the general operation of aerial perspective, and indeed, there they are (the lightest area is on the number cloth of the horse on the right,

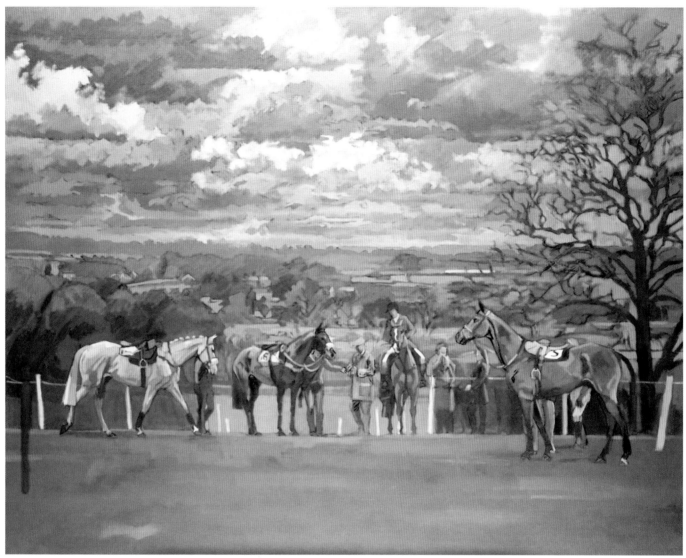

Tone underpainting completed.

and the darkest shadow area is on the same horse's black legs). Bear in mind that even the lightest parts of a white number cloth on a bright day are not usually pure white. If you make them pure white, what will you use for any highlights on the metal bit? Even for such highlights, surprisingly, if a fractional amount of another colour, usually yellow or blue (depending on the colour of the light in the painting) is added to white, it often looks brighter than when used straight from the tube; it is therefore wise to give yourself a little 'spare' tone range at this stage and not to use dead white for the lightest areas.

Similarly, actual pure black is not often seen, as pure black is a complete absence of both reflected and transmitted light. I tend to make my darkest dark at this stage no darker than raw umber, with perhaps a little ultramarine blue; that means I have some room left for areas of very dark tone later on.

Interim tones are then progressively added, with larger areas being covered as soon as possible, as their tones will affect the relative values of all the others proportionately more because they cover a larger area. As I work, I will sometimes find a tone is 'out of kilter' with the tones around it, and I will adjust it.

Once an underpainting is completed, it is left to dry. With the particular colours I use at this stage, and the fact that I paint in a very thin layer, thinning the paint with just a little turpentine and no oil, it usually takes around a day or two to dry to the point where I can work on the next layer. (In acrylics this will take only a very short time.)

There is one specific circumstance in which both staining and underpainting are inappropriate even in oils and acrylics, and that is where the artist is aiming for a very light or high-toned result, and is using paint in thin glazes to allow the light to

■ THE PAINTING

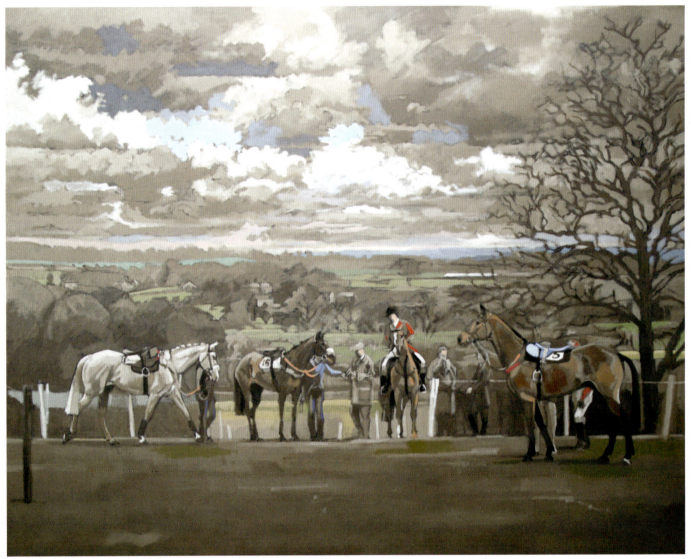

The first stage in the painting, with some key colours placed.

penetrate the paint layer, bounce off the white priming, and come back though the paint layer. In such a case, even underdrawing has to be done with great care, if at all, as mistakes cannot be covered up. As paint becomes more transparent with age, any corrections visible will become steadily more intrusive over time. If mistakes are made on paintings using thin transparent layers, the paint will have to be wiped or scraped carefully off back to the priming layer before being repainted with the correct colour.

Stages in Colour

Whether or not staining, drawing-up, or underpainting had been done, I'd still proceed in the same way from this point. In essence, the procedure is similar to that for the underpainting. I'd identify the key colours (the extreme colours, the important colours, and any large areas of colour) fairly early on, and then everything else takes its place in between as the painting develops. I also like to cover the canvas as quickly and simply as possible so that no large areas of priming, staining, or underpainting remain for long in either tones or colours that are significantly different from the way they will appear when the painting is completed.

In the first of the colour illustrations, the key colours have been indicated, the red coat in the middle of the painting being one of them. Paintings of horses usually involve a landscape with grass – often a lot of grass. If the season means there are leaves on the trees, there may be greens of one sort or another taking up a lot

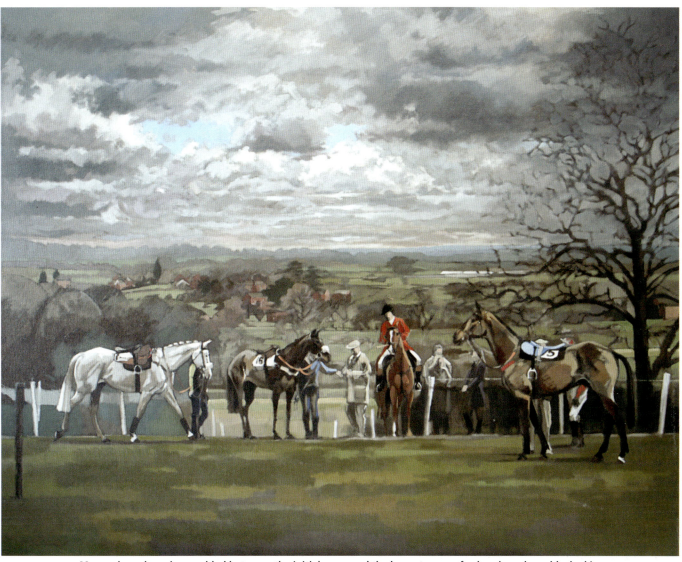
More colours have been added between the initial ones, and the largest areas of colour have been blocked in.

of the picture area. This does need to be balanced rather carefully if the painting is not to become 'A Study In Green'. Landscape painters have long been aware of this, and as we saw in Chapter 6, one solution is to have a little red somewhere in the picture, such as Constable's red Suffolk collars, to perform this function.

Only a little is needed, in the same way that a small light area can balance a large dark one, but without it, a painting with a lot of green can appear rather dull. The red both strengthens the greens, because it is the complementary colour of green, and balances them.

I'd usually place some of the foreground colours and the more distant background colours at an early stage. (This will show the effect of aerial perspective.) Key colours, such as those in any sky present, are also marked down at this stage, as are some of the colours of the main subject, and any of the colours may be adjusted if they don't fit together.

I would then develop the painting, working across it all the time and not allowing any part of it to lag behind the rest. I find that if I work in too much detail on any one part, it becomes difficult to keep a large and complex painting together and it tends to become an assembly of flat components that don't seem to be in the same space.

There is also the risk that I might find when I worked on the rest of the painting that the work I had already done needed to be altered, because it was wrong in tone, or overall colour, or because it needed to be moved. It is much more frustrating to move a highly finished element than to move one that has just been blocked in simply. When the simply painted areas seem to be working together well, then it is possible to work in more

■ THE PAINTING

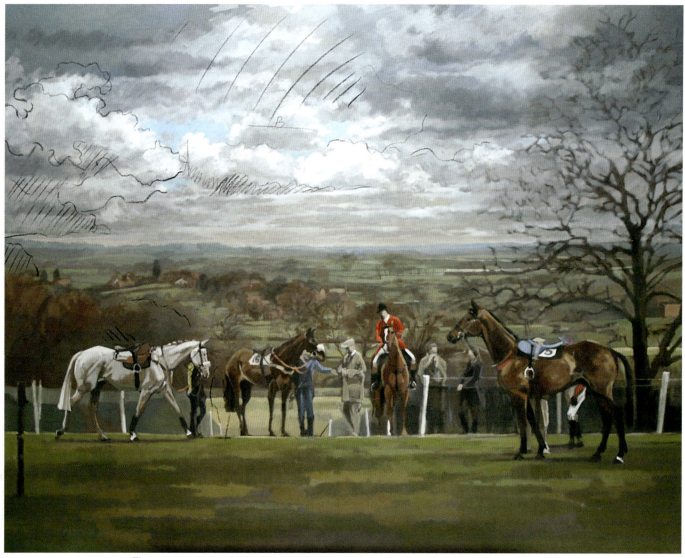

The painting is now fairly complete, but some alterations have been marked in charcoal.

detail with more confidence the work won't have to be lost.

With media such as transparent watercolour, where alterations are notoriously difficult, often the only way to proceed after a bad error is to begin again, so I'd still keep things simple for as long as possible.

Some paintings progress with very few changes, following the original drawings and/or sketch very closely. Others (usually, but not always, the paintings with the most complex compositions) may have to go through some alterations. The size of the painting doesn't, for me, have much to do with it; a simpler painting tends always to go more smoothly, however large it may be. I always keep any relevant drawings and sketches in front of me as I work, as I find this helps me keep my original idea on track.

I also find that the clearer my original idea is, the easier it is to achieve it. If the idea is about, for example, the contrast between a grey horse and a dark background and the resulting colour of the light, it's usually pretty easy to stick to it and make it work. If the idea is about something more elusive, like a weather effect, however much preparatory work you do, it can still be a matter of trial and error to discover the best way to make it work at full scale. In the painting of *The Paddock, Sandon*, my aim was to create the space and atmosphere of a particular place, which is a very difficult thing to pin down. As the painting progressed, I did make several changes. The sky changed a good deal, as I felt at first that it was too distracting. When I'd changed it, I decided that it was then too flat, so I changed it back again. I changed the slope of a post here and there, darkened some areas a little and lightened others, and softened some hard edges. I also removed

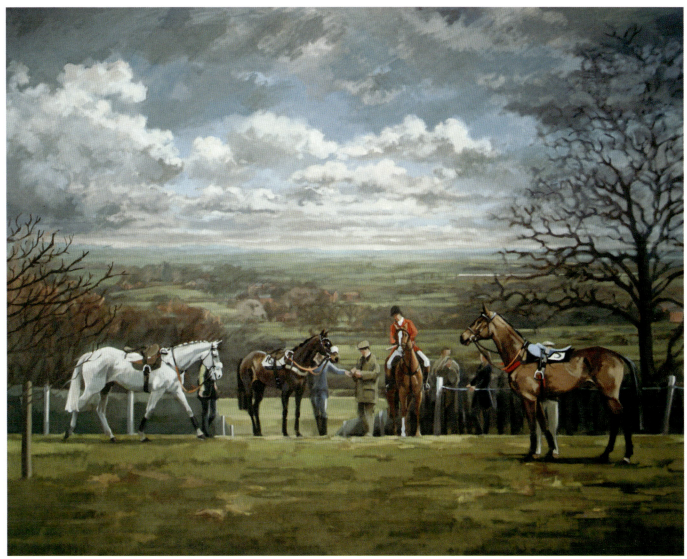

The Paddock, Sandon Point-to-Point Races. **40 × 50 in (102 × 127 cm).**

the figure of the jockey on the right and some posts completely because I felt they drew the eye away from the distant landscape I wanted the painting to be about.

In one respect in particular, larger paintings like this one can be less manageable: unless you have a large studio, you may find it difficult to step back regularly to a point where you are far enough away from it to see it as a whole. If so, it might be helpful to take the painting outside occasionally to look at it, or take it temporarily to a larger room. It can be helpful with paintings of any size to take a look at them in a mirror, or even upside down.

The eye gets jaded by looking at a painting for days on end when you're working on it, and seeing it in a mirror can be a revelation. If a painting starts to get out of hand, or you don't know what to do next, stop, and turn it face to the wall for a few days. Looking at it with a fresh eye after a break will often tell you what is wrong. It may even be that nothing is wrong, and that it was just time to stop.

Overworking paintings is all too easy. We all do it at times, despite our best intentions. When in doubt, it's always better to stop working too soon than too late.

THE PAINTING

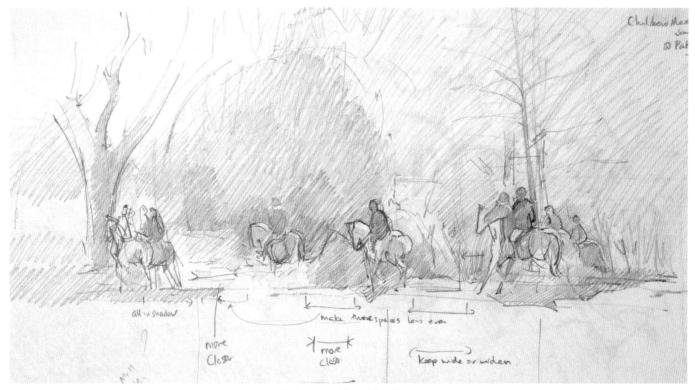

First compositional drawing.

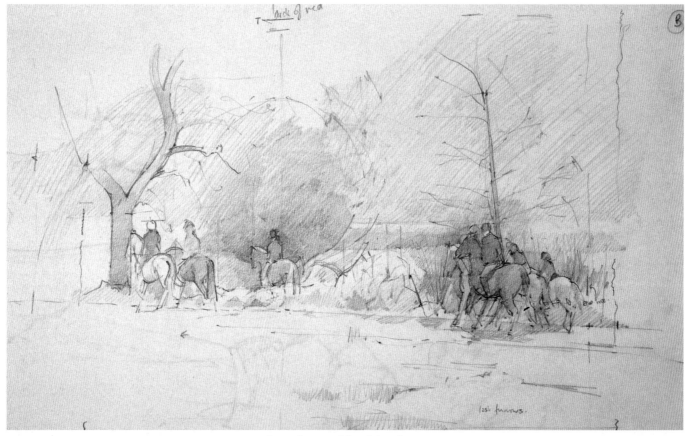

Second compositional drawing.

FROM DRAWING TO SKETCH TO PAINTING: *GAMESLEY BROOK*

The idea of this painting was to create a feeling of the season of the year and its lighting effects in the landscape, making a feature of the bare trees and the ploughed field.

The painting began with two drawings, exploring different compositional possibilities. In the first drawing, there is a figure on a grey horse to the right of the centre. Though I liked the horse, it seemed to me to be too much of a feature in the painting. Its movement drew attention to itself and detracted from my idea. I tried another horse a little further to the left, hiding its legs and straightening its tail to make the pose less dynamic and more vertical in feel; the new horse and rider looked quieter and fitted better into the landscape rather than standing out of it.

However much you like something for its own sake, you have to be willing to remove it if it is getting in the way of your main purpose. In the second drawing, the first horse has been removed in favour of the second, and the painting is calmer, which was more what I wanted. I have moved the horse closer to the two on the left, making it associate visually with them, and have split them up a little to differentiate them better. This produces a nicely uneven group of three, instead of a two and a one. As I mentioned earlier, even numbers of things tend to be less interesting, as do evenly spaced things.

The changed spacing of the horses draws the eye to the trees in the middle ground, and emphasizes the horizontals in the picture, thereby giving it breadth – again bringing the painting back to my original intentions for it. It also places the grey horse and the red coat, which will draw the eye to themselves, well off-centre. Focal points dead in the centre of paintings tend to be less interesting to look at. The eye fixes on them, and seems to say 'well, that's it then' and not look around the picture for anything else. The horse and rider have not been moved to a third of the way in from the side, but rather more than a third. (I find that using 'thirds' tends to put important things a little too close to the edges for my taste.)

In the colour sketches, first the tones have been explored, and then colour has been added and adjusted until I was satisfied that the painting would 'work' at full size. This is a larger sketch than I usually do, but the painting was fairly large, and the figures, which are small compared to the total size of the painting, would have been a bit too small to manage on a board of a smaller size.

A second tree has been added on the left, and the gap between the grey horse and the group on the right is smaller than in the drawings, to make the painting more compact, but the grey horse still isn't in the centre of the painting, or in the centre of the gap.

Sketch for *The North Staffordshire at Gamesley Brook*, **stained and roughly lined.**

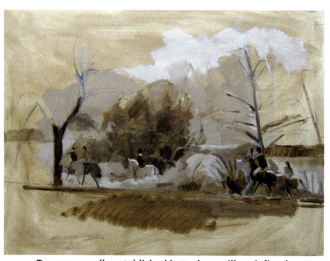

Tones generally established but edges still undefined.

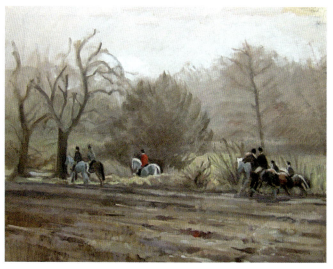

Completed sketch, 16 × 20 in (41 × 51 cm).

■ THE PAINTING

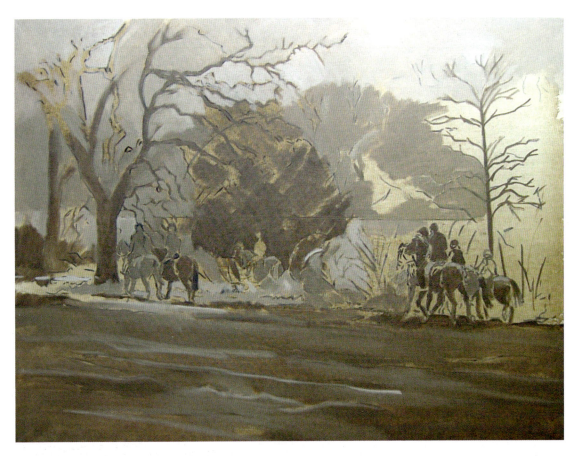

Canvas stained, drawn up, and tone underpainting nearly completed.

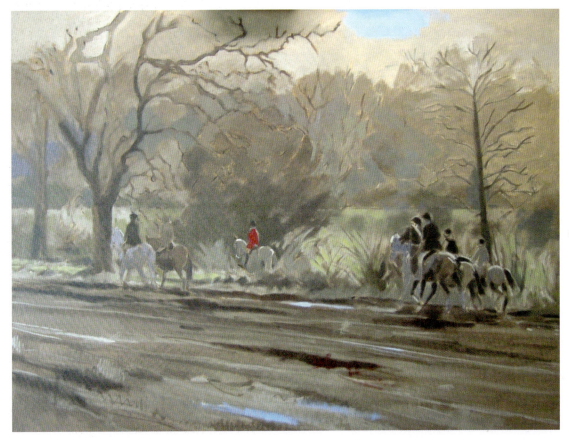

Colour introduced to the tone underpainting, crucial colours first.

THE PAINTING

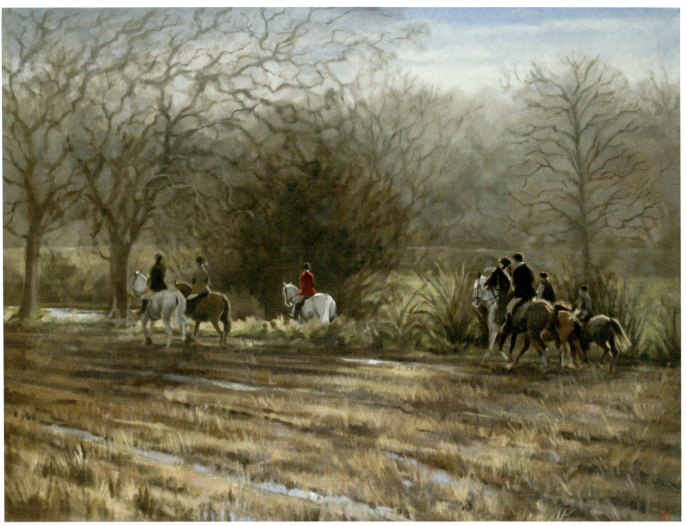

The North Staffordshire at Gamesley Brook. **26 × 35 in (66 × 89 cm).**

The painting then proceeded to the canvas, which was drawn up in paint, and then blocked in with tone. Colour was gradually introduced, with the most important colours (the red of the jacket, the blues in the sky, and the greens in the middle distance) being adjusted first. During the course of the painting, I changed the colour of the stubble and soil in the foreground to be somewhat warmer than in the sketch, and so the greens were adjusted to be a little yellower.

There is little space for sky in this painting, but it became increasingly obvious that the blue of the sky needed to be more prominent than it was in the sketch in order to establish the light. The sketch did have a light sky, but it was too grey to explain the high contrasts and strong colours in the figures and the shadows. I also wanted some blue to balance the redder soil in order to prevent the painting becoming too brown all over. However, in this sort of weather, the strongest blues tend to be very high up in the sky. Only the lower reaches of the sky are visible in the picture here, and in these weather conditions the sky there isn't a bright, solid blue.

Pondering this problem on a similar day while out walking, I looked over into a ploughed field and saw my answer: the bright blue of the higher parts of the sky was being reflected in water standing in the furrows. I was able to introduce those blue reflections into the furrows in the painting, giving a clear indication of a blue sky, which would even have told its story if there had been no sky in the picture at all. It also broke up the foreground, making it more interesting.

It's a curious point that it is possible to use reflections to say something by implication that can't be said directly in the picture itself. The water in the furrows also gave depth and interest to the foreground, and emphasized the movement into and across the picture, which was an added bonus.

■ THE PAINTING

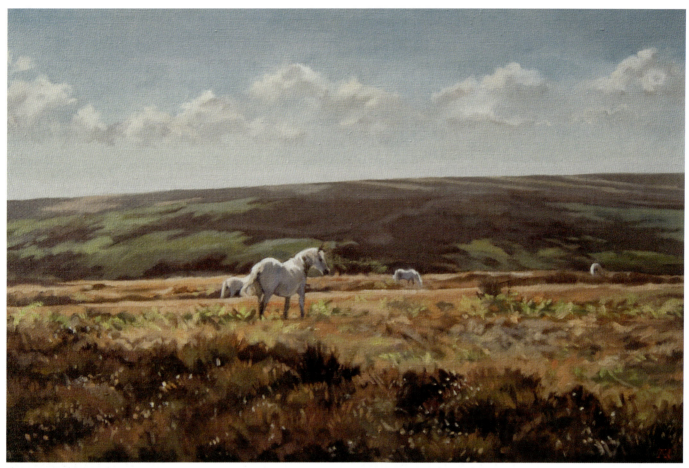

Ponies on the Moor. **18 × 26 in (46 × 66 cm).**

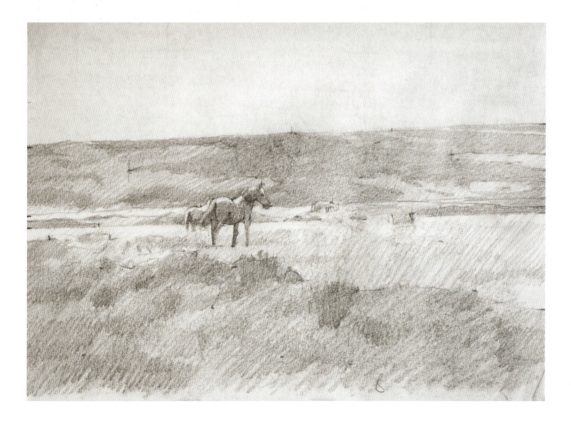

Drawing for *Ponies on the Moor.*

168

THE PAINTING

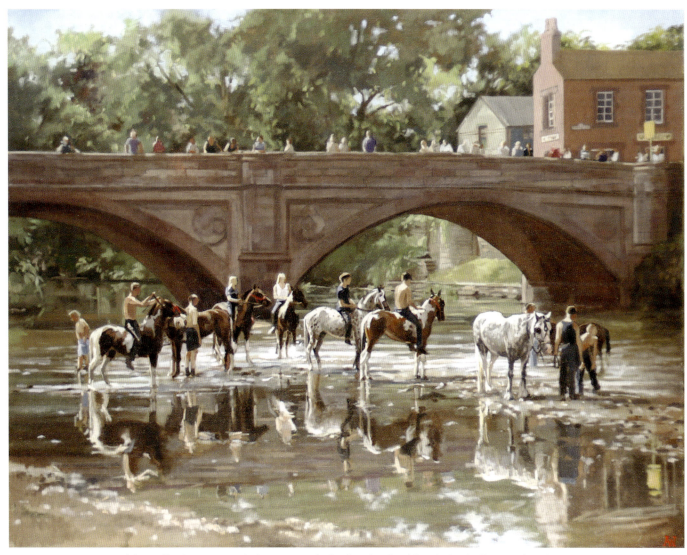

Appleby, Reflections. **32 × 41 in (81 × 104 cm). The drawing for this painting is illustrated in Chapter 2.**

TWO SUNNY PAINTINGS

Both of these paintings show sunny days, but in other respects are rather different. The painting of the grey ponies was intended to be a calm painting, showing a wide expanse of moor and ponies roaming across the heather and bracken to graze. To give the idea of wide open spaces, the landscape is composed of broad, roughly horizontal bands, and over a third of the canvas is a calm sky. The slight variations from horizontal of these bands and other features in the landscape creates a shallow, lazy zig-zag that drifts into the distance. There is a little aerial perspective, making the distant slopes slightly grey in colour – just enough to give depth and a slight feeling of heat haze.

With the Appleby painting, the sunlight is indicated by the use of strong contrasts in light and shade in the foreground of the painting, the sharpness of the shadows, and the strength of colour in the reflections. The focal point of this very complex composition is the skewbald horse and its rider in front of the right hand arch. The eye is drawn there by a variety of means, and held there by strong contrasts and larger colour variations than elsewhere in the composition including the sunlit yellows on the riverbank seen through the arch. The vertical of the rider's body, and the light catching his shoulders, also holds the eye.

There is very little sky in this painting, and though the top edge of the bridge provides a horizontal, this doesn't stand out tonally against its background. The many figures and horses, complete with their reflections, create a busier atmosphere than in the painting of the grey ponies, though the vertical stance of the riders and the horses' legs, and their vertical reflections, keeps a degree of unity and calm.

169

■ THE PAINTING

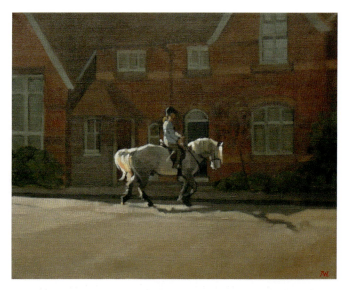

The School House. 12 × 15 in (30 × 38 cm). Notice how the shadow points to the horse and rider, as do the fascias on the roof.

LEFT: **Sketchbook page showing two drawings for** *The School House:* **the first in line, the second in tone. The leg positions of the horse have been changed between the two drawings, as has the position of the building behind the horse and rider. The door on the second drawing helps to focus attention on the horse's head, whereas in the first drawing it pulls the eye too far to the left.**

TWO BACKLIT PAINTINGS

In both of these paintings the main subjects are illuminated from behind, leaving them in shadow. In the painting of the Highland pony in front of the village school, the background is dark as the school itself is backlit, leaving the only strong light along parts of the pony's outline and through his forelock and tail. The painting is simple in its tone distribution: it has a large dark area with a few small lights in it, and a slightly smaller light area with a small dark area (the shadow of the horse) cutting into it.

In the racing scene, the light is falling on the landscape beyond, so the background of that painting is light in tone, gradually getting stronger in colour and a little darker in tone towards the foreground. In the dark area (the horses and the hedge) there are quite a number of lights, of different shapes and at different angles, making that area of the painting quite 'busy' and reinforcing the movement.

The colour range in the small painting is narrow, despite the strong light, which keeps the painting simple and the image clear. In both the paintings, the shadows cast by the horses indicate the strength of the light.

In the larger painting, the jockey's colours span a large range, linked to the landscape and the horses by greens and browns, with the red providing a focal point, as is often the case with a painting containing a lot of greens.

The Highland pony is walking calmly, giving an air of repose which is typical of a quiet summer Sunday morning, contained within horizontals and verticals. The racehorses are on a falling gradient, increasing the instability of the motion and making it appear faster. The angular shapes of the horses' legs increase the feeling of motion, with the light picking out the legs at the most interesting and dynamic angles. The strongest and most prominent contrasts are in the centre, on horse number eleven, with contrast decreasing with distance to the soft-edged, low-contrast trees in the distance, giving depth and space.

THE PAINTING

There is no right and wrong way to paint, only ways that work and ways that don't, and what will work varies according to the purpose of the picture and the skills of the artist. Instead of a solid opaque tonal underpainting, for this picture I used thin stains of colour (thinned with turpentine). The broad variation in bright colours of the jockey's silks was so important to the picture that I needed it in the painting right from the start.

I then built on top of it with solid paint. The disadvantage with a stained first layer is that although it does give an indication of the darks and the lights, it does it within a much narrower range of tones than either an opaque tone underpainting or a completed painting would be likely to have. This means that you have to keep a close eye on tone relationships as you work.

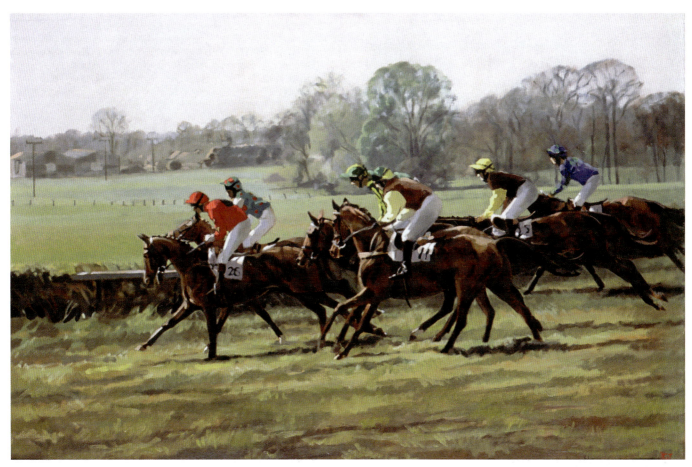

Down the Hill, Easingwold. 21 × 32 in (53 × 81 cm).

■ THE PAINTING

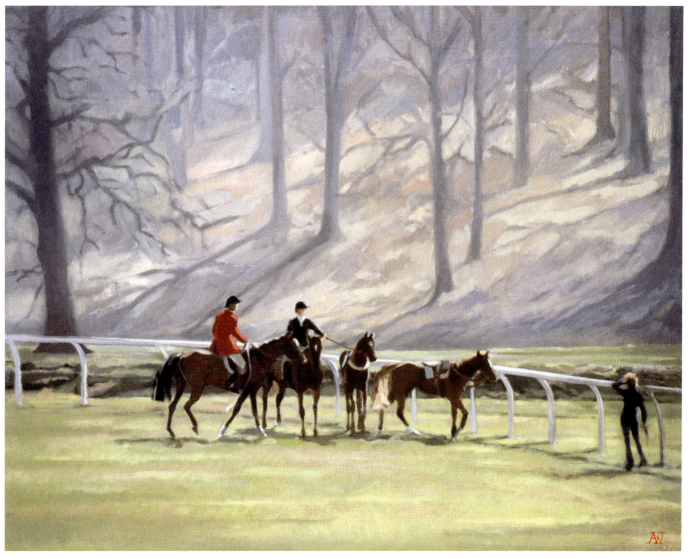

The Horse Catchers, Welbeck Abbey. **16 × 20 in (41 × 51cm).** Note how the eye travels across the picture until stopped by the spectator on the right.

A TALE OF TWO OPPOSITES

Here we have a painting that is high toned (light) over most of its surface and has high contrasts and a fairly wide range of colours, and another that is low toned (dark) over most of its surface with low contrasts and a very narrow range of colours (almost to the extent of being monochromatic). These two paintings show some very divergent possibilities.

The Welbeck painting is about action, supported by the crisp, bright effect of light. It has horses and human figures in a range of poses with lots of angles and directions, to create movement, and this effect is added to by the shadows of the trees, which point down to the main scene of the action. The near figure on the right helps hold the composition in on the right. It's worth noting that the backlit nature of the figures and the way the light catches their edges makes them look thinner and sharper.

In the other picture (the preliminary drawing for which can be found at the start of Chapter 2) the edges are softer, as is generally the case in low light. The contrasts have been kept low, with the whole painting having few areas that are at all light in tone. The purpose of this painting was to recreate the mysterious, gloomy, almost sinister atmosphere of a dark winter day in the forest. I wanted the viewer to be almost able to hear the horse's hooves touching the ground, the rustling leaves and the scampering of small creatures out of sight in the undergrowth, with an accompanying tingle of fear. There are no bright, intense colours at all, as any such colour would not have stood out in the gloomy light that is all that penetrates the trees on days such as this. Had I artificially introduced such colours, I would have not only broken up the simplicity of my design, I would have lost the continuity of the light, and my carefully constructed atmosphere would have been lost.

THE PAINTING

In Bishops Wood. **23 × 16 in (58 × 41 cm). In the composition here, the reins lead back from the horse's mouth to the rider's arm, up her shoulder, and then up to her head, keeping the eye in the most important part of the painting. The horizontal branches crossing in front of the vertical trees stop the painting becoming too vertical and keeps the movement going. The drawing for this painting is illustrated at the start of Chapter 2.**

■ THE PAINTING

Fred and the Grey Pony. 15 × 20 in (38 × 51 cm).

Drawing for Fred and the Grey Pony, showing how the painting evolved from a study purely in tone.

THE PAINTING

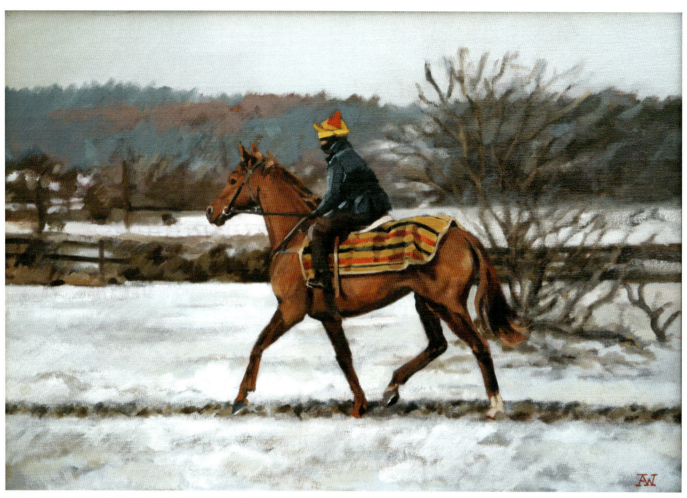

Winter Exercise. **14 × 20 in (36 × 51 cm). As in the painting** *In Bishops Wood,* **the reins lead the eye from the horse's head to the jockey.**

TWO SMALL PAINTINGS

Here we have a contrast in colour temperature. The painting of the grey pony is warm in colour, with brown trees and bracken, and golden light filtering through the trees. In the painting of the racehorse in the snow, the distant trees are blue, and although the chestnut horse and the colours on the rug are warm colours, the overall effect is one of cold, blueish light.

The more diffused light in the pony painting creates softer edges. Despite the early winter morning and the low light levels, the snow in the other painting reflects sufficient light for there to be sharp, high-contrast edges in the nearest parts of the composition (the horse and rider).

The racehorse's legs are crisply outlined against the light snow, and give a feeling of movement, whereas the pony's legs are hidden in the bracken; this, combined with the fact that the pony's movement across the canvas has been broken by the upright bough of the tree closer to us cutting across the pony's shoulder, makes the painting of the pony more static and calm. The more monochromatic nature of this painting also makes it calmer and less dynamic than the racehorse, with his brightly striped rug (this type of striped woollen rug in yellow, red and black, is called a Witney blanket and is often used in racing), and the work rider's bright hat.

Though there are no reds or orange yellows in the painting of the grey pony, it still feels warmer than the painting of the chestnut racehorse for all its bright colours. That's because the prevailing colours of the pony painting are warm, and we can see some distant sunlight filtering through the trees, whilst the blue greys in the snow, the work rider's blue jacket, the blue distant hills, and the absence of any strong, sharp shadows indicating direct light from the sun, make the racehorse look like he's out on a very cold day indeed.

■ THE PAINTING

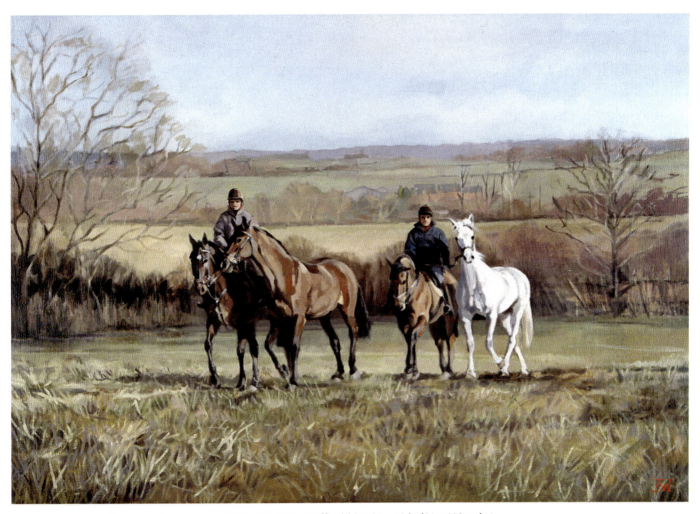

A Winter Morning, Staffordshire. **25 × 40 in (64 × 102 cm).**

HIGH CONTRAST, LOW CONTRAST

In the painting of the four horses being exercised, the level of contrast in the foreground figures and horses is quite strong and the edges between the colours are sharp, though this decreases with distance due to aerial perspective. The greens in the landscape also recede, changing from yellow greens (grass tends to have a yellow-green rather than a blue-green colour, especially in the winter) to bluer greens, and, eventually, to actual blues on the hills on the horizon. The colour range is fairly muted – mostly browns, yellows and blues, with a little red on one rider's collar.

The crisp contrasts in the foreground and the varying angles of the horses' legs make this a lively picture, with plenty of movement. The light areas on the grey horse, being close to the dark shadow on the jacket of the rider leading it, make an area of high contrast, keeping the viewer's attention there.

When I have more than one horse in a painting, I usually like to have their heads at different angles, as I have here, as it adds to the interest and movement in the painting.

In the New Forest picture, the mist and haze mean that even the log, closest to the front of the painting, doesn't show a great deal of contrast. The contrast is at its greatest on the left of the painting between the two upright boughs which are holding the composition in on the left. The soft edges in the painting, and low contrast, mean that is only after looking into the painting for a while that we begin to see the horses in the trees, adding to the atmosphere of mystery and discovery.

Aerial perspective is still evident in this painting even though the most distant objects are far closer than in the other picture. This is due to the dampness in the atmosphere from the morning mist. The main preparatory drawing for the first painting was in line, whereas for the second a careful tone study was necessary due to the subtler nature of the tones.

THE PAINTING

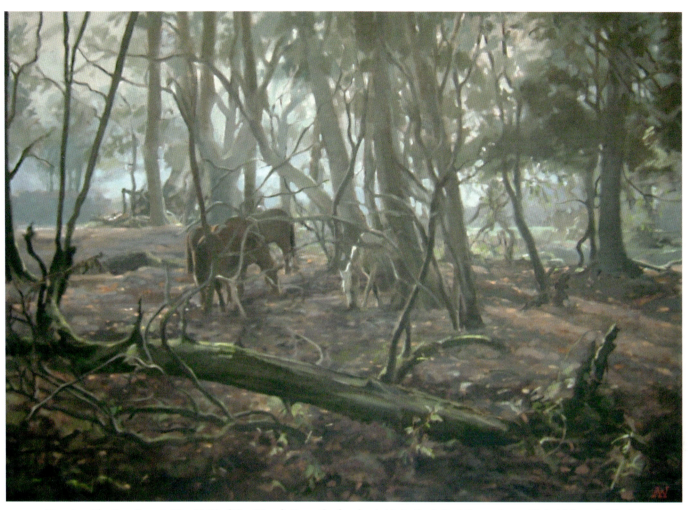

Morning, The New Forest. 23 × 32.5 in (58 × 83 cm). Here, the focal point is to the left of the centre and is held there by the tall branch coming up from the fallen tree.

Study drawing for *Morning, The New Forest*. As this painting was very much about tone, it was necessary to explore the tone relationships as well as the linear aspects of the composition. Note the changes between the drawing and the painting. I introduced the fallen tree at the front to give more depth and to make the viewer feel that they were watching from a greater distance.

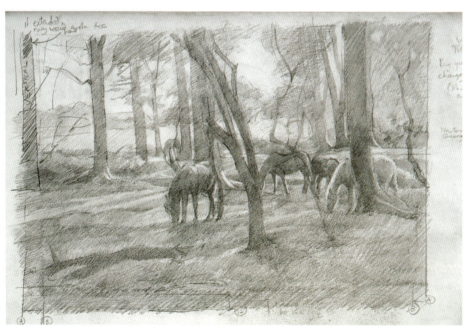

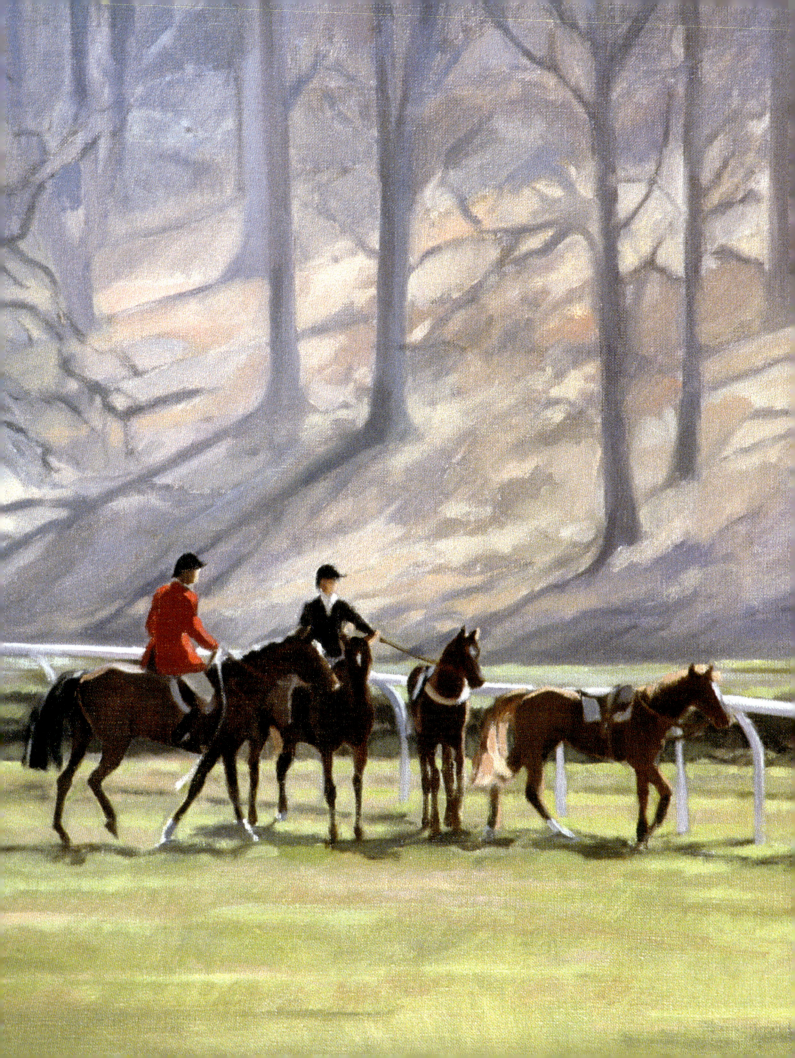

CHAPTER 10

PROFESSIONAL PRACTICE

'The art of protecting flat surfaces from the weather and exposing them to the critic.'
Definition of painting by Ambrose Bierce

PROFESSIONAL DEVELOPMENT

Professional artists are responsible for maintaining, updating and developing their own skills and working practices. This could include direct training, such as on a workshop or course at a local college, or private study at home. Colleagues may be able to give helpful advice.

Artists should try to attend a life class if at all possible, and visiting galleries is an essential part of an artist's ongoing training, whether it is to study a permanent collection, or to visit a special exhibition. Most artists gradually build up a stock of useful books, including books on technique, particular artists or schools of painting, permanent collection catalogues and special exhibition catalogues.

GROUPS AND EXHIBITING SOCIETIES

If you are a social animal, you may like to join a painting group. Groups may also exhibit and hold events, including workshops with tutors. Some are regional, some specialize in a subject, or a particular material, like oils or pastels.

Such organizations vary a lot in their style and how open they are to new members, so if you're thinking of joining one, ask to see their programme of events for the previous year, and for a few copies of their newsletter or magazine if they have one. That should give you an idea of whether they do the sort of things you'd be interested in, and at times and places that would suit you.

If they exhibit, go to their next exhibition. That will show you whether your work would 'fit' and whether the standard of work is at a level that would be appropriate for you. You may also meet some members in person, which could give an indication of how friendly the group might be.

LEFT: *The Horse Catchers, Welbeck Abbey.* **Detail.**

COMPETITIONS AND OPEN EXHIBITIONS

If you are thinking of entering for these, find out as much as you can beforehand. If it is a regular affair, look at the work of previous winners or visit the next exhibition (and if you need to sell your work, notice what, if anything, has sold, and for what sort of sums). Judges are not always the same the next time, but, particularly with panels of judges, one year's successful entries can sometimes offer at least a little guidance as to the sort of work preferred by the organization running the event.

General open exhibitions in Britain are not particularly sympathetic towards equestrian work at the present time, which makes it especially difficult for us.

Try to find out the general ratio of acceptances to rejections, so that you have a realistic idea of the odds that you are facing. If the chances you will be accepted are very slim, your entry fee will be most likely to end up subsidizing the fortunate who are accepted. If you are trying to earn your living as an artist, you need to work out all the costs involved, including entry fees, hanging fees, commission charged on any sales, and transport. Be realistic about the costs and benefits. Sometimes you can still be out of pocket even if you sell work.

Read all dates, rules and conditions carefully. In particular, make sure your frames and hanging fittings are as required. It is a nuisance for organizers when people turn up with work that is oversized, has the wrong fittings, or which falls foul of any other rules, and some organizations will reject work that doesn't conform to their rules without even looking at it.

Remember that having work accepted is no guarantee that it is good, just as having work rejected is no guarantee that it isn't. A painting is exactly the same painting the day after it goes in front of a selection panel as it was the day before: no better, no worse. If you want a constructive assessment of your work, go to an expert for a tutorial. Judges usually have to make selection decisions in a few seconds per piece, and it isn't reasonable to expect them to give feedback.

■ PROFESSIONAL PRACTICE

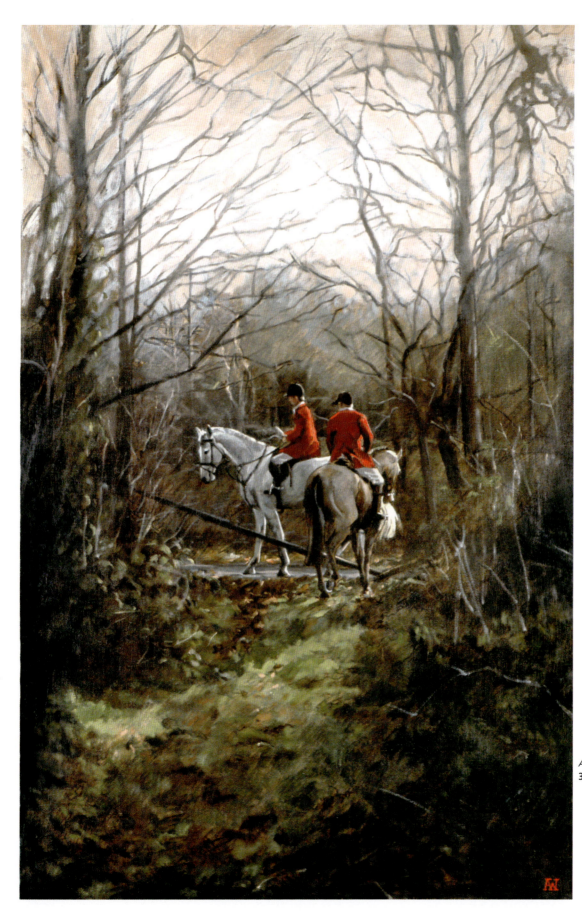

A Winter Afternoon.
30 × 23 in (76 × 58 cm).

GALLERIES AND WEBSITES

Galleries are closing everywhere, and often charge large commission fees; 40 per cent is about the average in Britain, plus tax, and your materials and framing costs have to be allowed for out of what's left, which doesn't always leave an artist with very much for their efforts.

It is worth considering having your own website and making direct sales. If you plan to sell this way, beware of fraud. Sadly, it is very common. Do some research on the Internet into the frauds currently in circulation, and be very careful about how you take payments.

HEALTH AND SAFETY

Be aware of any health and safety issues with the tools and materials you use, including solvents, and take practical steps to minimize any risks. Review your policy from time to time, and keep up with current advice, as this can change. In Britain, manufacturers are obliged to provide data sheets on their products and any associated risks on request.

Don't leave your tools or materials accessible to children or animals. Professional quality paints in particular can be highly poisonous. Keep them off your skin. Always wash/scrub your hands thoroughly after work, and before touching food.

STUDIO ORGANIZATION, STOCK CONTROL, AND RECORD KEEPING

Keeping equipment clean and well maintained is covered in Chapter 7. For efficient working, an artist also needs to keep control over their stock of materials so they don't run out of anything. If you are working professionally, you will probably have some kind of system for stocktaking; if you keep this up to date during the year, it can be helpful when ordering materials as you'll know what you're running out of.

Well designed and clearly labelled storage keeps artwork and materials in good condition, saving money, and means that equipment can be found quickly when needed, saving time. If you are fortunate enough to have a room of your own to work in, then it is worth spending a little thought on the best way to organize it to make the best use of space and natural light.

If you have to paint in artificial light, use lighting that replicates north light. Otherwise you may mismatch and/or misjudge colours.

As well as any financial records that you may need to keep for business purposes, it is useful to keep a record of sold works, and where unsold works currently are. If you have work for sale in a gallery on 'sale or return', they should give you a consignment note, listing the works you have left in their care. Apart from helping you and the gallery keep track of your work, if the gallery goes out of business the consignment note can help you to claim your property, so that it can't be sold to pay the gallery's debts.

TEACHING, DEMONSTRATIONS AND LECTURES

This sort of thing can be both interesting and rewarding. However, good planning is vital, and the less experienced you are, the more you will need to prepare.

Do a full rehearsal of any practical work and/or speaking you plan to do well in advance, and time it. Working without notes is great if you can do it, but only if you are totally confident you won't forget anything, and can deal with any eventuality. It is better to work well with some notes to keep you on track than to break down or get muddled without them. Make a list of anything you need to take with you so you don't forget anything vital, especially for demonstrations.

If you aren't used to speaking in public, start with small, friendly, informal groups, possibly working for free until you can be sure to deliver a good talk. Surprisingly, it can be easier to give a talk to strangers than to people you know.

Speak clearly and steadily. If you feel you are becoming nervous, take a few deep breaths, smile, ask your audience an easy question (this gives you a little time to think) and try not to let your voice get higher in pitch. Pretending you are confident will help you to be confident.

Watch your audience. If they seem to be losing concentration, be prepared to change your delivery a little, or break the pace by telling an anecdote or giving a tip. Audiences of artists in particular like to hear examples from the speaker's own experience.

I prefer, at least with small groups, to take questions as they arise as I find it helps me build a rapport with an audience. (Questioners may also forget what they were going to ask if they have to wait too long.) If you are worried that you might lose your train of thought if you have to answer questions, you might find it easier to deal with them at the end. Make it clear at the beginning of your talk which you plan to do.

When it comes to teaching, you need to be honest with yourself about your capabilities, and in particular, not take on serious teaching commitments unless you are sure you have the skills and experience to cope. Students may be anything from shy and nervous to very difficult indeed, and teaching is always hard work if done well. Being an artist is a solitary occupation, and not everyone, however good an artist they may be, has the right personality for teaching.

PROFESSIONAL PRACTICE

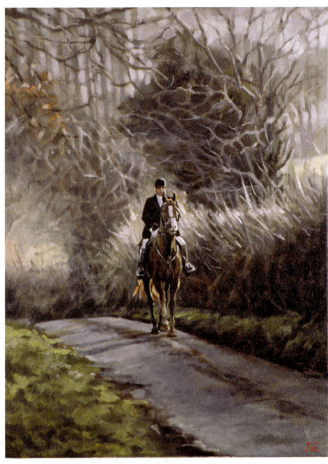

A Lane at Charnes. **20 × 15 in (51 × 38 cm).**

COMPUTERS

If you use a computer, the drill is: secure, save, back up and archive. Take regular professional advice for the best way to do this, as computing is changing all the time.

- Secure your system; most systems will need, at the very least, a regularly updated firewall and antivirus software.
- Save files regularly as you are working on them; I do this every few minutes.
- Back up (save copies of) your current files, preferably not on the hard drive you keep the original files on in case that fails. I do this at least once a day when working on the computer.
- Archive important files for long-term storage.

Far too few people archive their work properly; I have known several artists who have lost some, or, more appalling still, every single one of their photographs, including their only record of sold works, because they kept them all in one place on one device, which then failed. One person I know digitized their entire negative archive, destroyed the negatives to save space, and then lost the lot. It is far more likely that data will get damaged or corrupted than most people seem to think.

There are plenty of ways of archiving data, but there are advantages and disadvantages to all of them, and none are 100 per cent guaranteed. Take up-to-date professional advice on all these matters, but never rely on having only one place for storing important data. At the very least, keep a second copy of all your data, including any business records, on an external hard drive, so that you have at least one completely separate copy. Archiving can be expensive and time consuming, but ask yourself, how much is your data worth to you?

If the worst happens and important and irreplaceable data is damaged or lost, don't try to fix it yourself. Call the experts immediately. Go to a professional data retrieval company. This is likely to be very expensive, and there are no guarantees it will work (though some work on a 'no fix, no fee' basis) but it is probably the best chance you have of getting your data back. It might be worth seeking a second opinion if anyone suggests that wiping all your data is the only option.

FRAMING

Framing is important. A weak painting needs a good frame, and a good painting deserves one. If you plan to sell your work, unless you are good at carpentry it is generally best to find a good framer and hand the job over to them. Bad framing can lose you a sale.

I am always willing to sell paintings unframed, as some clients prefer to use their own framers; others want frames to match those on paintings they already have.

ARTIST'S BLOCK

If you get through your whole career without once experiencing this, then you're a very lucky (and very rare) person. Almost everybody gets it sooner or later. There are several types of artist's block, such as not being able to think of anything to paint, not being able to get down to working at all, and being able to work but being bored with what we're doing. The reasons behind artist's block can be just as varied, from a crisis of confidence resulting in a fear of failing, to simply being stuck in a rut.

Here are a few remedies that I, or other artists I know, have found useful against the dreaded block:

- Get some direct contact with horses – go to the horse sales, a gypsy fair, a circus, a horse show, or go to the

PROFESSIONAL PRACTICE

races.
- Go to an art gallery (and do some drawing there).
- Treat yourself to a book on an artist you admire.
- Arrange a trip to go sketching with an artist or a group of artists that you get on well with.
- Do some work using materials you haven't used before.
- Work much bigger, or smaller, than you usually do; if you normally work loosely, do some detailed work, and vice versa.
- Get out into the fresh air to work. It doesn't have to be horses: it might even be better if it isn't. Try painting or drawing something different – a landscape, perhaps – or take a trip to the zoo and draw there.
- Look back through old sketchbooks; there may be a good idea there that you've forgotten about.
- Set yourself a goal, like planning an exhibition.
- Tidy the studio.
- Prime some canvases.
- Do some routine exercises on basic skills.
- Join a life class.
- Dig the allotment.
- Go for a walk or a bike ride with your sketchbook every day for a week and promise yourself you'll do a drawing each time of something you see.

Remember that everyone gets artist's block and don't beat yourself up about it. Just do something about it. If lack of confidence is an issue for you, only set yourself manageable tasks, and avoid working under time pressure until you get your confidence back. The main thing is always to grit your teeth and get doing something. It doesn't have to be a masterpiece.

Development as an artist doesn't happen evenly. Sometimes we learn a lot in a short time, which feels wonderful, like suddenly seeing the light. It may then take as much as a year or even longer to consolidate new knowledge into our work, and that too can be exciting and interesting. But there are also times when our work sticks on a plateau for long periods of time, never getting any better. We may feel that we are going backwards – and we may even be right.

All this is perfectly normal, but that doesn't mean that we can just sit back and wait for it to solve itself. It won't. That's the only certain thing in all this. We have to take the initiative and work our way out of it, asking for help if necessary. Some people find it helpful to set themselves timetables, targets and rewards; others find such things add to the pressure and don't help at all. You have to discover what works for you, as in the end, it is up to you – no one else can do your work for you.

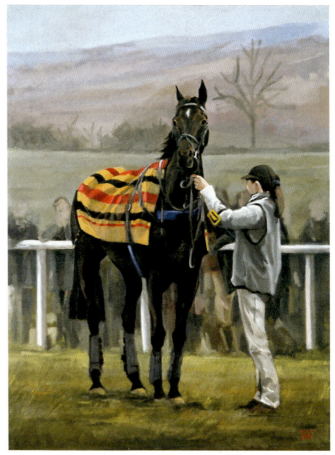

The Lord Roberts. **26 × 20 in (66 × 51 cm).**

It's part of the price we pay for developing. (An artist friend of mine often says that if you always do what you've always done, you'll always get what you've always got.) Unless you're the sort of person who can be perfectly happy trundling along doing the same undemanding old stuff all their life, at some point you'll have to tackle this problem.

Most professional artists also need some outside interest(s). It is a solitary job, and a hobby of some sort, particularly one that involves you in interactions with other people (other than artists) can help you stay sane and keep some degree of perspective on the problems that come up during the working day.

And finally, a few last words …

I remember from many years ago that my Foundation tutor used to bounce in to the studio and shout at us all, 'Are you happy in your work?' I hope you are, and that you remain so, and wish you every success with it.

GLOSSARY

ART TERMS

accent	heavy part of a line or lines at a particular point, usually marking a change of direction.
bleed	(of marks on paper) mark spreads out as on blotting paper.
blockbuster	big, fashionable exhibition of master paintings.
blocked in	simply painted base layer.
body colour	gouache, or watercolour used with the addition of white to make it opaque.
bulldog clip	sprung metal clip for holding paper.
cast	a plaster cast of a sculpture.
chroma	*see* intensity.
contrast	difference between light and dark.
dip nib	plain nib without a cartridge or other ink storage attached; ink is picked up by dipping the nib in the ink as you work.
foldback clip	sprung metal clip for holding paper.
fugitive	changes or fades with exposure to light, or over time for any other reason.
grisaille	painting in tones of grey.
ground	prepared surface to be painted on.
high-toned	light in tone.
hue	specific colour, e.g. scarlet, crimson.
intensity	(or chroma) how saturated a colour is.
lay figure	a jointed model, usually in wood, of a human or animal or part thereof.
mahlstick	stick used to rest and stabilize the hand when painting.
MDF	Medium Density Fibreboard, hard, smooth-surfaced board made from wood fibre mixed with resins and other materials.
monochrome	variations of one colour, possibly mixed with white and/or black.
permanent	pigment that doesn't change or fade with exposure to light, or over time for any other reason.
pigment	specific colour of a paint, e.g. Cadmium Yellow, or specific material which gives paint its colour, e.g. Cadmium Sulphide.
radial easel	specific type of easel with three short thick legs, which can be folded up for transport and storage; much heavier and more stable than a sketching easel.
reservoir	small clip-like device which slides onto a dip nib to aid it in holding more ink per 'dip'.
rigger	thin brush with very long hair.
sanding block	pad or block of sandpaper, used for sharpening points on drawing materials or torchons.
stable	material that doesn't deteriorate over time.
tone/value	how light or dark a colour is.
torchon	tightly rolled cylinder of paper which is used for blending pencil, charcoal or other similar materials. The end can be shaped using a sanding block.
watercolour block	paper glued round all four edges to make a block so that the paper can, with care, be used unstretched; pages are removed after being worked on by inserting a blade into a gap in the glue and sliding the blade round the sheet.
weight (of a line)	thickness and/or blackness of a line.

HORSE TERMS

Illustrations and/or explanations of terms relating to the parts of the horse and its general anatomy can be found in Chapter 4, as can terms relating to tack and saddlery.

bareback	being ridden without a saddle.
conformation	the proportions and structure of a horse.
forehand	parts of the horse in front of the withers, including chest, neck, head and front legs.
hindquarters	*see* quarters.

Glossary

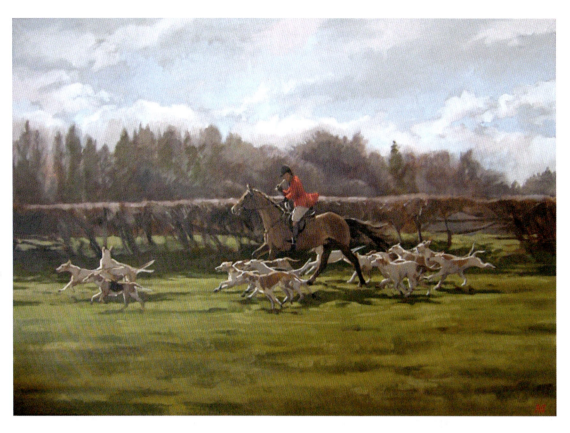

Huntsman and Hounds, Howick. 23 × 32.5 in (58 × 83 cm).

in-hand	horse being led.
ménage	outdoor area for schooling horses.
nearside	horse's left side.
numnah	pad or blanket used under a saddle.
offside	horse's right side.
point-to-point	amateur horse race over fences, often over farmland.
points	(of the horse) names for parts of the horse.
quarters	body between flanks, tail and upper part of hind legs.
surcingle	extra girth over the top of a saddle.
tack	horse equipment.
tacked up	horse fitted with bridle, saddle, or whatever will be required for working.
under saddle	being ridden using a saddle.

Common Horse Colours

bay	brown with black mane, tail, and a definite change to black in the legs.
black	black all over.
blue dun	black hair mixed with white, but skin, mane and tail will be black; it may have a black dorsal stripe; looks blueish.
brown	darker brown than a bay, sometimes shading to black in the legs.
chestnut	orange brown, usually including mane and tail, though some chestnut horses may have flaxen (pale yellow) manes and tails.
cream	creamy colour, often with a blue ('wall') eye.
dapple grey	white with grey or black dappling.
dun	see blue dun, yellow dun.
flea-bitten grey	white with speckles of grey or black all over.
grey	white.
iron grey	grey with darker grey dappling.
liver chestnut	similar to chestnut but darker, bluer coat.
palomino	golden yellow with white mane and tail
piebald	white with large black patches.
roan	white hair evenly mixed all over with hair of another colour. If the other colour is bay, it will be a red roan; if grey, a blue roan; and if chestnut, a strawberry roan.
skewbald	white with large patches other than black (usually brown).
yellow dun	pale golden brown, sometimes having a black dorsal stripe (stripe along the top of the back above the spine) and/or black markings on the legs.

BIBLIOGRAPHY

Where books I would like to recommend are no longer in print, I have tried to list a suitable alternative, but unfortunately this has not always been possible. I have marked with an asterisk those books which I think would be a good start for a working library.

As mentioned in Chapter 4, some of the names for muscles, tendons and bones in old books and their reprints will be different in modern books. There is a brief conversion list in an appendix to the 1996 Allen edition of L.D. Luard's book.

PAINTING AND DRAWING METHODS AND MATERIALS

*Calderon, W. Frank, *Animal Painting and Anatomy* (Dover, 2003) Reprint of a book of 1936. Very thorough in text and illustrations, and good on drawing and painting as well.
Coward, Malcolm, *Sketching Horses From Life* (Palette Press, 2012) Full of useful advice, both on drawing and painting.
Gottsegen, Mark, *The Painter's Handbook* (Watson Guptill, 1993) Some information in tabular form, making comparisons between materials easier than in other books.
Mayer, Ralph, *The Artist's Handbook of Materials and Methods* (Faber & Faber, updated 1991) Very technical and detailed, more suitable for the advanced/professional artist.
*Pearce, Emma, *Artists' Materials* (Arcturus, 2005) Clear, comprehensive, practical, and easy to follow, even for complete beginners.
Simpson, Charles, *Animal and Bird Painting* (Batsford, 1937)
Vicat Cole, Rex, *Perspective for Artists* (Dover, 1976)

ART HISTORY

Gombrich, E.H., *The Story of Art* (Phaidon, 1995) Basic history of Western art for those who have not studied art history.
*Mitchell, Sally, *The Dictionary of British Equestrian Artists* (The Antique Collectors' Club, 1985) The classic reference work on the subject.
Titley, Norah M. and Fountain, Robert, *A Bibliography of British Sporting Artists* (British Sporting Art Trust 1994, plus Supplements 1985–1994, and 1995–2001) Not illustrated. A detailed list of books and articles on all aspects of sporting art, available directly from BSAT (*see* Contacts section).
Berry, Claude, *The Racehorse in Twentieth Century Art* (The Sportsman's Press, 1989)
Fairley, John, *Racing in Art* (Rizzoli, 1990)
Pendred, Gerald, *Inventory of British Sporting Art in United Kingdom Public Collections* (Boydell Press, 1987) Useful for locating paintings (no illustrations).
Walker, Stella, *Sporting Art*, England 1700–1900 (Studio Vista, 1972)
Walker, Stella, *British Sporting Art in the Twentieth Century* (Sportsman's Press, 1989)

BOOKS ON THE HORSE

The British Horse Society, *The Manual of Horsemanship* (The Pony Cub, 2012) New, expanded edition of a very useful general book, including sections on tack and conformation. A must for anyone with no experience of horses.
*Draper, Judith, *The Ultimate Encyclopedia of Horse Breeds and Horse Care* (Ultimate, 2000)
Summerhayes, R.S., *Summerhayes' Encyclopaedia for Horsemen* (Warne, 1952, but many later editions) Useful for reference.
Summerhayes, R.S., *The Observer's Book of Horses and Ponies* (Warne, 1961) Pocket-sized book on horse breeds; black and white photographs. Out of print, but easy and cheap to find second hand.

Horse Anatomy

*Goody, Peter, *Horse Anatomy: A Pictorial Approach to Equine Structure* (J.A. Allen, 2001) Clear diagrams from many viewpoints.
Stubbs, George, *The Anatomy of the Horse* (Dover, 2012) Reprint of the great classic of 1766. Mostly of historical interest.

Anatomy/Movement Books Designed Specifically for Artists

*Calderon, W. Frank, *Animal Painting and Anatomy* (Dover, 2003) Reprint of a book of 1936. Very thorough.

Ellenberger, W., Dittrich, H., and Baum, H., *An Atlas of Animal Anatomy for Artists* (Dover, 1966) Reprint of a classic from 1949 which contains views from several angles. Mostly diagrams.

*Luard, L.D., *The Horse, its Action and Anatomy* (J.A. Allen, 1996) Preferable to the Dover edition (which is only in black and white). Diagrams, drawings, and extensive text explaining the mechanics of movement. Reprint of the text first published in 1935 with useful addenda to bring it up to date.

Horse Conformation

Harris, Susan E., *Conformation, Movement and Soundness* (Howell, 1997) Small but excellent book.

Oliver, Robert, *A Photographic Guide to Conformation* (Allen, 2002) Enlarged and updated edition of the 1991 classic.

Useful information on conformation can also be found in The British Horse Society's *The Manual of Horsemanship*.

Horse Movement

Higgins, Gillian, *How Your Horse Moves* (David and Charles, 2011) To illustrate the extensive text, the author painted bones and muscles onto horses which were then photographed whilst moving. This book helps if you are trying to relate anatomy diagrams on paper to real horses and the way they move.

*Muybridge, Eadweard, *Animals in Motion* (Dover, 1957) Reprint of 1887 edition. Closely spaced sequence photographs of animals, against a background grid. The photographs are black and white and small, but there is no other book which offers anything equivalent. Widely used by artists and animators.

*Smythe, R.H., Goody, P.C., Grey, Peter, *Horse Structure and Movement* (J.A. Allen, 1998) Modern book explaining skeletal structure and the function of muscles in detail.

Wyche, Sara, *The Horse's Muscles in Motion* (Crowood Press, 2002) This book simplifies the skeleton to a mechanical system and then explains how it works. I find it very helpful.

Wynmalen, Henry, *The Horse in Action* (Dover, 2005) Reprint of 1954 edition. Illustrated by Michael Lyne. Comprehensive sets of drawings on the gaits, including faulty gaits, with explanations.

Dissection

Ashdown, R.R., Done, S.H., Evans, S.A., *Colour Atlas of Veterinary Anatomy, Volume 2: The Horse* (Mosby-Wolfe, 1987) A detailed photographic record of dissections of horses with accompanying diagrams and captions. Unsuitable for the squeamish.

Tack

There are hundreds of books on this subject, but I find the most useful source of all-round information on riding tack, including how it should be fitted, is in fact in *The Manual of Horsemanship* listed above.

Ellis, Vivian and Richard, *Make the Most of Carriage Driving* (J.A. Allen, 1998) Illustrated by Joy Claxton.

Keegan, Terry, *The Heavy Horse: Its Harness and Harness Decoration* (Pelham, 1973)

Spooner, Patricia and Victoria, *All About Riding Side-Saddle* (J.A. Allen, 1999) Short book with information on side-saddle tack.

Zeuner, Diana, *The Working Horse Manual* (Old Pond Publishing, 2011)

OTHER BOOKS MENTIONED IN THE TEXT

Cennini, Cennino, *The Craftsman's Handbook (Il Libro dell'Arte)* (Dover, 1960) Translation of the 15th-century original.

Glass, F.J., *Sketching from Nature* (Macmillan, 1897)

Goubaux and Barrier, *The Exterior of the Horse* (Lippincott, 1892) Translated from the second French edition.

Reynolds, Sir Joshua, *Discourses on Art* (Yale, 1975) Modern edition of the 1797 original.

Speed, Harold, *Oil Painting Techniques and Materials* (Dover, 1987) Reprint of the 1924 edition.

Stokes, Adrian, *Landscape Painting* (Seeley, Service and Co., 1925)

da Vinci, Leonardo, *Leonardo On Painting* (Yale, 1989) Modern translation of original published in 1651 (many years after the artist's death).

Willoughby, David P., *Growth And Nutrition In The Horse* (Barnes, 1975)

ACKNOWLEDGEMENTS

My thanks are due to all my teachers, especially the late Don Matthews whose teaching in the life room at Burnley College gave me the professional tools which I have used ever since.

As a scenic artist I was privileged to be taught by Hilary Vernon-Smith, and Lester Polakov. Many of the things they taught me in the theatre I still use every day in the studio.

Being an artist is a solitary life, so artists need other artists whom they can trust for honest (and at times robust) opinions. I am lucky to have such friends; they know who they are, but special mention here has to be made of Malcolm Coward, who has generously advised me often, as he has many others.

Anyone who has ever taught owes a lot to their students, so my thanks to them as well. I hope they have all forgiven me by now for snapping at them when they didn't concentrate.

I'd also like to thank all those from the horse fraternity who have helped me over the years, and particularly the Freer family and their staff, who have made horses of every shape and size available to me as models for the last twenty years, even riding out for me in the snow.

As do all authors, I have to thank my family and friends for their patience, advice, and practical help during the writing of this book. I wish John, Peggy, and Jim were here to share this with us.

My heartfelt thanks are due to those people and organizations who have helped me with this particular book, though of course, all errors or omissions in the book remain entirely mine. Particular thanks to all my draft and proof readers, and to Malcolm Coward, Robin Furness, Hannah Merson, Roy Miller, Glynis Mills, John Beresford and Susie Whitcombe, for generously allowing me to reproduce their work. Thanks also to The Walker Art Gallery, Liverpool, the City of Birmingham Art Gallery, and the York City Art Gallery for permitting reproduction of their paintings. Thanks to Glynis Mills for advice on the horse gaits and tack section, Janneke Sleutjens of Pool House Equine Clinic for answering veterinary questions, and the Veterinary School at the Sutton Bonington campus of Nottingham University for allowing me to draw their skeleton.

Finally, my sincere thanks to all the horses that have stood patiently while I painted and drew them for no more in return than a pat and a few polo mints, and the even more tolerant ones who have graciously allowed me to ride them over the years. Horses do a lot for us, and ask very little in return. Whether we ride, paint or draw them, they deserve the best we can do.

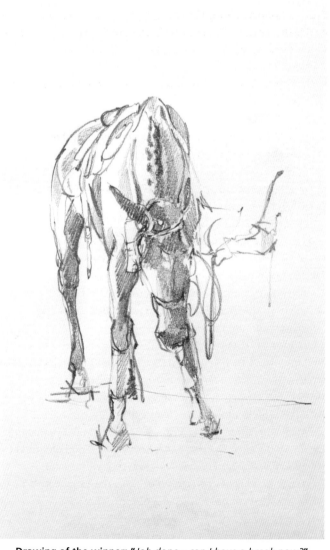

Drawing of the winner: *"Job done – can I have a break now?"*

MATERIALS SUPPLIERS AND USEFUL CONTACTS

MATERIALS SUPPLIERS

BestBrella (by website only) Website: www.bestbrella.com
Painting umbrella – a robust product, unlike many others.

Bird and Davis, 45 Holmes Road, Kentish Town, London NW5 3AN Website: www.birdanddavis.co.uk Linen canvas, stretchers (including bespoke), and Old Holland paint.

L. Cornelissen and Son, 105 Great Russell Street, London WC1B 3RY Website: www.cornelissen.com General art materials and Robersons sketchbooks.

Daler Rowney Website: www.daler-rowney.com Manufacturers of artists' materials.

Jacksons Website: www.jacksonsart.com General art materials including pencil caps and extenders.

M.A.B.E.F. Srl, Via A. Volta 77/79, 21010 Cardano Al Campo (VA), Italy Website:www.mabef.it Easels.

Old Holland Classic Colours, Nijendal 36, 3972 KC, Driebergen, The Netherlands Website: www.oldholland.com
Paint.

The Paper House Website: www.bargainartistshop.co.uk General art and graphics supplies.

Plasplugs Products Limited, Windsor House, Windsor Industrial Estate, Hawkins Lane, Burton-upon-Trent DE14 1QF Website: www.plasplugs.com Retractable scalpel with safer blade-changing system (they call it a 'craft knife').

Rosemary & Co. Artists' Brushes, PO BOX 372, Keighley, West Yorkshire BD20 6WZ Website: www.rosemaryandco.com Brushes (including short-handled bristle for oils suitable for sketchboxes, and a bespoke brush-making service).

St Cuthbert's Mill Website: www.stcuthbertsmill.com
Manufacturers of high quality papers, including a unique high-white rag paper. This excellent new website even gives soaking times for those wishing to stretch their papers.

Winsor and Newton Website: www.winsornewton.com
Manufacturers of artists' materials.

USEFUL CONTACTS

British Horse Society Website: www.bhs.org.uk
If you are looking for a riding school in Britain, the British Horse Society has a list of approved establishments.

The British Horseracing Authority
Website: www.britishhorseracing.com Information on professional horse racing.

British Sporting Art Trust Website: www.bsat.co.uk
A charity which has a collection of historical sporting art, items from which it exhibits at the National Horseracing Museum, where it also has a library of books on sporting art. BSAT promotes sporting art and publishes articles and books on the subject.

Jumping for Fun Website: www.jumpingforfun.co.uk
An independent and informal website for people interested in British point-to-point racing.

The National Horseracing Museum Website: www.nhrm.co.uk
Based in Newmarket, well worth a visit.

The Point-to-Point Racing Company Website: www.point-to-point.co.uk Official site for point-to-point (amateur) horse racing.

United Kingdom Copyright Service, 4 Tavistock Avenue, Didcot, Oxfordshire OX11 8NA
Website: www.copyrightservice.co.uk

INDEX

References to illustrations are listed in bold.

acrylics 7–8, 54, 118, 153, 154, 157, 159
Adam, Emil 13
aerial perspective, *see* perspective, aerial
Agasse, Jacques-Laurent 13
aim of a painting or drawing 28–29, 51, 107, 144, 162
Alken family 13
alkyds 8
anatomy of the horse 22, **60**, 61–67, **62–67**, 89,
angles of view 48–49
aquatint 93
accuracy vs. detail 29
Arabian horse 78
Armour, George Denholm 13
art terminology 184
artist's block 182–183
Assyrian sculpture **58, 59**
backgrounds 9, 48, **48**, 83, 89, 129
backlit subjects 170–171, **170–171**
balance (in composition) 112
Barber Institute of Fine Arts, University of Birmingham **94**
Beresford, John **54**, 188
Bevan, Robert 11
Biegel, Peter 13
Bierce, Ambrose 179
Birmingham Museum and Art Gallery 96, **96**, 188
Bonheur, Rosa 11
box easels 117–118, **118**
breeds 78, 80–81, **79–81**
bridle, double **77**
bridle, snaffle **77**
bridles 77
British Museum **58–59**
Calderon, W. Frank 7, 11, 19, 23
canter 72, **72–73**, 75
canvas clamps 117
canvas pins 117
canvas size, proportion, format 107–109, **108–110**
cartoons 94
cattle 42–43, **43**
Cennini, Cennino 59
Cezanne, Paul 94
chalks 39, 54, 149
charcoal 39, **39**, 92, 95, 97, **132**, 149, 154, 156
charcoal, compressed 39, 92
choosing a subject 133–137

Clark, Sir Kenneth 61
cleaning and maintaining equipment 119
clouds 50, **50**
cob 78, **79**
Cole, Rex Vicat 26–27
colour relationships 104
colour temperature 103, 130, 175, **174–175**
colour, exercise 128–129, **128–129**
colour, observed 103
colour, reflected 103–104, 131
colour, relative 104
coloured pencil **94**, 95, 97
combining source material 130–131
competitions 179
composition 110–114, **111, 115**, 139–140, 142–151, **142–151, 164**, 165, 169, 172, **173**
computers 182
conformation 22, 80–81
Constable, John 52, 94, 111, 115, 117, 161
conté 39
contour 21–22
contrast 106, **106–107**, 130, 169, 170, **170–171**, 172, 175, 176, **176–177**
copying, *see* transcription
copyright 34, 95
cotton 153
Courbet, Gustave 11
Coward, Malcolm **14**, 188
cropping images 107–8
Cuneo, Terence 13
Curling, Peter 13
Cuyp, Aelbert 11, **94**, 96, 97
Da Vinci, Leonardo 61, 83, 94
De Dreux, Alfred 11
Degas, Edgar 11, 94, 103
Delacroix, Eugene 52
demonstrations 181
detail 29, 99, 113, 114–115, **114**, 133–134
detail, accuracy and 29
diagonals 99, 111
direct measurement 84–85, **84–85**
dissection 61–62
distance 106
draught horse 78
drawing exercise, memory 88–89, **88–89**
drawing exercise, motion 90–91, **90–91**
drawing exercises, general 92